The History and Decoration
of the Ponte S. Angelo

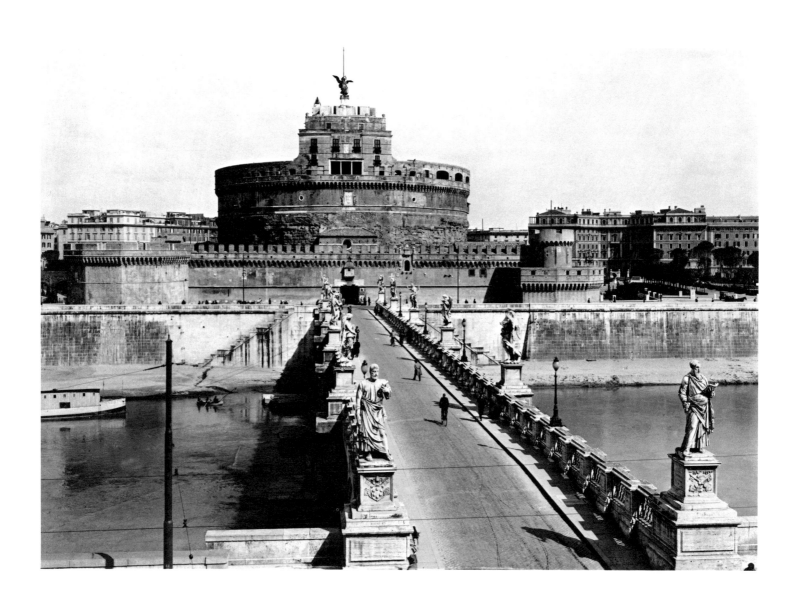

The History and Decoration

of the Ponte S. Angelo

Mark S. Weil

The Pennsylvania State University Press

University Park and London

Library of Congress Cataloging in Publication Data

Weil, Mark S.
 The history and decoration of the Ponte S. Angelo.

 Bibliography: p. 155
 1. Rome (City)—Bridges—Ponte San Angelo.
 2. Sculpture, Baroque—Rome (City) I. Title.
NB620.W44 730'.945'632 72–163216
ISBN 0–271–01101–7

To Howard Hibbard

Contents

Acknowledgments

Most of the research for the present study of the Ponte S. Angelo was carried out in Rome during the years 1965–67. I went to Rome with the intention of writing my dissertation (Columbia University, 1968) on some aspect of workshop procedure and the relationship between master and assistants in seventeenth-century Rome. The study of Bernini's decoration of the Ponte S. Angelo proved to be an excellent vehicle for such research because it allowed me to examine one project in detail and at the same time to study the relationship of the eight sculptors who collaborated in the decoration of the bridge to Bernini and other important artists of the Roman baroque. In addition the topic allowed me to expand my horizons by becoming involved in the history of the city of Rome and the iconology of the Eucharist.

My approach to the probems presented by the Ponte S. Angelo is in large measure the result of my having been fortunate enough to study with Rudolf Wittkower, whose lectures and publications served as a challenge and an inspiration and shaped the way in which I think about baroque art. My debt to Professor Wittkower is not just a general one, however, for he made suggestions that greatly improved this study.

My work has been facilitated by the kindness and cooperation of many other individuals and institutions. I am idebted to Professor Wolfgang Lotz and the staff of the Bibliotheca Hertziana, who always have been generous with time, space, and advice, as have been Mrs. Inez Langobardi and the staff of the library of the American Academy in Rome. I would also like to thank Professor Marcello del Piazzo, Director of the Archivio di Stato, Rome, for giving me permission to publish the documents appended to this book, and the Graduate School of Arts and Sciences of Washington University for a grant that allowed me to spend two weeks in Rome during the spring of 1971, checking footnotes and arranging for photographs of the statues on the Ponte S. Angelo and those in S. Andrea delle Fratte.

The individuals who aided me in the preparation are too numerous to list. I am especially grateful to Jennifer Montagu and Rudolf Preimesberger for freely sharing their considerable knowledge of baroque sculpture; to Kevin Herbert for helping with the translation of a latin poem that is of great importance to the present study; and to Ernest Nash and Alfred Frazer for criticizing drafts of the first chapter of this book. My manuscript was read by Ellis Waterhouse and Ann Percy, both of whom made many useful suggestions; as has my wife, Phoebe, who helped me at every stage of the development of this study. My greatest debt of gratitude is to Howard Hibbard, to whom this book is dedicated.

List of Illustrations

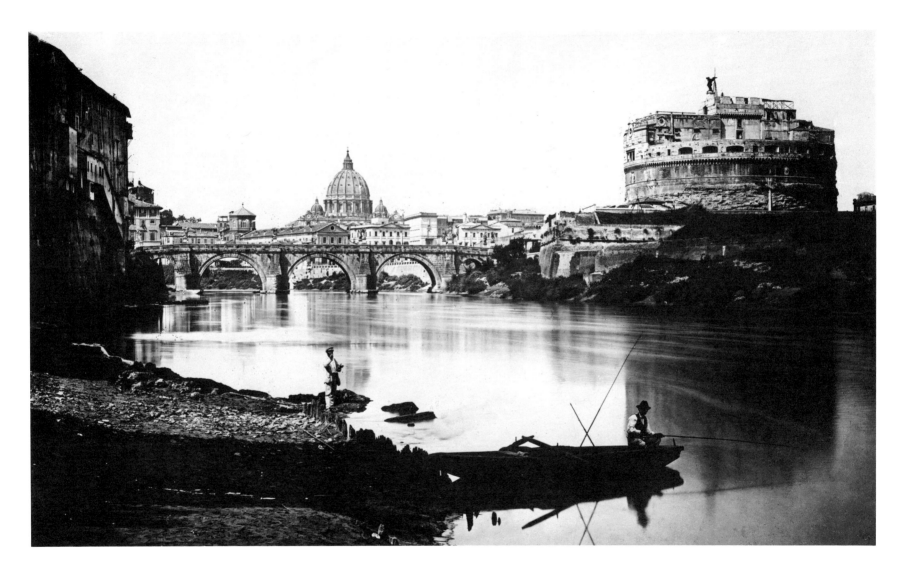

1. Castel and Ponte S. Angelo before 1892

I

The Ponte S. Angelo

The story of the Ponte S. Angelo (figs. 1–4) involves more than the history of its construction and decoration. The ancient origin of the bridge and its central location within the city of Rome caused it to develop into a monument of primary interest to those Romans and visitors to Rome who were concerned with the history and traditions of the city. The bridge served as the chief link between the Vatican and the major population center of the city and hence as part of the road taken by all pilgrims and visitors to the Basilica of St. Peter, as well as by all papal processions to and from the basilica. The seventeenth-century decoration of the Ponte S. Angelo was, therefore, an organic outgrowth and a culmination of its relationship to the city and religion that it served.

The organic relationship of the Ponte S. Angelo to the city of Rome and to St. Peter's is not clear to many modern visitors to Rome. Today the Ponte S. Angelo is one of the smaller of many bridges crossing the Tiber, and it no longer carries visitors and pilgrims to the Vatican. Traffic has been routed across the larger Ponte Vittorio Emanuele, a late nineteenth-century bridge that crosses the Tiber just south of the Ponte S. Angelo. The Ponte S. Angelo and the Castel S. Angelo, the fortress to which the bridge leads, have become historical curiosities. The Castel S. Angelo, which served as the chief fortress of the pope for several centuries, has become a museum of art and military history. The bridge is now a pedestrian island from which one can enjoy views of the Tiber and St. Peter's, as well as the statues that decorate the bridge.

The beauty and monumentality of the Ponte S. Angelo continue to be impressive but in fact have been reduced along with its function. The bridge crosses high above the Tiber between the two massive embankments built on either side of the river in the 1890s; between 1892 and 1894 its shape was adjusted to fit the new embankments. The bridge now spans the Tiber with a roadway carried by five equal arched openings, of which only the three central openings and the four piers supporting them are part of the original bridge.

The original bridge, the ancient Pons Aelius—dedicated in 134 A.D. and named for its builder, the emperor Hadrian (Publius Aelius Hadrianus)—was conceived as the monumental approach to the Mausoleum of Hadrian (dedicated in 139 A.D.; fig. 104).[1] The mausoleum was constructed on two levels, a rectangular base surmounted by a high cylindrical drum. The entire structure was faced with marble and decorated with statues. The fifth-century historian Procopius describes the splendor of the Mausoleum of Hadrian in the following terms:

> The tomb of the Roman emperor Hadrian stands outside the fortifications, a very noteworthy site. For it is made of Parian marble; and the stones fit closely one upon the other, having nothing at all between them. And it has four sides which are all equal, being about a stone's throw in length, while their height exceeds that of the city wall; and above there are statues of the same marble, representing men and horses of wonderful workmanship. . . .[2]

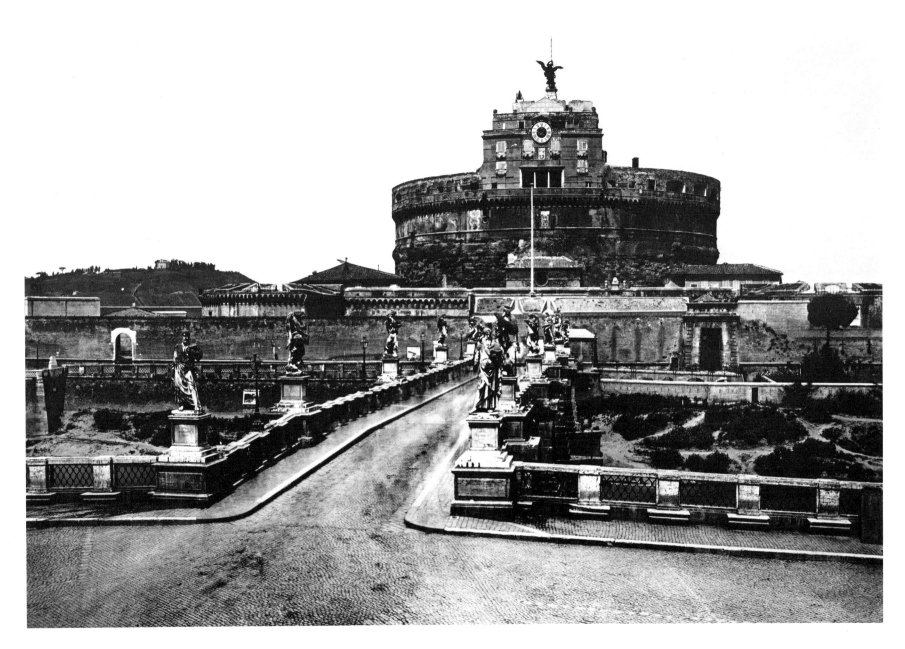

2. Castel and Ponte S. Angelo before 1892

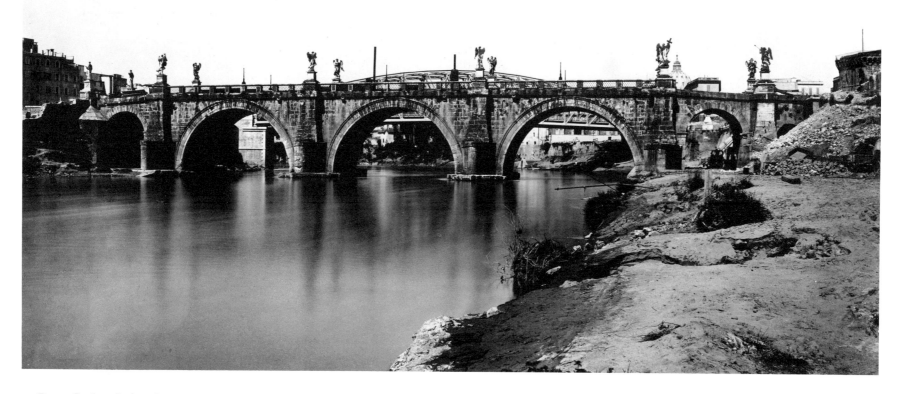

3. Ponte S. Angelo in 1892

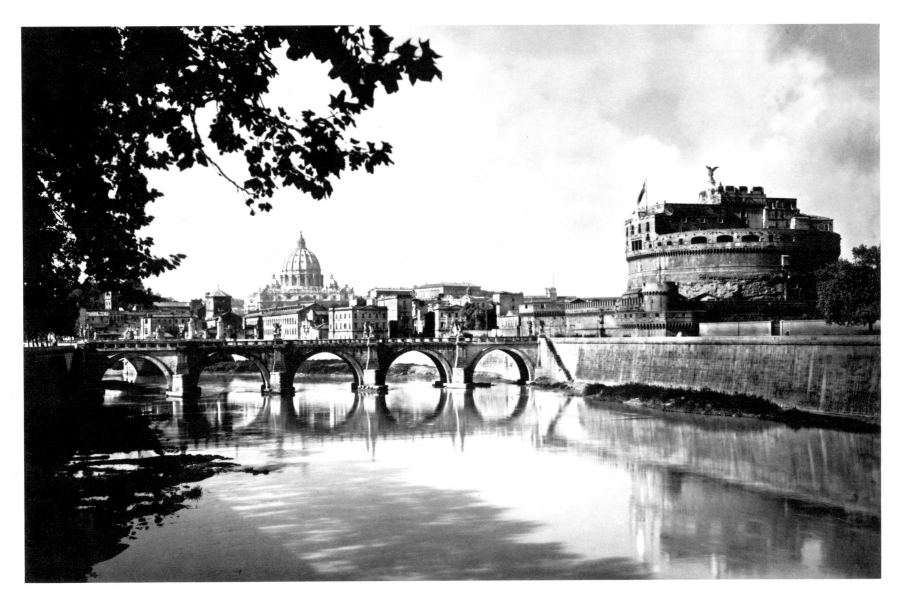

4. Castel and Ponte S. Angelo (after 1894)

The Pons Aelius seems to have been decorated with the same splendor. The original design for the bridge appears on the reverse of an ancient bronze medal (fig. 5), the obverse of which contains a profile portrait of Hadrian and the motto HADRIANVS AVG. COS. III. P.P.[3] The illustration of the Pons Aelius shows the bridge spanning the Tiber over seven arched openings, three under the large central section and two smaller ones under each of the ramps that slope downward to the banks of the river. It is represented with a parapet on each side of the roadway and has eight columns, each carrying a statue, two of which rise over each of the four central piers of the bridge; four smaller statues are supported by the bases flanking the entrances to the bridge.

The excavation and destruction of the ramps of the Pons Aelius in 1892, as well as the appearance of the Ponte S. Angelo itself, have served to verify the image on the reverse of the ancient medal. The Pons Aelius was built over a riverbed that had been divided into a triple section; that is, it had a deep central channel from which it stepped up into two shallower levels as it approached the banks. As it was built, the Pons Aelius (fig. 6) crossed the Tiber over eight arched openings. The deep central channel of the river was spanned by a section of roadway about eighty meters long carried by three vaults springing from four piers, of which the two centermost rested on colossal concrete piles rising from the lowest part of the riverbed. The central section of the bridge was flanked by ramps carrying the roadway down to the riverbanks at an angle of fifteen degrees. The roadway of the right ramp was twenty-six meters long and was carried by two vaults; that on the left was more than thirty-six meters long and was supported by three vaults. The eighth vault—that is, the small one at the end of the left ramp—probably was meant to support the road that ran parallel to the Tiber and to allow water to run under it and would not have been visible when the bridge was built.[4]

The form of the Pons Aelius was articulated by the blocks of travertine that faced all of the surfaces of the bridge with the exceptions of the carriage road, which was paved with blocks of flint, and the undersides of the vaults, where the structural material (peperino) of the intrados of the arches was left visible. Travertine blocks of uniform size were laid

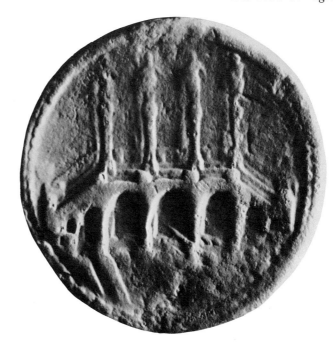

5. Medal of the emperor Hadrian, reverse with an image of the Pons Aelius (134 A.D.)

in even courses running the entire length of each façade of the bridge. This regular pattern was broken by the articulation of the piers and arches, which served to emphasize the weight-carrying functions of these structural elements. The central arches were delineated by carved mouldings, and the arches of the ramps were articulated by their voussoirs and impost blocks.

The four central piers were given visual emphasis by the large buttresses rising from massive breakwaters. The breakwaters were pointed on the upstream side of the bridge, in order to divert the force of the water around the piers, but were blunt on the downstream side. The buttresses rose from the breakwaters in five diminishing steps, each the thickness of one course of travertine. From the fifth step each buttress rose in an undifferentiated shaft to the level of the carriage road. The carriage road was 4·75 meters wide

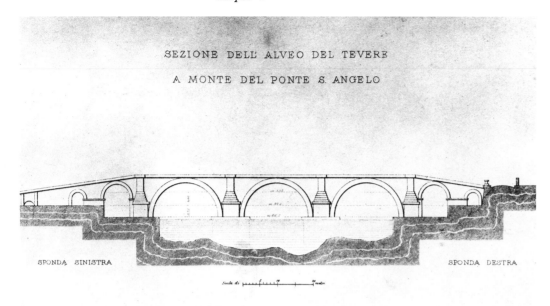

SEZIONE DELL' ALVEO DEL TEVERE

A MONTE DEL PONTE S. ANGELO

SPONDA SINISTRA SPONDA DESTRA

6. R. Lanciani, reconstruction of the Pons Aelius (from Lanciani, "Recenti Scoperti," pl. I)

and was flanked by two travertine sidewalks, each of which was 3·10 meters wide. The edges of the sidewalks projected over the façades of the bridge, forming a simple cornice visually supported by the buttresses of the four central piers. The horizontal line articulated on each façade by the edge of the sidewalk was further emphasized by the parapets that ran the full length of the bridge as a protection for pedestrians. The parapets were constructed of small travertine piers alternating with thinner slabs of the same stone. An inscription identifying the builder of the bridge was carved in a marble tablet set into each of the travertine slabs.[5] Over each of the buttresses was a large base that was probably meant to carry some kind of sculptural decoration, such as the statues represented in the Hadrianic medal.[6]

The Pons Aelius served four major functions before the end of the nineteenth century. The bridge was built as the

entrance to the Mausoleum of Hadrian and was used as such between 138, the year in which Hadrian's remains were placed in the central *loculus* of the mausoleum, and 212, when the mausoleum was used as an imperial tomb for the last time. The Pons Aelius was one of eight bridges that crossed the Tiber within the walls of Rome in ancient times and along with the Pons Triumphalis, a bridge built during the reign of the emperor Nero, was one of two bridges connecting the Vatican area with the heart of the city of Rome. With the destruction of the Pons Triumphalis in the fourth century, the Pons Aelius became the only major bridge crossing the Tiber in Rome,[7] and hence it became an important point in the religious life and the defense of the city. As early as the late third century the bridge and mausoleum became a significant part of the fortifications of Rome. The mausoleum slowly developed into the city's most important fortress (the Castel S. Angelo) and continued to be used as such until 1870, the year in which Rome was politically unified with the new Italian Republic.[8] With the advent of Christianity and the building of the Basilica of St. Peter in the fourth century, the Pons Aelius became a link between the basilica and the city of Rome and hence part of the normal route used by pilgrims and papal processions.

The bridge did not undergo any important structural change until the last decade of the nineteenth century. On the other hand, its appearance was altered many times between the third and eighteenth centuries. During these fifteen hundred years the slopes of the ramps of the bridge were adjusted to the rising level of the city; the openings under the ramps were hidden by rubble and by the foundations of structures built on or near the bridge. At times the bridge was encumbered with fortified towers and other structures, and in modern times it has been decorated twice with statues. The most important changes in the appearance of the bridge are explained by the outline history which follows.

270–82 The emperors Aurelian and Probus enclosed Rome within a new wall. The city of Rome as defined by the Aurelian Wall included the Campo Marzio, but not the Pons Aelius or the Mausoleum of Hadrian. The wall, which

ran along the left bank of the Tiber, was a solid mass of masonry pierced by several gates, one of which, the "Porta Aurelia," gave access to the bridge. This gate continued to exist for several centuries under the name Porta Sancti Petri.[9]

ca. 400–537 The Mausoleum of Hadrian was fortified as a strong point in the defenses of Rome in order to help protect the city from the invading Goths. Walls were built connecting the front of the mausoleum to the Tiber in such a way that a person crossing the Pons Aelius from the Campo Marzio found himself in an enclosed area when he reached the mausoleum end of the bridge. He emerged from this protected area through a gate in its south wall; once outside the wall he could enter a portico leading to the Basilica of St. Peter.

The mausoleum-fortress was attacked by the Goths in 536. In order to defend their position the Romans were forced to break up the colossal statues that decorated the mausoleum and hurl them upon the invaders.[10]

590 Pope Gregory the Great and the people of Rome saw a vision of the Archangel Michael standing atop the mausoleum fortress, sheathing his sword as a sign of the end of a terrible plague. The vision of the angel began a tradition that by the fifteenth century had caused the fortified mausoleum and bridge to be called the "Castel S. Angelo" and the "Ponte S. Angelo."[11]

847–55 During the reign of Pope Leo IV, a wall was built around the Vatican Borgo to protect it from the Saracen invasions. The wall began its circuit at the Mausoleum of Hadrian, encircled the Vatican, and returned to the Tiber by way of the modern Porta di S. Spirito. With the building of the Leonine Wall, the Pons Aelius—or Pons Sancti Petri, as it was commonly known in the Middle Ages —became an internal link between the two parts of Rome, both enclosed within the walls of the city.[12]

1299–1300 In preparation for the Jubilee Year of 1300, Pope Boniface VIII widened the streets approaching the bridge and raised the level of the pavement of the city ramp to coincide with the level of the Campo Marzio, which was higher above the riverbed than it had been in ancient times.

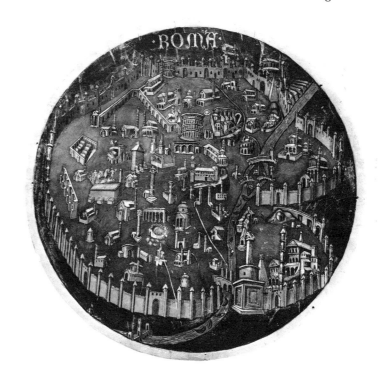

7. Taddeo di Bartolo, map of Rome. Fresco. Siena, Palazzo Pubblico, Cappella Interna (1414)

Despite the narrowness of the bridge, Pope Boniface had it divided into two parts, probably by shops running down the center of the carriage road. Traffic moved to St. Peter's on one side of the shops and back to the Campo Marzio on the other side.[13]

1300–48 During the early Trecento the Pons Aelius was guarded by three towerlike gates, one at each end and one in the middle of the bridge. These gates are illustrated in four early fifteenth-century perspective maps of Rome (see fig. 7), all of which reflect the same pre-1348 prototype.[14]

1348 The Black Death raged throughout Italy. In Rome the end of this plague was signaled by a repetition of

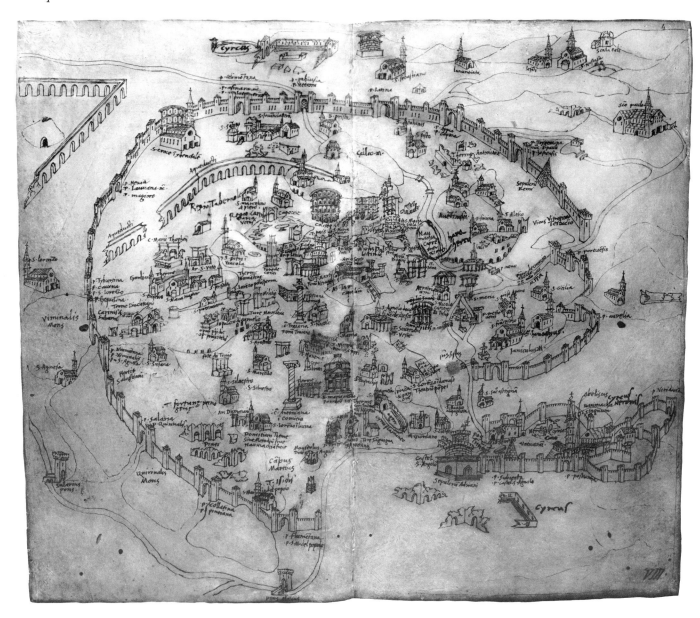

8. Alessandro Strozzi, map of Rome. Florence, Biblio-
teca Laurenziana (1472)

St. Gregory's miracle of 590. In order to assuage God's wrath, Pope Clement VI led a procession from the Church of S. Maria in Aracoeli to St. Peter's. As the procession approached the Pons Aelius, the pope and more than sixty other people saw the marble angel, which had been placed atop the mausoleum-fortress in commemoration of the miracle of 590, bow in obeisance to the holy image of Mary being carried in the procession. It is probable that the names "Castel S. Angelo" and "Ponte S. Angelo" came into common usage shortly after the occurrence of this second angelic miracle.[15]

1400–50 The appearance of the Ponte S. Angelo during the first fifty years of the Quattrocento may be reconstructed on the basis of a map and a romanticized view, both of which were drawn after 1450 but were based on earlier prototypes. The perspective map drawn by Alessandro Strozzi in 1472 (fig. 8)[16] shows that the bridge was still guarded by two gates, one at either end. The gates also appear in a view of the bridge (fig. 9) found in a manuscript attributed to Giovanni Marcanova and dated 1453–65.[17] The miniature gives a fairly accurate picture of the Ponte S. Angelo in the early Quattrocento, if one discounts the elongated proportions and ornamental quality of all the buildings and objects represented. The bridge is depicted as crossing the Tiber over five openings, which probably was the number visible before 1450. The miniaturist clearly illustrates the buttresses of the piers and a parapet wall constructed of small piers alternating with slabs of stone. An ornamental device crowns each of the buttresses of the piers of the bridge.

1450 On 19 December, six days before the end of the Jubilee of 1450, Pope Nicholas V attracted a great crowd of people to the Basilica of St. Peter by announcing the exhibition of the Veil of St. Veronica. At about four o'clock in the evening, the pope sent word that the Sudarium would not be shown because it was then too late in the day. Anxious to return home, the crowd rushed to the Ponte S. Angelo, the only direct link between the Vatican Borgo and the rest of the city. The narrow passage of the bridge, congested with unusually heavy traffic and by small shops, was blocked by a characteristically recalcitrant mule. In

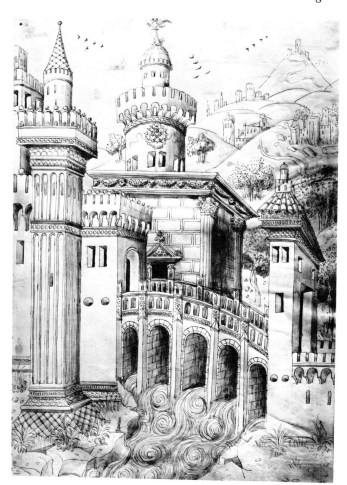

9. View of the Castel and Ponte S. Angelo from a manuscript attributed to Giovanni Marcanova. Modena, Biblioteca Estense (1453–65)

the ensuing crush 172 persons were either trampled to death or pushed into the river and drowned. In addition to the loss of life, the parapets of the bridge were badly damaged.

In the wake of this disaster Nicholas V had the bridge repaired, altering its appearance but leaving its basic structure intact. The old gates that guarded the ends of the bridge were demolished, and a new gate flanked by two large

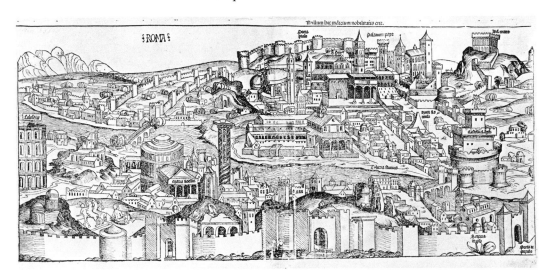

10. Map of Rome, from H. Schedel, *De temporibus mundi
. . .*, Nuremberg, 1493

Nicholas V had erected on the right ramp of the bridge. The gate was replaced by a large round tower that stood against the wall of the fortress opposite the entrance of the bridge. The approach to St. Peter's Basilica was now made by crossing the bridge, turning to the left in front of the Castel S. Angelo, and entering the road to the basilica by way of the Porta Collina, a fortified gate that Pope Alexander VI had constructed between the Castel S. Angelo and the river.[20] The Ponte and Castel S. Angelo as they appeared during the first years of the sixteenth century are illustrated in a fresco of the *Miraculous Apparition of the Archangel Michael to Pope Gregory the Great* (fig. 12) in the Church of the Trinità dei Monti.[21]

1527–35 During the pontificate of Pope Clement VII (1523–34), the two chapels flanking the Campo Marzio entrance to the Ponte S. Angelo were removed and replaced by two statues, one of St. Peter (fig. 13), carved by Lorenzetto for the decoration of the bridge, and one of St. Paul

square towers was built in front of the Castel S. Angelo. The two towers of this gate were connected to the fortress by walls that were somewhat lower in height. Two changes were made at the city end of the bridge: a row of houses was razed between the Church of S. Celso and the end of the bridge, creating a new square (usually called the Piazza di S. Celso), and the Porta Sancti Petri was demolished and replaced by two small chapels dedicated to the Magdalen and the Holy Innocents. These small octagonal chapels flanked the entrance to the bridge; Mass was said daily at their altars for the souls of the victims of the disaster of 19 December.[18] The square towers and small chapels built in 1451–53 encroached upon the ramps of the bridge in such a way that only the central section of the structure was left visible. The appearance of the Ponte S. Angelo after the restorations of Nicholas V is illustrated by the perspective map of Rome published by Schedel in 1493 (fig. 10) and by the view of the fortress and bridge in the Codex Escurialensis (fig. 11).[19]

1492–1503 Pope Alexander VI refortified the Castel S. Angelo and in so doing destroyed the gate that Pope

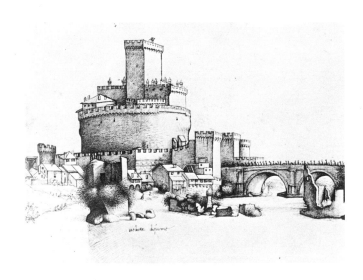

11. School of Domenico Ghirlandaio, view of the Castel and Ponte S. Angelo from the Codex Escurialensis. El Escorial, Biblioteca Laurentina (ca. 1491)

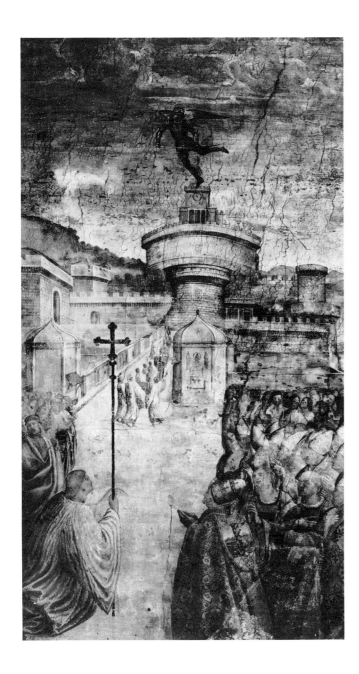

12. *The Miraculous Apparition of the Archangel Michael to Pope Gregory the Great.* Fresco. Rome, Trinità dei Monti

(fig. 14), carved by Paolo Romano in 1464.[22] Pope Clement VII had the chapels removed because they had been damaged by artillery fire from the Castel S. Angelo during the Sack of Rome of 1527 and by floodwaters of the disastrous inundation of the Tiber that occurred just after the Sack. The flood was aggravated by the Ponte S. Angelo, which, having been reduced to a short bridge crossing the Tiber over only three openings, acted like a dam and blocked the flow of the floodwaters. The removal of the chapels from the city end of the bridge eased this situation by freeing a fourth opening under the left ramp. The replacement of the chapels by the statues of SS. Peter and Paul is commemorated by inscriptions carved into what is now the outside face of the base of each statue. The inscription on the base of that of St. Peter reads:

CLEMENS VII PONT MAX
PETRO ET PAVLO APOSTOLIS
VRBIS PATRONIS
ANNO SALVTIS CHRISTIANAE
M D XXX IIII
PONTIFICATVS SVI DECIMO

and that under the statue of St. Paul reads:

BINIS HOC LOCO SACELLIS
BELLICA VI ET PARTE PONTIS
IMPETV FLVMINIS DISIECTIS
AD RETINEND LOCI RELIGIONE
ORNATVMQ HAS STATVAS
SVBSTITVIT.[23]

The front and back faces of the two bases are decorated with carvings in low relief. Those on the front face of the statue of St. Peter and on the back face of the statue of St. Paul represent a pair of crossed keys. The reliefs on the opposite sides of the two bases represent the coat-of-arms of Pope Clement VII. An inscription related to the role of each saint in the Catholic hierarchy is carved into the inner face of each of the bases. The inscription under the statue of St. Peter reads HINC RETRIBUTIO SUPERBIS; that under the statue of St. Paul reads HINC HUMILIBUS VENIA.

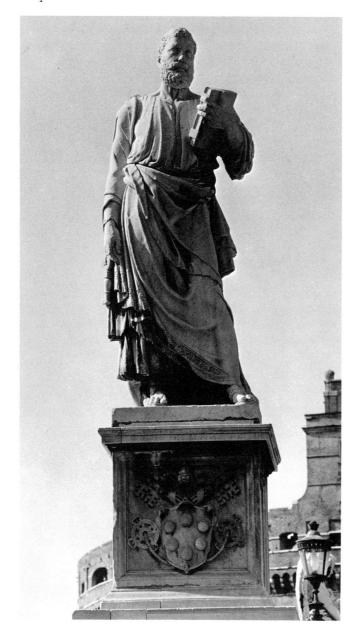

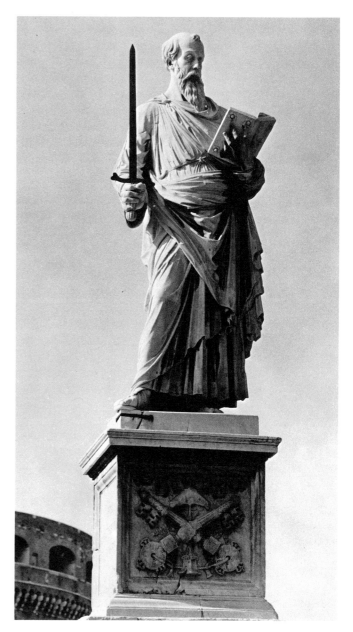

13. Lorenzetto, statue of St. Peter. Rome, Ponte S. Angelo

14. Paolo Romano, statue of St. Paul. Rome, Ponte S. Angelo

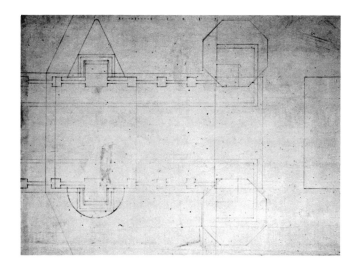

15. Battista Sangallo, plan of the left ramp of the Ponte S. Angelo, ca. 1534. Florence, Gabinetto dei Disegni e delle Stampe degli Uffizi

A plan of the left end of the Ponte S. Angelo (Gabinetto dei Disegni e delle Stampe degli Uffizi; fig. 15) attributed to Battista Sangallo ("Il Gobbo") must date from the period of the destruction of the chapels, for it illustrates both the octagonal plans of the chapels and the square plans of the bases of the statues that replaced them. The plan also shows the comparative sizes of the carriage road, sidewalks, parapets, buttresses, and breakwaters of the bridge.[24] The Ponte S. Angelo as it appeared between 1535 and 1628 is illustrated in an engraving by Étienne du Pérac (fig. 16), first published in 1565.[25]

1536 On 5 April the emperor Charles V entered Rome to make amends to Pope Paul III, the successor of the pope who had been besieged in the Castel S. Angelo by the emperor's troops during the Sack of Rome. Pope Paul III had the route of the emperor's entry decorated with triumphal arches, statuary, and other adornments. The sculptors Lorenzetto and Raffaello da Montelupo modeled eight stucco statues that were placed over the piers of the Ponte S. Angelo. Behind the statue of St. Peter were statues

of the Four Evangelists, and behind the statue of St. Paul were statues of four patriarchs; Adam, Noah, Abraham, and Moses.[26] These statues, which decorated the bridge for only a brief period, are not represented in any known view of the bridge. The general aspect of the Ponte S. Angelo as it must have appeared in April 1536 is recorded in a later drawing (fig. 17), attributed to du Pérac, in the Berlin Kupferstichkabinett.[27]

1623–44 Pope Urban VIII had the Castel S. Angelo restored and refortified. In the process he had the round tower of Pope Alexander VI destroyed and the two vaults under the right ramp of the bridge reopened. The reopening of the two vaults was intended to alleviate the flooding of the Tiber by allowing its waters freer passage through the bridge. New parapets were built along the

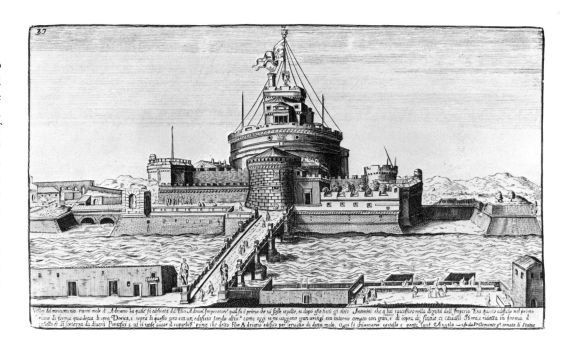

16. Étienne du Pérac, view of the Castel and Ponte S. Angelo, from *I Vestigi di Roma antica*, Rome, 1565

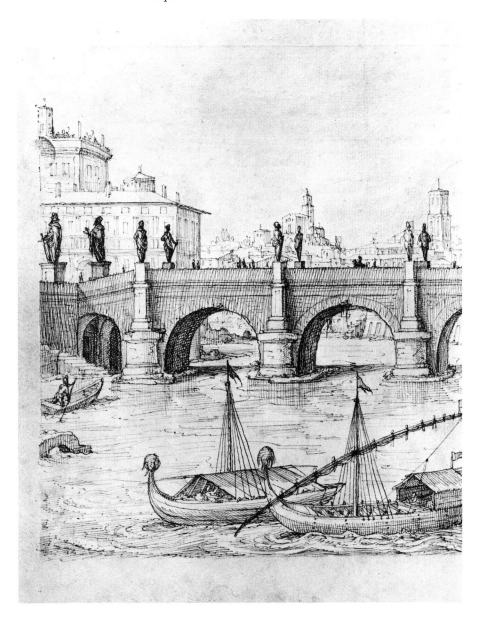

17. Étienne du Pérac, view of the Ponte S. Angelo. Drawing. Berlin-Dahlem, Staatliche Museen, Kupferstichkabinett (ca. 1580)

banks of the Tiber at both ends of the bridge. These parapets were connected to the bases marking the corners of the bridge and were composed of travertine piers and large travertine slabs on which were carved the arms of the pope.[28] The appearance of the fortress and bridge as they were restored at this time is recorded in a drawing and a map of the Vatican Borgo, both by Domenico Castelli (figs. 18, 19),[29] and in an engraving by Lievin Cruyl, dated ca. 1665 (fig. 20).

1667–72 Gian Lorenzo Bernini, working under the commission of Pope Clement IX (1667–69) and later under Pope Clement X (1670–76), planned and supervised the decoration of the Ponte S. Angelo, which was adorned with ten statues of angels carrying instruments of the Passion of Christ. The bridge was also given new parapets composed of travertine supports and iron grilles, and the piers of the ramps were decorated with buttresses that matched the buttresses of the central piers. The bridge as it appeared in 1672 is recorded in a drawing by Lievin Cruyl (fig. 21), owned by the Ashmolean Museum in Oxford.[30]

Bernini's decoration of the Ponte S. Angelo is the culminating point in its history and in the history of thought about the bridge (see chapter 5), for the decoration permanently monumentalized the bridge and marked it as a site of great importance in the city of Rome. The rest of this book is devoted to a study of this decoration: to its history as recorded in contemporary documents; to the design and execution of the statues adorning the bridge, as well as to the sculptors who carved them; and, finally, to the iconology of the bridge and the statues.

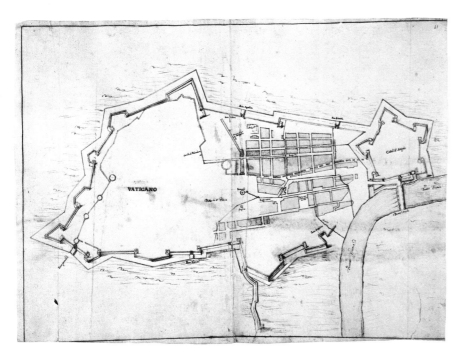

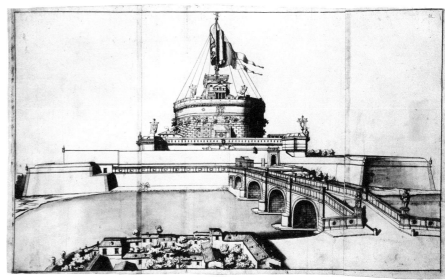

19. Domenico Castelli, view of the Castel and Ponte S. Angelo. Drawing. Rome, Biblioteca Apostolica Vaticana (ca. 1644)

18. Domenico Castelli, plan of the Vatican Borgo. Drawing. Rome, Biblioteca Apostolica Vaticana (ca. 1644)

20. Lievin Cruyl, view of the Castel and Ponte S. Angelo. Engraving, ca. 1665

21. Lievin Cruyl, view of the Castel and Ponte S. Angelo.
Drawing, ca. 1672. Oxford, Ashmolean Museum

2

The Decoration of the Bridge
1667-72

The history of the decoration of the Ponte S. Angelo can be reconstructed in great detail owing to the existence of an unusually rich number and variety of documents. In 1965 Howard Hibbard found *giustificazioni* for payments to the artists and craftsmen who worked on the decoration of the bridge. Using these documents, along with previously published *avvisi*, Professors Hibbard and Wittkower collaborated on an excellent chronological report of the production of the statues decorating the bridge. This discussion was published in the second edition of Wittkower's Bernini monograph.[1] In the 1966 issue of *Commentari* Maria Cristina Dorati published the most interesting of many *avvisi* concerning the decoration of the Ponte S. Angelo found in the diary of Carlo Cartari, who was an advocate of the Papal Consistory and the archivist of the Castel S. Angelo.[2]

Both sets of documents mentioned above are fully quoted in the appendices (I, 2 and I, 3) to this study, as are the papal chirographs (I, 1), miscellaneous *avvisi* and documents (I, 4), and excerpts from eighteenth-century printed documents (I, 5) concerning a lawsuit brought by the marble dealer who supplied most of the marble blocks for the statues of angels. The chirographs and miscellaneous *avvisi* are, in fact, somewhat redundant as a result of the discovery of the *giustificazioni* and the pertinent *avvisi* from the diary of Carlo Cartari. All documents are quoted, however, for the sake of completeness. Discussions of the Ponte S. Angelo in printed sources written by authors who witnessed the decoration of the bridge are not quoted in

the appendices. Such sources corroborate the evidence taken from the documents and demonstrate the popularity of the bridge. For example, Titi identified the sculptor of each of the statues in his guidebook of 1674, as did Bonanni in his *Numismata pontificum romanorum* of 1699. Bonanni also demonstrated the popularity of the bridge by including engravings of each of the statues as well as a view of the bridge engraved by Alessandro Specchi. Bernini's role in the decoration of the Ponte S. Angelo was discussed in the biographies of the master by Filippo Baldinucci, published in 1682, and Domenico Bernini, published in 1713.[3]

The following chronological survey of the decoration of the Ponte S. Angelo is based on the similar chart in the second edition of Wittkower's Bernini monograph. Whereas lack of space necessitated limiting the entries in the monograph to basic facts about the planning and carving of the statues of angels, the chart below has been expanded to include all of the pertinent information, in order to give the clearest possible picture of what the documents tell us about the decoration of the Ponte S. Angelo. The numbers in parenthesis within each of the entries refer to documents quoted in the appendices.

1667

20 June Cardinal Giulio Rospigliosi is elected pope, taking the name Clement IX.[4] The commission for the decoration of the Ponte S. Angelo was obviously one of the first acts of the new pope, for on 22 September an initial payment was authorized for the purchase of eight blocks of

marble for statues of angels to decorate the bridge. By 16 April 1668 payments were being made for ten, rather than eight, such blocks. *A conto* payments continued through March 1669 (docs. 67–77, 80).[5]

1668

8 February Carlo Cartari reports that work has begun on the new parapets of the bridge. The parapets consist of travertine piers alternating with uniform iron grilles. Additional entries in Cartari's diary inform us that the parapets were first placed on the bridge and then along the riverbanks at the Piazza di S. Celso and the road in front of the Castel S. Angelo. The parapets of the bridge were almost finished by 3 July 1668. The parapets along the riverbank at the Piazza di S. Celso were completed by 4 January 1669. On 21 January of the same year the parapets placed in front of the other entrance to the bridge during the pontificate of Pope Urban VIII were removed. On 14 April the parapets had been completed and the ironwork was being painted black (docs. 197, 198, 203, 206, 211, 216, 217, 220). Payments to ironworkers run from 18 February 1668 to 4 December 1669 (docs. 33–49).

4 April Workmen begin unloading blocks of marble from the boats which transported them from Carrara. Eight blocks were transported by buffalo cart to the sculptors' studios on the following dates: to Bernini on 13 April and 11 May, to Girolamo Lucenti on 17 May, to Paolo Naldini on 19 May, to Domenico Guidi on 25 May, to Cosimo Fancelli and Antonio Giorgetti on 2 June, and to Antonio Raggi on 8 June.[6] The ninth and tenth blocks of marble were not delivered because Bernini did not consider them to be of sufficiently high quality to be used in the decoration of the bridge. The rejected blocks evidently were replaced quickly, for blocks of marble were delivered to the remaining sculptors, Lazzaro Morelli and Ercole Ferrata, by 24 November. After Bernini's death in 1680 the marble dealer, Filippo Frugoni, sued to be reimbursed for the rejected blocks (docs. 78, 79, 199, 202, 240, 251–55).

18 May Cartari reports that all of the six small buildings along the riverbank at the Piazza di S. Celso (see fig. 16) are being destroyed. On the same day the statues of SS. Peter and Paul flanking the Campo Marzio entrance to the bridge are removed so as not to interfere with the construction of the new parapets. A report from the same source informs us that some of the buildings had yet to be demolished on 15 August (docs. 198, 200, 203, 206). The owners of the buildings were reimbursed for their property in 1670 and 1671 (docs. 190–96).

1 June Cartari reports the destruction of the brick pedestal that had supported the statue of St. Paul (doc. 200).

6 June Cartari reports that the pope visited the bridge and was greeted with cheers of "Viva Papa Clemente." On that date a travertine base was seen on one side of the Campo Marzio entrance to the bridge. Eventually twelve such bases were placed over the buttresses of the piers of the bridge and at the corners of the parapets flanking the entrances. Second bases of fine Carrara marble were placed on ten of the travertine bases to serve as pedestals for the statues of angels; the last two marble pedestals were seen on the bridge on 20 June 1669. The other two travertine bases served to support the statues of SS. Peter and Paul and their original marble bases (docs 201, 204, 208, 216, 219, 220, 222). Payments to *scarpellini* for work in travertine and marble run from 17 November 1667 to 4 December 1669 (docs. 8–32).

27 July First payments are made to two of the sculptors commissioned to carve angels, Paolo Naldini and Cosimo Fancelli. The other sculptors received first payments as follows: Ercole Ferrata, 31 July; Antonio Giorgetti, 3 August; Girolamo Lucenti, 7 August; Domenico Guidi, 13 August; Antonio Raggi, 15 November; and Lazzaro Morelli, 4 January 1669. Regular payments to the eight sculptors continue to July through November 1669. Each sculptor was paid a total of 700 scudi, final settlement being made on 20 July 1670. On 17 August 1670 Bernini and his son Paolo each received a single payment of 700 scudi for statues of angels (docs. 88–162).

15 August Cartari reports that the marble base of the statue of St. Paul bearing the old inscriptions and arms of Pope Clement VII has been placed on a new travertine

base at the Campo Marzio end of the bridge. Cartari also comments, "One sees from this that the living pope wishes to preserve the old inscriptions and coats-of-arms. On the other hand, some say that in many of his works he does not wish his coat-of-arms to be seen. . . ." Cartari's surprise at the humility of Pope Clement IX is reflected in the next two *avvisi* about the bridge, which show that he was watching for the arms of the pope to appear (docs. 206–8).

6 September Cartari reports that the statue of St. Peter has been placed at the entrance of the Ponte S. Angelo "on its old base, which, like that of the statue of St. Paul, contains no reference [*memoria*] to the living pope!" (doc. 207).

26 September Cartari reports that the road in front of the entrance of the Castel S. Angelo is being widened. On 27 October he states that the mouth of the bridge in front of the entrance of the fortress has been widened to relieve traffic congestion at times of processions (docs. 209, 212).

19 November Cartari reports that the secretary of Monsignor (Pier Filippo) Bernini[7] has told him that Cavalier Bernini is making one statue of an angel to be placed on the Ponte S. Angelo and that one of Bernini's sons is carving another angel (doc. 214).

1669

3 January Cartari visits Bernini's studio and finds Bernini and his son working on the statue of the *Angel Carrying the Crown of Thorns*, which is "close to being finished." He also reports that another of Bernini's assistants is working on the statue of the *Angel Carrying the Superscription*, which is "closer to being finished, the said cavalier having also worked on this piece. . . ." At this time Bernini expected the statues to be placed on the bridge within two months (doc. 215).

15 February Cartari visits Bernini's studio a second time and learns that the pope is thinking of sending the two statues to Pistoia but will not make a final decision until he sees the finished angels (doc. 218).

20 June Cartari reports that Luigi Bernini has told him that four statues are completed and that the two made

by his brother could easily be sent to Pistoia. The fact that Pope Clement IX made the final decision to send the statues to Pistoia, his birthplace, and to have copies made for the bridge at this time is confirmed by a payment dated 4 July for one block of marble cut to Bernini's specifications for one of the copies. Payments for two blocks of marble for the copies continue through 18 August 1670 (docs. 222, 81–85). Bernini's statues of the *Angels Carrying the Superscription and the Crown of Thorns* were not sent to Pistoia but remained in the sculptor's house until March 1729, when Prospero Bernini, the son of Paolo Bernini,[8] donated them to the Church of S. Andrea delle Fratte (doc. 250).

20 August Cartari reports that he has seen the angel carved by Domenico Guidi and that the statue is almost completed. The artist informed Cartari that the pope wanted to see some of the statues placed on the bridge for the Feast Day of St. Michael on 29 September (doc. 223).

9 September Cartari reports that the first statue, the *Angel Carrying the Scourge*, has been placed on the Ponte S. Angelo near the statue of St. Peter. An *avviso* of 13 September from the diary of Don Guiseppe Cervini wrongly states that Domenico Guidi's *Angel Carrying the Lance* was the first statue to be placed on the bridge. In a second entry of 9 September Cartari states that Guidi's statue is complete and informs us that Guidi has been "mortally wounded by several dagger stabs. It is not known who did it, but it is thought to have been in revenge [*in cambio*]" (docs. 224, 225, 242).

13 September Cartari reports that the second angel, the one carrying the Nails (Girolamo Lucenti), has been placed on the bridge (doc. 226).

17 September Cartari reports that the pope has inspected the two statues of angels that had been placed on the bridge (doc. 227).

18 September Cartari reports that the *Angel Carrying the Robe and Dice* (Paolo Naldini) has been placed opposite the *Angel Carrying the Nails* (doc. 228).

19 September Cartari reports that the *Angel Carrying the Sponge* has been placed on the pier nearer St. Peter's on the fortress end of the bridge. Cartari identifies the sculptor as Giorgetti and states that the statue is the best of the four then on the bridge (doc. 229).

21 September An *avviso* informs us that the pope has inspected five angels on the Ponte S. Angelo. On 26 September Cartari reports that he saw the fifth statue, the *Angel Carrying the Lance* (Domenico Guidi), placed opposite the angel carved by Giorgetti. Cartari also informs us that Guidi and Giorgetti are "reputed to be among the first sculptors of Rome, for which reason these angels are the best of the five put in place up to this time." This statement was partially supported by Guidi, who on 12 October told Cartari that the *Angel Carrying the Lance* was the best statue on the bridge and that it was worth 1200 scudi. In the same conversation Guidi singled out the *Angel Carrying the Nails* as the worst statue (docs. 243, 230, 231).

22 November Cartari reports that the *Angel Carrying the Cross* (Ercole Ferrata) has been placed on the bridge (doc. 232).

9 December The death of Pope Clement IX[9] temporarily halts most of the work on the Ponte S. Angelo. One of the pope's last acts was to write a chirograph (1 December) in which he officially stated that the two angels carved by Bernini and his son Paolo Bernini were to be given to his cardinal nephew and that two copies were to be made for the Ponte S. Angelo. It is probable that Pope Clement IX feared that his successor might pressure Bernini to place the original statues on the bridge. In fact, such pressure seems to have been applied: on 25 May 1670 Cartari reports that "there remain two pedestals on the St. Peter's side [of the Ponte S. Angelo], on which to place the ninth and tenth angels [carved] by Cavalier Bernini, or by other sculptors if he does not wish to place his completed ones there." Further evidence that Pope Clement X Altieri (elected 29 April 1670)[10] did not want papal funds spent for two additional angels is supplied by the fact that the two marble blocks for the copies had arrived in Rome by 15 December 1669 but were not delivered to the sculptors until the following summer (docs. 235, 82, 84).

1670

22 May Cartari reports that the seventh statue, the *Angel Carrying the Sudarium* (Cosimo Fancelli), has been placed on the bridge (doc. 233).

25 May Cartari reports that the *Angel Carrying the Column* (Antonio Raggi) has been placed on the bridge (doc. 235).

10 July Paolo Naldini receives the first payment for the copy of Bernini's statue of the *Angel Carrying the Crown of Thorns*. On 23 July Giulio Cartari, the favorite assistant of the aged Bernini, received the first payment for the copy of the *Angel Carrying the Superscription*. Both sculptors received a total of 700 scudi. The final payments were made on 12 November 1671 (docs. 163–182).

27 November Cartari reports that the new pavement of the Ponte S. Angelo has been completed up to the entrance of the Borgo Nuovo and the Borgo Vecchio (the two streets that lead from the Castel S. Angelo to the Piazza di S. Pietro; doc. 236).

1671

19 October Cartari reports that the statue of the *Angel Carrying the Crown of Thorns* (Paolo Naldini) has been placed on the bridge (doc. 237).

28 October An *avviso* in the Archivio di Stato in Modena states that, because Bernini finally has resolved to finish his statue, the Ponte S. Angelo is being visited by everyone in order to admire Bernini's valor and also to see which of the sculptors has best satisfied the taste of the world. On 8 November Cartari reports seeing the *Angel Carrying the Superscription* (Gian Lorenzo Bernini) placed on the bridge. On 14 November a payment was made to the workmen who placed the last two statues on the bridge; the work had been carried out between 12 October and 7 November (docs. 244, 238, 186).

1672

4 March Cartari reports that the pope has seen the arms and inscriptions of Pope Clement IX placed on the two bases supporting the statues of angels at the fortress end

of the bridge and that a passage from the Holy Scriptures appropriate to the instrument of the Passion carried by each angel has been carved into the base of each statue. Bernini was instructed to place the inscriptions and coats-of-arms on the bases of the statues by a letter dated 18 February 1672. The letter was written by Cardinal Massimo and addressed to Monsignor Gianuzzi, who forwarded it to Bernini. Bernini wrote the inscriptions, or had them written and then approved by Cardinal Altieri, before ordering that they be carved into the bases below the statues. The inscription of Pope Clement IX reads:

CLEMENTI NONO PONT. OPT. MAX.
AELIO PONTE AD S. ANGELI ARCEM
ANGELORVM STATVIS
REDEMPTIONIS MYSTERIA PRAEFERENTIVM
EXCVLTO ET EXORNATO
QVOD SINE EIVS TITOLO ET INSIGNIBVS
OPVS ABSOLVI
EX ANIMI MODERATIONE MANDAVERAT
CLEMENS X PONT. MAX.
VT BENEFICENTISSIMI PRINCIPIS
MEMORIA EXTARET
POSVIT. ANNO MDCLXII.[11]

The inscriptions from the Holy Scriptures are quoted in fig. 52. Payment for the carving of the coats-of-arms and the inscriptions was authorized on 7 April (docs. 239, 245–47, 189).

The changes made in the Ponte S. Angelo between 1667 and 1672 are illustrated by a comparison between two views of the bridge by Lievin Cruyl (figs. 20 and 21).[12] The riverbank at the Piazza di S. Celso was cleared of small buildings, and the road in front of the Castel S. Angelo was widened. A gate and some other structures appear to have been removed from the area between the Castel S. Angelo and the Borgo Nuovo,[13] thus enabling a person standing on the fortress ramp of the bridge to have a clear view of the entrance to the Scala Regia, the ceremonial entrance into the Vatican Palace. The pier under the right ramp of the bridge was decorated with buttresses like those of the four central piers. The old travertine parapets of the bridge were removed and replaced by parapets composed of travertine piers alternating with uniform iron grilles. Ten statues were placed over the buttresses of the piers of the bridge, and, finally, inscriptions identifying the meaning of the decoration of the bridge and the name and motive of its patron were carved into the marble bases supporting these statues.

3

Gian Lorenzo Bernini
Architect and Sculptor

Bernini's role in the decoration of the Ponte S. Angelo can be understood most clearly against a background of the master's personality and working methods.[1] He was at the same time very thorough, very passionate, and, from the time he was forty years old, deeply religious. The master's painstaking nature and his enthusiasm go hand-in-hand and are especially well illustrated by the tenacity with which he studied as a young man. Domenico Bernini, in his *Vita di Cavalier Gio Lorenzo Bernino*, notes that as a youth his father was so anxious to learn the lessons taught by the observation of ancient sculpture that almost every morning over a period of three years he walked from his father's house near S. Maria Maggiore to the Vatican (a distance of about four kilometers, using modern roads), where he remained until sunset drawing from the antique statues preserved there.[2]

Domenico Bernini relates another anecdote that illustrates the extremes to which the young Gian Lorenzo would drive himself in order to learn something useful to his work. Domenico notes that while carving the marble statue of *St. Lawrence on the Grill* (ca. 1616) the seventeen-year-old Bernini wished to show the pain on the saint's face as realistically as possible; in order to learn the appearance of such pain, he studied his own face in the mirror while placing an arm or leg against burning coals.[3] The study of ancient sculpture and of human expressions (*affetti*) theoretically were part of the education of every Italian artist in the early seventeenth century. Bernini differed from his contemporaries in his intensity and in the degree to which he carried out such studies.

At times the artist's passion overflowed the bounds of decorum, as in around 1635 when he had a fiery affair with Costanza Bonarelli, the wife of one of his assistants.[4] In 1638 he was seen with sword in hand, chasing his brother through streets and even through the Basilica of S. Maria Maggiore. The latter event evidently was not totally out of character, for it caused Bernini's mother to write a letter to Cardinal Francesco Barberini, the nephew of the pope, asking him to help control her forty-year-old son. Bernini was the favorite artist of the pope and as such was so powerful that he could only be controlled by the papal family. It may have been this incident that caused the pope to require Bernini to marry in 1639. With characteristic zeal, he became an excellent husband and a deeply religious man; his wife had eleven children before her death in 1673. Marriage did not soften Bernini however; he continued to use his position as papal favorite to place himself above other men. He made himself a kind of dictator in control of artistic commissions in the city of Rome and hence earned the enmity of many artists.[5]

Bernini's thoroughness also is evident in his approach to religion. In 1640 he became a member of the Congregazione dei Nobili dell'Assunta, a Jesuit congregation composed of clerics and laymen dedicated to the adoration of the Eucharist.[6] From that time on he attended Mass every morning at S. Andrea delle Fratte, the church across the street from his house, and every evening he walked to the Gesù, where he attended religious devotions. He took Communion at least once a week, gave generously to

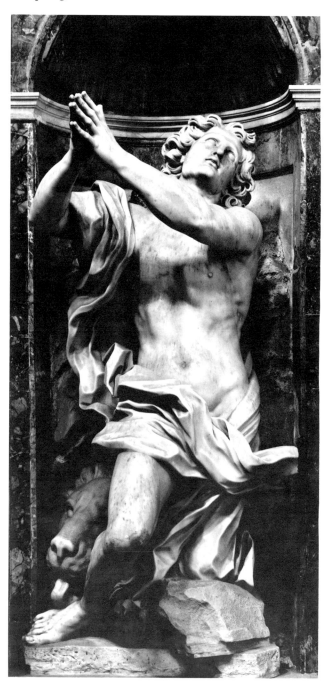

22. Gian Lorenzo Bernini, *Daniel*.
Rome, S. Maria del Popolo,
Cappella Chigi

the poor, and often discussed religious matters with his close friend Gian Paolo Oliva, General of the Society of Jesus.[7] Perhaps the most convicing evidence of the depth of Bernini's religious feeling is his late religious sculpture, the expressive intensity of which has rarely been equaled in the history of art.

Bernini's deep religious feeling, his passionate personality, and his thoroughness all had considerable effect on his art and his working method. It is difficult to generalize about the working method of any artist, for in so doing one is bound to oversimplify the process, and this is especially true of Bernini, for whom each project was a new and special problem. Fortunately, he made several statements about his working process, which were recorded by his early biographers and chroniclers. For example, Filippo Baldinucci —whose biography of Bernini was published in 1682, two years after the master's death—tells us that Bernini taught his students that in planning a work of art "first comes the concept, then reflection on the arrangement of the parts, and, finally, giving the perfection of grace and sensitivity to them."[8]

Bernini's own working process seems to have been very close to this precept. Upon receiving a commission the artist's first step was to record his ideas or *pensieri* as quickly as they came to him, by sketching them on the wall of a gallery in his house or on large folios of paper. He would let the sketches rest for a month or longer and then return to them and choose the best for further consideration and development.[9] Wittkower has demonstrated more than once that Bernini's first ideas were often rather conservative and at times close to ancient statues. As the master developed a composition through a series of drawings and clay models, his idea developed until every part of the design supported the meaning of the subject represented.[10]

Bernini's development of the design for the statue of Daniel in the Cappella Chigi in S. Maria del Popolo (1655–57; fig. 22) is a good example of his working method. The first extant drawing for this statue shows that the torso of the figure is derived from that of Laocoön in the famous marble group in the Vatican. In the finished statue the source is no longer recognizable, for the figure is attenuated and twisted in such a way as to express the depth and intensity of Daniel's religious experience. This metamor-

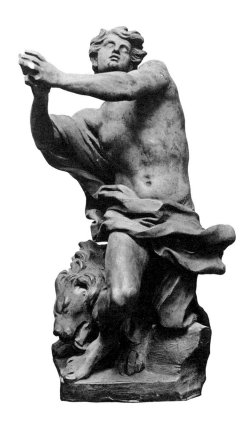

23. Gian Lorenzo Bernini, bozzetto for *Daniel*. Rome, Vatican Museum

phosis may be traced through several drawings.[11] The last phase of Bernini's design, which implied "giving the [final] perfections of grace and sensitivity to [the parts of the statue]," involved controlling the expression of the statue by carefully planning all details to support its meaning and by making sure that each of these details was historically correct. In the case of the statue of Daniel, this meant assuring that the twist of the body and the flow of drapery around the figure reflected the internal intensity of the prophet's prayer but did not make him appear to be moving violently, an act unfitting to one whose faith tamed lions. A comparison of the statue of Daniel with the rather highly finished bozzetto for it in the Vatican Museum (fig. 23)[12]

demonstrates that Bernini subdued the violent movement evident in the model by changing the hair style and reducing the diagonal sweep of drapery across the body. In addition, he transformed the rather fierce lion of the model into an animal that has been tamed beyond the possibility of doing bodily harm to the prophet.

Another well-known example of Bernini's working process is the development of the statue of St. Longinus, designed and carved for its place in the crossing of St. Peter's (1629–38). The first designs for the *St. Longinus*, like those for the *Daniel*, were conservative, but the artist developed these designs through drawings and clay models until he created a statue of the saint at the moment of his religious conversion.[13] The statue of St. Longinus is of further interest because it was made as a part of the decoration of the crossing of St. Peter's, a project by which Bernini organized the space beneath the dome of the basilica. The artist handled the crossing project in much the same way that he later managed the decoration of the Ponte S. Angelo. The decoration of the crossing of St. Peter's is composed of four colossal statues of saints in the lower niches of the piers of the crossing, reliefs related to those saints in the upper niches of the same piers, and the bronze baldachin over the high altar, which stands beneath the dome of the basilica. The project began on 7 June 1627, when the Congregation of St. Peter's decided to build altars dedicated to the saints related to four major relics owned by the basilica. These altars were to be placed in the niches of the piers of the crossing. In May 1628 Bernini made a design for a statue of St. Andrew to fill one of the niches; eventually he made sketches, at least, for the statues of SS. Veronica and Helena, as well as designing and carving the statue of St. Longinus.

By 1629 commissions for the statues other than that of St. Longinus had been given to Francesco Mochi (*St. Veronica*), Francesco Duquesnoy (*St. Andrew*), and Andrea Bolgi (*St. Helena*). Each sculptor was required to follow Bernini's design only to the extent that he could not make changes that would upset the iconography of the crossing or the fundamental balance of the design. Basically, this meant that SS. Helena and Veronica were to be looking down toward the high altar, while SS. Longinus and Andrew, in

contrast, were to be looking upward at the figure of the resurrected Christ that was to be placed atop the baldachin.[14] Of the four statues, only *St. Veronica* seems to vary greatly from Bernini's intentions. The saint's running pose and rushing drapery are typical of Mochi's style, but these elements create an image that is too violent for the space beneath the dome of the basilica. The statue of *St. Helena* is very classicizing and may reflect Bolgi's conservative attitude; on the other hand, it has been noted that Bernini's first designs for statues tended to be conservative. The statue of *St. Andrew* is very much like the *St. Longinus;* one can easily imagine that a Bernini design lies behind it.

Bernini's primary role in the decoration of the crossing of St. Peter's was that of an architect. He was responsible for designing and ordering the space beneath the dome in conformity with the wishes and iconographic limitations established by the pope and the Congregation of St. Peter's. Most of the physical labor was carried out by craftsmen and collaborating sculptors. Bernini himself helped prepare models of the baldachin, aided in the casting of its colossal bronze columns, and carved one huge statue.

The crossing of St. Peter's was the first of many projects in which Bernini was less involved as a sculptor than as general planner, producing complex designs for works in several media. In 1640 he designed the Cappella Raimondi in S. Pietro in Montorio. The chapel is decorated with a a relief of St. Francis in ecstasy in the niche above the high altar, as well as with a tomb on each of the two side walls. Each tomb is adorned with a portrait bust and a long, narrow relief. All of the sculpture was carved by assistants.[15] The decoration of the interior of the nave of St. Peter's—a colossal project that included the adornment of the pilasters of the nave and aisle piers with marble reliefs of putti carrying portraits of early popes and symbols of their office, as well as the modeling of the gigantic allegorical figures filling the spandrels above the arches flanking the nave—was executed in 1647–49 by a large group of masons and sculptors working under Bernini's supervision. From 1645 to 1652 Bernini was involved in the decoration of the Cornaro Chapel in S. Maria della Vittoria. For this project he carved the famous group of the *Ecstasy of St. Teresa* but left the execution of the rest of the decoration to

collaborators, who followed his designs so closely that the entire chapel reads as an ensemble. Other examples of important Bernini projects on which the master did little physical labor himself include the Fountain of the Four Rivers (1647–50), the colonnades of the Piazza di S. Pietro (1656–67), the *Cathedra Petri* in St. Peter's (1657–66), the Church of S. Andrea al Quirinale (1658–70), the Tomb of Pope Alexander VII in St. Peter's (1671–78), and the altar of the Cappella del Sacramento in St. Peter's (1672–74).[16] All of these projects include several statues, none of which was executed by the master.

It is not surprising, therefore, that for Bernini the decoration of the Ponte S. Angelo included more than the design and carving of statues. He was the architect of the project, responsible for clearing the Piazza di S. Celso of unwanted buildings, for designing new parapets, pedestals, and statues for the bridge, for hiring sculptors to carve the statues, and for widening the road at the Castel S. Angelo end of the bridge. In addition to all of this, he decided to execute two of the statues, the *Angels Carrying the Crown of Thorns and the Superscription*, himself; but even in the carving of these statues he was assisted by his son Paolo and an unnamed assistant.[17]

Bernini's role as the principal designer of the statues decorating the Ponte S. Angelo needs to be emphasized. Most writers have treated these statues superficially, reserving the more important parts of their discussions of the Ponte S. Angelo to an analysis of the master's statues of the *Angels Carrying the Superscription and Crown of Thorns* in S. Andrea delle Fratte (figs. 45–51). These two statues, which have stood apart from the other ten statues for three centuries, have come to be thought of as a complementary pair that were designed at the same time and were meant to be viewed as they are seen today, flanking the choir of S. Andrea delle Fratte.[18] This traditional view is correct to the degree that Bernini thought of the statues as a pair while he was designing them; on the other hand, it is quite clear that he first thought of the Ponte S. Angelo as decorated with an ensemble of ten angels, each holding a symbol of the Passion of Christ and each designed as a variation of the same pose. Before assigning specific statues to the chosen sculptors, Bernini made a design for each angel, in order to

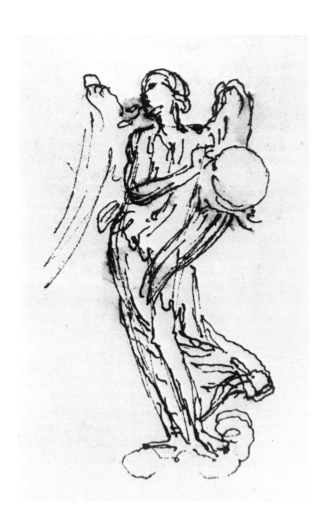

24. Gian Lorenzo Bernini, sketch for the *Angel Carrying the Crown of Thorns*. Leipzig, Museum der bildenden Künste

assure uniformity in the proportions and general poses of the angels and a controlled diversity in the emotional expressions and drapery patterns.

As has been noted above, Bernini's first step in the design of a sculptural or architectural project was to record his ideas or *pensieri* as quickly as they came to him by sketching

them on the wall of a gallery in his house or on large sheets of paper. The only known Bernini *pensiero* associated with the decoration of the Ponte S. Angelo is a sketch for the *Angel Carrying the Crown of Thorns* in the Museum der Bildenden Künste in Leipzig (fig. 24).[19] There is ample evidence, however, that *pensieri* existed for all of the statues, as Bernini turned over several sketches to a studio draughtsman who, following the master's indications, made wash drawings in brown ink for each of the statues of angels carrying instruments of the Passion. Of this series of drawings there exist six originals or reliable copies (each of which shows an angel standing approximately 20 cm. high) and several less reliable versions.

Two of the six trustworthy drawings represent the *Angel Carrying the Cross* (fig. 25) and the *Angel Carrying the Sponge* (fig. 26). The *Angel Carrying the Cross* stands on a flat plinth, showing that the drawing was made before Bernini decided to place the angels on clouds, whereas the *Angel Carrying the Sponge* is supported by clouds. These two drawings, formerly in the Rospigliosi collection, were published by Fraschetti in 1900 as originals by the hand of Bernini,[20] but the attribution was discarded by Brauer and Wittkower, who considered the drawings to be workshop productions.[21]

In 1946 Luigi Grassi published three similar drawings in the Galleria Pallavicini as originals by Bernini; one of these is of the *Angel Carrying the Superscription* (fig. 27) and appears to belong to the same series as the drawings of the *Angels Carrying the Cross and the Sponge*. The first of the other Pallavicini sheets contains drawings of the *Angels Carrying the Scourge and the Robe and Dice* (fig. 28); the second contains the *Angels Carrying the Crown of Thorns and the Nails* (fig. 29). These last four figures appear to be unreliable pastiches made after the original series of Bernini workshop drawings. The figures are too small in scale and their poses are too distant from the final statues for them to be closely related to the original series. Grassi attributes the drawings to Bernini on the grounds that they are related to the statues decorating the Ponte S. Angelo; and he notes, in disagreement with Brauer and Wittkower, that it is a mistake to expect every Bernini drawing to be of excellent quality.[22] Federico Zeri, in his catalogue of the Galleria Pallavicini (1959), criticizes Wittkower for not having accepted the

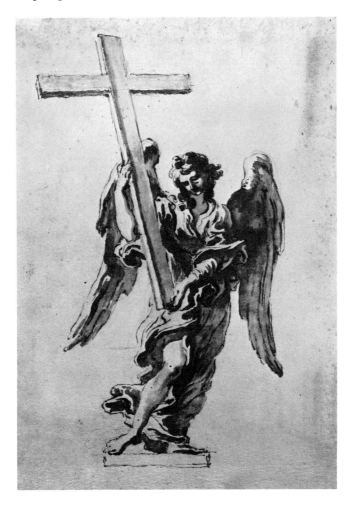

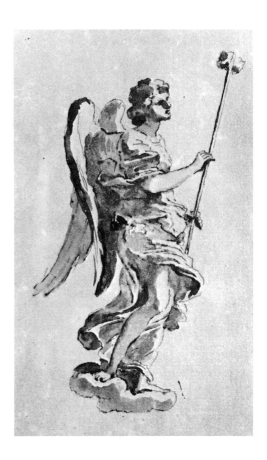

26. Bernini workshop, drawing for the *Angel Carrying the Sponge*. Formerly Rome, Rospigliosi Collection

25. Bernini workshop, drawing for the *Angel Carrying the Cross*. Formerly Rome, Rospigliosi Collection

drawings in the first edition of his Bernini monograph and, as proof of the master's authorship, cites an inventory of 1713 in which the drawings are attributed to Bernini.[23]

In the second edition of his Bernini monograph, Wittkower provisionally accepted the Rospigliosi and Pallavicini drawings on the basis of Zeri's work. The drawings also

have been accepted by Hans Kauffmann, who treats them as first projects for the statues represented. Wittkower cited two additional drawings related to the series of Bernini workshop drawings for the angels. The first is a study for the *Angel Carrying the Column* in the Gabinetto Nazionale delle Stampe in Rome (fig. 30). The second, a lost drawing of the *Angel Carrying the Cross*, is reproduced in an eighteenth-century acquatint (fig. 31).[24] A sixth reliable wash drawing, which appears to be a copy of a Bernini workshop drawing for the *Angel Carrying the Crown of Thorns* (Kupferstich-

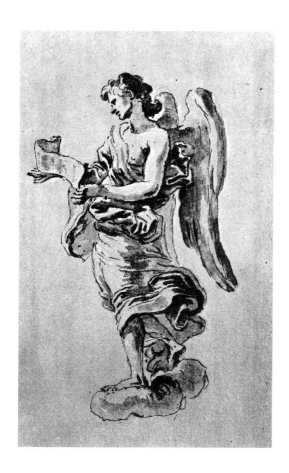

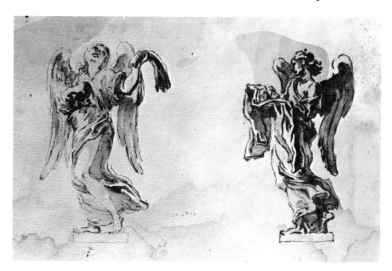

28. Follower of Bernini, drawing of the *Angels Carrying the Scourge and the Robe and Dice*. Rome, Galleria Pallavicini

27. Bernini workshop, drawing for the *Angel Carrying the Superscription*. Rome, Galleria Pallavicini

kabinett, Staatliche Museen, Berlin-Dahlem; fig. 32), was published by Hanno-Walter Kruft and Lars Olaf Larsson in 1966. The part of the Berlin drawing that contained the instrument has been destroyed, but the figure is identified as the *Angel Carrying the Crown of Thorns* because its pose and drapery are close to other studies for that statue.[25]

The original set of workshop drawings were probably presented to Pope Clement IX in order to give him an idea of the planned appearance of the statues. Similar drawings were circulated among the sculptors commissioned to carve

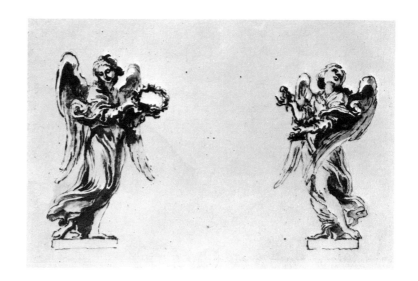

29. Follower of Bernini, drawing of the *Angels Carrying the Crown of Thorns and the Nails*. Rome, Galleria Pallavicini

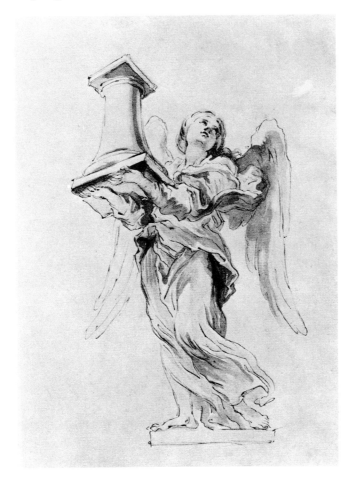

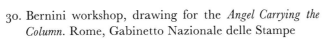

30. Bernini workshop, drawing for the *Angel Carrying the Column*. Rome, Gabinetto Nazionale delle Stampe

31. Charles Rogers, acquatint after a Bernini workshop drawing of the *Angel Carrying the Cross*, from *A Collection of Prints in Imitation of Drawings*, London, 1781

the angels. A comparison between the drawing of the *Angel Carrying the Cross* (fig. 25) and Ercole Ferrata's statue of the same angel (fig. 70) shows that Ferrata completely accepted the pose as shown in the drawing. He reduced the size of the Cross and changed the cut of the drapery in such a way that the abundance of small diagonal folds on the angel's skirt continue the line of the shaft of the Cross and at the same time flow along with the curve of the angel's body, as

does the column of drapery covering the angel's supporting leg. On the other hand, Ferrata retained certain details of drapery that serve a logical function in the drawing but are clearly useless appendages on the statue. The wind-blown bit of drapery behind the angel's free, bare leg and the puffs of drapery on both sleeves in the drawing serve to give the figure the aspect of being airborne; on the statue, the bit of drapery behind the free leg is not clearly con-

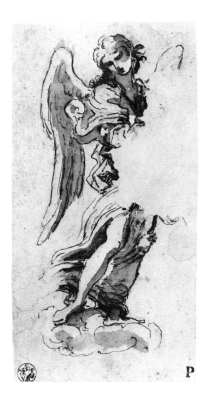

32. Bernini workshop, drawing for the *Angel Carrying the Crown of Thorns*. Berlin-Dahlem, Staatliche Museen, Kupferstichkabinett

the drawing and gazes at the Sponge with an expression reflecting its sorrow. In both drawing and statue the drapery has the same basic internal shape and silhouette; it covers the supporting leg, unfurls behind the free leg, lifts in a thick fold at the waist, covers the upper portion of the torso in a relatively inactive, flat plane crossed by a diagonal strap, and piles up into deep folds at the elbows. On the other hand, Giorgetti has changed its expressive content: the robe of the angel in the drawing is made up of irregularly tight, deep folds that give the impression of a great deal of movement in all directions and hence express a momentary tension, while the drapery of Giorgetti's angel floats in soft, broad folds and fans out in large, windblown planes. The impression is one of slow, sustained movement and hence expresses a long, deep meditation.

We have now seen that Bernini made designs for all the statues of angels decorating the Ponte S. Angelo and that in two cases the sculptors basically followed Bernini's designs. Assuming that the other sculptors tried to carve their statues in the spirit of Bernini's instructions, and recalling that Bernini's two statues of angels in S. Andrea delle Fratte have frequently been considered as a complementary pair, we may wonder whether or not any other two statues might not appear as a visual unit if isolated from the other statues decorating the bridge. Comparing photographs of Giorgetti's *Angel Carrying the Sponge* (fig. 73) and Lazzaro Morelli's *Angel Carrying the Scourge* (fig. 56), it becomes evident that these statues might be called a complementary pair despite the fact they were never meant to be viewed at the same time. Both are statues of angels standing on clouds, and both angels carry instruments of the Passion, to which they react with slightly different emotions. In each case the sculptor has attempted to have the angel's bitterness or sadness reflected by the drapery. We have seen that in carving the *Angel Carrying the Sponge* Giorgetti maintained the pose and proportions of the angel represented in the Bernini workshop drawing, and noting further that the *Angel Carrying the Scourge* might be seen as a complement to Giorgetti's statue and that the poses and proportions of the two statues are indeed similar, it is not surprising to learn that in carving his statue Morelli copied a model by Bernini (see p. 78).

nected with the rest of the angel's gown, and the puffs of drapery on the arms become knots of twisted cloth. It seems probable that Ferrata retained these bits of drapery in order to maintain the silhouette of the angel as designed by Bernini.

A second comparison, between the drawing of the *Angel Carrying the Sponge* (fig. 26) and Antonio Giorgetti's statue of the same angel (fig. 72), shows that, like Ferrata, Giorgetti was guided by Bernini's *pensiero* in the execution of his statue. Giorgetti maintained the contrapposto pose with the weight-bearing leg covered and the free leg nude almost to the top of the thigh. The angel holds the shaft on which it carries the Sponge in the delicate manner prescribed by

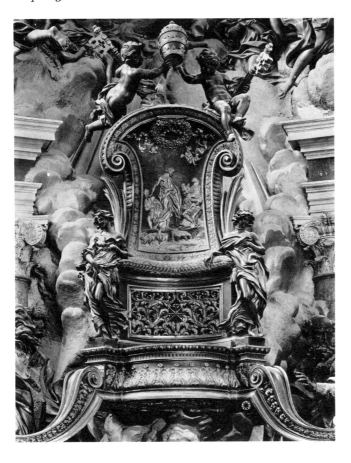

33. Gian Lorenzo Bernini, *Cathedra Petri*. Rome, St. Peter's Basilica

Reasoning in this fashion, we might hypothesize that the degree to which any of the angels decorating the Ponte S. Angelo conforms to Bernini's design may be judged by the extent to which it maintains the basic pose, proportions, and drapery pattern set forth in the Bernini workshop drawings—or, in the cases of statues for which no drawings exist, by the ease with which it may be coupled with other statues to form a complementary pair. Assuming this hypothesis to be correct, all of the statues, with the exception of the *Angel Carrying the Nails*, may be shown to follow the basic

form of Bernini's *pensieri* but to have been carved according to the styles of the individual artists (see chapter 4). Bernini did not design the statues in detail or supervise their execution but allowed each sculptor to interpret the basic design in his own way.

Bernini began the evolution of the designs of the *Angels Carrying the Superscription and Crown of Thorns* (figs. 45–51) with the sketches he made while considering the designs of all ten statues. The *pensieri* were followed by a large number of drawings and terracotta models, through which the artist slowly changed and developed the angels until every aspect of the design of each supported the conceit of figures suffering at the thought of the Passion of Christ. Professor Wittkower pointed out that Bernini developed the statues "in conjunction, as a unified and closely inter-related task" and that he thought of them as a complementary pair based on the statues of angels framing the *Cathedra* in St. Peter's (fig. 33). He notes that the statue of the *Angel Carrying the Superscription* and all but one of the studies for it show the angel standing on its left leg, holding the superscription over its free right leg and turning its head away from the object. Early studies for the *Angel Carrying the Crown of Thorns* show that Bernini thought of it as almost the reverse of the *Angel Carrying the Superscription*, as it supports its weight with its right leg, holds the Crown of Thorns over its free left leg, and turns its head to the right. Later in the development of the two statues Bernini gave up the idea of carving them as symmetrical angels. He changed the pose of the *Angel Carrying the Crown of Thorns* in such a way that it carries its weight on its left leg, as does the *Angel Carrying the Superscription*. Wittkower concludes that "the original concept of creating a complementary pair is still noticeable in the marble angels, but it was superseded by an emphasis on contrasts in expression, proportion, and the treatment of garments."[26]

In analyzing the expressive content of the two angels, Wittkower pointed out that the instruments of the Passion they carry supply the "key-note to their passionate intensity."[27] The outwardly directed grief of the *Angel Carrying the Crown of Thorns* is shown not only in its facial expression but also in the bold sweep or arc of drapery rising under and echoing the Crown of Thorns. In fact,

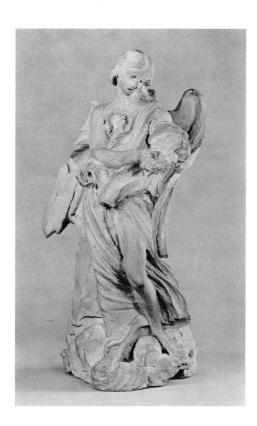

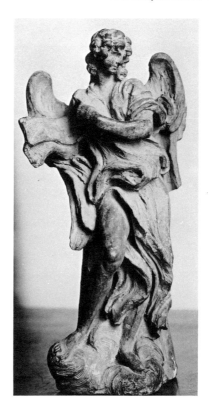

34. Gian Lorenzo Bernini, bozzetto for the *Angel Carrying the Crown of Thorns*. Cambridge (Mass.), Courtesy of the Fogg Art Museum, Harvard University, Purchase/ Alpheus Hyatt and Friends of the Fogg Fund (acc. no. 1937.68)

35. Gian Lorenzo Bernini, bozzetto for the *Angel Carrying the Superscription*. Rome, Palazzo Venezia

every detail reflects the openness of the angel's grief: each fold of drapery is clearly and deeply carved, the angel's hair flows in loose curls, and the arm crossing its chest makes an open angle as it bends at the elbow. In contrast, the *Angel Carrying the Superscription* reflects an inwardly directed sorrow that is indicated by the Superscription, which is tightly curled at one end. Again, every detail of the statue reflects the theme: the angel's hair is tightly curled, its eyes half-opened, its left arm pressed to its body

and closed in an acute angle at the elbow, and its drapery broken into crisp folds.

Wittkower's interpretation of the evolution of the designs for the *Angels Carrying the Superscription and Crown of Thorns* seems to be correct. The surviving drawings and bozzetti (obviously only a fraction of those produced) made during the course of the development of the two statues fall into two general groups, i.e., those studies related to the early *pensieri* and those related to the final statues. The first group is composed of Bernini's sketch for the *Angel Carrying the Crown of Thorns* in Leipzig (fig. 24), the workshop drawing for the *Angel Carrying the Superscription* in the Galleria Pallavicini (fig. 27), and two bozzetti, one for the *Angel Carrying*

47

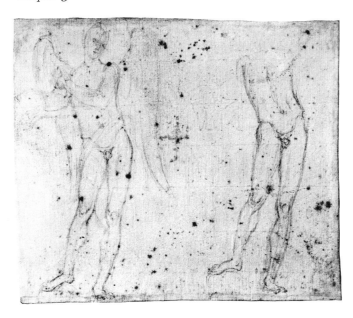

36. Gian Lorenzo Bernini, two studies for the *Angel Carrying the Superscription*. Rome, Gabinetto Nazionale delle Stampe

the Crown of Thorns in the Fogg Art Museum, Cambridge, Mass. (acc. no. 1937.68; fig. 34) and one for the *Angel Carrying the Superscription* in Palazzo Venezia, Rome (fig. 35).[28] The bozzetto in the Fogg Museum is closely related to the Leipzig sketch, the only important compositional difference being that the angel's face is turned toward (rather than away from) the Crown of Thorns. The bozzetto in the Palazzo Venezia might be placed in the group of studies related to the final statues, for its pose is close to that of the final statue and the pattern made by its garment begins to reflect the form of the superscription as it does in the statue. The bozzetto seems to be related to an early *pensiero*, however, for it lacks the emotional intensity of the later studies.

The second group begins with figure studies, such as the sheet containing two drawings for the *Angel Carrying the Superscription* in the Gabinetto Nazionale delle Stampe in Rome (fig. 36) and a large bozzetto for the *Angel Carrying*

the Crown of Thorns in the Fogg Museum (acc. no. 1937.58; fig. 37), through which Bernini corrected the basic pose of the angels and began to develop the expressive content of each figure.[29] The more complete (left) drawing on the Gabinetto delle Stampe sheet repeats the pose of the Palazzo Venezia bozzetto; it contains a few lines indicating the flow of drapery around the body in a pattern similar to that made by the garment in the completed statue. The angel represented in the bozzetto in the Fogg Museum is a mirror image of that represented in the drawing, except for one detail that prefigures the emotional contrast of the completed statues. The right arm of the Fogg angel crosses the torso to hold the Crown of Thorns in a descending diagonal and forms an open angle at the elbow, whereas the left arm of the *Angel Carrying the Superscription* in the drawing is closed in an acute angle and pressed to the body.

In later studies for the two statues, the expressive qualities of the angels are emphasized to the extent that the statues become distinct variations on the conceit of the suffering figure. Looking at the bozzetto for the *Angel Carrying the Superscription* in the Richard Davis collection (fig. 38) and at another for the *Angel Carrying the Crown of Thorns* in the Louvre (fig. 39),[30] it may be noted that the proportions of both angels have been attenuated and the torsion of their contrapposto poses has been increased to emphasize their suffering. The drapery of the two angels is handled in very different manners; that of the *Angel Carrying the Superscription* is broken into complex, crisp folds while that of the *Angel Carrying the Crown of Thorns* flows smoothly around the figure's body. Other late studies for the *Angel Carrying the Superscription* include two bozzetti in the Fogg Museum (acc. nos. 1937.69 and 1937.67; figs. 40–41) that show stages in the development of details of drapery, such as the arc of folds over the angel's left leg, and a drawing in the Gabinetto Nazionale delle Stampe in Rome (fig. 42) that represents a stage in the design of the angel's face, with its tightly curled hair and half-opened eyes.[31] In two remaining studies for the *Angel Carrying the Crown of Thorns* (i.e., bozzetti in the Richard Davis Collection and the Fogg Museum acc. no. 1937.57; figs. 43–44)[32] Bernini shifted the figure's weight to its left leg and developed the flat arc of drapery rising up under the Crown of Thorns.

resulting angel is totally helpless in its feeling of desolation at Christ's suffering. It does not look down at the viewer as the first Bernini angels do, but lets its head fall slightly backward, its mouth open, its nostrils flared, and its eyes half-closed.

All three statues are unusual in Bernini's oeuvre because they were designed to be seen from many angles and to have three main views. It often has been pointed out that Bernini preferred to control the placement of his statues so that they would be seen from one main viewpoint. In planning the statues for the Ponte S. Angelo he could not achieve such control because the statues were to be free-standing, placed upon pedestals with only the sky as a backdrop. Yet the artist conceived his statues carefully, so that to the pilgrim walking past them each successive view gave new insight into the angels' suffering.

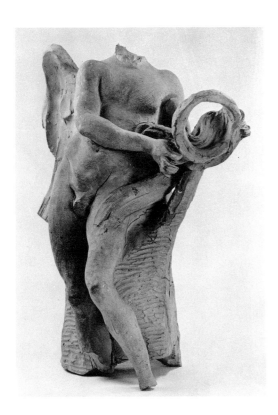

37. Gian Lorenzo Bernini, bozzetto for the *Angel Carrying the Crown of Thorns*. Cambridge (Mass.), Courtesy of the Fogg Art Museum, Harvard University, Purchase/ Alpheus Hyatt and Friends of the Fogg Fund (acc. no. 1937.58)

Bernini's third statue for the Ponte S. Angelo—that is, the second *Angel Carrying the Superscription* (figs. 66–69)—is the master's most powerful expression of the suffering angel. Rudolf Wittkower pointed out that its design contains elements of both the statues in S. Andrea delle Fratte.[33] Its drapery is handled with sweeping boldness like that of the *Angel Carrying the Crown of Thorns*, yet there is a crispness and tightness in the handling of the Super-scription, the hair, and the fingers that is close to the handling of the first *Angel Carrying the Superscription*. The

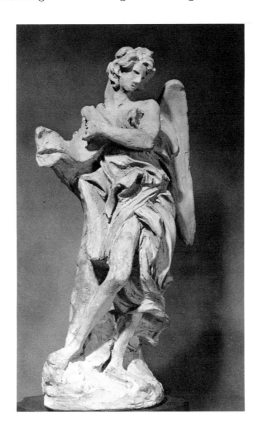

38. Gian Lorenzo Bernini, bozzetto for the *Angel Carrying the Superscription,* London, Richard S. Davis Collection

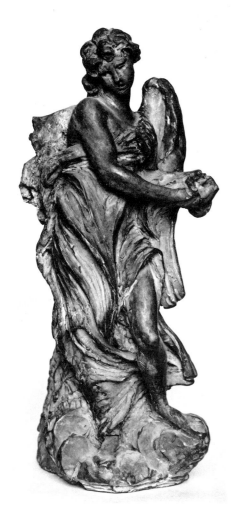

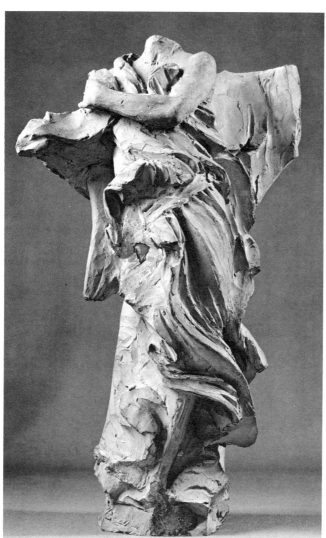

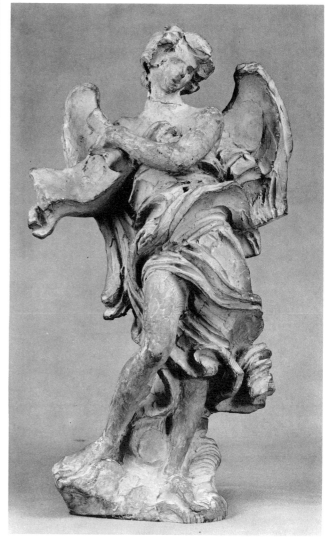

39. Gian Lorenzo Bernini,
bozzetto for the *Angel Carrying
the Crown of Thorns*. Paris, Louvre

40. Gian Lorenzo Bernini, bozzetto for the *Angel Carrying
the Superscription*. Cambridge (Mass.), Courtesy of the
Fogg Art Museum, Harvard University, Purchase/
Alpheus Hyatt and Friends of the Fogg Fund (acc. no.
1937.69)

41. Gian Lorenzo Bernini, bozzetto for the *Angel Carrying
the Superscription*. Cambridge (Mass.), Courtesy of the
Fogg Art Museum, Harvard University, Purchase/
Alphus Hyatt and Friends of the Fogg Fund (acc. no
1937.67)

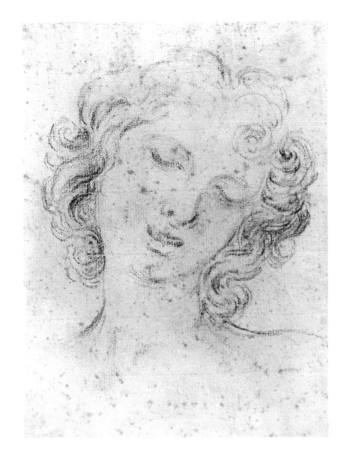

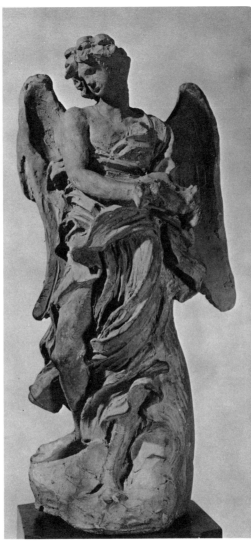

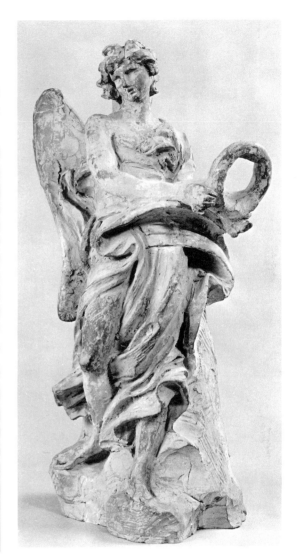

42. Gian Lorenzo Bernini, drawing for the head of the *Angel Carrying the Superscription*. Rome, Gabinetto Nazionale delle Stampe

43. Gian Lorenzo Bernini, bozzetto for the *Angel Carrying the Crown of Thorns*. London, Richard S. Davis Collection

44. Gian Lorenzo Bernini, bozzetto for the *Angel Carrying the Crown of Thorns*. Cambridge (Mass.), Courtesy of the Fogg Art Museum, Harvard University, Purchase/ Alpheus Hyatt and Friends of the Fogg Fund (acc. no. 1937·57)

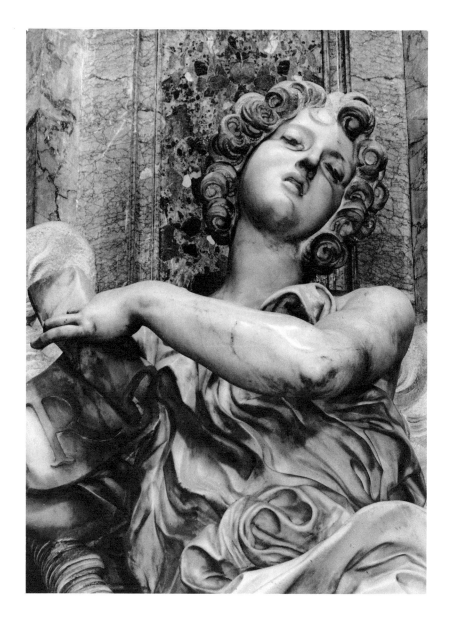

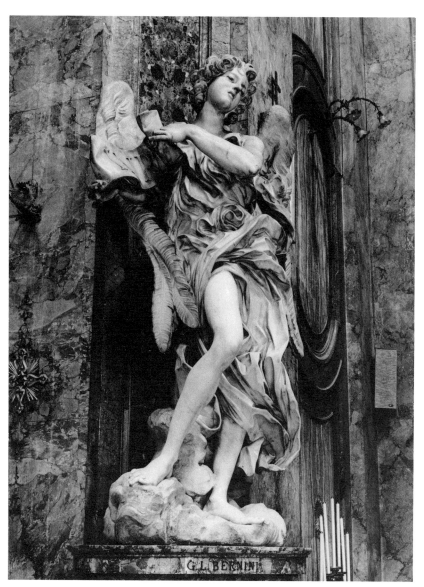

45–47. Gian Lorenzo Bernini, *Angel Carrying the Super-scription*. Rome, S. Andrea delle Fratte

46

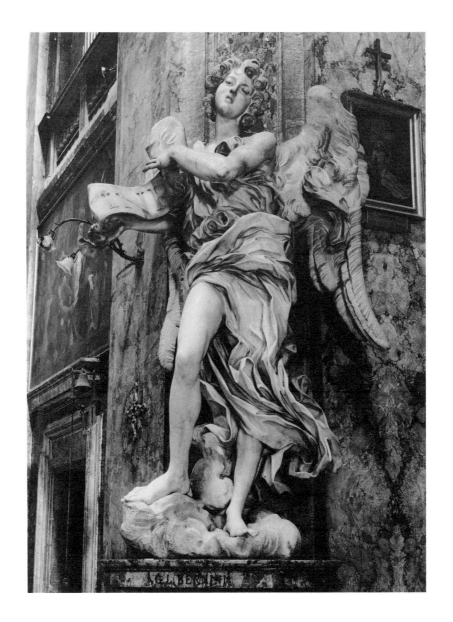

47

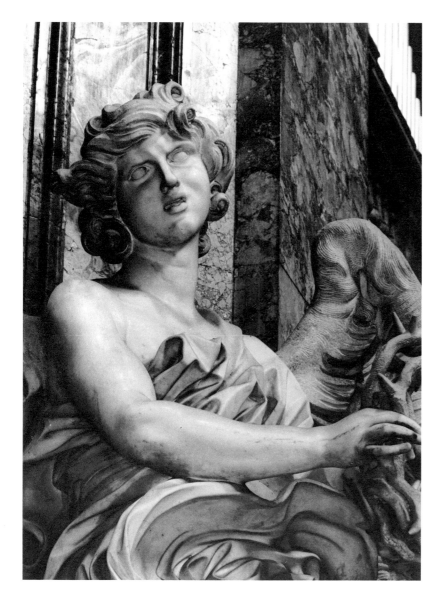

49

48–51. Gian Lorenzo Bernini, *Angel Carrying the Crown of Thorns*. Rome, S. Andrea delle Fratte

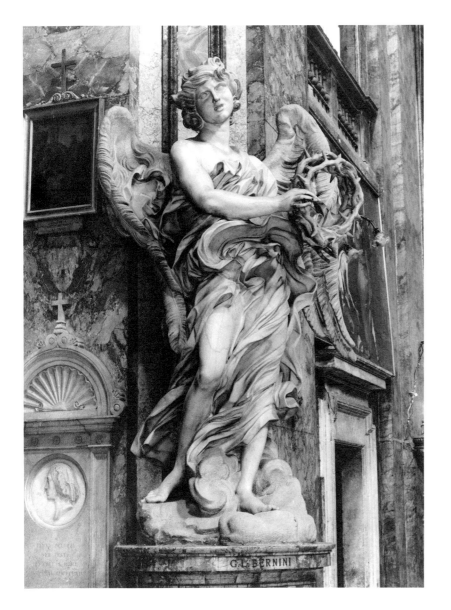

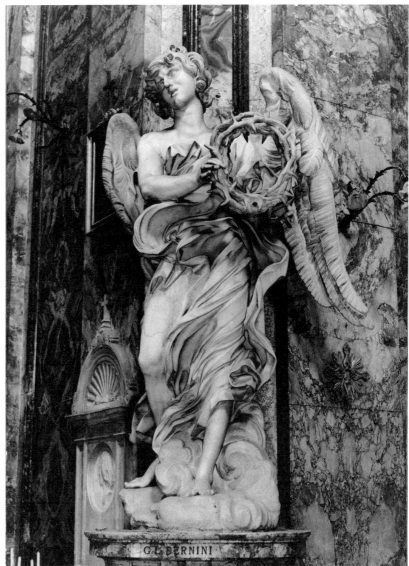

50

51

Castel Sant'Angelo

SPONGE
Antonio Giorgetti
POTAVERUNT ME ACETO
(Ps. LXVIII,22)

LANCE
Domenico Guidi
VULNERASTI COR MEUM
(Song of Solomon IV,9)

SUPERSCRIPTION
Gian Lorenzo Bernini
REGNAVIT A LIGNO DEUS
("Vexilla regis prodeunt"; a
hymn celebrating the Cross as
the instrument of salvation)

CROSS
Ercole Ferrata
CUIUS PRINCIPATUS SUPER
HUMERUM EIUS
(Is. IX,6)

ROBE AND DICE
Paolo Naldini
SUPER VESTEM MEAM
MISERUNT SORTEM
(Ps. XXI,19)

NAILS
Girolamo Lucenti
ASPICIANT AD ME QUEM
CONFIXERUNT
(Zach. XII,10)

CROWN OF THORNS
Paolo Naldini
IN AERUMNA MEA DUM
CONFIGITUR SPINA
(Ps. XXXI,4)

SUDARIUM
Cosimo Fancelli
RESPICE FACIEM CHRISTI TUI
(Ps. LXXXIII,10)

SCOURGE
Lazzaro Morelli
IN FLAGELLA PARATUS SUM
(Ps. XXXVII,18)

COLUMN
Antonio Raggi
TRONUS MEUS IN COLUMNA
(Eccl. XXIV,7)

ST. PETER
Lorenzetto, ca. 1534
HINC RETRIBUTIO SUPERBIS

ST. PAUL
Paolo Romano, 1464
HINC HUMILIBUS VENIA

Campo Marzio

52. Iconographic chart of the Ponte S. Angelo

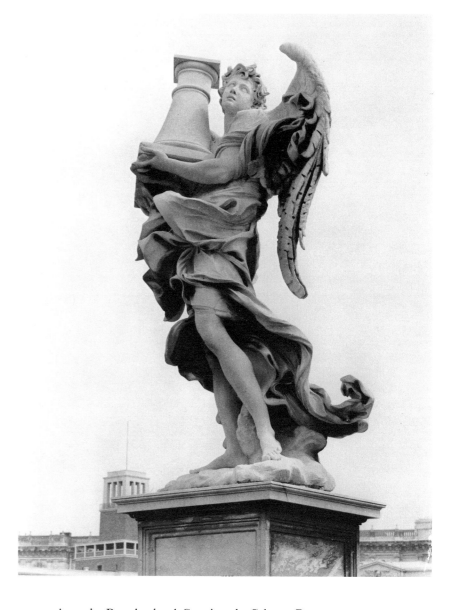

53–55. Antonio Raggi, *Angel Carrying the Column*. Rome,
Ponte S. Angelo

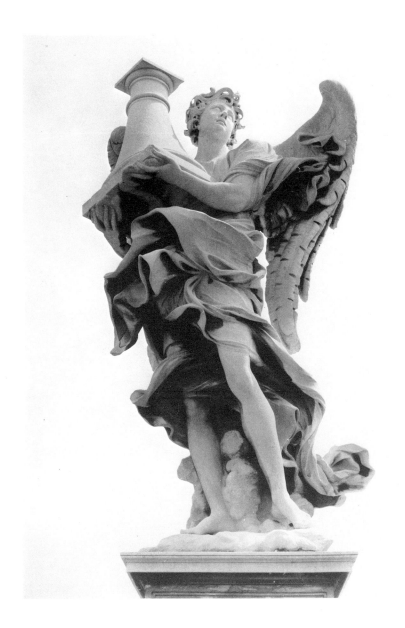

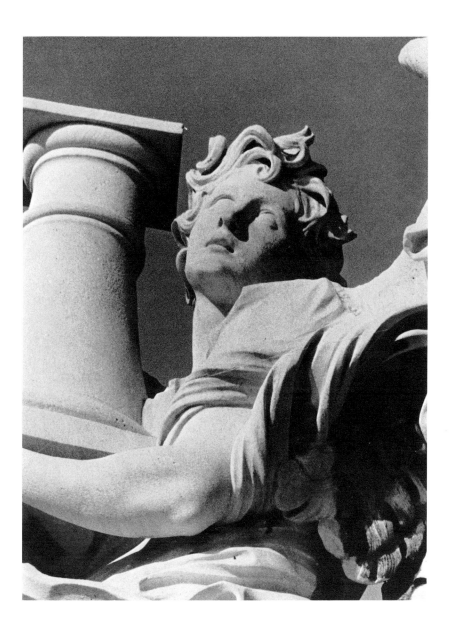

54

55

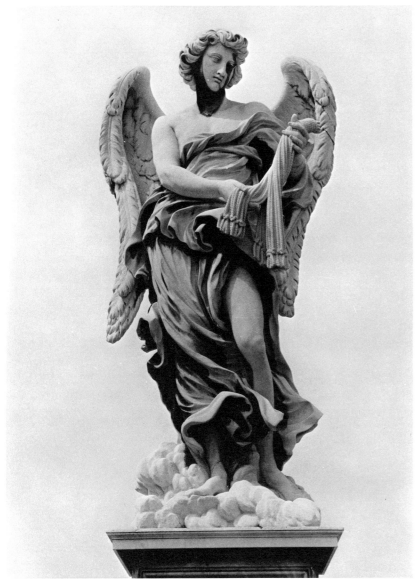

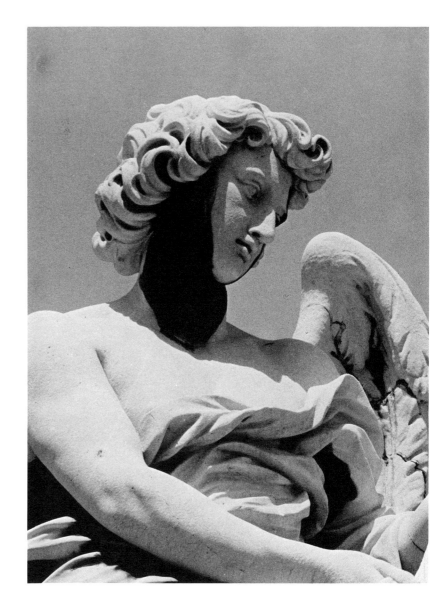

56–57. Lazzaro Morelli, *Angel Carrying the Scourge*. Rome, Ponte S. Angelo

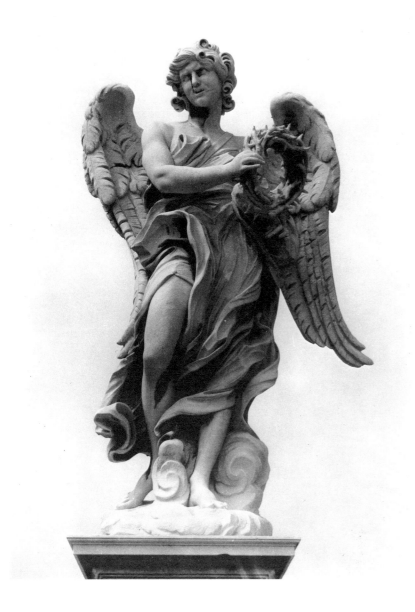

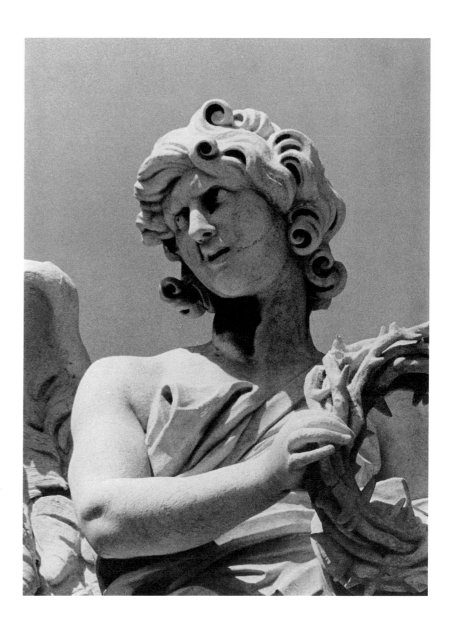

58–59. Paolo Naldini, *Angel Carrying the Crown of Thorns*. Rome, Ponte S. Angelo

59

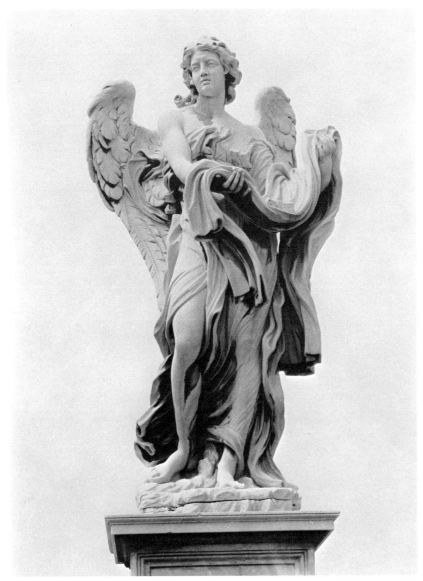

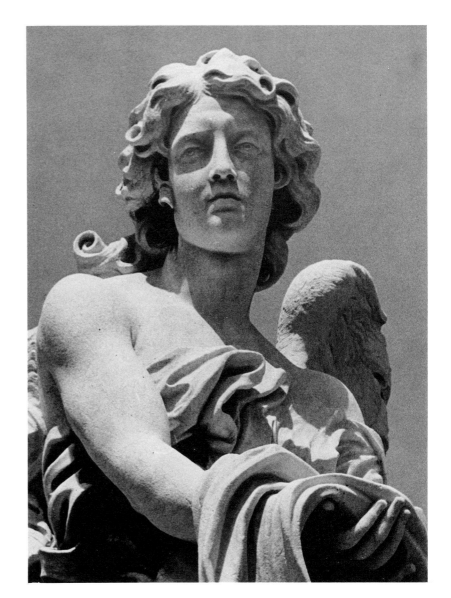

60–61. Paolo Naldini, *Angel Carrying the Robe and Dice.*
Rome, Ponte S. Angelo

61

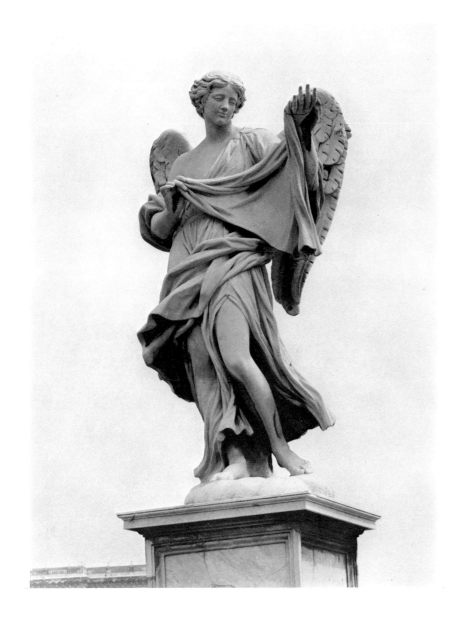

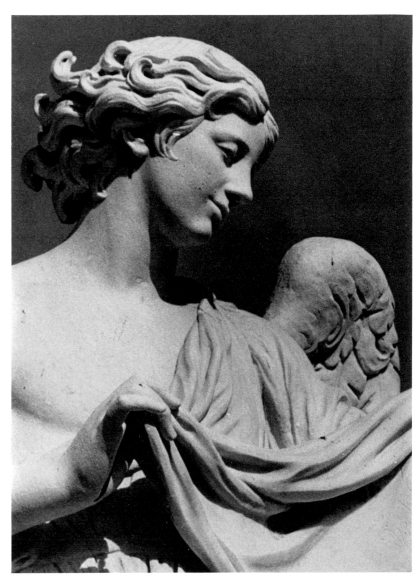

62–63. Cosimo Fancelli, *Angel Carrying the Sudarium*. Rome, Ponte S. Angelo

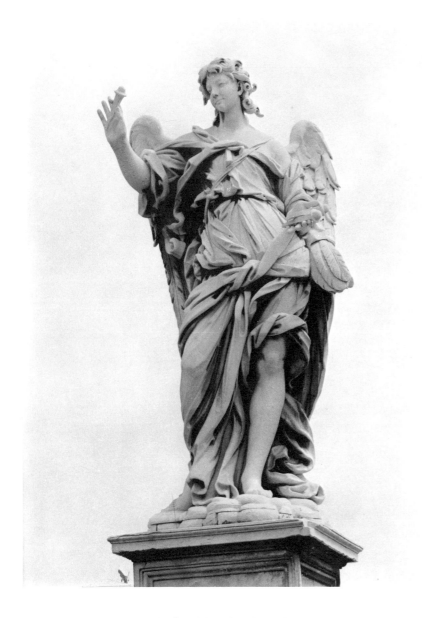

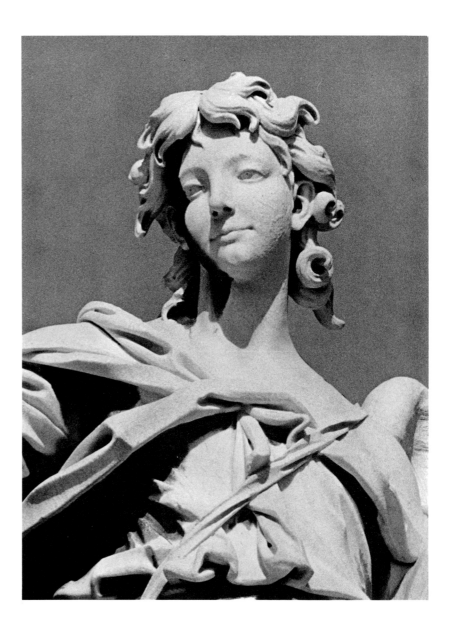

64–65. Girolamo Lucenti, *Angel Carrying the Nails*. Rome,
Ponte S. Angelo

65

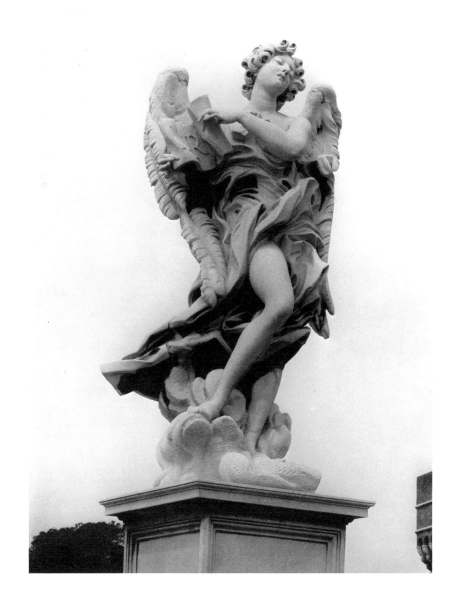
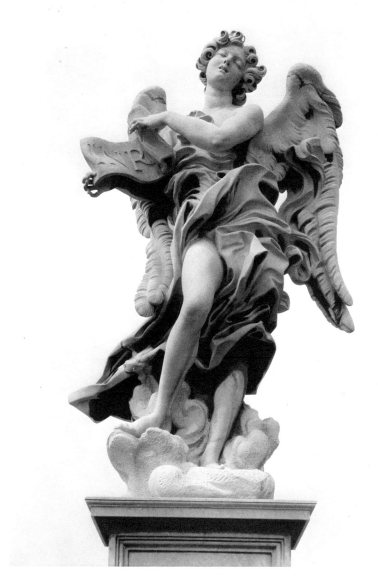

66–69. Gian Lorenzo Bernini, *Angel Carrying the Super-scription*. Rome, Ponte S. Angelo

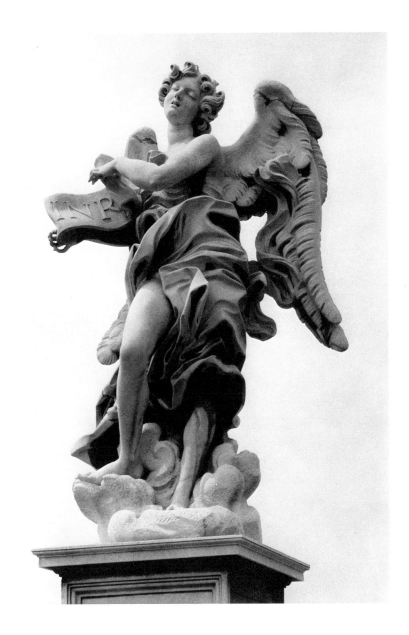

68

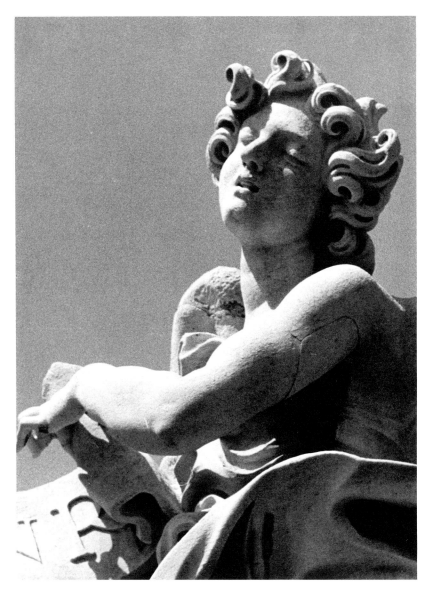

69

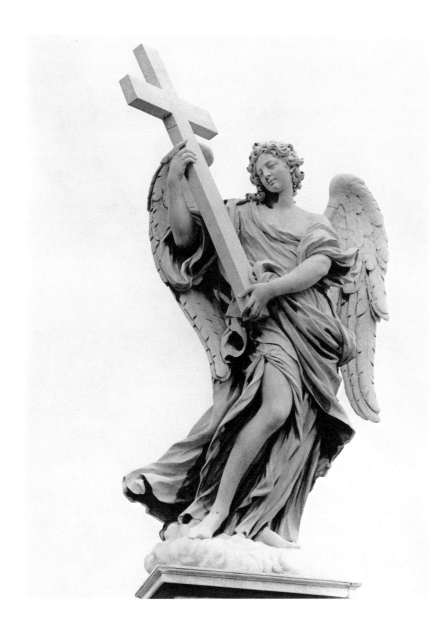

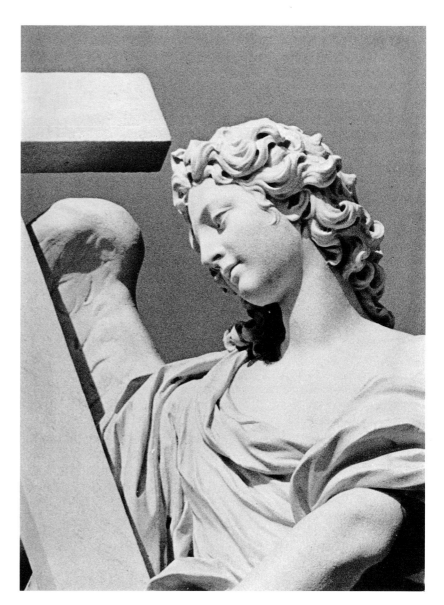

70–71. Ercole Ferrata, *Angel Carrying the Cross*. Rome, Ponte S. Angelo

71

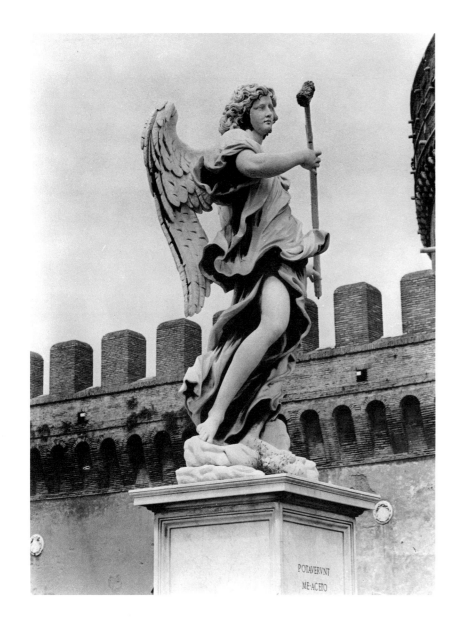

72–75. Antonio Giorgetti, *Angel Carrying the Sponge*. Rome,
Ponte S. Angelo

73

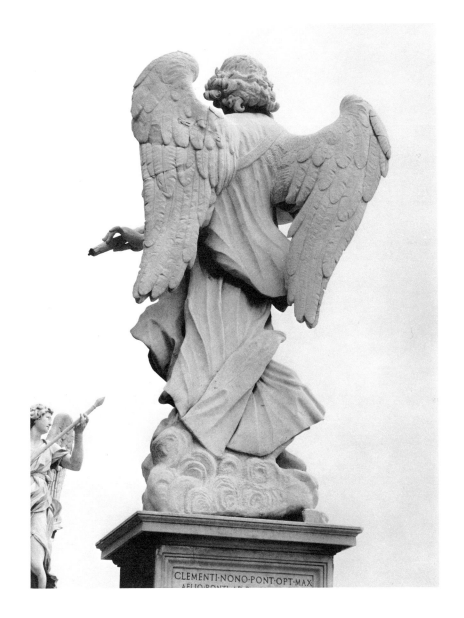

74

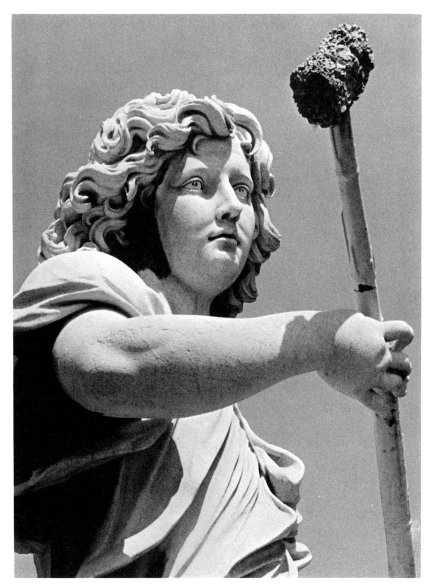

75

CLEMENTI·NONO·PONT·OPT·MAX

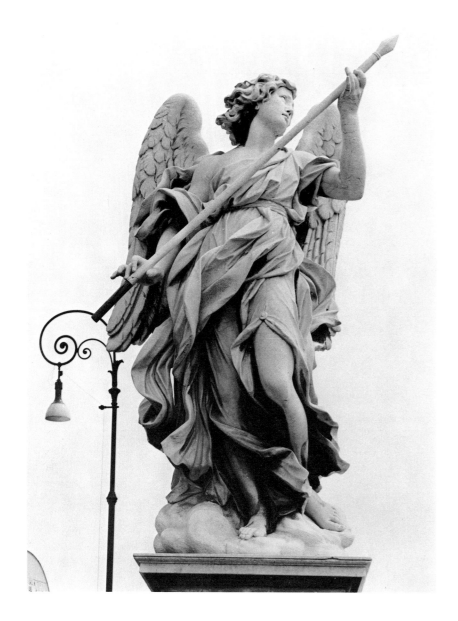
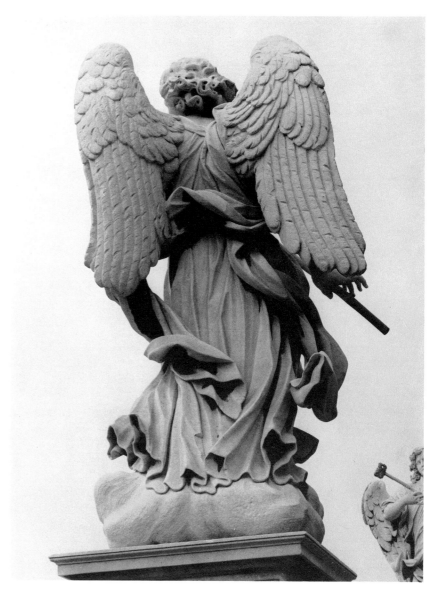

76–78. Domenico Guidi, *Angel Carrying the Lance*. Rome, Ponte S. Angelo

77

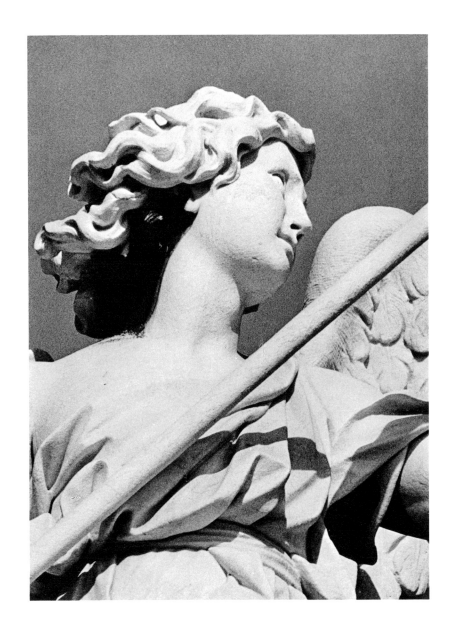

78

4

The Sculptors and the Statues

The angels that Bernini's collaborators carved for the decoration of the Ponte S. Angelo suffer when compared with those carved by the master himself, but such a comparison is at least partially unfair. Bernini was the great artist of his period; he began as a child prodigy under the protection of popes and cardinals and was free to learn his profession and to develop his style and talent without conforming to the discipline of a master to whom he was apprenticed. His genius was such that he maintained his position as papal favorite throughout most of his long career. Bernini's powerfully emotional renderings were very popular with the papal court and quite naturally became the standard against which all other sculpture of the period was judged.

The sculptors who collaborated with Bernini did not have the freedom to develop without conforming to the discipline of a master. Most of them found their first work in Rome in the late 1640s on the large projects of Bernini and Alessandro Algardi. Those who could adapt to the style of a master and execute work according to his wishes found a ready market for their talents; those who could not work under such discipline, or who rebelled against the system, either found little work or supported themselves with small private commissions and by restoring antique statues. Despite the system, the best of the sculptors who carved statues for the bridge developed independent styles or artistic outlooks quite different from Bernini's.

As was noted in the last chapter, each sculptor was supplied with a design to which the basic pose, proportions, and drapery pattern of his statue were to conform. On the other hand, Bernini did not supervise the carving of the statues but left his collaborators free to vary the internal treatment of the statue—that is, the drapery, facial expression, hair treatment, and other details—to suit their own tastes. Each statue is best judged, therefore, against a background of knowledge of the sculptor's education and career. Such information is supplied in the short biographies that follow and by the oeuvre lists contained in Appendix II. The statues and sculptors are discussed in the order prescribed by the iconographic chart (fig. 52), beginning with Antonio Raggi's *Angel Carrying the Column* and making a zig-zag path across the bridge, ending with Domenico Guidi's *Angel Carrying the Lance*.

The Angel Carrying the Column (figs. 53–55)

Antonio Raggi was born in Vicomorcote, a small village in the mountains above Lake Lugano in 1624. He went to Rome as a youth, with some training as a sculptor or *stuccatore*, and found a place in Algardi's workshop.[1] In 1647 he entered Bernini's circle as one of the many artists who collaborated on the decoration of the pilasters of the nave and aisles of St. Peter's.[2] Bernini obviously was impressed with the talent of the young Raggi, for during the next fifteen years the master used Raggi as his chief collaborator in the execution of marble and stucco sculpture. In most cases Bernini supplied Raggi with detailed models and supervised his work so closely that Raggi's statues express Bernini's conceptions almost as well as would

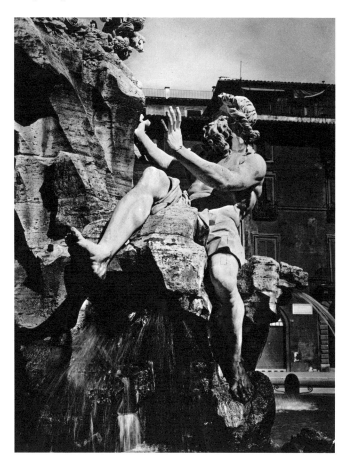

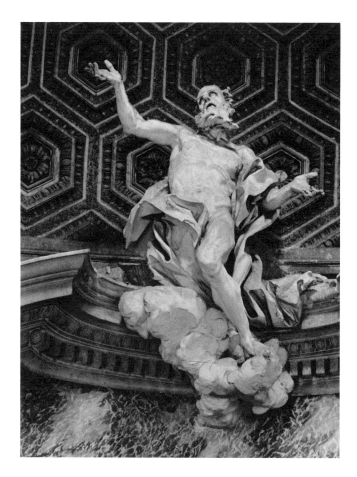

79. Antonio Raggi, *The Danube*. Rome, Piazza Navona, Fountain of the Four Rivers

80. Antonio Raggi, *St. Andrew Rising to Heaven*. Rome, S. Andrea al Quirinale

statues by the master's own hand. Two examples, the colossal marble statue of *The Danube* (fig. 79) on the Fountain of the Four Rivers in Piazza Navona and the stucco statue of *St. Andrew Rising to Heaven* (fig. 80) in S. Andrea al Quirinale, will suffice to show how closely Raggi could follow Bernini's designs. *The Danube*, which was carved in 1650–51, is one of four colossal statues that represent the major rivers of the four parts of the Christian world and hence serve as basic parts of the composition and iconography

of the fountain. Each of these statues was carved by a different sculptor, who executed his statue according to a large model supplied by Bernini. Similarly, the statue of St. Andrew, which was modeled between 1662 and 1665, is the focal point of the drama of the martyrdom and apotheosis of that saint with which Bernini activated the interior space of the church. Furthermore, the intensity of the representation of St. Andrew, an emaciated figure with arms lifted and face turned toward heaven, lifted on a cloud and buoyed up by his

own windblown drapery, is typical of Bernini, for every detail is designed to add to the ecstatic effect of the statue.

It is not surprising, therefore, that Raggi has gained the reputation of being one of the best, as well as the most Berninesque, sculptors of his generation. He was quite prolific and executed work of a very high quality, especially when working in conjunction with Bernini. On the other hand, Raggi's personal style is less Berninesque than one might expect, a fact that can be demonstrated by comparing his independent work with that of Bernini. The nature of Raggi's artistic personality is illustrated by a comparison of the angels carrying escutcheons under the two organ lofts in S. Maria del Popolo (figs. 81–82). These stucco ornaments were modeled by Raggi as a part of the decoration of the church commissioned by Pope Alexander VII and carried out under the supervision of Bernini in 1655–57.[3] The ornament under the organ loft on the right (fig. 82) was clearly modeled according to Bernini's design. It serves a dual purpose, as a decoration for the church, acting as a visual support for the organ loft, and as the expression of a noble conceit, i.e., the idea of a heavenly being supporting a papal coat of arms, hence referring to the pope's role as vicar of Christ. The design of the ornament is in keeping with the theme: the escutcheon, floating vertically between two arches, is delineated in clear, crisp lines, and the perfectly balanced, flying angel carries its load effortlessly. Its legs are bent at the knees, and the drapery sweeps around them so as to increase the illusion that the figure is in flight. The putto on the right, playfully supporting the garland of flowers, serves to balance the composition.

The ornament under the left organ loft (fig. 81) appears to be a free variation of the ornament on the right. It is a witty, almost proto-rococo decoration, in which the coat of arms of the pope seems in danger of being dropped. The angel, which has alighted on the impost block of the arch, has stepped on the edge of its robe and lost its balance. In addition, its robe has slipped from its shoulders, binding its arms and interfering with its ability to carry the load. The coat of arms, which is soft and beginning to curl at the edges, is turned diagonally and appears to be in danger of falling. Even the putto is worried and seems to be struggling to support himself.

81. Antonio Raggi, ornament beneath the left-hand organ loft of S. Maria del Popolo, Rome

82. Antonio Raggi, ornament beneath the right-hand organ loft of S. Maria del Popolo, Rome

83. Gian Lorenzo Bernini, Tomb of Maria Raggi. Rome, S. Maria sopra Minerva

84. Antonio Raggi, Tomb of Cardinal Bragadin. Rome, San Marco

The difference between the two ornaments is typical of the difference between Bernini and Raggi. Bernini carefully planned every detail of his work so that its meaning would be immediately clear to the viewer. Raggi spent most of his career working as a collaborator, executing sculpture for large projects designed by Bernini and other artists; it is not surprising, therefore, that when given the opportunity to design independent works of art, he was more interested in working out technical problems and producing attractive statues or reliefs than he was in expressing specific ideas. As a result, his independent works appear either to be playful, like the ornament under the left organ loft in S. Maria del Popolo, or to reflect the nervous tension apparent in much of Bernini's work without maintaining the master's clarity of purpose.

A comparison between Bernini's Tomb of Maria Raggi in S. Maria sopra Minerva (1643; fig. 83) and Raggi's Tomb of Cardinal Bragadin in S. Marco (ca. 1658; fig. 84)[4] helps

to clarify the difference between the two artists. Bernini's careful planning of the Maria Raggi Tomb is evident in the unity of its design. The key to the composition is the Cross that leans slightly to the left at the top of the tomb, repeating the tilt of Maria Raggi's head in the medallion. The cruciform shape is reflected by the form of the marble drapery and by the positions of the putti supporting either side of the medallion. The purpose of the tomb also is clear from the concept of the portrait, which represents Maria Raggi at the moment of death, and by the expressions of the putti, which reflect the sadness of their task.

The Tomb of Cardinal Bragadin is clearly based on that of Maria Raggi and might be called Berninesque in execution, but it lacks the unity of conception found in the earlier monument. The Bragadin Tomb is divided into two distinct compositional units. The lower one is composed of a marble medallion, flanked by two putti, containing an inexpressive portrait of Cardinal Bragadin. The two putti fall away from the portrait as if in amazement rather than sorrow; they do not support the medallion but are themselves supported by folds of the black marble drapery. At the top of the monument, two putti struggle to carry aloft the coat of arms of Cardinal Bragadin.

Similar handling of Berninesque motifs is apparent in monumental marble sculpture carved by Raggi; for example, the relief of the *Death of S. Cecilia* in S. Agnese in Piazza Navona (1660–67; fig. 85).[5] Another sculptor, Giuseppe Peroni, was originally commissioned to carve the relief and finished a full-size model for it before his death in 1662. For the most part Raggi seems to have followed Peroni's composition in executing the relief. On the other hand, the handling of the principal figures reflects Raggi's style. This is especially true of the man on the far right, whose drapery rises up over his body in deep folds, creating an image of excitement or action uncalled for by the scene represented.

Like the other sculptors who carved angels for the Ponte S. Angelo, Raggi was commissioned to carve a statue that was to be based on Bernini's design (fig. 30). Bernini conceived the statue as an angel carrying a column that is a replica of the Column of the Flagellation enshrined in the Church of S. Prassede as a relic of the Passion of Christ.[6]

85. Antonio Raggi, *Death of St. Cecilia*. Rome, S. Agnese in Piazza Navona

75

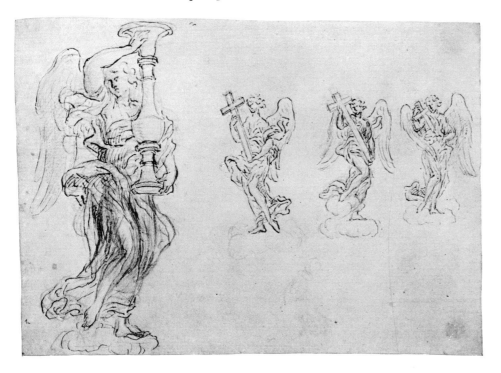

86. Antonio Raggi, studies for the *Angel Carrying the Cross*. Düsseldorf, Kunstmuseum

The angel was to reflect both the idea of a column—a straight, vertical supporting member—and the squat, quickly tapering Column in S. Prassede. Hence the figure stands very straight; there is little movement in its body, and both legs are almost completely covered by its garment. The vertical line of its pose is broken by its two arms reaching forward and supporting the Column of the Flagellation. The short, quickly-tapering lines of the Column are abstractly reflected by the drapery, which hangs loosely over the hips, tapers at the waist, and is capped by the angel's squared shoulders.

Bernini's design would have produced a statue equally attractive and probably more meaningful than the one carved by Raggi; Raggi, however, was forced to change the form of the *Angel Carrying the Column* in order to secure the massive marble Column, the weight of which would have caused the outstretched marble arms of the angel to break had the statue been carved as Bernini conceived it. Raggi's approach to the problem of redesigning the statue is partially recorded by two sheets of drawings from his hand in the Düsseldorf Kunstmuseum.[7] These black chalk and ink drawings probably represent his first concrete ideas about the decoration of the Ponte S. Angelo, for they contain copies and variations of three of the many Bernini and Bernini workshop drawings made in preparation for the ten statues decorating the bridge. The first sheet (fig. 86) contains one study of an angel carrying a candelabrum and three smaller studies of angels carrying the Cross. A comparison of the angel carrying the candelabrum with the Bernini workshop drawing of the *Angel Carrying the Cross* (fig. 25) shows that the former is a variation of the latter. With the exception of the arms, the pose of the angel carrying the candelabrum is an adaptation of the pose of the *Angel Carrying the Cross*. The drapery of Raggi's angel is also based upon the Bernini design; although the two flourishes of drapery, one over the angel's right hip and the other by its left knee, were superimposed on the drawing by Raggi as an afterthought, the original outlines of the drapery covering the angel's legs are very close to the comparable outlines in the Bernini workshop drawing. Raggi used his drawing of the angel carrying the candelabrum to study the problem of an angel carrying an object. From this figure he developed three variations of the *Angel Carrying the Cross*.

The second and third drawings (fig. 87–88) in Düsseldorf are the recto and verso of the same sheet. The verso contains three very free figure sketches of the *Angel Carrying the Sudarium*, which are probably variations on a lost Bernini sketch for the same angel. The recto shows three studies for the *Angel Carrying the Column*. The figure in the center, the first drawn on the sheet by Raggi, is based on a Bernini drawing very much like the one in the Gabinetto Nazionale delle Stampe in Rome (fig. 30). Raggi's study is of a figure for which the problem of supporting the Column without causing the arms to break has been taken into consideration. The angel holds the Column close to its body and is aided in supporting the heavy object by a great mass of windswept drapery that rises from the skirts of its garment. This

upward sweep of drapery effectively destroyed the colum-
nar aspect of the angel and left Raggi with a rather top-
heavy figure supported by a pair of visually insubstantial
legs. The sculptor was certainly aware of this problem, for
in the other two sketches for the *Angel Carrying the Column* on
the same sheet he de-emphasized the supporting nature of
the legs by lifting the free foot of the angel higher than in
the central sketch.

In executing the statue, Raggi returned to the central
study of the sheet and hence maintained the contrapposto
pose called for by the Bernini workshop drawing, but
destroyed the simple logic of the drapery apparent in
Bernini's design. Raggi used the upsweep of drapery to hide
the fact that the base of the Column is not completely
carved but sinks into and is supported by the torso of the
angel. In so doing he caused the angel to appear slightly
awkward, for he left both its legs uncovered and masked the
curve of the contrapposto pose behind a mass of extremely
active drapery that rises and twists for no apparent reason.

Raggi's angel reflects little interest in a conceit, either
formally or emotionally. As was the case with the ornament
under the organ on the left in S. Maria del Popolo, Raggi
looked upon his colossal marble statue of the *Angel Carrying
the Column* more as an ornament than as an expression of a
religious subject.

The Angel Carrying the Scourge (figs. 56–57)
Lazzaro Morelli was born in Ascoli Piceno on 30 October
1608, the son of Fulgenzio Morelli, a sculptor from Flor-
ence, and Angela d'Antonio Giosafatti from Venice.
Lazzaro was educated as a sculptor and seems to have had
some success before leaving his hometown. He migrated to
Rome when he was about thirty years old, and after a great
deal of hardship he was introduced by a priest to François
Duquesnoy, in whose studio he found employment. Pascoli
informs us that Morelli soon made friends with Bernini,
with whom he went to study after Duquesnoy became ill
in 1643.[8]

Morelli worked almost exclusively for Bernini until the
master's death in 1680. The younger sculptor was one of
several artists who collaborated with Bernini in the decora-
tion of the interior of St. Peter's between 1646 and 1651.

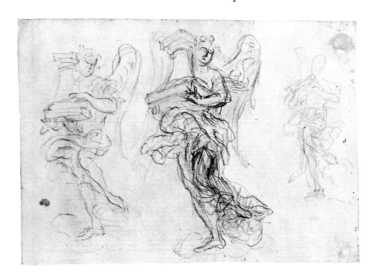

87. Antonio Raggi, studies for the *Angel Carrying the Column*.
Düsseldorf, Kunstmuseum

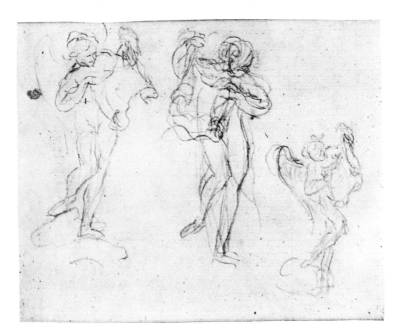

88. Antonio Raggi, studies for the *Angel Carrying the
Sudarium*. Düsseldorf, Kunstmuseum

Morelli carved the two putti over the Tomb of Pope Urban VIII; he was one of many sculptors who helped decorate the pilasters of the nave and aisles of the basilica and was one of seven sculptors who modeled the gigantic stucco figures that fill the spandrels of the arches of the nave and chapels. On 5 November 1655 he was paid for modeling the stucco figure of St. Pudenziana, one of ten figures of female martyrs and saints executed after Bernini's designs for the spandrels of the nave arches in S. Maria del Popolo. On 15 July and 26 August 1656 he received *a conto* payments for modeling the Chigi *monti* on the city side of the attic story of the Porta del Popolo;[9] between 1661 and 1672 he carved between twenty and forty travertine statues of saints that decorate the attic of the colonnades embracing the Piazza di S. Pietro. Morelli did not design the travertine statues but carved them from designs supplied by Bernini.

It is not surprising, therefore, that when he was confronted with the task of carving the *Angel Carrying the Scourge* for the Ponte S. Angelo, Morelli rather mechanically copied a model supplied to him by Bernini: his statue is clearly dependent upon Bernini's bozzetto for the *Angel Carrying the Superscription* in the Fogg Museum (fig. 34).[10] The only significant change between the bozzetto and statue is an added loop of drapery at the bottom of the angel's gown.

The Angel Carrying the Crown of Thorns (figs. 58–59)
The Angel Carrying the Robe and Dice (figs. 60–61)
Paolo Naldini was born in Rome in 1614. He was inclined toward painting and sculpture at an early age and was apprenticed to the painter Andrea Sacchi. Naldini evidently had no success as a painter, because Sacchi and Carlo Maratti, his lifelong friends, advised him to become a sculptor. Heeding their advice, Naldini entered the workshop of Bernini but remained there only a short time. He seems to have felt himself to be more advanced than the other students and smothered by the omnipresent dominance of Bernini. On the other hand, Bernini always respected Naldini's talent. The older master used Naldini as a collaborator on several occasions and once wrote that, after Raggi, Naldini was the best sculptor in Rome.[11] Bernini's high opinion of Naldini is also reflected by the fact that

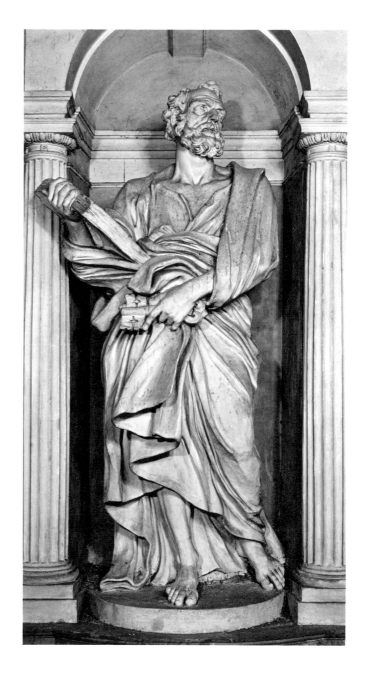

89. Paolo Naldini, *St. Peter*. Rome, S. Martino ai Monti

Naldini was the only sculptor other than Bernini to carve more than one statue for the decoration of the Ponte S. Angelo.

Naldini's conception of the human figure was based, as one might expect, on "Baroque classicism" as interpreted by Sacchi. The most important of the sculptor's surviving independent works is a series of colossal stucco statues of saints modeled between 1649 and 1652 for the decoration of the interior of S. Martino ai Monti.[12] One statue from this series, the figure of St. Peter (fig. 89), may be used to represent the entire group. St. Peter stands in the classic contrapposto position of a man in repose. His weight is carried by his right leg, his left leg is bent at the knee, his left shoulder is slightly raised, and his head leans slightly toward the raised shoulder. The saint's dress is based on the style of a Roman *figura togata*. The garment is wrapped around the body and reacts to gravity and the movement of the body, but is not used to express emotional content.

The *Angel Carrying the Robe and Dice* reflects Naldini's classicizing taste. He chose to emphasize the form of the figure rather than to stress its emotional reaction to Christ's suffering. Like the statue of St. Peter, the angel stands in a simple contrapposto pose, draped in a garment that hangs naturally over its body. Even the shape of the robe carried by the figure falls over its arms in such a way that it conforms to the silhouette of the body. The classicizing nature of the statue is given added impact by its head and face, which are modeled on ancient portraits of Alexander the Great, such as those in the Capitoline Museum and the Museo Barracco in Rome.[13] Naldini's statue of the *Angel Carrying the Crown of Thorns* is based on Bernini's statue in S. Andrea delle Fratte and on a model by Bernini in the Hermitage Museum in Leningrad (fig. 90).[14] Hence both the facial expression and the drapery contain more psychological force and are more active than their counterparts in the *Angel Carrying the Robe and Dice*. On the other hand, the *Angel Carrying the Crown of Thorns* reflects Naldini's classicism: in comparison with Bernini's statue of the same subject, every element of Naldini's statue is reduced to its simplest form, and the statue is transformed into a compact stationary unit.

90. Gian Lorenzo Bernini, bozzetto for the second *Angel Carrying the Crown of Thorns*. Leningrad, Hermitage

The Angel Carrying the Sudarium (figs. 62–63)

Cosimo Fancelli was born in Rome in 1620, the son of Carlo Fancelli, a *scarpellino* from Arezzo, and the brother of Giacomo Antonio Fancelli, the sculptor who carved the statue of The Nile on the Fountain of the Four Rivers in Piazza Navona. Both Giacomo Antonio and Cosimo were trained by Bernini and often worked together on the same projects. As is the case with several of the artists who carved statues decorating the Ponte S. Angelo, our earliest notices (1647–49) of Cosimo Fancelli show him collaborating on the decoration of the pilasters of the nave of St. Peter's

Basilica. Between 1648 and 1650 he carved three smaller-than-life-size statues of female saints and two small alabaster reliefs of the Madonna and Child appearing to S. Martina, in connection with Pietro da Cortona's decoration of the crypt of the Church of SS. Luca e Martina and the altar over the tomb of S. Martina. From that date until Pietro da Cortona's death in 1668, Cosimo worked almost exclusively on projects designed by the older master.[15]

It is not surprising that the *Angel Carrying the Sudarium* has been called Cortonesque.[16] The slightly squat proportions of the angel and the use of an apparently soft drapery that masks the form of the body are reminiscent of paintings by Pietro da Cortona, such as the *Guardian Angel* of 1656 in the Galleria Nazionale in Rome and the angel in the painting of the *Annunciation* of ca. 1665 in Cortona.[17] On the other hand, it is quite clear that in carving the *Angel Carrying the Sudarium* Fancelli dryly followed a Bernini *pensiero*. Bernini's conceit for the angels carrying the instruments of the Passion (see chapter 3) called for a series of standing angels, each reflecting on or reacting emotionally to the moment of the Passion represented by the instrument that it carries. In every case, the angel's pose and the pattern of its drapery were to add emphasis to the emotional reaction. On the most obvious level, this means simply that the pose of the angel and the pattern made by the folds of its drapery should reflect the shape of the instrument carried, and Fancelli understood Bernini's *pensiero* only in this sense. The right border of the Sudarium is reflected in the right side of the angel's skirt, and the slant of its top border, which falls from the angel's left hand to its right hand, is echoed by the diagonal twist of drapery that crosses the angel's hips. This piece of drapery meets the third side of the visually triangular Sudarium at right angles, and the twisted form of the fold of drapery repeats the shape of its upper and right edges.

The Angel Carrying the Nails (figs. 64–65)
Girolamo Lucenti, the son of Ambrogio Lucenti, a bronze founder who worked for the Fabbrica di S. Pietro, was born in about 1621. Nothing more is known of his early life, but we may assume that he spent a great deal of time working in his father's foundry, because bronzecasting was to become his chief occupation. Passeri informs us that Lucenti was a disciple of Alessandro Algardi and that on the occasion of Algardi's death he divided the contents of the master's studio with Domenico Guidi and Ercole Ferrata.[18]

Lucenti first worked for Bernini in 1647–49, when he collaborated on the decoration of the pilasters of the nave and aisles of St. Peter's Basilica. He does not appear again in documents concerning Bernini until 1668, the year in which he received his first payment for the *Angel Carrying the Nails*. During the intervening years, Lucenti was busy making bronze cannon for the papal artillery and serving as a captain and instructor in the use of weapons in the papal army. In 1669 he received the title *cavaliere* in recognition for his services to the Papal States. From then on his services were much sought after in a variety of fields: he became a die-engraver for the papal mint, a bronze-founder for the Fabbrica di S. Pietro, and a sculptor in marble and bronze.[19]

Lucenti's statue of the *Angel Carrying the Nails* is related to Bernini's design only in the sense that it maintains the contrapposto pose common to all of the angels. The figure's proportions are more massive than those of the other statues, and its head is smaller in relation to its body. Its garment is carved in a manner that is neither classical nor Berninesque. A classicist such as Naldini used drapery to accent the form of the body by causing the folds to follow the line and motion of the figure. In designing the angels for the Ponte S. Angelo, Bernini used drapery formally to suggest the various instruments of the Passion and psychologically to reflect the emotional state of the angels. Lucenti divided the drapery of the *Angel Carrying the Nails* into numerous ribbonlike folds that move in every direction and make no coherent pattern. The folds tend to hide rather than accent the form of the body and to bind the angel to its flat, plinthlike cloud. Bernini and the other sculptors emphasized the freedom of movement of their angels by leaving their free legs nude; Lucenti, in contrast, bound the free leg of his angel in a massive swathe of drapery.

The Angel Carrying the Superscription (figs. 66–69)
Giulio Cartari, the sculptor paid for carving the second version of the *Angel Carrying the Superscription*, is described by

91. Gian Lorenzo Bernini, bozzetto for the second *Angel Carrying the Superscription*. Leningrad, Hermitage

Domenico Bernini as a youth who entered Bernini's service at less than eighteen years of age and who showed such love of the sculptor's profession that he was taken into Bernini's home, where he became a favorite pupil. The year in which Cartari began studying with Bernini is not known, but it must have been before 1665, when the youth accompanied the master to Paris.[20] In any case, Cartari never became more than a skilled craftsman. He had never been asked to carve a monumental statue before receiving the commission for the *Angel Carrying the Superscription* and is not known to have produced a single work that was not designed and executed under Bernini's supervision.

Domenico Bernini and Baldinucci state that Bernini secretly carved the second version of the *Angel Carrying the Superscription* after Pope Clement IX had decided that the artist's first two statues for the bridge were too beautiful to be exposed to the weather.[21] Both writers note that Bernini did not want the Ponte S. Angelo to be without a work by his own hand. Bernini's authorship of the statue is borne out by a bozzetto by his hand in the Hermitage Museum in Leningrad (fig. 91) and by the statue itself. The statue is not a copy of the *Angel Carrying the Superscription* in S. Andrea delle Fratte but is a new interpretation of the conceit of a heavenly being suffering while meditating on Christ's Passion (see p. 49). The second version of the *Angel Carrying the Superscription* was probably produced in the same manner as were the statues now in S. Andrea delle Fratte (see p. 40), with Giulio Cartari preparing the marble according to Bernini's design and under his supervision and then working with the master to finish the statue.

The Angel Carrying the Cross (figs. 70–71)
Ercole Ferrata was born in Pelsoto (now Péllio) in the diocese of Como in 1610. At an early age he was taken by his parents to Genoa, where he was apprenticed to the little-known sculptor Tommaso Orsolino, with whom he studied for seven years. By 1637 Ferrata had left Genoa and gone to Naples, where he is mentioned in that year in a list of members of the Corporazione di Scultori e Marmorari di Napoli as "Ercole Ferrata Marmoraio." He remained in Naples for nine years, during which time he is reported to have carved no less than ten statues and a great deal of decorative ornament, both in collaboration with Cosimo Fanzago and independently. In 1646 Ferrata went to Aquila, where he designed and carved at least two statues. In the same year he traveled to Rome in the company of Monsignor Virgilio Spada, who introduced him to Bernini. Bernini tested the young sculptor by having him make models for the decoration of the pilasters and aisles of St. Peter's. He was evidently satisfied with Ferrata's models, for he had him carve two pairs of putti carrying medallions with papal portraits and two pairs of putti carrying keys.[22]

Ferrata proved to be one of the most prolific sculptors of his period. Between 1647 and 1654 he collaborated with

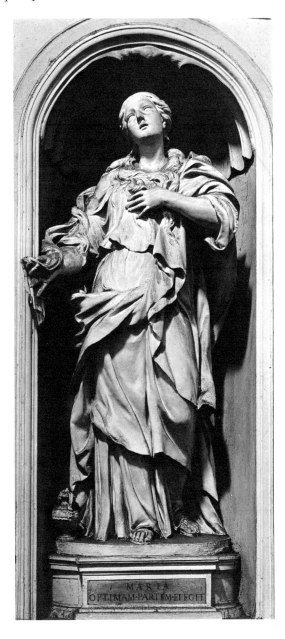

92. Alessandro Algardi, *St. Mary Magdalen*. Rome, S. Silvestro al Quirinale, Cappella Bandini

Bernini on the decoration of St. Peter's and the Tomb of Cardinal Domenico Pimentel (d. 1653) in S. Maria sopra Minerva, and he carved a medallion with the image of S. Francesca Romana accompanied by an angel holding a book as part of Bernini's decoration of the crypt of S. Francesca Romana. During the same years he worked with Algardi on the colossal *Attila* relief in St. Peter's and collaborated with Domenico Guidi on the execution of Algardi's design for the high altar of S. Nicola da Tolentino.[23] Between 1654 and his death in 1668 Ferrata collaborated on the execution of projects designed by almost every major architect and designer in Rome and yet found time to establish his own studio, in which he produced many works of his own design and trained a large number of sculptors. Between 1667 and his death he devoted a great deal of his time to teaching; documents from these years show that Ferrata and Ciro Ferri were employed by Duke Cosimo III to instruct young Florentine artists studying the arts of design and sculpture in Rome.[24]

Ferrata's manner is very similar to that of Algardi. Wittkower described Algardi's stucco statue of *St. Mary Magdalen* in the Cappella Bandini of S. Silvestro al Quirinale (ca. 1628; fig. 92) as being "half-way between the subjectivism of Bernini's *St. Bibiana* and the classicism of Duquesnoy's *St. Susanna*."[25] Like the *St. Bibiana*, the *Magdalen* stands in a contrapposto pose, eyes turned to heaven, with her inner emotion reflected by the movement of her drapery. The drapery of the *Magdalen* differs from that of the *St. Bibiana*, however, in that it does not have a life of its own but instead falls in clear, linear folds that define the form and the movement of the saint's body. In the same way, Ferrata's statue of *St. Agnes on the Pyre* in S. Agnese in Piazza Navona (begun 1660; fig. 93) may contain Berninesque motifs but is basically classicizing in the sense that the activity of the drapery defines the form of the saint's body and gives the pose a kind of permanence.[26] In a slightly later work, the statue of *Faith* in the Cappella Falconieri in S. Giovanni dei Fiorentini (1665–70; fig. 94),[27] Ferrata's adherence to clarity of form is even more apparent. *Faith* sits draped in a heavy gown that sweeps around her in almost parallel folds, which contain and emphasize the shape and gentle movement of the figure.

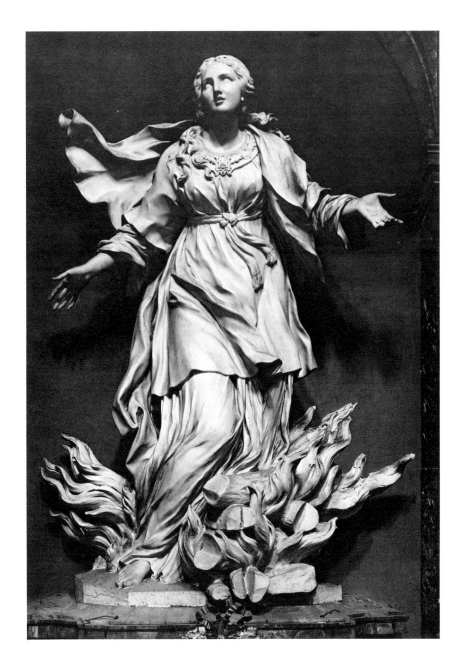

93. Ercole Ferrata, *St. Agnes on the Pyre*. Rome, S. Agnese in Piazza Navona

94. Ercole Ferrata, *Faith*. Rome, S. Giovanni dei Fiorentini, Cappella Falconieri

95. Rome, S. Girolamo della Carità, Cappella Spada

It should now be clear that the *Angel Carrying the Cross* differs from Bernini's *pensiero* in a way that is typical of Ferrata's manner (see pp. 44–45). The statue maintains the pensive mood of the *pensiero*, but the angel's garment emphasizes the clarity of the figure and pose rather than helping to express its mood.

The Angel Carrying the Sponge (figs. 72–75)
Less is known about Antonio Giorgetti than any of the other sculptors who carved statues for the Ponte S. Angelo.[28] His father was Giovanni Maria Giorgetti, a highly successful cabinetmaker and woodcarver who worked with Bernini and Francesco Borromini and who was on the payroll of Cardinal Francesco Barberini. Antonio seems to have been trained by Algardi and was well enough established by 1658 to take on the ten-year-old Lorenzo Ottoni as an apprentice. He was married on 15 September 1668 and

died on Christmas night of the following year. Antonio and his younger brother Giuseppe, who was also a sculptor, were employed by Francesco Barberini, as was their father. Antonio executed several works for the cardinal, including the iconostasis of the Abbey Church of Grottaferrata in 1660–65, a work that includes two monumental marble and bronze statues of angels kneeling in adoration of an image of the Madonna; the Tomb of Lucas Holstenius in S. Maria dell'Anima in 1661–63; a small relief of the *Death of St. Thomas Aquinas* for the Abbey at Fossanova in 1666–67; and a relief of the *Nativity* for a church in the village of Santa Marinella in 1668. Aside from the *Angel Carrying the Sponge*, other important commissions include the two marble angels holding a cloth of colored stone that serves as the balustrade of the Cappella Spada in S. Girolamo della Carità (ca. 1660) and a *tableau vivant* designed for a fireworks display of 19 February 1662, given in honor of the birth of the Spanish Prince Don Carlos.

Giorgetti's style may be judged from the angels of the Cappella Spada balustrade (fig. 95), which are very similar in pose and style to the angel accompanying St. Philip Neri in Algardi's famous group over the altar of the sacristy of S. Maria in Vallicella. The most significant difference between Giorgetti's angels and that by his master is the way in which the younger sculptor broke up the drapery covering his angels into a series of almost parallel folds that help accentuate the torsion of the angels' bodies. The angels are a bit crude but show that Antonio promised to become one of the better sculptors in Rome. In a sense, that promise was fulfilled with the carving of the *Angel Carrying the Sponge*, in which the young sculptor followed Bernini's *pensiero* rather closely and in so doing created one of the most successful statues decorating the Ponte S. Angelo (see p. 45).

The Angel Carrying the Lance (figs. 76–78)
Domenico Guidi was born in 1625 in Torano, a small village in the marble quarries above Carrara. Guidi undoubtedly learned to carve in his native stone quarries. He also may have worked with a bronze founder, for his early biographers note that when he was about eighteen years old he was working in Naples with his uncle, Giuliano Finelli, for whom he made bronze casts of several statues for the treasury of the cathedral of that city. In any case, Guidi had had some training as a sculptor by the time he fled from Naples to Rome, as a result of the popular uprising against the excesses of Spanish rule in Naples in July, 1647. Upon his arrival in Rome, Guidi immediately found a place in Algardi's workshop and during the next seven years became the master's favorite assistant.[29]

Pascoli informs us that Guidi hated the leading artists of Rome and was hated in turn for flooding the market with works of mediocre quality.[30] The reason for this mutual animosity was probably the fact that Guidi was ambitious. After Algardi's death in 1654 Guidi did not collaborate on the execution of the decorative projects of Bernini or Pietro da Cortona; he preferred—or was forced, as the case may be—to make his living executing works of his own design. At first this meant constructing small funerary monuments and carving portrait busts or an

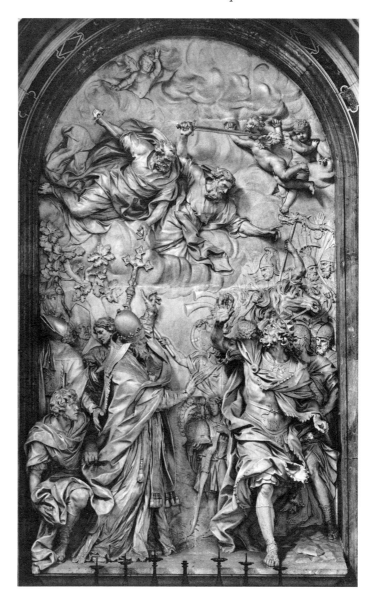

96. Alessandro Algardi, *The Meeting of Pope Leo and Attila.* Rome, St. Peter's Basilica

occasional statue. But by 1659 Guidi's reputation was such that he received the commission for the altar relief of the Cappella del Palazzo del Monte di Pietà,[31] one of the more important commissions available at that time. By the mid 1670s Guidi was receiving as many independent commissions as any other sculptor in Rome, if not more. During the same decade (1670–80) his fellow artists officially recognized his ability by electing him *principe* of the Accademia di S. Luca in 1670 and again in 1675. In 1675 Guidi established official artistic relations with France by inviting Charles Le Brun to become *principe* of the Roman academy. It was suggested that Charles Errard, director of the French Academy in Rome, govern in place of Le Brun, who was unable to leave Paris. Le Brun accepted the honor for the years 1676 and 1677. In return, Guidi was appointed one of the four rectors of the French Royal Academy and was honored by being commissioned to carve the marble group of *Fame Recording the History of Louis XIV* ("*La Renommée*") that Le Brun had designed for the gardens of Versailles. Hence, by 1676 Guidi had proven his ability to succeed as an independent artist, but he found himself forced to follow the designs of another artist—Le Brun—in the execution of his most important public commission.[32]

The style of Guidi's sculpture is best seen as an outgrowth of Algardi's late manner. Guidi assisted Algardi in the carving of the colossal relief of the *Meeting of Pope Leo and Attila* in St. Peter's (fig. 96). The spatial and formal concept of this relief had a great influence on Guidi, a fact that may be demonstrated by defining the manner in which the words "plastic" and "glyptic" apply or do not apply to reliefs carved by the two artists.[38] A marble relief might be termed "glyptic" in the conceptual sense of the word when its frontal plane—i.e., the original face of the marble block from which it was carved—is the forward limit past which no figure or object can protrude. The depth to which the relief is carved to produce the illusion of space may vary at the artist's pleasure, within the limitation of the thickness of the marble. In conceiving a "plastic" or modeled relief, the artist thinks in terms of adding material onto a flat slab, which becomes a backplane that no figure or object can penetrate. The artist can create space, or the illusion of space, by modeling figures and objects in high relief.

97. Alessandro Algardi, *Madonna, Child, St. Augustine, and St. Monica Appearing to S. Nicola da Tolentino*. Rome, S. Nicola da Tolentino, high altar

Algardi conceived the Attila relief with a distinct back-plane, from which figures, objects, and clouds protrude. Background figures are carved in very low relief and therefore stand out only slightly from the backplane. Figures in the middle ground stand in higher relief, and the main protagonists are carved almost in full relief and stand on a stagelike platform that projects beyond the frame of the relief. One result of Algardi's plastic conception of the *Attila* relief is a telescoping of space, i.e., a tendency to pile up foreground and background figures one on another and to crowd them together in such a way that the background of supporting figures distracts one's eye from the central confrontation.

In the last major work designed by Algardi for a Roman church, the group of the *Madonna, Child, St. Augustine, and St. Monica appearing to S. Nicola da Tolentino* placed in the niche above the high altar of the Church of S. Nicola da Tolentino (fig. 97), Algardi eliminated all but the main figures so that the viewer would not be distracted by super-fluous details. Algardi—or Ferrata and Guidi, the execu-tants of the decoration[34]—also eliminated the problem of the telescoping of space by almost completely negating depth. There is no backplane of stone, yet the figures are carved in a two-dimensional row, reading from the Madonna on the left to the kneeling S. Nicola on the right. All of the figures are carved almost in the round. No figure recedes deeply into the background, nor does any protrude from the frame. The sculptural quality of the marble is used only to differentiate the figures and to create patterns of light and dark.

Domenico Guidi took over the spaceless quality of Algardi's late manner and made it the basis of his own style. In his relief for the altar of the chapel in the Palazzo del Monte di Pietà (fig. 98), the figures form a two-dimensional spiral that rises from the Magdalen in the lower right to God the Father at the top and descends to Joseph of Arimathea at the center right. The spiral of figures is limited at the back by a hard marble slab and at the front by the original face of the marble block. Within this narrow space the figures are blended into a continuous band, criss-crossed by heavy drapery and undercuttings. Guidi's *Pietà* appears as an ephemeral, flickering vision. This is in con-

98. Domenico Guidi, *Pietà*. Rome, Palazzo del Monte di Pietà, Chapel

99. Domenico Guidi, *Charity*. Rome, S. Giovanni dei Fiorentini, Cappella Falconieri

trast to Algardi's *Attila* relief, in which the space of the scene illustrated and the space of the viewer are joined by the figures of Pope Leo and Attila, which are carved in high relief, and to Bernini's *St. Teresa*, in which the vision exists in a space different from but as real as that of the viewer.[35]

Negation of space is also apparent in Guidi's statues and sculptural groups. The artist's group of *Charity*, begun in 1665 for the Cappella Falconieri of S. Giovanni dei Fiorentini (fig. 99),[36] displays something akin to a fear of representing space. Charity is seated in a niche, her head and knees turned to her left; a fat baby rests on her left knee and clutches her left breast. The baby is balanced by a medallion containing relief portraits of Orazio Falconieri and his wife, Ottavia Sacchetti. The sculptor has eliminated voids within the marble block by placing a baby beneath the medallion and another under Charity's left knee.

In designing the statue of the *Angel Carrying the Lance*, Guidi accepted the pose and proportions called for by Bernini's *pensiero* but flattened the figure by representing it holding the shaft of the lance close to its body. Thus both arms are drawn back almost into the same plane as the torso. The head is turned in profile. The pattern of the drapery basically reflects the shaft of the Lance but breaks into small, crisp folds that help dissipate the three-dimensional form of the figure.[37]

Of all the statues decorating the Ponte S. Angelo, only the two carved by Guidi and Giorgetti are designed to be viewed from behind (figs. 74 and 77). The sculptors had to consider the appearance of the backsides of their statues, because they were to be placed at the lower end of the Castel S. Angelo ramp of the bridge where the reverse sides could be seen. The problem of designing the reverse of a statue was usually ignored in seventeenth-century Rome, because statues were normally meant to be seen from a single point of view. Giorgetti turned to the antique for a solution to the problem; he carved the back of the *Angel Carrying the Sponge* in an abstract pattern similar to that of the backs of the trophies on the balustrade of the Capitoline Hill. Guidi conceived the rear view of his statue as a two-dimensional pattern of varied textures: soft, feathered wings at the top and soft clouds at the bottom, with the shallow folds of the angel's robe, crossed by two windblown strands of drapery, in between.

5

Iconology

The decoration of the Ponte S. Angelo between 1667 and 1672 was the result of a history and tradition that dates back to the construction of the bridge by the emperor Hadrian and to the fact that during Christian times it has served as a vital link between the city of Rome and the Vatican Borgo. Pope Clement IX communicated his knowledge of the antiquity of the bridge in 1668 when he commissioned two medals, the reverses of which contain the motto AELIO PONTE EXORNATO and images of the Ponte S. Angelo decorated with statues (figs. 100–101).[1] The pope's awareness that the bridge was related to the Vatican is suggested by Domenico Bernini, who stated that Pope Clement IX had the Ponte S. Angelo decorated in order to increase the magnificence of the Basilica of St. Peter,[2] a statement that is basically correct despite the fact that the basilica and bridge are widely separated. The Pons Aelius was considered to be a gateway to St. Peter's from the early Middle Ages, when a portico or covered street was built leading from a point near the bridge to the steps in front of the atrium of the basilica. The portico had disappeared by the fourteenth century but was never forgotten. It is mentioned as an example of a covered road by Leon Battista Alberti in his *De re aedificatoria*; Alberti emphasized the importance of the Pons Aelius as a part of the road leading to the basilica by reconstructing it as having been covered by a similar portico.[3]

Later Renaissance and Baroque reconstructions of the ancient bridge and projects for the decoration of the modern bridge attest to the importance of the Ponte S. Angelo and

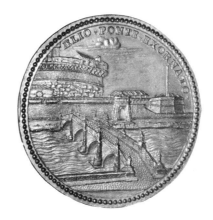

100. Medal of Pope Clement IX, reverse with an image of the Ponte S. Angelo. Rome, Biblioteca Apostolica Vaticana (1667–68)

101. Medal of Pope Clement IX, reverse with an image of the Ponte S. Angelo. Rome, Biblioteca Apostolica Vaticana (1667–68)

to the constant awareness among Romans of its relationship to the Vatican. In 1520 Giulio Romano included detailed reconstructions of several ancient monuments, including the Mausoleum of Augustus, the Pons Aelius, the Mausoleum of Hadrian, and a pyramid—the Meta Romuli—in the background of his fresco of *Constantine's Vision of the True Cross* (figs. 102–103) in the Sala di Costantino of the Vatican Palace.[4] The reconstruction of the Pons Aelius in Giulio's fresco is based on the representation of the bridge

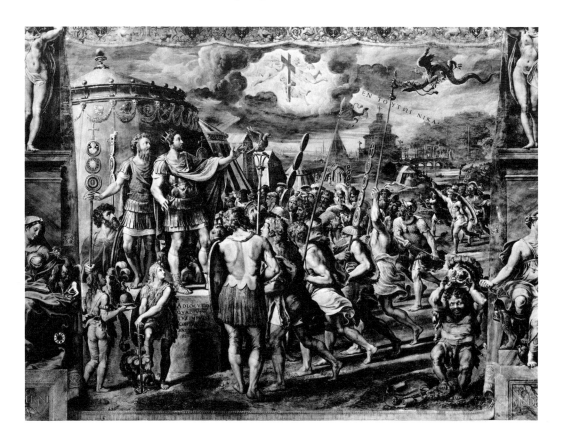

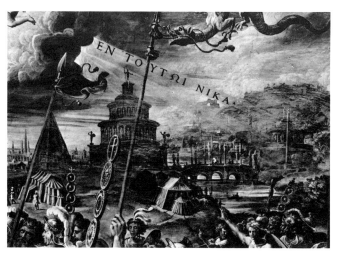

103. Giulio Romano, *Constantine's Vision of the True Cross.* Detail (1520–24)

102. Giulio Romano, *Constantine's Vision of the True Cross.* Fresco. Rome, Vatican Palace, Sala di Costantino (1520–25)

on the reverse of the Hadrianic medal that records the original design of the bridge (see p. 19; fig. 5). Giulio painted the bridge as spanning the Tiber over seven arches, as having a central section flanked by two ramps, and as being decorated by columns carrying statues. A comparison between the detail of Giulio's fresco and the comparable area in Pirro Ligorio's map of ancient Rome of 1661 (fig. 104) demonstrates that Giulio used the mausolea of Augustus and Hadrian, the Meta Romuli, and the Pons

Aelius with a topographical correctness that locates Constantine's vision of the Cross at the site of the Vatican and in so doing implies that Constantine and his followers, the modern emperors, owe homage not only to Christ but also to the Church. The paganism of the old, dead emperors, represented by the mausolea, is contrasted with the living religion of a living emperor.

The theme of the emperor owing homage to the Church was repeated in the decoration of the route for the Triumphal Entry of Charles V into Rome in 1536. The route of the emperor's triumph ran from S. Paolo fuori le Mura to St. Peter's by way of the Porta S. Sebastiano, the Arch of Constantine, and the Arch of Vespasian, across the Roman Forum to the Arch of Septimius Severus, then to the Piazza S. Marco, in which a triumphal arch was constructed, and finally across the Ponte S. Angelo. All of the monuments mentioned above were temporarily decorated with paintings and stucco statues celebrating the glory of Charles V, whose military exploits performed under the banner of Christ equaled those of the ancient Roman emperors. The decoration emphasized the fact that in Christian times the

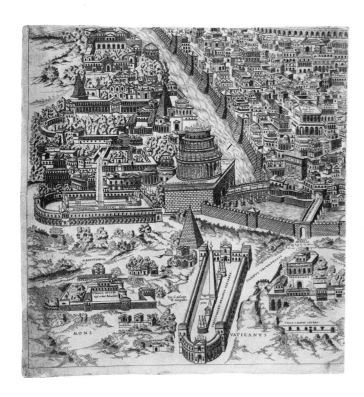

105. Théodor de Bèze, emblem comparing the Mausoleum of Hadrian and the Castel S. Angelo, from *Icones . . .*, Genoa, 1580

104. Pirro Ligorio, map of Ancient Rome, 1661. Detail

functions of the ancient emperors as temporal and religious rulers had been divided between the emperor and the pope and that the two must work together for the triumph of Catholicism. The decoration of the Ponte S. Angelo with statues of four patriarchs of the Old Testament whose lives prefigure the life of Christ and ones of the Four Evangelists, who tell of his life and Passion, reminded the emperor of the deep roots of his religion, of which the focal point—St. Peter's—was also the terminating point of the imperial procession.[5]

The decoration of the Ponte S. Angelo with statues of patriarchs and Evangelists, like the representation of the Pons Aelius and other ancient structures in the background of Giulio Romano's fresco of *Constantine's Vision of the True Cross*, should be seen as a conscious emblem contrasting the

original pagan purpose of the bridge with the Christian role served by the Castel and Ponte S. Angelo. Such an interpretation was given in 1580 by an emblem contrasting the Mausoleum of Hadrian and the Pons Aelius with the Castel and Ponte S. Angelo (fig. 105). The emblem was published by Théodore de Bèze, who accompanied it with a Latin verse, which, freely translated, reads: "The building that once enclosed the ashes of the emperor is now the holy fortress of the Roman bishop. How appropriate it is that this sacred house, which for the mortal is now protector from his death, was occupied by Death."[6]

The popes of the seventeenth century may or may not have been aware of de Bèze's emblem, but they were certainly in sympathy with its meaning. The opening of the two arches under the right ramp of the Ponte S. Angelo during the pontificate of Pope Urban VIII seems to have inspired at least two pre-Clement IX projects for the monumentalization of the bridge. The first project, which was based on Alberti's reconstruction of the bridge and portico leading to St. Peter's, is recorded by Pompilio Totti in his

Ritratto di Roma moderna of 1638. The project called for the building of a portico that would have extended from the Piazza di S. Celso to the Basilica of St. Peter. The portico was lauded because it would protect one from the heat of the summer sun and from the rain, and because the bridge and road leading to the Vatican were said to have been covered in ancient times.[7] The portico project was abandoned partially because the ancient precedent was doubted and partially because such a structure would have blocked the view of and from the Castel S. Angelo, the chief fortress of the city as well as the site of an important miracle. Gasparo Alveri, in his *Roma in ogni stato* of 1664, noted the failure of the portico project and in so doing stated that many people thought that the large bases over the buttresses of the bridge had originally carried statues.[8] Alveri's statement might be interpreted as evidence that the idea of decorating the Ponte S. Angelo with statues was being discussed during the pontificate of Pope Alexander VII (1655–67).[9]

Alexander VII may even have thought of decorating the Ponte S. Angelo with statues of angels carrying instruments of the Passion of Christ, a suitable decoration for the bridge for at least three reasons. First, statues of angels called to mind the miracle from which the fortress and bridge had received their modern names. Second, by the seventeenth century angels carrying instruments of the Passion were commonly used as eucharistic symbols, i.e., as reminders of the gift of salvation through Christ's sacrifice on Calvary and on the altar of the Catholic church during mass. Third, three relics of Christ's Passion—a fragment of the Cross, the tip of the Lance that pierced his side, and the Sudarium—are housed under the dome of St. Peter's.[10] Hence, statues of angels carrying instruments of the Passion must have seemed especially suitable as a decoration for part of the road leading to that basilica. The use of such symbols in the decoration of the Ponte S. Angelo is a reminder of both the human and institutional sides of salvation, for, according to Catholic theology, the Church is the sole earthly arbiter of heavenly redemption.

The miracle from which the Castel and Ponte S. Angelo received their names took place at the end of the sixth century. In the year 589 Rome was struck by a murderous

106. Medal of Pope Alexander VII, reverse with an image of St. Peter chasing the plague from Rome. Rome, Biblioteca Apostolica Vaticana (1657)

plague. St. Gregory the Great, who was elected pope in 590, immediately set about alleviating the suffering of the people of the city. Having found that no medical precautions were sufficient to end the misery and death caused by the plague, Pope Gregory organized a procession in which the people of Rome marched from S. Maria Maggiore to St. Peter's, carrying the image of the Madonna thought to have been painted by St. Luke and singing hymns imploring the Madonna to intercede with Christ to end the plague. On approaching the Pons Aelius, Pope Gregory and his followers witnessed an apparition of the Archangel Michael standing atop the mausoleum and sheathing his bloody sword as a signal that the plague had ended.[11] The miraculous vision of the archangel was commemorated by a chapel dedicated to St. Michael built atop the mausoleum and later by a statue of an angel placed atop the chapel. Pope Gregory's vision was never forgotten. It was confirmed by a similar miracle marking the end of the Black Death of

107. Gian Lorenzo Bernini, drawing for the reverse of the medal illustrated in fig. 105 (Royal Institution of Cornwall County Museum and Art Gallery, Truro)

1348 (see p. 21), is mentioned in many well-known topographies of Rome, and is recorded in that city by two important sixteenth-century frescoes, one in the Church of the Trinità dei Monti (fig. 12) and the other in the Cappella Salviati of the Church of S. Gregorio Magno.[12]

During the pontificate of Pope Alexander VII the apparition of St. Michael was called to mind by the plague of 1656–57. The plague ravaged Naples but caused only moderate suffering in Rome, because the pope personally supervised precautions against its spread. The dead were removed from the city as quickly as possible and the sick were quarantined on the Tiber Island, where they received the best possible medical treatment. Pope Alexander VII celebrated the end of the plague by commissioning two medals, of which the reverse of one is based on a drawing

by Bernini (figs. 106 and 107).[13] The reverse shows St. Peter flying above the earth and gesturing toward St. Peter's in the background on the left. In front of the basilica is a corpse and a supplicant imploring St. Peter for aid. On the right, a winged figure flees, carrying a sword in its right hand and a skull in its left. At the bottom is a motto that reads VT VMBRA ILLIVS LIBERARENTVR. The iconography of the medal is clarified by a description of a *tableau* or *apparato* designed by Domenico Rainaldi for a Devotion of the Forty Hours (*Orazione delle Quarant'ore*) that took place during the first week of Carnival in 1658.[14] As in the medal, the scene took place in front of the city of Rome. At the lower left were corpses, from which the figure of Death was chased by a group of armed saints who descended from heaven led by SS. Peter and Paul, "the most glorious Apostles, protectors of Rome." Other saints were shown kneeling in adoration of the ciborium of the Holy Sacrament, the focal point of the tableau. An angel hovering in the air on the right side of the scene carried a banderole containing the motto LIBERATORI DEO ROMA GRATA. It is clear, therefore, that many Romans felt that they had been saved from the plague of 1656–57 by the intervention of God and that they connected the good fortune of the city with the apparition of the Archangel Michael signaling the end of the plague of 590. It is probable that Pope Alexander considered a plan to decorate the Ponte S. Angelo with statues of angels signifying heavenly salvation in general as well as the salvation of Rome from the plague. The placing of statues of angels on the bridge would have made a fitting memorial to the end of the plague, for both the motif of angels and the location recall a miraculous event of great importance in the history of the city.[15]

The reverse of the second medal struck in celebration of the end of the plague of 1656–57 bears an emblem of Religion (*Religio*), i.e., a winged woman leaning on a cross, holding a book up to heaven with one hand, carrying a bridle with the other, and standing on a skeleton. The reverse also contains the motto POPULUM RELIGIONE TVETVR. Such an emblem of Religion must have been well known in seventeenth-century Rome, for it had been published by Théodore de Bèze in 1580 (fig. 108) and

108. Théodor de Bèze, emblem of Religion from *Icones . . .*,
 Genoa, 1580

described by Cesare Ripa in the 1603 edition of his *Icono-logia*.[16] Both authors explain the image with a Latin verse, which, freely translated, reads:

> Who are you that you go about dressed in such a ragged garment? *Religio*, the true daughter of the most holy Father. Why do you have such poor clothes? I despise perishable belongings. What book is that? The venerable law of my Father. Why is your breast uncovered? That is suitable to the friend of sincerity. Why do you lean on the Cross? The Cross is my only resting place. Why do you have wings? I teach men to fly over the stars. Why do you have a halo? I drive away the darkness of the spirit [soul]. What does the bridle teach? To control the emotions. Why do you stand on Death? Because I am the death of Death.

The emblem, which asked those who suffered as a result of the plague to find consolation in their religion, is most fitting. It is also related to the Ponte S. Angelo and its decoration, for the bridge leads to St. Peter's—the earthly seat of God's law and, as such, the resting place of the faithful, wherein they find victory over death. Since the bridge leads to St. Peter's, it was likened to religion, which leads mankind over the stars, i.e., to Heaven.

Angels carrying instruments of the Passion might be interpreted as an extension of the emblem of Religion, for they are a long-recognized symbol of the redemption of mankind through God's sacrifice of Christ on the Cross and the consecration of the Eucharist on the altar. The doctrine of the Eucharist, the basic dogma of the Catholic Church, teaches that salvation is the gift of Christ's sacrifice, that it is available to all men but is received only by those who partake of the sacraments and especially of the Eucharist, that is the daily sacrifice of the Body and Blood of Christ on the altar.[17] Angels carrying instruments of the Passion developed as eucharistic symbols from two sources. First, illustrations of instruments of the Passion have long been employed as natural symbols of redemption because they recall the sacrifice of Christ. During the thirteenth and fourteenth centuries such symbols were often represented in Italian paintings of the Last Judgment, where they were placed on an altar just below the figure of Christ the Redeemer. In some cases the altar was represented as flanked by two angels.[18] The importance of the central position beneath the Redeemer is illustrated by the fact that in Northern European representations of the Last Judgment this space is occupied by the figure of the Archangel Michael weighing souls and hence acting as God's agent in deciding who will and who will not be redeemed. The invention of the legend of the Mass of Pope Gregory the Great in the fourteenth century gave new impetus and specific eucharistic meaning to the motif of instruments of the Passion. Once, while saying Mass, Pope Gregory the Great was said to have seen a vision of the sacrificed Christ surrounded by the instruments of the Passion. The miracle is said to have occurred just at the moment in which the saint consecrated the host and wine. Representations of the miracle were popular from the late fourteenth century through the first half of the sixteenth century (fig. 109).[19]

Third, representations of angels—supernatural beings in the service of God—have always been connected with salvation. On many ancient Roman sarcophagi *vittorini*, pre-

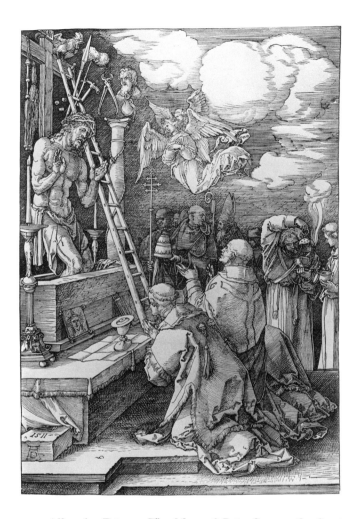

109. Albrecht Dürer, *The Mass of Pope Gregory the Great.* Engraving. St. Louis, St. Louis Art Museum

Angels also appear in representations of the Last Judgment as assistants of Christ the Redeemer.[21]

In the fifteenth century angels carrying instruments of the Passion appear in several very important paintings, such as Jan van Eyck's Ghent Altarpiece (1426–32), in which God is seated over an altar bearing the Mystic Lamb with blood spouting into a chalice from a wound in its side. The altar and Lamb are flanked by fourteen kneeling angels, two of which hold instruments of the Passion.[22] In a few fifteenth-century Italian representations of the Last Judgment, angels carrying instruments of the Passion replace the older imagery of the altar laden with instruments flanked by angels. Fra Angelico includes two angels carrying instruments of the Passion and a third blowing a trumpet under the figure of Christ in his painting of the Last Judgment in the Galleria Nazionale (Palazzo Barberini) in Rome (fig. 110).[23] In the Beaune Altarpiece, Rogier van der Weyden placed the figure of St. Michael weighing souls beneath the Redeemer according to the Northern tradition, but he retained the sacramental aspect of the subject by flanking the Redeemer with instrument-carrying angels.

Representations of angels carrying instruments of the Passion occur only rarely during the first three-quarters of the sixteenth century, and when they do appear they are used in much the same way as they were in the fifteenth century. They symbolize the gift of salvation in Michelangelo's fresco of the Last Judgment, in which they fill the lunettes at either side of the top of the wall, and in Alessandro Allori's painting of the Harrowing of Hell in the Galleria Colonna in Rome (fig. 111). In Allori's painting, heaven is filled with a glory of angels carrying instruments of the Passion, from which a circle of light shines on the saved, leaving the damned to suffer in darkness.[24]

During the post-Tridentine period, representations of angels carrying instruments of the Passion became a popular symbol that was understandable even when depicted independently of other subject matter. The new popularity of the theme seems to have come from the fact that, as symbols of the Eucharist, they reaffirm the belief that faith and participation in the Mass and the sacrifice of the Body and Blood of Christ are necessary for salvation, a central tenet of the Catholic church denied by many Protestant

decessors of Christian angels, carried medallions containing portraits of the deceased.[20] The early Christians translated this motif into angels carrying a symbol of Christ and hence of heavenly salvation. In the Middle Ages angels were often connected with the act of salvation; they appear in representations of mystic Masses, assisting God in the sacrifice of Christ, just as deacons assist a priest in the sacrifice of Mass.

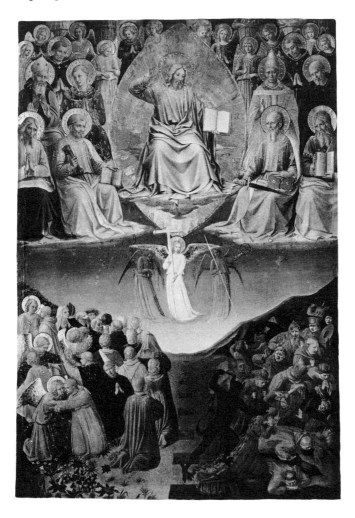

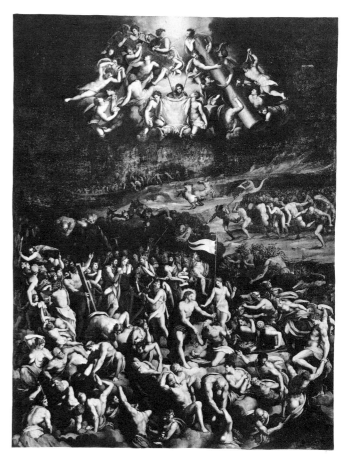

111. Alessandro Allori, *The Harrowing of Hell*. Rome, Galleria Colonna

110. Fra Angelico, *The Last Judgment*. Rome, Palazzo Barberini

sects. Hence, any eucharistic symbol reaffirms the unique position of the Catholic church as the Church of Christ.

Émile Mâle notes that during the Counter Reformation a large number of paintings of eucharistic subjects such as the Last Supper, the last Communion of saints, and the Triumph of the Eucharist were produced.[25] In Rome the

Triumph of the Eucharist became a popular subject of *apparati* erected for the Devotion of the Forty Hours, a religious ceremony at which the Eucharist is exposed to and venerated by the clergy and laymen. In the seventeenth century the *apparati* developed into temporary stage sets or *tableaux* erected in the churches during Carnival and on religious holidays in order to attract people to take part in the Devotion of the Forty Hours rather than the more profane pleasures offered by the city of Rome.[26] The

tableaux represented visions based on biblical or current events showing the manner in which the sacrifice of Christ continually works for the salvation of mankind. One such vision, constructed during the Jubilee Year of 1650 in SS. Quirico e Giulitta, combined three figures of angels carrying instruments of the Passion, a representation of the Lamentation over the body of Christ, and a scene of the Harrowing of Hell, all illuminated by the light of the Eucharist placed in a ciborium glowing in the center of heaven.[27] Another *apparato* in which angels and instruments of the Passion played a major role is preserved in a Cortonesque drawing in the Gabinetto Nazionale delle Stampe in Rome (fig. 112).[28] At the top of the drawing three putti carry aloft a ciborium containing the Holy Sacrament. Just below the putti, the Archangel Michael descends, carrying the banner of the Kingdom of Heaven. Below and to the right of St. Michael the mouth of Hell has opened, pouring forth the believers saved in the Harrowing of Hell. On the left, one sees instruments of the Passion arranged as an *Arma Christi* and accompanied by two angels carrying the Sudarium and Column. Both Death and the devil are tied to the base of the Cross, the central unit of the *Arma Christi*. In the background one sees a city that probably should be identified as Rome, because it contains a dome reminiscent of St. Peter's Basilica. The drawing informs us that salvation, victory over death and the devil, comes not only through the death of Christ but also through participation in the Eucharist. The angels are shown as the chief mourners at the death of Christ, the putti carrying the ciborium and the angels carrying the Sudarium and Column all have pained facial expressions, and, as the messengers of God's word, the banner carried by St. Michael and the *Arma Christi* accompanied by his colleagues are both symbols of salvation.[29]

Painted and sculpted figures of angels carrying instruments of the Passion often were represented in the same manner as they were seen in the *apparati*—that is, as part of a vision bringing the promise of salvation. Beginning in 1612, Cardinal Pietro Aldobrandini had Carlo Maderno build a new Cappella del Sacramento in the cathedral of Ravenna. In 1615–16 Guido Reni and his assistants decorated the chapel with paintings symbolizing the triumph of the Eucharist.[30] Reni decorated the dome of the chapel

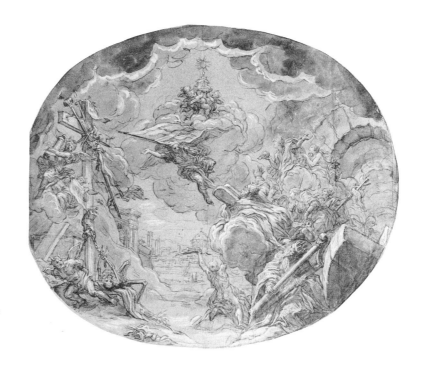

112. Anonymous, drawing for an *apparato* for the Devotion of the Forty Hours. Rome, Gabinetto Nazionale delle Stampe

with a fresco of Christ in Glory holding the Cross (fig. 113). Christ is surrounded by angels carrying other instruments of the Passion and accompanied by the Archangels Michael (holding a spear as protector of the Church), Raphael (accompanied by Tobias), and Gabriel (holding the lily of the Annunciation). In order to insure the clarity of the eucharistic meaning of the dome fresco, the chapel was decorated with an altarpiece illustrating the story of Moses and the manna in the desert (Exod. 16:11 ff.) and the lunettes frescoed with the sacrifice of Melchisedech (Gen. 14:18) and Elijah in the desert fed by an angel (1 Kings 17:6), all scenes that prefigure the Holy Sacrament. In 1634 Pietro da Cortona painted a vision in the vault of the

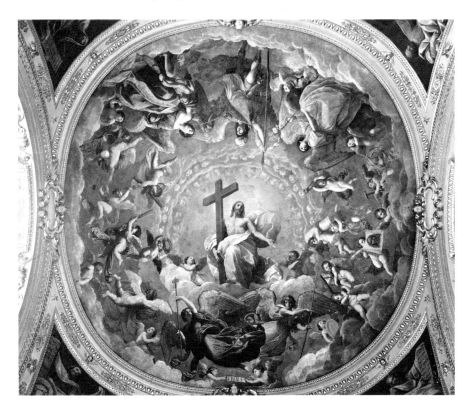

113. Guido Reni, *Christ in Glory*. Fresco. Ravenna, Cathedral, Cappella del Sacramento

sacristy of the Chiesa Nuova (fig. 114).[31] Amidst the clouds and cherubs of heaven, he depicted St. Michael carrying the Cross, surrounded by putti carrying other instruments of the Passion. The mood is not one of mourning but of triumph, as if St. Michael and his companions are showing the way to salvation. In 1649 Bernini designed a group of Christ appearing to Mary Magdalen (*Noli me tangere;* fig. 115) for the Cappella Alaleona in SS. Domenico e Sisto. In the lunette above the central group, he placed an angel carrying the Cross accompanied by putti carrying instruments of the Passion, all silhouetted against a burst of

114. Pietro da Cortona, *St. Michael and Putti Carrying Instruments of the Passion*. Fresco. Rome, Chiesa Nuova, Sacristy, vault

115. Bernini workshop, drawing for the Cappella Allaleona, SS. Domenico e Sisto, Rome. Florence, Gabinetto dei Disegni e delle Stampe degli Uffizi.

heavenly light that shines downward on the figure of Christ. The group clearly communicates the idea that the Magdalen was saved through her faith in Christ, who was sacrificed to redeem her sins.[32]

The statues of angels carrying instruments of the Passion decorating the Ponte S. Angelo should be considered as a vision reminding all who cross the bridge that the gift of heavenly salvation is the result of the sacrifice of Christ. The history of the bridge and its proximity to St. Peter's make it clear that the fruits of the gift are limited to those who follow the teachings of the Church. Seventeenth-century popes had Bernini and other artists decorate St. Peter's as a reminder that the Catholic Church was the only earthly institution through which heavenly salvation is obtainable. In front of the basilica, the colonnades designed by Bernini embrace a wide oval piazza that symbolizes the universal authority of the Church. Colossal statues of saints, the pillars of the Church, rise above the cornice of the colonnades. On approaching the basilica, one sees Ambrogio Buonvicino's high relief of *Christ Giving the Keys to Peter* placed over the central portal of the façade. On entering the narthex, Bernini's high relief of Christ's charge to Peter, the *Pasce oves meas*, appears over the central door leading into the nave of the basilica. Bernini decorated the pilasters of the nave and aisles with reliefs of putti carrying portraits of the early popes and symbols of their office. The high altar, which stands over the tomb of SS. Peter and Paul,[33] is marked by Bernini's colossal bronze baldachin, over which rises the dome decorated by the Cavaliere d'Arpino with representations of God, Mary, the Twelve Apostles, and a choir of angels, three of which carry instruments of the Passion. At the liturgical east end of the basilica, Pope Alexander VII had Bernini place the *Cathedra Petri*, symbol of the primacy of the popes, supported by four doctors of the Church.[34] Hence, the statues of angels carrying instruments of the Passion decorating the Ponte S. Angelo refer to the fact that the bridge leads the faithful to salvation as symbolized by St. Peter's.

The role of the Ponte S. Angelo as a point on the road to St. Peter's, and by extension as a point on the road to salvation, also is suggested by an engraving designed by Pietro da Cortona for the adornment of a broadsheet

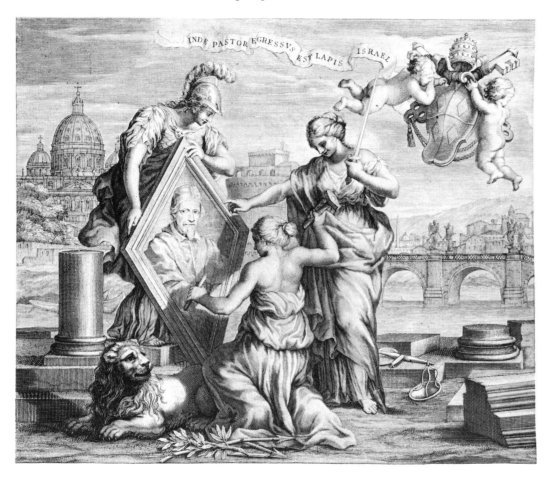

116. Pietro da Cortona, *Allegory of Pope Clement IX*. Engraving. London, British Museum

announcing the results of a meeting of the Papal Consistory held 22 March 1668 (fig. 116).[35] In the background of the engraving one sees St. Peter's, the Castel S. Angelo, and the Ponte S. Angelo decorated with statues of angels. In the foreground, a figure of Faith stands on a base, supporting a diamond-shaped slab of stone into which Clemency is carving the portrait of Pope Clement IX. Justice stands at the right, pointing at the portrait with her right hand and

raising her sword in her left hand.[36] In the upper right, two putti carrying the coat of arms of the pope look toward the Ponte S. Angelo. From the coat of arms floats a banderole inscribed with the motto INDE PASTOR EGRESSVS EST LAPIS ISRAEL ("Thus the pope has come forth as the rock of the faithful").

The statues of angels are arranged on the Ponte S. Angelo in such a way that the instruments they carry and the inscriptions carved into the bases below the statues symbolically tell the story of the Passion of Christ in chronological order, when one takes a zig-zag course across the bridge. The proper order of the statues is as follows (see fig. 52): the *Angels Carrying the Column and the Scourge* (figs. 53–57) represent the Flagellation of Christ; the *Angel Carrying the Crown of Thorns* (figs. 58–59), the mocking of Christ; the *Angel Carrying the Sudarium* (figs. 62–63), the holy act of St. Veronica and the entire story of the carrying of the Cross; the *Angel Carrying the Robe and Dice* (figs. 60–61), the casting of lots for Christ's robe; the *Angel Carrying the Nails* (figs. 64–65), Christ nailed to the Cross; the *Angels Carrying the Superscription and the Cross* (figs. 66–71), the Crucifixion; and the *Angels Carrying the Sponge and the Lance* (figs. 72–78), the two final tortures inflicted upon Christ.[37] In this way the angels, whose faces express sadness and bitterness at the thought of Christ's suffering, invite all who cross the bridge to prepare for salvation by joining in their meditation and mental anguish.

Angels carrying objects recalling the tortures of Christ's Passion were an appropriate decoration for a landmark on the road to salvation in the mid-seventeenth century. By that time meditation on the Passion of Christ had become such an important and common form of religious exercise that a bibliography of seventeenth-century books dealing with such meditation would be vast. Books of this type fall into three main catagories. First, meditation on the Passion of Christ is mentioned as a means of salvation by saints and mystics whose writings were popular in the seventeenth century. Thomas à Kempis, in *The Imitation of Christ*, discusses "The Royal Pathway of the Cross." He advises his readers: "This is a hard saying, 'Deny thyself, take up thy Cross, and follow Jesus.' But far harder will it be to hear that word at last, 'Depart from me, ye cursed, to ever-

lasting fire'; for those who gladly hear the word given by the Cross, and follow it, they will not fear to hear eternal condemnation. . . ."[38] St. Teresa of Avila mentions such meditation as a form of prayer in her autobiography and uses salvation through the sacrifice of Christ as the theme of many of her poems, one of which begins: "Through the Cross both happiness/ and life are given,/ *For there is no other road/ That leads to Heaven.*"[39]

Second, there are a great number of poems and books of verse that might be considered verbal meditations on Christ's Passion. The most important of these for the meaning of the decoration of the Ponte S. Angelo is Jacopo Salviati, *Fiori dell'orto di gessemani e del Calvario . . . alla santità di N. S. Clemente IX Pont. O. M.* (Florence, 1667).[40] Salviati explores the meaning of the Passion of Christ and emphasizes the role of the instruments of the Passion in meditation on the death of Christ as a means of personal salvation.

Third, meditation on the Passion of Christ is a major part of many books devoted to instruction in acts of public and private piety. Giovanni Severano, *Memorie sacre delle sette chiese di Roma . . .* (Rome, 1630), informs us that one makes the visit to the seven churches in memory of the seven bitter processions that Christ made during his Passion. One meditates on one of the processions of Christ as he travels to each of the basilicas. Severano's book is of special interest for the iconography of the Ponte S. Angelo, for it includes a stop and a short prayer at the Castel S. Angelo in honor of the apparition of St. Michael to St. Gregory the Great.[41] Giuseppe Rainaldi, *Cibo dell'amima overo dell' orazione mentale, pratica ordinata alla Passione di Cristo Signore nostro per tutti li giorni del mese* (1st ed. Rome, 1633), one of the most popular devotionals written in the seventeenth century, is devoted entirely to meditation on the Passion of Christ.[42] Rainaldi makes the need for such meditation clear in a passage in which he states that after giving Communion to the Apostles at the Last Supper, Christ said, "All I want from you, Christian, is that you remember how much I have done for you. This, the only sign of gratitude that I require from you for all the favors that I have done for you, even giving my blood and my life for you, is that you remember my Passion."[43]

The function of meditation on the Passion of Christ is stated most clearly by the *Spiritual Exercises* of St. Ignatius of Loyola.[44] St. Ignatius divided his exercises into four weeks, which might be termed as four stages on the road to salvation. During the first week the retreatant (the person taking the exercises) learns to fear the Lord through contemplation of sin and the meaning of damnation. The second week he learns to serve the Lord through contemplation of Christ's role as Eternal King and of his duty to the King and through meditation on the life of Christ from the Nativity through the Entry into Jerusalem. The third week is devoted to learning the meaning of Christ's sacrifice by suffering with him through the tortures of his Passion. The fourth week the retreatant learns the joy of eternal salvation by rejoicing with Christ in his glory and by achieving Divine Love.

The decorated Ponte S. Angelo is analagous to the third week of the *Exercises*, and the angels carrying instruments of the Passion to retreatants meditating on the Passion of Christ and sharing his suffering. The concept of angels as suffering retreatants of the *Exercises* could have been devised only by men who were deeply involved in religious meditation as a path to personal salvation and who were used to dramatizing religious ideas. Bernini and Pope Clement IX (Giulio Rospigliosi) were both such men. They followed the precepts of St. Ignatius of Loyola as members of the Congregazione dei Nobili dell'Assunta and by their acts and style of life further showed themselves to be deeply religious.[45]

By the time Giulio Rospigliosi became pope, his friendship with Bernini was a relationship between two successful men close to seventy years of age, who had known each other and worked together for more than thirty years.[46] They became friends during the 1630s when both were favorites of the Barberini family. Giulio Rospigliosi was born in Pistoia on 28 January 1600. He studied theology and philosophy in Rome and at the University of Pisa where he taught from 1623–25. He returned to Rome early in the pontificate of Pope Urban VIII, whom he served not only as a member of the papal government but also as a poet and playwright. It is in the latter capacity that he worked with Bernini. Rospigliosi wrote no fewer than seven

successful plays, all of which were based on religious and moral themes. The first, *Sant'Alessio*, was set to music by Stefano Landi and produced for the inauguration of the Barberini Theater in 1634. A later play, *La Comica di Cielo*, was produced during Carnival 1668 in the Palazzo Rospigliosi with sets designed by Bernini. The friendship of Bernini and Giulio Rospigliosi, which was born of a common interest in the theater, was fed by the parallel nature of their careers. During the reign of Pope Urban VIII, Bernini became the most important and powerful artist in Rome. During the same period, Giulio Rospigliosi moved through the ranks of the Vatican hierarchy and became nuncio (ambassador) to Spain in 1644, the year of the Pope's death. Both prelate and artist fell from favor during the pontificate of Pope Innocent X, who hated the Barberini and anybody who had been patronized by them. Pope Alexander VII gave both Bernini and Giulio Rospigliosi new commissions, which allowed them to develop their talents in new directions. Bernini was given a virtual monopoly over the important architectural projects of the pope and his family. Rospigliosi became secretary of state and was named cardinal on 9 April 1657.

Giulio Rospigliosi's election as Pope Clement IX was the final recognition of his talents and of the deep religious feeling that governed his life and work. The character of the pope is well illustrated by a latin poem entitled, *An Elegy on the Aelian Bridge. Decorated by Our Most Holy Lord Clement IX, Pontifex Maximus, with Statues of Angels Showing the Torments which Christ the Lord Endured for Us* (appendix III). The poem, published in 1669 by Giuseppe Maria Suarez—another close friend of the pope, summarizes Clement's pontificate and shows that the decoration of the Ponte S. Angelo was a deeply religious act, as were many of those undertaken by the Pope during his brief pontificate (see appendix III), the history of which makes a good summary of the iconology of the bridge. Shortly after the election of Clement IX as pope in 1667 he commissioned a medal, the reverse of which was decorated with a mother pelican feeding her brood with her own blood (a well-known Christian symbol of self-sacrifice) and inscribed with the motto ALIIS NON SIBI CLEMENS ("Serve others, not self"). Neither the pelican in her piety nor the motto

were empty symbols. Unlike many of his predecessors, Clement IX not only did not seek to increase his personal fortune, but also refused to raise his relatives to positions from which they could amass great wealth and power. Instead, he did all that he could to improve the lot of the people of Rome, both through his government of the city and through personal charity. As temporal ruler of the city he increased the amount of bread available by lowering the duty on flour entering Rome, despite the fact that this lowered tax revenues. He also looked after the justice of the city by personally hearing the complaints of the humblest plaintiffs. Not only did he give great sums of money to charity, he personally fed thirteen poor persons at the Vatican every day.

Clement's greatest accomplishments came in the field of international diplomacy. Like many of his predecessors, he held the desire to unify the Catholic powers in an alliance against the Turks. In 1667 such an alliance was needed to save Candia, the last Venetian stronghold on Crete. Before forming an expedition to save Crete, the pope had to remedy the doctrinal and political problems that were dividing the Catholic countries of Europe. Clement helped find a peaceful solution to the Jansenist movement in France, a heresy that threatened to split the French and Roman churches during several decades of the seventeenth century. Next he helped negotiate peace treaties ending two long wars between Spain and France and between Spain and Portugal. Finally, at the beginning of 1669, he convinced several Catholic powers to send aid to the beleaguered defenders of Candia. Unfortunately, help arrived too late: after almost two decades of fighting, in which thirty thousand Christians and over a hundred thousand Turks lost their lives, the Christians were driven from Crete in September 1669. The news of this disaster is said to have hastened Clement's death, which occurred on 9 December 1669.

The depth of Clement's religious feeling is shown by the fact that he performed all the liturgical functions expected of the pope despite his advanced age and delicate physical condition. On Advent Sunday 1668 he climbed the *Scala Sancta* on his knees, an act that has great significance for the meaning of the decoration of the Ponte S. Angelo. The *Scala Sancta* is the staircase that led to the Tribune of

Pontius Pilate, wherein Christ was judged and condemned to death by crucifixion; thus, in a sense, it is an instrument of the Passion. A medieval tradition informs us that St. Helena, the mother of the Emperor Constantine, had the relic transported to Rome before the year 326. Pope Sixtus V (1585–90) had the steps put into their present setting at the Lateran Palace and the walls and vault covering them frescoed with scenes of the Passion of Christ, so that a penitent can contemplate Christ's suffering as he slowly climbs the stairs. At the top of the *Scala Sancta* the penitent sees the exterior wall of the *Sancta Sanctorum* Chapel, the only surviving piece of the old Lateran Palace, which is frescoed with a scene of the crucified Christ being mourned by his Mother and St. John. The small dome above the corridor separating the *Scala Sancta* and the *Sancta Sanctorum* is frescoed with a choir of angels.[47] Hence, like the third week of the *Spiritual Exercises* of St. Ignatius of Loyola, the ascent of the *Scala Sancta* aids the penitent to prepare himself for the joy of salvation by allowing him to share the sufferings of Christ.

It is just this moment of shared suffering leading to eternal joy that Pope Clement IX wished the decorated Ponte S. Angelo to express. Like other papel commissions connected with the decoration of St. Peter's, the decoration of the Ponte S. Angelo reflects the conceit of *Ecclesia triumphans*, the belief that heavenly salvation may be obtained only by those who accept the teachings of the Catholic Church. In this way the decoration of the Ponte S. Angelo expresses the triumph of the Church over pagan religions, as well as the fact that only the Catholic Church and none of the Protestant sects had been chosen by Christ as the earthly arbiter of salvation. To Pope Clement IX, however, the decoration also represented a hope for personal salvation through sharing the tortures of Christ's Passion.

Notes

Chapter 1

1. The dedication of the Pons Aelius was recorded by inscriptions carved into marble tablets placed in the travertine slabs of the parapets. The inscriptions read: IMP. CAESAR. DIVI TRAJANI PARTHICI. FILIVS./ DIVI. NERVAE. NEPOS. TRAIANVS. HADRIANVS./ AVGVSTVS. PONTIF. MAXIM. TRIBVNIC. POTEST./ XVIII. COS. III. P. P. FECIT. Hadrian's eighteenth term as tribune ran from December 133–December 134. See *Corpus Inscriptionum Latinarum* (Berlin, 1826), VI, pt. 1, no. 973; R. Valentini and G. Zucchetti, *Codice topografico della città di Roma* (Rome, 1940–53), IV, 72. For recent discussions of the history of the bridge, see J. Le Gall, *Le Tibre fleuve de Rome dans l'antique* (Paris, 1953), pp. 211–15, and C. D'Onofrio, *Il Tevere e Roma* (Rome, 1968), pp. 128–47. For the history of the Castel S. Angelo (Mausoleum of Hadrian), see E. Rodocanachi, *Le Château Saint-Ange* (Paris, 1909), and M. Borgatti, *Castel Sant'Angelo in Roma* (Rome, 1931).

2. Procopius, *History of the Wars*, I, 22, 19 ff.; trans. H. B. Dewing, Loeb Classical Library (Cambridge, Mass., 1961), III, 212–13.

3. The medal was known in the early sixteenth century but seems to have been first published by Sebastiano Erizzo, *Discorsi sopra le medaglie degli antichi* (Venice, 1559), p. 245. F. Gnecchi, *I Medaglioni romani* (Milan, 1912), II, 8, and Le Gall, *Le Tibre*, p. 213, note that the authenticity of the medal often has been doubted but that some examples are now accepted.

4. The results of the excavation were reported by L. Borsari, "Notizie degli Scavi," *Atti della R. Accademia dei Lincei*, ser. 4, 9 (1892), 230–33, 412–28; R. Lanciani, "Recenti scoperti di Roma e suburbia," *Bullettino della Commissione Archeologica Comunale di Roma* 21 (1893), 14–26, pl. I, who discusses the shape of the river-bed underneath the bridge in ancient and modern times and publishes a measured elevation of the ancient bridge. The articles by Borsari and Lanciani are summarized by C. Huelsen, "Vierter Jahresbericht ueber neue Funde und Forschungen zur Topographie der Stadt Rom, 1892," *Römische Mitteilungen des Deutschen Archaeologischen Instituts* 8 (1893), 321 ff.; R. Pierce, "The Mausoleum of Hadrian and the Pons Aelius," *The Journal of Roman Studies* 15 (1925), 95 ff.; Le Gall, *Le Tibre*, pp. 212 f. Neither Borsari nor Lanciani published a complete set of measurements of the Pons Aelius, but measurements may be taken from the scale drawings published by Lanciani and Huelsen. Le Gall notes the original purpose of the terminal arch under the left ramp.

5. See note 1 above.

6. Two similar but smaller bases were found at the end of the right ramp of the bridge in 1892. The one that is presently on exhibit in the Castel S. Angelo has a square depression in its upper surface, showing that it once carried some kind of sculptural decoration. See Borsari, "Notizie degli Scavi," p. 418, fig. 5.

7. For discussions of the bridges of ancient Rome, see S. B. Platner and T. Ashby, *A Topographical Dictionary of Ancient Rome* (London, 1929), pp. 396–402; E. Nash, *Pictorial Dictionary of Ancient Rome* (New York, 1962), II, 178–97.

8. Borgatti, *Castel Sant'Angelo*, p. 500.

9. Platner and Ashby, *Topographical Dictionary*, pp. 404–5; Ian A. Richmond, *The City Wall of Imperial Rome* (Oxford, 1930), pp. 237–39, fig. 45. The triumphal arch of Gratianus, Valentinus, and Theodosius, built in 379–83, stood within the Aurelian Walls and may have spanned the road leading to the Porta Aurelia. The arch was not erected on the ramp of the Pons Aelius as has been suggested. See R. Lanciani, *Formis urbis Romae* . . . (Milan, 1893–1901), II, pl. XIV (repr. by Amato Pietro Frutaz, *Le Piante di Roma* [Rome, 1963], map LI, pl. 103).

10. Richmond, *City Wall*, pp. 20–26, discusses the dating and the form of the first fortification of the mausoleum. The portico is mentioned by Procopius, *The Gothic War*, I, 22. Its history is discussed by P. Adinolfi, *La Portica di S. Pietro ossia Borgo nell'età di mezzo* (Rome, 1859), pp. 5–18, 26 ff.

11. A more complete description of the miracle and its significance for the decoration of the Ponte S. Angelo in the seventeenth century is given in chapter 5, pp. 92–93.

12. F. Castagnoli et al., *Topografia e urbanistica di Roma* (Rome, 1958), pp. 237–38, discusses the building of the Leonine Wall and states that there was an earlier fortification on the same site.

13. F. Gregorovius, *Geschichte der Stadt Rom im Mittelalter* (Stuttgart, 1892), V, 536. Gregorovius's source for the division of the Pons Aelius during the Jubilee of 1300 is Dante, *L'Inferno*, XVIII, 28–33, which reads: "Come i Romani, per l'essercito molto, / L'anno del Giubbileo, su per lo ponte / Hanno a passar lo gente modo tolto: / Che dall'un lato tutti hanno la fronte / Verso il castello, e vanno a Santo Pietro: / Dall'altra sponda vanno verso il monte."

14. Frutaz, *Piante*, maps LXXVI–LXXVIII, pls. 148–50.

Enrico Stevenson, "Di una pianta di Roma dipinta da Taddeo di Bartolo nella cappella interna del Palazzo del Comune di Siena (ca. 1413–1414)," *Bullettino della Commissione Archeologica Comunale di Roma* 9 (1881), 74–105, dates the prototype of the paintings before 1348 on the basis of the topography of Rome as illustrated in the paintings.

15. The first author to use the name "Sant'Angelo" in reference to the Castel S. Angelo seems to have been Petrarch, in his *Familiarium rerum libri* (6:2:11). See Valentini and Zucchetti, *Codice topografico*, IV, 8, line 11. The name "Ponte S. Angelo" does not appear in writing until the fifteenth century.

16. Biblioteca Laurenziana, Florence, MS Redi 77, fols. VIIᵛ–VIII. See Giustina Scaglia, "The Origin of an Archaeological Plan of Rome by Alessandro Strozzi," *Journal of the Warburg and Courtauld Institutes* 27 (1964), 137–63.

17. Biblioteca Estense, Modena, L. 5, fol. 15. See C. Huelsen, *La Roma antica di Ciriaco d'Ancona* (Rome, 1907); Holmes Van Mater Dennis, III, "The Garret Manuscript of Marcanova," *Memoirs of the American Academy in Rome* 6 (1927), 113–26; E. B. Lawrence, "The Illustrations of the Garret and Modena Manuscripts of Marcanova," *Memoirs of the American Academy in Rome* 6 (1927), 127–31, pls. 23–48.

18. Ludwig von Pastor, *The History of the Popes from the Close of the Middle Ages* (London and St. Louis, 1894–1953), II, 96–99, reconstructs the story of the disaster from contemporary reports. Documents for the restoration of the Ponte S. Angelo, the creation of the Piazza di S. Celso, and the building of the two chapels are to be found in ASR, *Camerale* I, *Fabbriche*, 1502. The documents have been published in part by A. Bertolotti, "Paolo di Mariano scultore nel secolo XV," *Archivio storico, artistico, archeologico e letterario della città e provincia di Roma* 4 (1880), 291–301; idem, *Artisti lombardi a Roma* (Milan, 1881), I, 17; Eugene Müntz, *Les Arts à la cour des papes* (Paris, 1878), I, 151–54.

19. H. Schedel, *De temporibus mundi, de historiis aetatum mundi . . .* (Nuremberg, 1493), fols. LVIIᵛ–LVIII. See Frutaz, *Piante*, map XCVI, pl. 66. The drawing of the Castel and Ponte S. Angelo is in the Escorial, Codex 28–II–12, fol. 26ᵛ, and is discussed by H. Egger, *Codex Escurialensis* (Vienna, 1906), p. 90. Folio 30ᵛ of the same manuscript is a view of the Castel S. Angelo from the Vatican, showing the gate that Pope Nicholas V had placed at that end of the bridge from the side (ibid., p. 94). See also H. Egger, *Römische Veduten* (Vienna, 1932), I, 18, pls. 8, 9.

20. Borgatti, *Castel Sant'Angelo*, pp. 224–69, discusses the changes made in the Castel S. Angelo during the pontificate of Pope Alexander VI.

21. See p. 31, n. 112.

22. The purpose for which the statue of St. Paul was carved is not known. See Charles Seymour, Jr., *Sculpture in Italy, 1400–1500* (Baltimore, 1966), p. 158. For Lorenzetto, see G. Vasari, *Le vite . . .*, ed. Milanesi (Florence, 1897), IV, 577–81.

23. Before 1892 the long inscriptions appeared on the back faces of the pedestals. The short inscriptions mentioned below were carved into the front faces. The date 1535 in the inscription under the statue of St. Peter shows that the statues were put in place during the pontificate of Pope Paul III (1534–49). The significance of the inscription is discussed by F. Spada, *Alcune mie congetture intorno ad una iscrizione monumentale di Pietro Bembo quale essa leggesi sotto la statua di S. Paolo nella faccia posteriore del suo piedi-stallo al Ponte S. Angelo in Roma* (Rome, 1886), and by D'Onofrio, *Il Tevere*, pp. 132 ff.

24. Two sketches, each showing the minor vault under the left ramp and the parapet above it, appear on two sheets of visual notes (Gabinetto dei Disegni e delle Stampe degli Uffizi, 1233A and 1270A) attributed to Antonio da Sangallo the Younger and Battista da Sangallo, respectively. The measurements on the sketch attributed to Battista da Sangallo inform us that the vault was "*pie* 12" wide and "34–14" deep and that there were "*pie* 6–6" between the top of the vault and the parapet.

25. Étienne du Pérac, *I Vestigi di Roma antica* (Rome, 1565), pl. 37.

26. The attribution of the statues to Lorenzetto and Raffaello da Montelupo, rather than simply to the latter (Vasari, *Le Vite*, IV, 545), is based on payments to artists for the decoration of the entry route (ASR, *Camerale* I, *Viaggi*, 1563/64, fasc. 2). These documents have been partially and inaccurately published by B. Podestà, "Carlo V a Roma," *Archivio della Società Romana di Storia Patria* 1 (1878), 303–17. H.-W. Kruft and L. O. Larsson, "Entwürfe Berninis für die Engelsbrücke in Rom," *Münchner Jahrbuch der bildenden Kunst* 17 (1966), 155, have come to the same conclusion. The significance of the triumphal entry of 1536 for the iconology of the bridge is discussed on pp. 90–91.

27. I learned of the drawing during a *Sitzung* given by Matthias Winner at the Bibliotheca Hertziana in Rome in May 1967. The drawing has been published by H. Kauffmann, *Giovanni Lorenzo Bernini, die figürlichen Kompositionen* (Berlin, 1970), p. 292, fig. 161, who attributes it to a French draughtsman in the circle of du Pérac.

28. The architect of the restoration of the Castel and Ponte S. Angelo is identified by F. M. Bonini, *Il Tevere incatenato, overo l'arte di frener l'acque correnti* (Rome, 1666; 1st ed. 1663), p. 159; F.

Bonanni, *Numismata pontificum romanorum . . .* (Rome, 1699), II, 538. See also Kauffmann, *Giovanni Lorenzo Bernini*, p. 293. O. Pollak, *Die Kunsttätigkeit unter Urban VIII* (Vienna, 1927), I, 7, publishes payments dated 1623–41 for work on the Ponte S. Angelo. The last document in the series is an *a conto* payment for carving coats of arms of the Barberini family into the parapet in front of the Castel S. Angelo. The opening of the two arches was dated 1628 by an inscription placed on the bridge. See P. Totti, *Ritratto di Roma moderna* (Rome, 1638), p. 242; G. Alveri, *Roma in ogni stato* (Rome, 1664), II, 110.

29. Domenico Castelli, "Prospetti e piante di tutti gl'edificij eretti dentro come fuori di Roma dalla felice mem.ª d'Vrbano VIII," BV, *Barb. Lat.* 4409, fols. 41, 42. Castelli illustrates the new parapets as if they were pierced by oculi. The fact that they were decorated with coats of arms rather than oculi is demonstrated by the documents cited in note 28 above and by an *avviso* from the diary of Carlo Cartari (Appendix I, 3; doc. 217).

30. Lievin Cruyl's views of the Castel and Ponte S. Angelo are discussed by T. Ashby, "Lievin Cruyl e le sue vedute di Roma," *Memorie della Pontificia Accademia Romana di Archeologia* 1 (1923), 221–29, pl. X; Egger, *Römische Veduten*, I, 19–20.

Chapter 2

1. R. Wittkower, *Gian Lorenzo Bernini, the Sculptor of the Roman Baroque*, 2nd ed. (London, 1966), pp. 248–51, cat. no. 72.

2. Maria Cristina Dorati, "Il Bernini e gli angeli di Ponte S. Angelo nel diario di un contemporaneo," *Commentari* 17 (1966), 349–52. For information about Carlo Cartari, see P. Pagliucchi, *I Castellani del Castel S. Angelo* (Rome, 1928), II, 71, 80.

3. Titi, 1674, pp. 470–72; Bonanni, *Numismata*, pp. 714–16; F. Baldinucci, *Vita del Cavaliere Gio. Lorenzo Bernino*, ed. Sergio Samek Lucovici (Milan, 1948; 1st ed. Florence, 1682), pp. 129–30; idem, *The Life of Bernini*, trans. Catherine Enggass (University Park, Pa., 1966) pp. 63–4; and Domenico Bernini, *Vita del Cavalier Gio. Lorenzo Bernino* (Rome, 1713), pp. 158–60.

4. Pastor, *History of the Popes*, XXXI, 318.

5. D'Onofrio, *Il Tevere*, pp. 137–38, hypothesizes that there was an early plan to decorate the bridge with eight rather than ten statues because the first marble order is for eight blocks of stone.

6. Ibid., p. 137.

7. Ibid., p. 139. D'Onofrio identifies Monsignor Bernini as Pier Filippo, the eldest son of Gian Lorenzo.

8. Ibid., p. 141.

9. Pastor, *History of the Popes*, XXXI, 429.

10. Ibid., pp. 436–37.

11. See V. Forcella, *Iscrizioni delle chiese e d'altri edificii di Roma* (Rome, 1884), XIII, 55, and D'Onofrio, *Il Tevere*, pp. 146–47.

12. See chapter 1, n. 30.

13. There is no known documentation for the destruction of buildings between the Ponte S. Angelo and the Borgo Nuovo. The widening of the road is reported in a few entries in the diary of Carlo Cartari (Appendix I, 3; docs. 209, 213, 236).

Chapter 3

1. Our knowledge of Bernini's personality and working methods are owed in large measure to the research of Rudolf Wittkower, whose work or influence is a part of virtually every study of Bernini since the publication of H. Brauer and R. Wittkower, *Die Zeichnungen des Gian Lorenzo Bernini* (Berlin, 1931). Wittkower's two most comprehensive recent studies of Bernini are *Gian Lorenzo Bernini* and *Art and Architecture in Italy, 1600–1750*, 2nd ed. (Baltimore, 1965), pp. 96–129. Other twentieth-century monographs about the master that are important for the study of his personality and working methods include: S. Fraschetti, *Il Bernini* (Milan, 1900); H. Hibbard, *Bernini* (Harmondsworth, 1965); Maurizio and Marcello Fagiolo dell'Arco, *Bernini, una introduzione al gran teatro del barocco* (Rome, 1967), which contains an excellent chronological bibliography of Bernini studies; and Kauffmann, *Giovanni Lorenzo Bernini*.

2. D. Bernini, *Vita del Cavalier Gio. Lorenzo Bernino*, pp. 12 ff.

3. Ibid., pp. 15 ff.

4. The best evidence for the nature of the affair and for Costanza Bonarelli's personality is Bernini's portrait bust of her. See Wittkower, *Gian Lorenzo Bernini*, p. 203, cat. no. 35; Fagiolo dell'Arco, *Bernini*, cat. no. 70. Both cite additional literature.

5. The letter sent by Bernini's mother is published by P. Pecchiai, "Il Bernini furioso," *Strenna dei Romanisti* 10 (1949), 181 ff. For his control over the arts in Rome, see Wittkower, *Art and Architecture*, p. 96; F. Haskell, *Patrons and Painters* (New York, 1963), p. 16.

6. P. Giuseppe Castellani, *La Congregazione dei Nobili presso la chiesa del Gesù* (Rome, 1954), p. 273.

7. Bernini, *Vita*, pp. 169 ff.; Wittkower, *Gian Lorenzo Bernini*, p. 37. For more recent and more detailed discussions of Bernini's religious life, see Rudolf Kuhn, "Gian Paolo Oliva und Gian Lorenzo Bernini," *Römische Quartalschrift* 64 (1969), 229 ff.; idem,

"Gian Lorenzo Bernini und Ignatius von Loyola," *Argo, Festschrift für Kurt Badt*, ed. Martin Gosebruch and Lorenz Dittmann (Cologne, 1970), pp. 297–323; Irving Lavin, "Bernini's Death," *The Art Bulletin* 54 (1972), 158–86. All three of the articles came to my attention too late to be used in the preparation of this study.

8. F. Baldinucci, *Vita del Cavaliere Gio. Lorenzo Bernini*, p. 145; idem, *The Life of Bernini*, p. 78.

9. Paul de Fréart, Sieur de Chantelou, *Journal du voyage du Cavalier Bernini en France* (Paris, 1885), p. 156, records a conversation of 6 June 1665 in which Bernini described his manner of sketching on the wall of a gallery in his house in Rome. See also Brauer and Wittkower, *Die Zeichnungen*, pp. 7 ff.

10. Wittkower, *Art and Architecture*, pp. 108–10, discusses the role of the conceit in Bernini's work.

11. R. Wittkower, "The Role of Classical Models in Bernini's and Poussin's Preparatory Work," *Studies in Western Art. Acts of the Twentieth International Congress of the History of Art* (Princeton, 1963), III, pp. 41–50.

12. The bozzetto was published by A. E. Brinckmann, *BarockBozzetti* (Frankfurt, 1923–24), II, 60 ff., pl. 29, Wittkower, *Gian Lorenzo Bernini*, pp. 233–34, discusses its attribution and the problem of the coat of bronze-colored oil paint that covers it.

13. The most recent study of the *St. Longinus* is that by Irving Lavin, *Bernini and the Crossing of St. Peter's* (New York, 1968), pp. 28 ff.

14. Ibid. Other recent studies of the crossing of St. Peter's include H. Thelen, *Zur Entstehungsgeschichte der HochaltarArchitektur von St. Peter in Rom* (Berlin, 1967), and Kauffmann, *Giovanni Lorenzo Bernini*, pp. 85–108.

15. For additional information and bibliography concerning the Raimondi Chapel and the other Bernini projects mentioned below, see the appropriate catalogue entries in Wittkower, *Gian Lorenzo Bernini*, and Fagiolo dell'Arco, *Bernini*.

16. For the altar of the Sacrament Chapel, see M. Weil, "A Statuette of the Risen Christ Designed by Gian Lorenzo Bernini," *Journal of the Walters Art Gallery* 29–30 (1966–67), 7–15.

17. See appendix 1, 3; doc. 215.

18. See pp. 46–48.

19. Brauer and Wittkower, *Die Zeichnungen*, p. 160, pl. 120a.

20. Fraschetti, *Il Bernini*, pp. 372–73. The present location of these drawings is unknown. Their measurements have not been published.

21. Brauer and Wittkower, *Die Zeichnungen*, p. 160, n. 3.

22. L. Grassi, "Disegni inediti del Bernini e la decorazione di Ponte S. Angelo," *Arti figurative* 2 (1946), 186–99.

23. F. Zeri, *La Galleria Pallavacini in Roma* (Florence, 1959), pp. 42–44, nos. 40–42, who gives the measurements of the drawing of the *Angel Carrying the Superscription* as 210 x 137 mm., and those of the other two Pallavicini drawings as 208 x 273 mm.

24. Kauffmann, *Giovanni Lorenzo Bernini*, p. 298, n. 47. The drawing of the *Angel Carrying the Column* measures 263 x 187 mm. and has the collector's mark *CR* stamped in the lower left corner. This mark is not identified by Frits Lugt, *Les Marques de collections de dessins et d'estampes* (Amsterdam, 1921). The history of the drawings of the *Angels Carrying the Column and the Cross* has been discussed by Brauer and Wittkower, *Die Zeichnungen*, p. 160, n. 3, and Wittkower, *Gian Lorenzo Bernini*, p. 251, cat. no. 72. In the eighteenth century they belonged to Charles Rogers, who published aquatints of them in his book *A Collection of Prints in Imitation of Drawings* (London, 1781), I, 112–14. Wittkower also mentions a sheet of studies of angels carrying instruments of the Passion in the Witt Collection, Courtauld Institute Galleries, London. The Witt drawing does not seem to be related to the decoration of the Ponte S. Angelo because the proportions of the angels are quite different from those of the angels in other studies for the decoration of the bridge.

25. Kruft and Larsson, "Entwürfe," p. 152, fig. 15; Brauer and Wittkower, *Die Zeichnungen*, p. 169, n. 3. The drawing measures 185 x 095 mm. Kruft and Larsson (fig. 12) reproduce a sheet of drawings in the Staatliche Graphische Sammlung in Munich. The Munich sheet contains poor copies of Bernini workshop drawings for the *Angels Carrying the Cross and the Column*.

26. Wittkower, *Gian Lorenzo Bernini*, pp. 250–51. I. Lavin, "The Bozzetti of Gianlorenzo Bernini," Ph.D. dissertation, Harvard University, 1955, pp. 179–86, and Hibbard, *Bernini*, pp. 198–203, have come to conclusions similar to those of Wittkower. Kauffmann, *Giovanni Lorenzo Bernini*, pp. 299 ff. handles the development of the two angels separately; however, he divides studies for both statues into early sketches and models related to *pensieri* and workshop drawings and later studies more closely related to the final statues.

27. Wittkower, *Gian Lorenzo Bernini*, p. 10.

28. R. Norton, *Bernini and Other Studies* (New York, 1914), p. 48, no. 17, pl. XXIIIa, published the bozzetto in the Fogg Museum, which measures 266 mm. high. The instrument once carried by this angel has been broken off, so that the original purpose of the model can be ascertained only by comparing it with other studies and with the marble statues. Wittkower demonstrated to me (in conversation) that the model should be related to the *Angel Carrying the Crown of Thorns* because of its similarity to the Leipzig

sketch; Hibbard, *Bernini*, p. 202, has come to the same conclusion. Wittkower, *Gian Lorenzo Bernini*, p. 251, and Lavin, "Bozzetti," p. 180, note the relationship of the bozzetto to Morelli's statue of the *Angel Carrying the Scourge*. Lavin recognized the relationship of the model to the Leipzig sketch but suggested that it was modeled as a design for Morelli's statue. Kauffmann, *Giovanni Lorenzo Bernini*, p. 300, n. 55, finds the model to be closely related to a bozzetto for the *Angel Carrying the Crown of Thorns* in the Louvre (fig. 39).

The bozzetto in the Palazzo Venezia was published by A. Santangelo, *Catalogo delle sculture nel museo di Palazzo Venezia* (Rome, 1954), pp. 78 ff., fig. 87, who gives the height of the model as 360 mm.

29. Wittkower, *Gian Lorenzo Bernini*, p. 250, figs. 106, 107, noted that the two studies form a bilateral unit. The drawing measures 172 x 211 mm. and has been published by Fraschetti, *Il Bernini*, p. 369; Brauer and Wittkower, *Die Zeichnungen*, p. 161, pl. 120b; and Wittkower, "The Role of Classical Models," pp. 48 ff. Wittkower uses the drawing to illustrate the extent to which Bernini relied on the *Antinous Belvedere*. The Fogg bozzetto, which was published by Norton, *Bernini*, p. 48, no. 15, pl. XXI, is 381 mm. high.

30. Kruft and Larsson, "Entwürfe," p. 153, fig. 14; Kauffmann, *Giovanni Lorenzo Bernini*, p. 300, n. 55, notes that the Louvre model is about 320 mm. high.

31. The two bozzetti are published by Norton, *Bernini*, p. 48, nos. 18, 20, pls. XIXb, XXIIIb, and measure 288 mm. and 295 mm. high respectively. The drawing, which measures 195 x 149 mm., has been published by Fraschetti, *Il Bernini*, p. 365, as being by Bernini and is mentioned in a note by Brauer and Wittkower, *Die Zeichnungen*, p. 161, n. 5, who thought it might be an original by Bernini. Kauffmann, *Giovanni Lorenzo Bernini*, p. 303, n. 65, accepts Fraschetti's attribution.

32. The bozzetto in the Fogg Museum, which measures 425 mm., was published by Norton, *Bernini*, p. 48, no. 16, pl. XXII. No measurements are available for the bozzetti in the Davis Collection.

33. Wittkower, *Gian Lorenzo Bernini*, p. 251.

Chapter 4

1. For biographies, bibliography, and illustrations of Raggi's work, see L. Pascoli, *Vite de' pittori, scultori ed architetti* (Rome, 1730–36), I, 248–52; U. Donati, *Artisti ticinesi a Roma* (Bellinzona,

1942), pp. 433–99; M. Weil, "Antonio Raggi," master's thesis, Columbia University, 1964.

2. Additional information and bibliography about the Bernini projects cited in this chapter is to be found in the appropriate catalogue entries in Wittkower, *Gian Lorenzo Bernini;* Fagiolo dell'Arco, *Bernini*.

3. Documents recording payments to the artists and craftsmen who worked on the decoration of S. Maria del Popolo have been published in G. Cugnoni, "Appendice al commento della vita di Agostino Chigi il Magnifico," *Archivio della Società Romana di Storia Patria* 8 (1941), 523–39.

4. F. Titi, *Studio di pittura, scoltura et architettura nelle chiese di Roma* (Rome, 1674), p. 201. Cardinal Bragadin died on 28 March 1658; see C. Eubel, et al., *Hierarchia catholica medii et recentioris aevi . . .* (Regensberg, 1933–58), IV, 24.

5. Wittkower, *Art and Architecture*, p. 205, discusses the relief in relation to Raggi's style.

6. E. Mâle, *L'Art religieux après le Concile de Trente* (Paris, 1932), p. 264; B. M. Appollonj Getti, *Santa Prassede*, Le chiese di Roma illustrate, 66 (Rome, 1961), fig. 34.

7. Ille Budde, *Beschreibender Katalog der Handzeichnungen in der staatlichen Kunstakademie Düsseldorf* (Düsseldorf, 1930), nos. 117, 118; Brauer and Wittkower, *Die Zeichnungen*, p. 160, n. 3; Kruft and Larsson, "Entwürfe," figs. 1–3.

8. Biographical material about Morelli has been published by Pascoli, *Vite*, II, 445–47; in U. Thieme and K. Becker, *Allgemeines Lexikon der bildenden Künstler* (Leipzig, 1907–50; hereafter cited as Thieme-Becker), XXV, 136; G. Fabiani, *Artisti del sei- settecento in Ascoli* (Ascoli Piceno, 1961), pp. 166–69. Fabiani has documented Morelli's life and work in Ascoli Piceno. For the dating of Duquesnoy's illness and death, see M. Fransolet, *François du Quesnoy, sculpteur d' Urbain VIII, 1597–1643* (Brussels, 1942) pp. 65 ff.

9. F. Titi, *Descrizione delle pitture, sculture e architettura esposte al pubblico in Roma* (Rome, 1763), p. 392; Cugnoni, "Appendice," pp. 524, 525, 529, 530.

10. For documentary evidence suggesting that Bernini supplied Morelli with a model for the *Angel Carrying the Scourge*, see appendix I, 5, doc. 255.

11. Biographies of Naldini are found in Pascoli, *Vite*, II, 457–67; Thieme-Becker, XXV, 336, in which Naldini's birth date is given as ca. 1615. Bernini's letter is quoted by Giovanni Incisa della Rocchetta, "Notizie sulla fabbrica della chiesa collegiata di Ariccia," *Rivista del R. Istituto d'Archeologia e Storia dell'Arte* 1 (1929), 369.

12. Ann B. Sutherland, "The Decoration of San Martino ai Monti—II," *The Burlington Magazine* 106 (1964), 115–20.

13. The different types of Alexander portraits have been published by M. Bieber, *Alexander the Great in Greek and Roman Art* (Chicago, 1964).

14. I. Lavin, "Bozzetti and Modelli: Notes on Sculptural Procedure from the Early Renaissance through Bernini," *Akten des 21. Internationalen Kongresses für Kunstgeschichte in Bonn 1964* (Berlin, 1967), III, 102 ff., notes that a calibrated scale to be used in enlarging this bozzetto has been incised into its right side.

15. For biographies of Fancelli, see Pascoli, *Vite*, II, 467–77; Georg Sabotka in Thieme-Becker, XI, 241–44.

16. Wittkower, *Art and Architecture*, p. 209.

17. G. Briganti, *Pietro da Cortona, o della pittura barocca* (Florence, 1962), pp. 258, 266, cat. nos. 127, 140, pls. 274, 281.

18. For summaries of Lucenti's life and career, see Thieme-Becker, XXIII, 436; C. G. Bulgari, *Argentieri gemmari e orafi d'Italia* (Rome, 1958–66), II, 59. Lucenti's relationship to Algardi is mentioned by G. B. Passeri, *Die Künstlerbiographien*, ed. J. Hess (Leipzig and Vienna, 1934), p. 206.

19. For Lucenti as a cannon-maker, see L. Ozzola, "L'Arte alla corte di Alessandro VII," *Archivio della Società Romana di Storia Patria* 31 (1908), 74 ff. Lucenti's military career is reflected in a broadsheet that he drew up as a manual of instruction in the use of cannon (Biblioteca Corsiniana, Rome, MS 34–K–13, fol. 4). The broadsheet contains the earliest dated (1669) example of the signature *Eques Lucenti*. Lucenti's work as a die-engraver for the papal mint in Rome is reported by E. Martinori, *Annali della Zecca di Roma* (Rome, 1917–22), fasc. 15, p. 102, fasc. 16, pp. 11, 26, 32, 33; F. Bartolotti, *La Medaglia annuale dei romani pontefici da Paolo V a Paolo VI* (Rimini, 1967), pp. 76 ff.

20. Bernini, *Vita*, pp. 113 ff., 124.

21. Ibid., pp. 155 ff.; Baldinucci, *Vita*, pp. 129 ff.

22. Early biographies of Ferrata were written by F. Baldinucci, *Notizie de' professori del disegno* (Florence, 1681–1728), IV, 516–28, and Pascoli, *Vite*, I, 237–47. Baldinucci's biography of Ferrata seems to be based on information supplied by the sculptor himself, as he cites Ferrata as his source when discussing the sculpture in the Cappella Gavotti of S. Nicola da Tolentino. The accuracy of Baldinucci's life of Ferrata has been demonstrated by A. Nava-Cellini, "Contributo al periodo napoletano di Ercole Ferrata," *Paragone* 12, no. 137 (1961), 37–44, who has reconstructed the history of Ferrata's sojourn in Naples. See also B.C.K. in Thieme-Becker, XI, 465 ff.

23. The number of Algardi projects on which Ferrata collaborated is not clear. Baldinucci, *Notizie*, p. 520, informs us that Ferrata made both small and large models for the statue of *Liberalità* on the Tomb of Pope Leo X in St. Peter's; that he carved the figure of St. Peter on the *Attila* relief; and that he carved the God the Father with two putti and the statue of S. Nicola da Tolentino decorating the high altar of the church dedicated to that saint. In discussing the Tomb of Leo X, Passeri, *Die Künstlerbiographien*, pp. 202 ff., attributes the statue of *Liberalità* (which he calls *Generosità*) to Giuseppe Peroni and the figure of *Fortezza* to Ferrata. Passeri (p. 206) agrees with Baldinucci concerning the work on the high altar of S. Nicola da Tolentino and (p. 209) informs us that Ferrata worked with Domenico Guidi on completing Algardi's bronzes of the four elements, represented by Jupiter (fire), Juno (air), Cybele (earth), and Neptune (water), which were made for the king of Spain. See also G. P. Bellori, *Le Vite de'pittori, scultori et architetti moderni* (Rome, 1672), p. 399; J. Hess, "Ein Spätwerk des Bildhauers Alessandro Algardi," *Münchner Jahrbuch der bildenden Kunst* 7 (1931), 292 ff., reproduces photographs of the original bronzes that now serve as fountain decorations in the palace park at Aranjuez, Spain, and cites other examples. Wittkower, *Art and Architecture*, p. 203, points out that the Tomb of Pope Leo X was all but completed and that work on the Attila relief had been begun by the time Ferrata arrived in Rome; thus Ferrata could not have worked on the tomb and may not have worked on the relief. Documents concerning the tomb are published in Pollak, *Die Kunsttätigkeit*, II, 281–92.

24. K. Lankheit, *Florentinische Barockplastik* (Munich, 1962), pp. 29–37 discusses the Florentine Academy in Rome.

25. Wittkower, *Art and Architecture*, p. 174.

26. Ibid., p. 203.

27. See note 36 below.

28. J. Montagu, "Antonio and Giuseppe Giorgetti: Sculptors to Cardinal Francesco Barberini," *The Art Bulletin* 52 (1970), 278–98, has done an excellent job of reconstructing the work of the Giorgetti family. All that I can add to her article is the fact that Giovanni Maria worked on the bookcases of the Biblioteca Alessandrina of the Palazzo della Sapienza (ASR, *Università di Roma*, busta 202, fols. 413 and 435[r+v]).

29. Published biographies of Domenico Guidi include Pascoli, *Vite*, I, 252–56; G. Campori, *Memorie biografiche degli scultori, architetti, pittori, ecc. nativi di Carrara e di altri luoghi della Provincia di Massa* (Modena, 1873), pp. 129–47; C. Lazzoni, *Carrara e le sue ville* (Carrara, 1880), pp. 351 ff.; and Weigelt in Thieme-Becker, XV, 273 ff. Notices of Guidi as a favored assistant of Algardi are found in Passeri, *Die Künstlerbiographien*, pp. 203–11. David

Bershad recently has published two articles in which he cites previously unknown documents and little-used sources for the life and work of Guidi. The articles are: "A Series of Papal Busts by Domenico Guidi," *The Burlington Magazine* 112 (1970), 805–9, and "Domenico Guidi and Nicolas Poussin," *The Burlington Magazine* 113 (1971), 544–47. In the former article Bershad cites F. Baldinucci, "Notizie di Domenico Guidi and Giuliano Finelli, scultori," Biblioteca Nazionale Centrale, Florence, MS II, II, 110, fols. 53–60, which seems to be the most important source for Guidi's life and work. In the second article Bershad cites the record of Guidi's baptism, proving that the artist was born in 1625 rather than in 1628 as was thought previously. The dates of Guidi's arrival in Naples and Rome are not documented. Bershad, "Guidi and Poussin," p. 544, gives the dates 1639 for the arrival in Naples and 1649 for Rome but does not explain either date. Guidi's departure from Naples is usually dated 1647, because all of his biographers state that he left as a result of the Masaniello Revolt, which began in July of that year.

30. Pascoli, *Vite*, I, 252.

31. The history of the chapel in the Palazzo del Monte di Pietà has been reconstructed by H. Hibbard, *Carlo Maderno* (University Park, Pa. 1971), pp. 218–20.

32. For Guidi's tenure as *principe* of the Accademia di S. Luca, see M. Missirini, *Memorie per servire alla storia della romana Accademia di S. Luca* (Rome, 1823), pp. 124–27; R. Wittkower, "Domenico Guidi and French Classicism," *Journal of the Warburg and Courtauld Institutes* 2 (1938–39), 188 ff.; idem, *Art and Architecture*, pp. 288 ff.

33. This manner of analyzing sculptural relief was suggested to me by Rudolf Preimesberger, who will probably explain it in greater detail in his forthcoming book on the sculptural decoration of the church of S. Agnese in Piazza Navona, to be published by The Pennsylvania State University Press.

34. See J. Montagu, "Alessandro Algardi's Altar of S. Nicola da Tolentino and some related models," *The Burlington Magazine* 112 (1970), 282–91.

35. See also Wittkower, *Art and Architecture*, p. 206.

36. The Archivio Falconieri, Carpegna, *Opere Pie*, I, contains documents that date the sculptural decoration of the chapel. Documents 11 and 12 of this *busta* are copies of contracts between the Falconieri and Guidi (29 December 1665) and Antonio Raggi (19 May 1665) for the *Charity* and *Baptism of Christ*, respectively. Raggi received a final payment for his group on 26 October 1676, bringing the total that he was paid to 2,220·50 scudi. No record of payments to Guidi exists in the archive. According to the contract,

Guidi was to be paid 800 scudi. Document 20 of the same *busta* records a final payment (17 September 1685) to Ercole Ferrata for his statue of *Faith*. Ferrata was paid a total of 700 scudi.

37. Brinckmann, *Barock-Bozzetti*, II, 72, pl. 34, publishes two bozzetti in the Istituto di Belle Arti, Siena, as models by Bernini for statues decorating the Ponte S. Angelo. One of the bozzetti (Brinckmann, pl. 34, 1) is reminiscent of the *Angel Carrying the Lance* and might be by Guidi. V. Martinelli, *Scultura italiana*, V, *Dal manierismo al rococò* (Milan, 1968), p. 42, cites the existence of a bozzetto for Guidi's statue in a private collection in Rome.

Chapter 5

1. F. Bonanni, *Numismata*, II, 716.

2. Bernini, *Vita*, pp. 158 ff.

3. Leon Battista Alberti, *De re aedificatoria*, Florence, 1485; 1st English ed., transl. James Leoni (London, 1726), ed. J. Rykwert (London, 1955), p. 172. Alberti's reconstruction of the Pons Aelius was accepted by Bernardo Rucellai, "De urbe Roma," written between 1492 and 1494 (Valentini and Zucchetti, *Codice*, IV, 437–56). Cf. Andrea Palladio, *I Quattro Libri dell'Architettura* (Venice, 1570), p. 25, who states that the columns were made of bronze and that the portico was covered with statues and other decorations; also, Totti, *Ritratto*, pp. 190 ff. (see p. 91). Antonio Averlino Filarete reconstructed the Pons Aelius as crossing the Tiber over seven arches and eight piers, with towers flanking the ends of both ramps. On the other hand, Filarete notes that, "It is understood that it [the bridge] was covered. This seems probable because certain arches can still be seen." See John R. Spencer, *Filarete's Treatise on Architecture* (New Haven, 1965), I, 162; II, fol. 93ᵛ. Baldassare Peruzzi (Gabinetto dei Disegni e delle Stampe degli Uffizi, 590A) reconstructed the bridge as crossing the Tiber over seven openings and eight piers, the buttresses of which carry bases supporting ovoid forms that are reminiscent of the *cippi* that often decorated ancient Roman funeral monuments. See A. Bartoli, *I Monumenti antichi di Roma nei disegni degli Uffizi di Firenze* (Rome, 1915), II, pl. CXCI; VI, 60. Sebastiano Serlio published a reconstruction of the bridge that seems to be based on his memory of Peruzzi's drawing. See S. Serlio, *Tutte l'opere d'architettura et prospetiva* (Venice, 1619), p. 90. Most of the reconstructions cited here and in note 4 have been noted by Kauffmann, *Giovanni Lorenzo Bernini*, pp. 290 ff.

4. For discussions of the chronology, style, and meaning of the frescoes in the Sala di Costantino, see S. J. Freedberg, *Painting of*

the High Renaissance in Rome and Florence (Cambridge, Mass., 1961), pp. 568–75; F. Hartt, *Giulio Romano* (New Haven, 1958), pp. 42 ff. C. Q. Giglioli, "Il Sepolcreto imperiale," *Capitolium* 6 (1930), 556, takes note of Giulio's reconstruction of the Mausolea of Augustus and Hadrian and publishes a drawing by G. Fasolo illustrating Giulio's reconstruction of the Mausoleum of Augustus. Giulio's reconstruction of the Pons Aelius was the first of several based on the Hadrianic medal. Others include the images of the bridge in Pirro Ligorio's maps of ancient Rome published in 1523 and 1561 (fig. 103; Frutaz, *Piante*, maps XVI and XVII). The representations of the bridge in Étienne du Pérac's maps of 1573 and 1574 (ibid., maps XXI and XXII) and that in the manuscript *Disegni de le ruine di Roma e come anticamente erono*, facsimile ed., ed. R. Wittkower (Milan, 1963), fols. 34ᵛ–35, seem to be based on Ligorio's reconstruction in the map of 1561 rather than on the medal itself, because all four images show the bridge decorated with statues but crossing the river in a continuous arc. Wittkower attributes the manuscript to du Pérac and dates it between the early 1560s and 1575. For further discussion, see Craig Smyth, "Once more the Dyson Perrins Codex and St. Peters," *Journal of the Society of Architectural Historians* 29 (1970), 265. The Hadrianic medal was published by S. Erizzo in 1568 (see ch. 1, n. 3); it was copied by Pirro Ligorio in a drawing (Biblioteca Nazionale, Naples, codex XIII. B. 6, last of four folios bound between 289 and 291 (there is no 290) and reproduced in the form of line engravings in several guidebooks to Rome, beginning with Totti *Ritratto*, p. 240. Two important eighteenth-century reconstructions of the bridge based on the Hadrianic medal are by Johann Bernhard Fischer von Erlach, *Entwürf einer historischen Architektur* (1st ed. Vienna, 1721), book II, pl. 8, and Giovanni Battista Piranesi, *Campus Martius antiquae urbis* (Rome, 1762), Italian title page.

5. V. Forcella, *Tornei e giostre, ingressi trionfali e feste carnevalesche in Roma sotto Paolo III* (Rome, 1885), pp. 35–50, published a contemporary description of the triumphal entry of Charles V. H. Egger, "Entwürfe Baldassare Peruzzis für den Einzug Karls V in Rom," *Jahrbuch der kunsthistorischen Sammlungen des allerhöchsten Kaiserhauses* 23 (1902), 1–44, discusses the designing of the decorations. See also ch. 1, n. 26 above.

6. Théodore de Bèze (Theodorus Beza), *Icones . . .* (Genoa, 1580), p. 25. See A. Henkel and A. Schöne, *Emblemata, Handbuch zur Sinnbildkunst des XVI. und XVII. Jahrhunderts* (Stuttgart, 1967), cols. 1211–12. Théodore de Bèze (1519–1605) was a famous Calvanist theologian. His works seem to have been greatly admired by Catholics, however, for in 1597 St. Francis de Sales made several attempts to bring him back into the Roman Catholic Church. See *The Oxford Dictionary of the Christian Church* (London, 1958), pp. 164–65.

7. Totti, *Ritratto*, pp. 190 ff. G. Severano, *Memorie sacre delle sette chiese di Roma e di altri luoghi che si trovano per le strade di esse* (Rome, 1630), I, 5 ff., discusses the portico, noting that it was thought that the portico extended from St. Peter's across the bridge to the Arch of Gratianus, Valentinianus, and Theodosius. Fiorovante Martinelli, "Roma ornata dall'architettura, pittura e scultura," Biblioteca Casanatense, Rome, MS 4984, fol. 347, wrote: "Il Ponte S. Angelo fù rifatto da Nicola V come si vede dal suo nome nel pilastro di mezzo e vi fù fatto col disegno di Leon Battista Alberto il coperto ad uso di loggia per difesa del sole ne tempi estivi, e delle piogge e de venti nell'inverno. . . ." See C. D'Onofrio, *Roma nel Seicento* (Florence, 1968), p. 267.

8. Alveri, *Roma*, II, 109 ff. Bonini, *Il Tevere*, p. 159, proposes the destruction of the Ponte S. Angelo and the rebuilding of the Pons Triumphalis as the Ponte Alessandrino, decorated with a portico and statues.

9. D'Onofrio, *Il Tevere*, p. 142, has come to a similar conclusion.

10. Lavin, *Bernini and the Crossing*, discusses the importance of the relics for the decoration of St. Peter's.

11. F. H. Dudden, *Gregory the Great* (London, 1905), I, 219 ff., discusses the different versions of the legend of the apparition of St. Michael.

12. The prototype for both these paintings was probably a fresco in the chapel dedicated to St. Michael atop the Castel S. Angelo. See Andrea Fulvio, *Delle Antichità della città di Roma* (Venice, 1543), fol. 96.

13. Pastor, *History of the Popes*, XXXI, 32–35, describes the precautions taken to keep the plague under control. The medals are discussed by Bonanni *Numismata*, II, 649 ff. Bernini's drawing is in the De Pars Collection, Cornwall County Museum of Art.

14. A pamphlet describing the *apparato* exists in ASR, *Cartari-Febei*, vol. 78, fols. 106–08ᵛ.

15. No known document or source written during the reign of Pope Alexander VII states that there was a plan to decorate the bridge with statues of angels. On the other hand, the fact that a few contemporary books (see notes 7 and 8 above) allude to projects for the decoration or destruction of the Ponte S. Angelo shows that the future of the bridge was being discussed.

16. Henkel and Schöne, *Emblemata*, col. 1567; C. Ripa, *Iconologia* (Rome, 1603), p. 439.

17. Jean Pradel, *Le Sacrifice eucharistique d'après Saint Grégoire le Grand* (Brignais, 1913), gives a detailed and clear explanation of

the meaning of sacrifice and of the Eucharist as conceived by the Church Fathers. The meaning of and need for participation in the Eucharist was reiterated in the thirteenth session of the Council of Trent on 11 October 1551. See *Canons and Decrees of the Council of Trent*, trans. H. J. Schroeder (St. Louis, 1960), pp. 72–80.

18. See W. Paeseler, "Die römische Weltgerichtstafel in Vatican," *Römisches Jahrbuch für Kunstgeschichte* 2 (1938), 311–94.

19. The fourteenth century is usually cited as the date of the invention of the legend of the Mass of St. Gregory, because illustrations of the miracle first appear in the second half of that century. The miracle is not referred to in the writings of St. Gregory, nor is it mentioned in the *Golden Legend* of Jacobus de Voragine. See Maurice Vloberg, *L'Eucharistie dans l'art* (Grenoble-Paris, 1946), II, pp. 199–208; L. Réau, *Iconographie de l'art chrétien* (Paris, 1958), III, 2, 614.

20. E. Panofsky, *Tomb Sculpture* (New York, 1964), pp. 35 ff., figs. 115, 126–27.

21. Karl-August Wirth, "Engel," *Reallexikon zur deutschen Kunstgeschichte*, Stuttgart, 1960, V, cols. 341–555, traces the concept of the angel in Christian thought and art from the late antique through the nineteenth century. Figs. 1, 6, 11, 18, 37, 39, 42, and 43 of Wirth's article illustrate angels associated with the sacrifice of Christ or the saying of mystic Masses and angels holding eucharistic symbols.

22. E. Panofsky, *Early Netherlandish Painting* (London, 1953), pp. 212–17, pl. 143.

23. J. Pope-Hennessy, *Fra Angelico* (London, 1952), pp. 191 ff., discusses the different versions of the *Last Judgment* by Fra Angelico.

24. C. de Tolnay, *Michelangelo* (Princeton, 1943–60), V, 22 ff., discusses the iconography of Michelangelo's *Last Judgment* and cites several fifteenth- and sixteenth-century representations of the same subject in which angels carrying instruments of the Passion are depicted. Allori's painting is discussed by H. Voss, *Die Maler der Spätrenaissance in Rom und Florenz* (Berlin, 1920), II, 340, fig. 125.

25. Mâle, *L'art religieux*, pp. 19–104, discusses the use of art as propaganda in defense of the Church against Protestantism. On pp. 72–86 he discusses subject matter related to the Eucharist.

26. A. De Santi, S.J., *L'Orazione delle quarant' ore e i tempi di calamità e di guerra* (Rome, 1919); see Castellani, *La Congregazione*, pp. 51–57, who discusses the *Quarant' Ore* in the Gesù.

27. I would like to thank Ronald Malmstrom for calling my attention to a description of this *apparato* in the Archivio Vicariato, Rome, *SS. Quirico e Giulitta, Battesimi*, vol. II, 1634–48, pp. 545–49.

28. The drawing is listed under the name Baldassare Franceschini, called "Il Volterrano," in the catalogue of the Gabinetto Nazionale delle Stampe.

29. Giovanni Interian de Ayala, *Istruzioni al pittor cristiano*, (Ferrara, 1854; 1st ed., Madrid, 1730), p. 72, explains how and why angels cry at the Passion of Christ in the following words: "Possono essi depingersi piagente: non gia per ridicole cagioni, ma bensì per motivi degni del loro pianta, quale appunto è la Passione del Signore. Que'spiriti beati godano di un gaudio perenne, e suscettibili non sono delle umane debolezze, o di dolore; ma col dipingerli piangenti, viene a darsi ai divoti riguardanti un senso acerbita in quella scena ch'e dipinta, e per quale pur essi piangerebbero. Dice lo stesso Isaia che gli *Angeli della pace piangevano amaramente*, quegli cioè che S. Girolamo interpretava essere i Custodi del Tempio di Salomone, dolenti di sapere a quanta ruina e distruzione andar dovea soggetto." L. Grassi, *Gianlorenzo Bernini* (Rome, 1962), p. 134, cites this passage in his discussion of Bernini's statues in S. Andrea delle Fratte. The angel as the messenger of God is discussed by Wirth (see note 20).

30. H. Hibbard, "Notes on Guido Reni's Chronology," *The Burlington Magazine* 107 (1965), pp. 508 ff. G. Rivani, "Guido Reni a Ravenna," *Il comune di Bologna* 18, no. 4 (1931), 25–35, publishes photographs of the altarpiece and the lunettes. For further bibliographical references, see C. Gnudi and G. C. Cavalli, *Guido Reni* (Florence, 1955), p. 73; and Hibbard, *Carlo Maderno*, p. 190.

31. Briganti, *Pietro da Cortona*, p. 205, cat. no. 50, pl. 143.

32. For the history of the Cappella Alaleona, see Wittkower, *Gian Lorenzo Bernini*, p. 223, cat. no. 52. The fact that the decoration of this chapel illustrates salvation through Christ's sacrifice is supported by a line from Jacobus de Voragine, *The Golden Legend*, trans. G. Ryan and H. Ripperger (New York, 1941), I, 221, that informs us that on the day of Christ's Resurrection, "He appeared first to Mary Magdalen, in order to show that He had died for sinners."

33. Beginning in the Middle Ages, it was believed that the bodies of SS. Peter and Paul had been divided, with half of each body being buried under the high altar of St. Peter's and the other half in S. Paolo fuori le Mura. See Lavin, *Bernini and the Crossing*, p. 1, n.1.

34. My iconographic description of St. Peter's is based on Wittkower, *Gian Lorenzo Bernini*, pp. 18 ff. Mâle, *L'Art religieux*, pp. 48–58, discusses the significance of St. Peter and the decoration of the Basilica of St. Peter in the art of the Counter Reformation.

35. A copy of the broadsheet exists in ASR, *Cartari-Febei*, vol. 81, fol. 173.

36. The allegorical figures are identified on the basis of Ripa, *Iconologia*, pp. 68 ff., 149, 187 ff.

37. H. G. Evers, *Die Engelsbrücke in Rom* (Berlin, 1948), pp. 15 ff., first suggested that the angels should be understood as stages in a history, like the Stations of the Cross. This idea has been repeated by Kruft and Larsson, "Entwürfe," p. 157, who published an iconographic chart of which my fig. 52 is an adaptation and correction.

38. Thomas à Kempis, *The Imitation of Christ* (London and Oxford, 1950), pp. 93–100.

39. Teresa of Jesus, *The Complete Works*, transl. E. Allison Peers (London and New York, 1957), I, 54 ff., 58, III, 277–312, esp. 298 ff.

40. A sketch by Baldassare Franceschini for the frontispiece of Salviati's book contains a dedication to Pope Alexander VII (Staatliche Graphische Sammlung, Munich, Inv. No. 9537).

41. Severano, *Memorie*, I, 2 ff., II, 5 ff., 9 ff., contains a discussion of the history of the Castel S. Angelo.

42. At least thirteen editions of Rainaldi's book were published between 1633 and 1883. Twelve editions are listed in *Bibliothèque de la Compagnie de Jésus*, pt. 1, *Bibliographie* (Paris, 1895), VI, cols. 1405 ff. The edition printed in Rome in 1641 is not listed in the bibliography.

43. G. Rainaldi, *Cibo dell'anima*, Rome, 1641, p. 38. The Italian reads: "Io non voglio altro da te Cristiano, se non che tenghi a memoria quanto hò fatto, e patito per te. Questo sia l'unico segno di gratitudine, che ricerco da te, per tanti beneficij, che ti hò fatti, fino à dare il sangue, e la vita per te, che ti ricordi della mia passione."

44. St. Ignatius, *The Spiritual Exercises*, trans. Thomas Corbishley, S.J. (New York, 1963), p. 22.

45. Castellani, *La Congregazione*, pp. 247, 273. Giulio Rospigliosi (Pope Clement IX) joined the congregation in 1628. Bernini's attitude toward religion is discussed on pp. 37–38.

46. For Pope Clement IX and his relationship to Bernini, see Pastor, *History of the Popes*, XXXI, pp. 314–40; Baldinucci, *Vita del Cavaliere Gio. Lorenzo Bernino*, pp. 128–29; and Bernini, *Vita del Cavalier Gio. Lorenzo Bernino*, pp. 155–63.

47. For the legend of the Scala Sancta and the history of its decoration during the pontificate of Sixtus V, see A. Cempanari and T. Amodei, *La Scala Santa*, Le chiese di Roma illustrate, 72 (Rome, 1963), pp. 25 ff. The Scala Sancta is considered to be an instrument of the Passion by Ch. Rohault De Fleury, *Memorie sur les instruments de la Passion de N.-S. J.-C.* (Paris, 1870), pp. 268 ff.

Appendices

Abbreviations

ASR Archivio di Stato, Rome

BV Biblioteca Apostolica Vaticana

Thieme-Becker Thieme, Ulrich, and Becker, Felix, eds. *Allgemeines Lexikon der bildenden Künstler von der Antike bis zur Gegenwart.* 37 vols. Leipzig, 1907–50.

Titi, 1674 Titi, Filippo. *Studio di pittura scoltura et architettura nelle chiese di Roma.* Rome, 1674.

Titi, 1686 Titi, Filippo. *Ammaestramento utile e curioso di pittura, scoltura et architettura nelle chiese di Roma.* Rome, 1686.

Titi, 1763 Titi, Filippo. *Descrizione delle pitture, sculture e architetture esposte al pubblico in Roma.* Rome, 1763.

▽ scudi
b baocchi

The scudo, the basic monetary unit in seventeenth-century Rome, was equal to one hundred baocchi.

Appendix I

Documents for the Decoration of the Ponte S. Angelo

1. Chirographs

The two following documents have been transcribed from ASR, *Camerale* I, *Chirografi*, 167. Both documents have been published previously by V. Golzio, "Documenti berniniani," *Archivi d'Italia* I (1933–34), 143–45.

1) p. 211

Piero, Filippo, e Giuseppe Nerli Dep.ri Genli Pagherete à Voi medesimi scudi Diecimila m.ta dequali ne darete credito alla nra Cam.ra in conto ap.te a disp.ne del Re.mo Card.le Nini nro promag.mo per pagarli con ordini dell'istesso Reu.mo Card.le p la fabrica di nro ordine si deue fare p risarcim.to et adornare il Ponte S. Angelo che cosi pagati, e posti à cred.o uogliamo che ui siano della nra Cam.ra acc.ti e fatti buoni a suoi conti ost.te non qualsia.a cosa in contr.o Dato nel nro Pal.o Ap.co di monte Cau.o q.to di 11 Nou. 1667.
Clemens Papa IX

2) p. 325

Mons.re Bernardino Rocci nro Maggiordomo Hauendo voi di nro ordine fatto fare diuerse spese cioè fatto accrescere alcune stanze al nro palazzo di Monte Cauallo, e quelle adornare con mobili, et altri abellimenti risarcire, et abbellire il Ponte S. Angelo, et à quest'effetto fatto demolire alcune case, tanto di pietre, quanto di legno con adornarlo anco di statue di marmo . . . E perche frà l'altre statue di marmo dell'Angeli, che hauete fatto farete p adornam.to del detto Ponte pagate, e da pagarsi con li denari sudetti (scudi ventiseimila), *ue ne sono due fatte*, una dal Cau.re Bernini, l'altra da Paolo suo figliolo, quali vogliamo donare al Rmo Card.le Rospigliosi nro nipote, e che ne facciate fare due altre, di moto scienza, e pienezza di potestà Sudette, ordiniamo à Voi, che facciate consegnare al d.o R.mo Card.le Rospigliosi le predette due statue, quali glieli doniamo p Donatione irreuocabile, che si dice inter uiuos, che uogliamo, che uaglia senza insinuatione, ò altre solennità necessarie consuete, sopra di che darete gl'ordini, che stimarete necessarij; . . .
Primo Decembre 1669
Clemens Papa IX

The following documents are précis of chirographs authorizing funds for the decoration of the Ponte S. Angelo. The précis are found in ASR, *Camerale* I, *Fabbriche*, 1552 (an audit dated 1678 of the cost of the decoration of the Ponte S. Angelo), fol. 15.

3) 1667

Reu.da Cam.ra cont'apparte à disp.ne dell'em.mo, e Reu.mo Sig.re Card.le Nini Promaggiordomo di Nro Sig.re p li ornam.to del Ponte S. Angelo Hauere A di 12 Nou.re ▽ 10000 m.ta rif. da Nomine dep.ri Genli della Reu.da Cam.le Aplica con Chirografo di Nro Sig.re in data delli ij stante, disse p pagarli con ord.e dell'Em.mo sig.re Card.le Nini p la fabrica, che d'ord.e di S. Sta Si deue fare p risarcire, et adornare il Ponte S. Angelo. ▽ 10000

4) 1668

E adi 9 ott.re ▽ 10000–m.ta rif. da Noi Med.i con Chirografo di S. S.ta che disse p. pagarli con ord.ne dell'istesso maggiordomo p proseguire la fabrica, che d'ord.e di S. Beatitud.ne Si fa p risarcire et adornare Il Ponte S. Angelo. ▽ 10000

5) E a di 12 Genn.ro ▽ 5040–m.ta, Se ne dà Credito d'ord.e di Mons.re Ill.o Niccolò Acciaioli Audit.re della Cam.ra à tergo Chirografo di Nro Sig.re in data de 9 St.e, de denari, che sono in Cred.o alle dep.ri Genli, alla quale, Si pongono in det.o proueni-enti dalla Copositione fatta dal Mesquita nel tribunale del Mons.re A.C. ▽ 5040

6) 1669

E a di X Ott.re △ 10000–m.ta, rif. da Noi med.i con girata di Mons.e Ill.o Bernard.o Rocci Sott'ord.e di Mons.re Ill.o Girol.o Gastaldo, che disse del pro de luoghi Cento del Monte rist.do r.do Spettanti al Popolo Romano e Cam.ra della Città in esecuzione del Chirografo di Nro Sig.re in data delli 13 Sett.re pross.o p le Spese del risarcim.to, et ornam.to del Ponte S. Angelo. ▽ 10000

7) 1675

E a di 18 lug. ▽ 3228.23 m.ta rif da Noi med.i de denari in Cro dell'Em.mo Sig.re Car.le Rocci Nel nro Banco Cont'app.re dell ▽ $\frac{m}{26}$ con ord.e di S. E. Che disse essere p resto, e saldo delli ▽ 38268.23 da Noi pagati di Suo ord.e a diuersi Artisti p L'adornam.to del Ponte S. Angelo. ▽ 3228·23
 ▽ 38268·23

2. *Giustificazioni*

Payments for Work on the Ponte S. Angelo, 1667–72
ASR, *Camerale* I, *Giustificazioni*, 169, fasc. 9.

 The documents have been rearranged in such a manner that all those concerning a single part of the work are placed together in chronological order. Documents referring to the payments to sculptors for statues of angels that decorate the bridge have been listed under the names of the individual artists. Because all of the documents are written according to the same basic formula, only the first document is fully quoted. Of the other documents only those parts that have substantive meaning for the history of the decoration of the bridge are quoted. Each document has two dates, the first being the date on which payment was authorized and the second the date on which payment was received. The number placed above each document refers to a number written in the upper right corner of the first page of that document and indicates its placement within the series.
Payments to *scarpellini*:

8) P.º

 Conto à parte per il Ponte S. Angelo
Ill.ri SS.ri Pietro, Filippo, e Giuseppe Nerli Le Piacerà di pagare à Mastro Gabrielle Renzi scarpellino di Palazzo ▽ TreCento-m.ta, quali se Li fanno pagare à bon conto de Lauori di Scarpelli fatti, e che ua facendo per L'adornamento del Ponte S. Angelo in conformità dell' ordine di Nro. Sig.re e per douerne render Conto. Che pigliandone iceuuta con darne debito in Conto à parte Saranno ben pagai. di Palazzo Li 17 Novembre 1667.
·˙7 300 m.ta

 Card. Nini
e per me al signiore Carlo previsani per spese delli per il lauoro che facemo assieme al ponte santagelo
Io gabriele renzi mano pp.º
Io infrascritto ho riceuti li sopradetti trecento m.ta questo di 19 di Nou.re 1667—

 Carlo Piervissani mano pp.º

9) 3
. . . à Mastro Gabrielle Renzi . . . ▽ TreCento-m.ta . . . à bon conto de Lauori di Scarpello fatti, e che ua facendo per L'Adornamento del Ponte S. Angelo . . . Li 6 Dec.re 1667 . . .
. . . riceuto . . . 16 di d.º 1667 . . .

10) 4
. . . à Mastro Gabrielle Renzi . . . ▽ TreCento-m.ta . . . à bon conto de Lauori di Scarpello fatti, e che ua facendo per L'Adornamento del Ponte S. Angelo . . . Li 13 Gennaro 1668 . . .
. . . ric.to . . . 21 Gen.º 1668 . . .

11) 5
. . . à Mastro Gabrielle Renzi . . . ▽ TreCento-m.ta . . . à bon conto de Lauori di Scarpello fatti, e che ua facendo per L'Adornamento del Ponte S. Angelo . . . Li p.mo Febraro 1668 . . .
. . . riceuto . . . 17 febraro 1668 . . .

12) 8
. . . à Mastro Gabrielle Renzi . . . ▽ TreCento-m.ta . . . à bon conto de Lauori di Scarpello fatti e che ua facendo per L'Adornamento del Ponte S. Angelo . . . Li 24 febraro 1668 . . .
. . . ric.to . . . 7 Marzo 1668 . . .

13) 9
. . . à Mastro Gabrielle Renzi . . . ▽ TreCento-m.ta . . . à bon conto de Lauori di Scarpello fatti, e che ua facendo per L'Adornamento del Ponte S. Angelo . . . 14 Marzo 1668 . . .
. . . riceuto . . . 22 Marzo 1668 . . .

14) 11
. . . à Mastro Gabrielle Renzi . . . ▽ TreCento-m.ta . . . à bon conto de Lauori di Scarpello, fatti, e che ua facendo per L'Adornamento del Ponte S. Angelo . . . Li 9 Aprile 1668 . . .
. . . riceuto . . . 18 Aprile 1668 . . .

15) à Mro Gabrielle Renzi . . . ▽ Quattrocento mta . . . à buonconto di Lauori di Scarpello fatti, e che ua facendo p L'adornamento del Ponte S. Angelo . . . Li 15 Mag 1668 . . .
. . . riceuto . . . 24 maggio 1668 . . .

16) 22
. . . à Mastro Gabrielle Renzi . . . ▽ TreCento-m.ta . . . à bon conto de Lauori di Scarpello fatti e che ua facendo per L'Adornamento del Ponte S. Angelo . . . 29 Mag. 1668 . . .
. . . ric.to . . . 8 Giug.º 1668 . . .

17) 24
. . . à Mastro Gabrielle Renzi . . . ▽ TreCento-m.ta . . . à bon conto delli Lauori di Scarpello fatti, e che ua facendo per Seruitio del Ponte S. Angelo . . . Li 18 Giug.º 1668 . . .
. . . riceuto . . . 21 Giug.º 1668 . . .

18) 28
. . . à Mastro Gabrielle Renzi . . . ▽ TreCento-m.ta . . . à bon conto delli Lauori di Scarpello fatti, e che ua facendo per Seruito del Ponte S. Angelo . . . Li 9. Lug.º 1668 . . .
. . . ric.º . . . 16 lug.º 1668 . . .

19) 33
. . . à Mastro Gabrielle Renzi . . . ▽ TreCento-m.ta . . . à bon conto de Lauori di Trauertino, e di marmi che detto fa e ua facendo per Seruitio del Ponte S. Angelo . . . Li 28 Luglio 1668 . . .
. . . riceuto . . . 9 Agosto 1668 . . .

20) 43
. . . à Mastro Gabrielle Renzi . . . ▽ CinqueCento-m.ta . . . à bon

conto de Lauori di Treuertino e di Marmo fatti e che ua facendo per Seruitio del Ponte S. Angelo . . . Li 22 Agosto 1668 . . .

. . . ric.^{to} . . . 11 Sett.^{re} 1668 . . .

21) 45
. . . à Mastro Gabrielle Renzi . . . ▽ CinqueCento m.^{ta} . . . à bon conto delli Lauori di Scarpello fatti, e ua facendo per Seruitio dell'adornamento del Ponte S. Angelo . . . Li 12 Sett.^{re} 1668 . . .

. . . riceuto . . . 9 ott.^e 1668 . . .

22) 51
. . . à Mastro Gabrielle Renzi . . . ▽ TreCento-m.^{ta} . . . à bon conto delli Lauori di Treuertino fatti, e che ua facendo per Seruitio del Ponte S. Angelo . . . Li 13 Ottobre 1668 . . .

. . . riceuto . . . 17 di Ott.^{re} 1668 . . .

23) 59
. . . à Mastro Gabrielle Renzi . . . ▽ QuattroCento-m.^{ta} . . . à bon conto de Lauori di Marmo, e Treuertino fatti e che ua facendo per Seruitio del Ponte S. Angelo . . . Li 21 Nou.^{re} 1668 . . .

. . . riceuto . . . 26 Nou.^{re} 1668 . . .

24) 69
. . . à Mastro Gabrielle Renzi . . . ▽ QuattroCento-m.^{ta} . . . à bon conto delli Lauori di Scarpello fatti, e che ua facendo per Seruitio del Ponte S. Angelo . . . Li 17 Dec.^{re} 1668 . . .

. . . riceuto . . . 22 di Dec.^e 1668 . . .

25) 78
. . . à Mro Gabrielle Renzi . . . ▽ TreCento-m.^{ta} . . . à bon conto delli Lauori di Marmo, e Trauertino fatti, e che ua facendo per Seruitio del Ponte S. Angelo . . . Li 16 Gennaro 1669 . . .

. . . riceuto . . . 22 di Gen.^o 1669 . . .

26) 84
. . . à Mastro Gabrielle Renzi . . . ▽ QuattroCento-m.^{ta} . . . à bon conto delli Lauori di Marmo, e Treuertino, che detto ua facendo per Seruitio del Ponte S. Angelo . . . Li 9 Feb.^{re} 1669 . . .

. . . riceuto . . . 22 di Februaro 1669 . . .

27) 87
. . . à Mastro Gabrielle Renzi . . . ▽ QuattroCento-m.^{ta} . . . à bon conto delli Lauori di Scarpello che detto ua facendo per Seruitio dell'Adornamento del Ponte S. Angelo . . . Li 27 febraro 1669 . . .

. . . riceuto . . . 8 Marzo 1669 . . .

28) 110
. . . à Mastro Gabrielle Renzi . . . ▽ DioCento-m.^{ta} . . . à bon conto de Lauori di Scarpello fatti, e che ua facendo per Seruitio del Ponte S. Angelo . . . Li 13 Maggio 1669 . . .

. . . riceuto . . . 22 Maggio 1669 . . .

29) 112
. . . à Mastro Gabrielle Renzi . . . ▽ QuattroCento-m.^{ta} . . . à bon conto delli Lauori di Marmo, e Treuertino che ua facendo per

Seruitio del Ponte S. Angelo . . . Li 29 Maggio 1669 . . .

. . . riceuto . . . 31 di Maggio 1669 . . .

30) 126
. . . à Mro Gabrielle Renzi . . . ▽ Trecento m.^{ta} . . . à buonconto di Lauori di Scarpello fatti e che ua facendo p Seruitio del Ponte S. Angelo . . . Li 17 Luglio 1669 . . .

. . . riceuto . . . 29 di lug.^o 1669 . . .

31) 137
. . . à Mastro Gabrielle Renzi . . . ▽ Cinquecento-m.^{ta} . . . à bon conto delli Lauori di Scarpello tanto di treuertino, come di Marmi fatti da Lui per Seruitio del Ponte S. Angelo . . . Li 30 Nou.^{re} 1669 . . .

. . . riceuto . . . 3 decembre 1669 . . .

32) 138
. . . à Mastro Gabrielle Renzi . . . ▽ DoiMila NoueCento Cinquantatre e 85 m.^{ta} . . . per Compimento di ▽ 11253:85 m.^{ta} che tanto importa il suo conto di tutti Li Lauori fatti da Lui di treuertini, e Marmi per Seruitio dell'Adornamento del Ponte S. Angelo . . . Li 4 Decembre 1669 . . .

. . . riceuto . . . 5 di Dec.^e 1669 . . .

Payments to ironworkers:

33) 6
. . . à Mastro Clemente Fiorelli Ferraro di Palazzo ▽ DuCento-m.^{ta} . . . à bon conto delle ferrate, che detto fa per Seruitio del Ponte S. Angelo . . . Li 18 febraro 1668 . . .

. . . riceuto . . . 21 di febraro 1668 . . .

34) 10
. . . à Mastro Clemente Fiorelli . . . ▽ DuCento-m.^{ta} . . . à bon conto delle ferrate, che detto fa per Seruitio del Ponte S. Angelo . . . Li 22 Marzo 1668 . . .

. . . reciuto . . . 28 di Marzo 1668 . . .

35) 14
. . . à Mastro Clemente Fiorelli . . . ▽ DuCento-m.^{ta} . . . à bon conto delle ferrate, che detto fa per Seruitio del Ponte S. Angelo . . . Li 20 Aple 1668 . . .

. . . 4 Mag. 1669 . . .

36) 15
. . . à Mastro Clemente Fiorelli . . . ▽ DuCento-m.^{ta} . . . à bon conto delle ferrate fatte e che ua facendo per Seruitio del Ponte S. Angelo . . . Li 5 Maggio 1668 . . .

. . . reciuto . . . 7 di Maggio 1668 . . .

37) 19
. . . à Mro Ascenzio Latini ferraro ▽ TreCento m.^{ta} . . . à buonconto delle ferrate fatte e che fa p Seruitio del Ponte S. Angelo . . . Li 14 Giug.^o 1668 . . .

. . . recuto . . . 7 di Giugno 1668 . . .

38) 25

. . . à Mastro Clemente Fiorelli . . . ▽ QuattroCento-m.^{ta} . . . à bon conto delle ferrate fatte e che ua facendo per Seruitio del Ponte S. Angelo . . . Li 20 Giugno 1668 . . .

. . . reciuto . . . 21 Giugno 1668 . . .

39) 32

. . . à Mastro Ascienzo Latini . . . ▽ Cento-m.^{ta} . . . à bon conto delle ferrate che ua facendo per Seruitio del Ponte S. Angelo . . . Li 6 Agosto 1668 . . .

. . . recuto . . . 7 di Agosto 1668 . . .

40) 36

. . . à Mastro Clemente Fiorelli . . . ▽ DuCento-m.^{ta} . . . à bon conto delle ferrate fatte, e che ua facendo per Seruitio del Ponte S. Angelo . . . Li 13 Agosto 1668 . . .

. . . reciuto . . . 14 di Ag.^{to} 1668 . . .

41) 37

. . . à Mastro Clemente Fiorelli . . . ▽ DuCento-m.^{ta} . . . à bon conto delle ferrate fatte, e che ua facendo per Seruitio del Ponte S. Angelo . . . Li 22 Agosto 1668 . . .

. . . riciuto . . . 23 Agosto 1668 . . .

42) 56

. . . à Mastro Clemente Fiorelli . . . ▽ DoiCento-m.^{ta} . . . à bon conto delle ferrate fatte, e che ua facendo per Seruitio del Ponte S. Angelo . . . Li 26 Ottobre 1668 . . .

. . . riciuto . . . 27 ottobre 1668 . . .

43) 66

. . . à Mro. Ascentio Latini . . . ▽ DoiCento-m.^{ta} . . . à bon conto delle ferrate fatte, e che ua facendo per Seruitio del Ponte S. Angelo . . . Li 14 Decembre 1668 . . .

. . . recuto . . . 17 decembre 1668 . . .

44) 71

. . . à Mro Clemente Fiorelli . . . ▽ TreCento-m.^{ta} . . . à bon conto de Lauori fatti, e che ua facendo per Seruitio del Ponte S. Angelo . . . Li 22 Dec.^{re} 1668 . . .

. . . r.^{to} . . . 29 X^{bre} 1668 . . .

45) 119

. . . à Roccho Lolli Indoratore di Palazzo ▽ Cinquantaquattro e b 60 m.^{ta} . . . per saldo d'un Conto di uernice nera data da Lui a tutte Le ferrate del Ponte S. Angelo . . . Li 15 Giugno 1669 . . .

. . . riceuto 2 luglio 1669 . . .

46) 130

. . . à Gio Mora Stagnaro ▽ Ottanta b 25 m.^{ta} . . . p Saldo di un Conto di Piombodato da Lui p impiombare Le ferrate che Si Sono fatte nel Ponte S. Angelo . . . Li 27 Ag.^{to} 1669 . . .

. . . ricuto . . . 10 sett.^{re} 1669 . . .

47) 139

. . . à Mastro Ascentio Latini . . . ▽ CentoVenticinque e b 23 m.^{ta} . . . per Compimento di ▽ 725:93 m.^{ta} che tanto importa un Suo Conto di tutte Le ferrate fatte da Lui per Seruitio dell Adornamento del Ponte S. Angelo . . . Li 4 Decembre 1669 . . .

. . . recuto . . .

48) 141

. . . à Mastro Clemente Fiorelli . . . ▽ Trentatre e b 77 m.^{ta} . . . per saldo di diuersi Lauori fatti da Lui per Seruitio dell Adornamento del Ponte S. Angelo . . . Li 5 Decembre 1669 . . .

. . . riceuto . . . 18 di dicembre 1669 . . .

49) 143

. . . à Mastro Clemente Fiorelli . . . ▽ MillecinqueCentoVentisette e b 03 1/2 m.^{ta} . . . per Compim.^{to} di ▽ 3627·03 1/2 m.^{ta} che tanto importa il Suo Conto di diuersi Lauori fatti da Lui per Seruitio del Ponte S. Angelo . . . Li 30 Nou.^{re} 1669 . . .

. . . ric.^{to} . . . 4 Dec.^{re} 1669

Payments to *muratori*, *falegnami*, and for miscellaneous labor:

50) 7

. . . à Mastro Donato, e Carlo Antonio Interlenghi, e Nicolo Perti Capi Mastri Muratori di Palazzo, e per esse à Mastro Donato Interlenghi ▽ DuCento m.^{ta} . . . à bon conto de Lauori di Muro, che detti fanno per Seruitio dell'Adornamento del Ponte S. Angelo . . . Li 21 Febraro 1668 . . .

. . . riceuti . . . questo di et Anno sudetto . . .

51) 13

. . . e per essi à Mastro Donato Interlenghi ▽ DuCento-m.^{ta} . . . à bon conto de Lauori di Muro, che detti fanno per Seruitio dell' Adornamento del Ponte S. Angelo . . . Li 16 Aprile 1668 . . .

. . . riceuti . . . questo di et Anno sudetto . . .

52) 21

. . . e per essi à Mastro Donato Interlenghi ▽ Cento-m.^{ta} . . . à bon conto de Lauori di Muro, che detti fanno per Seruitio dell' Adornamento del Ponte S. Angelo . . . Li 30 Maggio 1668 . . .

. . . riceuto . . . 8 Giugno 1668 . . .

53) 26

. . . e per essi à Mastro Donato Interlenghi ▽ DuCento-m.^{ta} . . . à bon conto de Lauori di Muro che detti fanno per Seruitio del Ponte S. Angelo . . . Li 21 Giugno 1668 . . .

. . . ric.^o . . . 22 Giugno 1668 . . .

54) 27

. . . al Sig.^{re} Francesco Cerioli Mastro di Casa di Nro Sig.^{re} ▽ Trenta-m.^{ta} . . . per suo rinborso d'altrettanti dati da Lui per Mancia delli Muratori, e Scarpellini, che Lauorauano nel Ponte S. Angelo . . . Li 13 Giugno 1668 . . .

... riceuti ... 28 di giugno 1668 ...

55) 29

... e per essi à Mastro Donato Interlenghi ▽ DuCento-m.^{ta} ... à bon conto de Lauori di Muro fatti, e che uanno facendo per Seruitio del Ponte S. Angelo ... Li 20 Luglio 1668 ...

... ric.° ... 24 Lug. 1668 ...

56) 38

... e per essi à Mastro Donato Interlenghi ▽ DoiCento-m.^{ta} ... à bon conto de Lauori di Muro fatti, e che uanno facendo per Seruitio del Ponte S. Angelo ... Li 23 Agosto 1668 ...

... riceuti ... 30 Agosto 1668 ...

57) 52

... e per essi à Mastro Donato Interlenghi ▽ DuCento-m.^{ta} ... à bon conto de Lauori di Muro fatti, e che uanno facendo per Seruitio del Ponte S. Angelo ... Li 13 Sett.^{re} 1668 ...

... riceuto ... 16 di 8bre 1668 ...

58) 55

... e per essi à Mastro Donato Interlenghi ▽ DoiCento-m.^{ta} ... à bon conto de Lauori di Muro fatti, e che uanno facendo per Seruitio del Ponte S. Angelo ... Li 18 Ottobre 1668 ...

... riceuti ... questo di et Anno sudetto ...

59) 60

... e per esso à Mro Donato Interlenghi ▽ DuCento-m.^{ta} ... à bon conto de Lauori di Muro fatti, e che uanno facendo per Seruitio del Ponte S. Angelo ... Li 21 Nou.^{re} 1668 ...

... Riceuti ... questo di et Anno sudetto ...

60) 70

... e per essi à Mastro Donato Interlenghi ▽ DuCento-m.^{ta} ... à bon conto de Lauori di Muro fatti e che ua facendo per Seruitio del Ponte S. Angelo ... Li 18 Decembre 1668 ...

... riceuti ... questo di et Anno sudetto ...

61) 80

... e per essi à Mastro Donato Interlenghi ▽ DoiCento-m.^{ta} ... à bon conto de Lauori di Muro fatti e, che ua facendo per Seruitio del Ponte S. Angelo ... Li 7 febraro 1669 ...

... riceuti ... 9 febraro 1669 ...

62) 94

... e p essi à Mro Donato Interlenghi ▽ Duicento m.^{ta} ... à buonc.^{to} de Lauori di Muro fatti e che ua facendo p Seru.° del Ponte S. Angelo ... Li 22 Marzo 1669 ...

... riceuto ... questo di et Anno sudetto ...

63) 102

... al Sig.^{re} Gio: Battista Contini ▽ Trenta-m.^{ta} ... per ricognitione di diuerse fatighe fatte da Lui in hauer Segniato in grande, et alzate Le piante di tutti Li Lauori tanto di treuertino, come de Marmi, come anco per hauer Segniato in grande Le ferrate et,

assistito continuamente à Sollecitare detti Lauori per Seruitio del Ponte S. Angelo ... Li 16 Aprile 1669 ...

... ric.^{ti} ... 20 Aple 1669 ...

64) 111

... e per essi à Mastro Donato Interlenghi ▽ DoiCento-m.^{ta} ... à bon conto delli Lauori di Muro fatti, e che uan facendo per Seruitio del Ponte S. Angelo ... Li 21 Maggio 1669 ...

... riceuti ... 24 Magio 1669 ...

65) 17/140

... à Mro Giovanni de Rossi Falegname di Palazzo ▽ Docici e b 80 m.^{ta} ... per Saldo d'un Suo Conto di diuersi Lauori fatti da Lui per Seruitio della Fabrica Nuoua del Ponte S. Angelo ... Li 30 Nou.^{re} 1669 ...

... riceuto ... 7 decebre 1669 ...

66) 148

... à Mastri Donato, e Carl'Antonio Interlenghi, e Nicolo Perti ... ▽ NoueCentoDodici, e b 85 m.^{ta} ... per Compimento di ▽ 3612:85 m.^{ta} che tanto importa il Conto di tutti Li Lauori fatto da Loro per Seruitio dell'Adornamento del Ponte S. Angelo ... Li 20 Maggio 1670 ...

... riceuto ... 23 Giunio 1670 ...

Payments for the purchase and transport of marble:

67) 41

... a Filippo Frugone, e p esso a Luca Berettini Suo Procurattore Scudi Cinquecento m.^{ta} ... a bon conto del prezzo dell'otto pezzi di Marmi bianchi Statuali, qual Si debbono fare della misura, e qualità che ha dato in nota ill.^{re} Cau.^{re} Bernini, cioè, che Siano Marmi Statuali della più esquisita bianchezza, e pasta, che Si troui conforme e Stato il marmo del Costantino Senza peli o macchie, ma di tutta perfettione à Sodisfattione dell'Em.° Sig.^{re} Card.^{le} Nini, e Sig.^{re} Cau.^{re} Bernini ... Li 22 7bre 1667 ...

... riceuto ... 17 ottobre 1667 ...

68) 2

... à Filippo Frugone, e per esso à Luca Berettini ... ▽ DuCento-m.^{ta} ... à bon conto de marmi statuali che detto fa uenire per Seruitio del Ponte S. Angelo ... Li 21 Nouembre 1667 ...

... riceuto ... 23 noue.^{re} 1667 ...

69) 12

... à Filippo Frugoni, e per esso à Luca Berettini ... △TreCento-m.^{ta} ... à bon conto delli Marmi che detti fanno per Li Dieci Angeli che uanno nel Ponte S. Angelo ... Li 16 Aprile 1668 ...

... riceuto ... 18 aprile 1668 ...

70) 16

... ▽ Ottocento m.^{ta} à Filippo Frugoni, e p esso à Luca Berettini ... a buonc.^{to} delli Dieci pezzi di Marmo che detto fa p L'Angeli

che si fanno per il Ponte S. Angelo . . .

Li 15 Mag. 1668 . . .

. . . riceuto . . . 18 maggio 1668 . . .

71) 17

. . . à Mastro Pietro da Lugano ▽ Ottanta-m.ᵗᵃ . . . à bonconto della Scaricatura fatta dalle barche in Terra Li Sette pezzi di marmo che Sono uenuti per fare Li Angeli . . . Li 12 Maggio 1668 . . .

. . . receuto . . . 17 maggio 1668 . . .

72) 20

. . . à Filippo Frugoni e per esso a Mastro Luca Berettini ▽ Doi-Cento-m.ᵗᵃ . . . à bon conto delli Dieci pezzi di Marmo che detto fa per Li Angeli, che Si fanno per il Ponte S. Angelo . . . Li 6 Giugno 1668 . . .

. . . riceuto . . . 7 giugni 1668 . . .

73) 23

. . . à Mastro Pietro ostini Capo Mastro Muratore ▽ Cinquanta-m.ᵗᵃ . . . à bonconto delle Scaricature, et alzature che detto fa alli dieci pezzi di Marmo, che Sono uenuti per Li Angeli che deuono andare Sul Ponte S. Angelo . . . 13 Giugno 1668 . . .

. . . receuto . . . 15 Giugno 1668 . . .

74) 39

. . . al S.ʳᵉ Carlo Peruisani ▽ Cento-m.ᵗᵃ . . . à bon conto della Portature fatte con i Suoi Carri e Bufale alle Case di otto Scultori il pezzo di marmo che Serue per fare Li Angeli che uanno nel Ponte S. Angelo . . . Li 22 Agosto 1668 . . .

. . . riceuto . . . 5 7ᵇʳᵉ 1668 . . .

75) 40

. . . à Filippo Frugoni e per esso à Mastro Luca Berettini ▽ Tre-Cento-m.ᵗᵃ . . . à bon conto delli Undici pezzi di ⁀armo, che detti hanno fatto e fanno per Li Angioli che uanno Sul Ponte S. Angelo . . . Li 22 Ag.ᵗᵒ 1668 . . .

. . . riceuto . . . 6 setem.ᵉ 1668 . . .

76) 50

. . . à Filippo Frugoni . . . e per esso à Mastro Luca Berettini ▽ Cento Cinquanta-m.ᵗᵃ . . . à bon conto delli marmi fatti uenire e che fa uenire per Seruitio delli Angeli, che uanno al Ponte S. Angelo . . . Li 14 Ottobre 1668 . . .

. . . riceuto . . . 16 ottobre 1668 . . .

77) 57

. . . à Filippo Frugoni Mercente di Marmi, e per esso à Mastro Luca Berettini ▽ CentoCinquanta m.ᵗᵃ . . . à bon conto delli dieci pezzi di Marmi, che detto ha fatti uenire per fare L'Angeli per Seruitio del Ponte S. Angelo . . . Li 5 Nouembre 1668 . . .

. . . riceuto . . . 7 noueᵇʳᵉ 1668 . . .

78) 88

. . . à Carlo Peruisani ▽ DioCentoCinque-m.ᵗᵃ . . . per Compimento di ▽ 305-m.ᵗᵃ . . . di Scaricature delli Marmi Statuarij per Li Angeli e condutture di essi con Li Suoi Carri, e Bufali alle Case di diuersi Scultori per Seruitio dell'Adornamento del Ponte S. Angelo dalli 4 Aprile 1668 a tutto Li 28 di Nouembre 1668 . . . Li 15 Febraro 1669 . . .

. . . riceuto . . . 8 Marzo 1669 . . .

79) 95

. . . à Mastro Pietro Ostini ▽ Cento Quindici-m.ᵗᵃ . . . per Compin.ᵗᵒ di ▽ 245-m.ᵗᵃ . . . di diuerse fatiche e spese fatte da lui in hauer scaricato Li Marmi Statuarij per fare Li Angeli, e detti recaricati Su Li Carri per portarLi nelle Case delli Scultori in conformità dell'ordine di Nro Sig.ʳᵉ dalli 4 Aprile 1668 à tutto Li 28 Nou.ʳᵉ 1668 . . . Li 15 Febraro 1669

. . . riceuto . . . 29 marzo 1669

80) 96

. . . à Luca Berettini ▽ Dugento mta . . . à buonc.ᵗᵒ delli marmi dati e da darsi p Seruitio del Lauoro dell Angeli che se fanno p il Ponte S. Angelo . . . Li 26 Marzo 1669 . . .

. . . riceuto . . . 2 aprile 1669 . . .

81) 121

. . . al Sig.ʳᵉ Gio: Batista Marcone ▽ Cento-m.ᵗᵃ . . . à bon conto di un pezzo di marmo bianco statuale che detto fa fare per Seruitio del Ponte S. Angelo in conformità del modello del S.ʳᵉ Cau.ʳᵉ Bernini Architetto . . . Li 4 Luglio 1669 . . .

. . . riceuto . . . 11 lug.ᵒ 1669 . . .

82) 142

. . . al Sig.ʳᵉ Gio: Batta Marcone ▽ Cento Cinquanta-m.ᵗᵃ . . . a bon conto delli doi Marmi, che detto ha fatto uenire per fare Le copie di due Angeli per Seruitio del Ponte S. Angelo . . . Li 15 Dec.ʳᵉ 1669 . . .

. . . ric.ᵗᵒ . . . 18 Xbre 1669 . . .

83) 151

. . . à Mro Pietro Ostini ▽ Novantotto b 35 mta . . . p Compim.ᵗᵒ di 348·35 m.ᵗᵃ . . . di diuerse fatiche, e Spese fatte da Lui p Scaricat.ʳᵉ di Marmi Statuarij et altro dalli 30 Maggio 1669 à tutto Li 23 Giugno 1670 . . . Li 14 Luglio 1670 . . .

. . . receuto . . . 16 Luglio 1670 . . .

84) 152

. . . à Carlo Pieruisani ▽ Trentacinque-m.ᵗᵃ . . . per Saldo et intiero pagamento della Caricatura e portatura di due pezzi di Marmi Statuarij con Li Suoi Carri e Bufale da Ripa alle Case di due Scultori che fanno Le Copie delli due Angeli del S.ʳᵉ Cau.ʳᵉ Bernini . . . Li 14 Luglio 1670 . . .

. . . riceuto . . . 17 lug.ᵒ 1670 . . .

85) 156

... al S.^{re} Gio: Batista Marconi ... ▽ Doi Cento Settantotto e 18 1/2 m.^{ta} ... per compim.^{to} di ▽ 528: 18 1/2 m.^{ta} che tanto importa il prezzo di due pezzi di marmi bianchi statuali dati da Lui per fare due Copie d'Angeli per Seruitio del Ponte S. Angelo ... Li 2 Agosto 1670 ...

... riceuto ... 18 Ag.^{to} 1670 ...

86) 179

... à Mastro Gabrielle Renzi Scarpellino di Palazzo ▽ Trentadue, e b 74 m.^{ta} ... per prezzo di Due Pezzi di Marmi bianchi dati da Lui per fare Le ali alla Copia dell'Angelo che fa il Paulo Naldini per Seruitio del Ponte S. Angelo ... Li 11 Maggio 1671 ...

... ric.^{to} ... 15 Magg.^o 1671 ...

87) 186

... à Mastro Gabrielle Renzi Scarpellino di Palazzo ▽ Noue, e b 40-m.^{ta} ... per suo rinborso d'altretanti Spesi da Lui in due pezzi di marmaro Statuale per fare due Tasselli per Seruitio dell'Angeli che si fanno per L'adornamento del Ponte S. Angelo ... Li 10 Ott.^{re} 1671 ...

... riceuto ... 22 otobre 1671 ...

Payments to the sculptors:

Paolo Naldini (*Angel Carrying the Robe and Dice*)

88) 30

... à Pauolo Naldini Scultore ▽ Cinquanta-m.^{ta} ... à bon conto di un Angelo di marmo, che detto fa per Seruitio del Ponte S. Angelo ... Li 27 Luglio 1668 ...

... riceuto 30 Luglio 1668 ...

89) 46

... al Sig.^{re} Pauolo Naldini Scultore ▽ Cinquanta-m.^{ta} ... à bon conto dell'Angelo, che detto ua facendo per Seruitio del Ponte S. Angelo ... Li 6 Ottobre 1668 ...

... riceuto ... 13 di ottobre 1668 ...

90) 61

... à Pauolo Naldini Scultore ▽ Cinquanta-m.^{ta} ... à bon conto dell'Angelo che detto ua facendo per Seruitio del Ponte S. Angelo ... Li 3 Decembre 1668 ...

... riceuto ... questo di et anno sudetto ...

91) 76

... al Sig.^{re} Pauolo Naldini Scultore ▽ Cinquanta-m.^{ta} ... à bon conto dell'Angelo che detto ua facendo per Seruitio del Ponte S. Angelo ... Li 15 Gennaro 1669 ...

... riceuto ... 16 Genaro 1669 ...

92) 79

... al Sig.^{re} Pauolo Naldini Scultore ▽ Cinquanta-m.^{ta} ... à bon conto dell'Angelo di Marmo che detto ua facendo per Seruitio

del Ponte S. Angelo ... Li 29 Gennaro 1669 ...

... riceuto ... 31 Gen.^{ro} 1669 ...

93) 92

... al Sig.^{re} Pauolo Naldini Scultore ▽ Cinquanta-m.^{ta} ... à bon conto dell'Angelo che ua facendo per Seruitio dell'adornamento del Ponte S. Angelo ... Li 13 Marzo 1669 ...

... riceuto ... 16 marzo 1669 ...

94) 99

... al S.^{re} Pauolo Naldini Scultore ▽ Cinquanta-m.^{ta} ... à bon conto dell'Angelo, che ua facendo per Seruitio dell'adornamento del Ponte S. Angelo ... Li 15 Aprile 1669 ...

... ric.^{to} ... 16 Ap.^{le} 1669 ...

95) 114

... al Sig.^{re} Pauolo Naldini Scultore ▽ cinquanta m.^{ta} ... à bon conto dell'Angelo che ua facendo per Seruitio dell'Adornamento del Ponte S. Angelo ... Li P.^{mo} Giug.^o 1669 ...

... riciuto ... 3 Giugno 1669 ...

96) 123

... al Sig.^{re} Paolo Naldino Scultore ▽ Cinquanta m.^{ta} ... à buonc.^{to} dell'Angelo di Marmo che d.^o ua facendo p Seruitio dell'adornamento del Ponte S. Angelo ... Li 15 Luglio 1669 ...

... riceuto ... 18 Lug.^o 1669 ...

97) 131

... al Sig.^{re} Pauolo Naldini Scultore ▽ Cinquanta-m.^{ta} ... à bon conto dell'Angelo che detto ha fatto per Seruitio dell'Adornamento del Ponte S. Angelo ... Li 10 Sett.^{re} 1669 ...

... riceuto ... 14 7bre 1669 ...

98) 160

... al Sig.^{re} Pauolo Naldini Scultore ▽ Duicento m.^{ta} ... p Compin.^{to} di ▽ 700-m.^{ta} ... della Statua dell'Angelo che il med.^{mo} ha fatto p Seruitio del Ponte S. Angelo ... Li 20 Luglio 1670 ...

... riceuto 5 7bre 1670 ...

Cosimo Fancelli (*Angel Carrying the Sudarium*)

99) 35

... à Cosimo Fancelli Scultore ▽ Cinquanta-m.^{ta} ... à bon conto di un Angelo di marmo, che detto fa per Seruitio del Ponte S. Angelo ... Li 27 Luglio 1668 ...

... riceuto ... 11 di agosto 1668 ...

100) 47

... al S.^{re} Cosimo Fancelli Scultore ▽ Cinquanta-m.^{ta} ... à bon conto dell'Angelo, che detto ua facendo per Seruitio del Ponte S. Angelo ... Li 6 Ott.^{re} 1668 ...

... riceuto ... 13 di ottobre 1668 ...

101) 65

... al Sig.^re Cosimo Fancelli Scultore ▽ Cinquanta-m.^ta ... à bon conto dell'Angelo, che detto ua facendo per Seruitio del Ponte S. Angelo ... Li 10 Dec.^re 1669 ...

... riceuto ... 12 di Decembre 1668

102) 82

... à Cosimo Fancelli Scultore ▽ Cinquanta mta ... à buonc.^to dell'Angelo, che ua facendo p Seruitio dell'Adornamento del Ponte S. Angelo ... Li 11 Febraro 1669 ...

... riceuti ... tredici di febraro ...

103) 97

... al Sig.^re Cosimo Fancelli ▽ Cinquanta mta ... à buonc.^to dell'Angelo, che d.^o ua facendo p Seruitio del Ponte S. Angelo ... Li 5 Aprile 1669 ...

... riceuto ... oto aprile 1669 ...

104) 115

... al S.^re Cosimo Fancelli Scultore ▽ Cinquanta-m.^ta ... à bon conto dell'Angelo che ua facendo per Seruitio dell'Adornamento del Ponte S. Angelo ... Li 6 Giugno 1669 ...

... riceuti ... oto giuno 1669 ...

105) 127

... al S.^re Cosimo Fancelli Scultore ▽ Cinquanta-m.^ta ... à bon conto dell'Angelo che ua facendo per Seruitio dell'Adornamento del Ponte S. Angelo ... Li 28 Agosto 1669 ...

... riceuti ... 30 di agosto 1669 ...

106) 133

... al Sig.^re Cosimo Fancelli Scultore ▽ Cinquanta-m.^ta ... à bon conto dell'Angelo, che ua facendo per Seruitio dell'Adorna-mento del Ponte S. Angelo ... Li 16 Ott.^re 1669 ...

... riceuto ... 19 di otobre 1669 ...

107) 154

... al Sig.^re Cosimo Fancelli Scultore ▽ Trecento m.^ta ... p Compimento di ▽ 700-m.^ta ... della Statua dell'Angelo che il med.^o ha fatto p Seruitio del Ponte S. Angelo ... Li 20 Luglio 1670 ...

... riceuto ... 31 di luglio 1670 ...

Antonio Giorgetti (*Angel Carrying the Lance*)

108) 31

... ad Antonio Giorgetti Scultore ▽ Cinquanta-m.^ta ... à bon conto dell'Angelo, che detto fa per Seruitio del Ponte S. Angelo ... Li 3 Agosto 1668 ...

... riceuto ... 6 Agosto 1668 ...

109) 67

... al Sig.^re Antonio Giorgetti Scultore ▽ Cinquanta-m.^ta ... à bon conto dell'Angelo che de tto ua facendo per Serui liotde

Ponte S. Angelo ... Li 8 Ott.^re 1668 ...

... ricetuo ... 20 Xbre 1668 ...

110) 68

... al Sig.^re Antonio Giorgetti Scultore ▽ Cinquanta-m.^ta ... à bon conto dell'Angelo di Marmo, che detto ua facendo per Seruitio del Ponte S. Angelo ... Li 12 Decembre 1668 ...

... riceuto ... 20 Decembre 1668 ...

111) 89

... al S.^re Antonio Giorgetti Scultore ▽ Cinquanta mta ... à buonc.^to dell'Angelo che ua facendo p Seruitio dell'adornamento del Ponte S. Angelo ... Li 11 feb.^o 1669 ...

... riceuto ... 12 Marzo 1669 ...

112) 113

... al S.^re Antonio Giorgetti ▽ Cinquanta mta ... à buonc.^to dell'Angelo che detto ua facendo p Seruitio del Ponte S. Angelo ... Li 8 Aprile 1669 ...

... riceuto ... 3 Giugno 1669 ...

113) 118

... al Sig.^re Antonio Giorgetti Scultore ▽ Cinquanta-m.^ta ... à bon conto dell'Angelo, che detto ua facendo per Seruitio dell'-Adornamento del Ponte S. Angelo ... Li 6 Giugno 1669 ...

... riceuto ... 28 di Giugnio 1669 ...

114) 125

... al Sig.^re Antonio Giorgetti Scultore ▽ Cinquanta mta ... à buonconto dell'Angelo che ua facendo p Seruitio dell'Adorna-mento del Ponte Sant'Angelo ... Li 15 Luglio 1669 ...

... riceuto ... 27 Luglio 1669 ...

115) 128

... al S.^re Antonio Giorgetti Scultore ▽ Cinquanta m.^ta ... a buonc.^to dell'Angelo di Marmo, che detto ua facendo p Seruitio dell'adornam.^to del Ponte S. Angelo ... 30 Agosto 1669 ...

... riceuto ... 31 Agosto 1669 ...

116) 158

... all'Eredi del q. Ant.^o Giorgetti Scultore Trecento mta ... p Compin.^to di ▽ 700-m.^ta ... della Statua dell'Angelo che il med.^o fatto p Seruitio del Ponte S. Angelo ... Li 20 Luglio 1670 ...

... ric.^to ... 22 Agosto 1670—

Io Giomaria Giorgetti mano ppa

Fidem facis p pntes Ego Notus pub Intrus quale die nona mentis Augusti 1670 Pro D. Ione Maria Giorgetto q. Antonij serue Montis Rotundi Pre herede q. Antonij Iuniorii dum uiscit in Vrbe Scultore Marmorum contra quosunng (?) Esc.^it Rome in off.^o mei per mes ad perpetua sei memoria Ioannes de Sebastianij q. Nicole Romanus testis e tatis sul annum triginta circa ut dixit legens Rome, et habitans in uia que a Patea nun cupato S.^ri Alois nationis Gallicans tendis ad Platea nun cupato della Scrofa Incisor

lignamina Domi scupti D. Io: Maria Giorgetti cui delato Iuram:^{to} ueritatis dicendo p.^t tactis Iurauit ad Interrogatione mei dixit, et deposuit p.^t infra uidelicet. Io testimonii sò e dico p uerità d'hauer conosciuto il Sig.^{re} Antonio Giorgetti figliolo del soprad.^o Sig.^{re} Gio:Maria Giorgetti, che mentre uisse faceua in Roma il scultore de marmori che mori La notte di natale prossimo passato, ch'io lo uiddi morto, e so che d'^o Sig.^{re} Antonio era figliolo legmo, e nale di d.^o Sig.^{re} Gio Maria, perche mentre d.^o Sig.^{re} Antonio uiueua, per suo Pre Legmo, e Nale sempre tenne, chiamò reputo è tratto per Padre suo legmo e nale d.^o Sig.^{re} Gio Maria come so al incontro d.^o Sig.^{re} Gio: Maria tratto, tenne e reputò il d.^o Sig.^{re} Antonio, e mentre uisse conuersauanno intrinsicamente, et il medemo faceu, come al pnte anco fò con il d.^o Sig.^{re} Gio. Maria suo Pre che ambidue come ho detto di sopra con occone di conuersarli li uedeuo e Sentiuo trattarsi chiamarsi, e reputarsi per Pre, e respettiuamente figlio come ho detto sopra so anco d.^o Antonio ha hauto moglie e benche ha hauto moglie sò che non ha lasciato figlioli di sorte alcuno, e quanto ho deposto ne e anco pub.^{ca} uoce e fama appresso tutti che hanno cognosciuto d.^o Sig.^{re} Antonio e che cognoscono d.^o Sig.^{re} Gio: Maria suo Pre in causa sientre.

Item quali: eag Die Pio eag con easg. ex.^{ti} Rome in off.^o mei ubi supra p mes ad perpetua sei mem. D. Ioseph Lutius fil. D. Palmerini Rom. etatis sua Annum triginta duouum Pistor ut dixit di forno à Soccio degens, et habitans prope platea nuncupatan della Scrofa cui delato Iuram.^{to} ueritatis dicends p.^t tactis Iurauit dixit et deposuit p.^t infra uidelicet. Io Testimonio so è dico p uerità d'hauer cognosciuto il Sig.^{re} Antonio Giorgetti figliolo del Sig.^{re} Gio. Maria Giorgetti che faceua L'intagliatore, e scultore de Marmori in Roma, quale Sig.^{re} Mori la notte del giorno di Natale prossimo passato, ch'io uiddi morto e so che d.^o Sig.^{re} Antonio era figliolo legmo e Nale del d.^o Sig.^{re} Gio. Maria Giorgetti suo Pre e questo io lo so pche essendo stato io amico di d.^o Antonio come Anco di d.^o Sig.^{re} Gio Maria suo Pre da molti, e molti anni in qua si conuersauano intrinsicamente come sogliono fare gl'amici cari, e uedeuo, e sentiuo, che fra loro si chiamauano p Pre e respettiuamente figlio, e p tali Si trattassano teneuano pubblicamente e da ogn'altro, che erano conosciuti erano trattati, e reputati p tali so anco che d.^o q. Antonio hebbe moglie che p morte sua restò uedoua, e so che non ci ha hauto ne lasciato figli di sorte alcuna, se fosse il contrario io lo saprei, e questo e la uerità essendone anco pub.^{ca} uoce e fama a tutti che hanno cognosciuto, e conoscono li detti Sig.^{ri} Antonio, e Gio Maria in causa Scientis et alias latius p in actis meis ad qua in quos fidem datur hac die 12 Augusti 1670.

Ita est Dom.^{cus} Valentinus Car Capp. Not . . .

Nota del debito del Sig.^{re} Gio; Maria Giorgetti con Ant.^o Pelicani et Anna Sua figliola p la Restitutione della dote quarto dotale habito Vedouile et alimenti p Sei mesi

In primis in contanti Scudi Quattrocento............	▽ 400
E più in biancherie, et altri mobili	▽ 112·40
E più p il quarto dotale........................	▽ 250
E più p l'alimenti............................	▽ 23
E più p l'Abito Vedouile........................	▽ 19·90
	▽ 804·30

Adi x Genn.^{ro} 1670 fù pagato il Soprad.^o debito dal Sig.^{re} Gio: M.^a Giorgetti Pre et Erede del q.^m Ant.^o Giorgetti, e ne fù fatto Instro p l'atti del Pini Noto di Vicario al Sig.^{re} Ant.^o Pellicano con patto espresso di douerse ratificare il p.^o Instro dalla figlia, e farne quiet.^{aa} al p.^o Slg.^{re} Gio. M.^a dichiarando d'hauer hauuta L'intiera Sodisfattione, Cioe

d'hauer riceuuto in Contanti......................	▽ 500
E più in biancherie e ueste......................	▽ 112·40
E più in un uetro di perle......................	▽ 125
E più p l'Abito Vedouile......................	▽ 19·90
E più a Compim.^{to} di tutto il debito promise pagare in Conto Scudi quarantasette......................	▽ 47
	▽ 804·30

E adi/23 Genn.^{ro} 1670 fù ratificato il Sud.^o Instro con l'interuento del Giudice, e tanto Ant.^o Pellicani, quanto Anna Sua figlia, fecero la quiet.^{za} al Sig.^{re} Gio: M.^a Giorgetti di tutto quello poteua pretendere, e fu rogato p l'atti del med.^o Noto.

Girolamo Lucenti (*Angel Carrying the Nails*)
117) 34
. . . al Sig.^{re} Girolamo Lucenti Scultore ▽ Cinquanta-m.^{ta} . . . à bon conto dell'Angelo che detto ua facendo per Seruitio del Ponte S. Angelo . . . Li 7 Agosto 1668 . . .
. . . riceuto . . . 9 Agosto Anno Sud.^{to} . . .
118) 53
. . . al Sig.^{re} Girolamo Lucenti Scultore ▽ Cento-m.^{ta} . . . à bon conto dell'Angelo, che detto ua facendo per Seruitio del Ponte S. Angelo . . . Li 6 Ottobre 1668 . . .
. . . Riceuto . . . 17 ottobre 1668 . . .
119) 64
. . . al S.^{re} Girolamo Lucenti Scultore ▽ Cinquanta-m.^{ta} . . . à bon conto dell'Angelo, che detto ua facendo per Seruitio del Ponte S. Angelo . . . Li 5 Decembre 1668 . . .
. . . Riceuto . . . 12 Xbre 1668 . . .
120) 77
. . . al Sig,^{re} Girolamo Lucenti Scultore ▽ Cinquanta-m.^{ta} . . . à bon conto dell'Angelo, che ua facendo per Seruitio del Ponte S.

Angelo . . . Li 15 Gennaro 1669 . . .

. . . riceuto . . . 19 Gennaio 1669 . . .

121) 90

. . . al S.re Girolamo Lucenti Scultore ▽ Cinquanta-m.ta . . . à bon conto dell'Angelo, che ua facendo per Seruitio del Ponte S. Angelo . . . Li 8 Marzo 1669 . . .

. . . riceuti . . . 13 marzo 1669 . . .

122) 98

. . . al S.re Girolamo Lucenti Scultore ▽ Cinquanta m.ta . . . à buonconto dell'Angelo, che d.o ua facendo p Seruitio del Ponte S. Angelo . . . Li 6 Aprile 1669 . . .

. . . riceuto . . . 10 Aprile 1669 . . .

123) 106

. . . al Sig.re Girolamo Lucenti Scultore ▽ Cinquanta-m.ta . . . à bon conto dell'Angelo, che detto ua facendo per Seruitio del Ponte S. Angelo . . . Li 8 Maggio 1669 . . .

. . . riceuto . . . 11 Maggio 1669 . . .

124) 135

. . . al Sig.re Girolamo Lucenti Scultore ▽ Cinquanta-m.ta . . . à bon conto dell'Angelo che detto ha fatto per Seruitio del Ponte S. Angelo . . . Li 16 Nouembre 1669 . . .

. . . riceuto . . . 20 9bre Anno sud.to . . .

125) 163

. . . al S.re Girolamo Lucenti Scultore ▽ Duicentocinquanta mta . . . p compimento di ▽ 700-mta . . . della Statua dell'Angelo che il med.mo ha fatto p Seruitio del Ponte S. Angelo . . . Li 20 Luglio 1670 . . .

. . . riceuto . . . 16 7bre 1670 . . .

Domenico Guidi (*Angel Carrying the Lance*)

126) 42

. . . à Dom:co Guidi Scultore ▽ Cinquanta-m.ta . . . à bon conto dell'Angelo che ua facendo per Seruitio del Ponte S. Angelo . . . Li 13 Agosto 1668 . . .

. . . riceuto . . . 11 7bre 1668 . . .

127) 54

. . . al S.re Dom.co Guidi Scultore ▽ Cinquanta-m.ta . . . à bon conto dell'Angelo che detto ua facendo per Seruitio del Ponte S. Angelo . . . Li 6 Ottobre 1668 . . .

. . . ric.to . . . 18 8bre 1668 . . .

128) 63

. . . al S.re Dom:co Guidi Scultore ▽ Cento-m.ta . . . à bon conto dell'Angelo che detto ua facendo per Seruitio del Ponte S. Angelo . . . Li 4 Decembre 1668 . . .

. . . ric.to . . . 12 Decembre 1668 . . .

129) 73

. . . al Domenico Guidi Scultore ▽ Cento mta . . . à buonconto dell'Angelo che detto ua facendo p Seruitio del Ponte S. Angelo . . . Li 3 Genn.ro 1669 . . .

. . . riceuto . . . 8 Genn.o 1669 . . .

130) 83

. . . al S.re Dom:co Guidi Scultore ▽ Cinquanta-m.ta . . . à bon conto dell'Angelo che detto ua facendo per Seruitio dell'Adornamento del Ponte S. Angelo . . . Li 5 febraio 1669 . . .

. . . ric.to . . . di (sic.) febraro 1669 . . .

131) 93

. . . al S.re Domenico Guidi Scultore ▽ Cinquanta-m.ta a bon conto dell'Angelo, che ua facendo per Seruitio dell'Adornamento del Ponte S. Angelo . . . Li 13 Marzo 1669 . . .

. . . ric.to . . . 21 Marzo 1669 . . .

132) 101

. . . al Sig.re Domenico Guidi ▽ Cinquanta mta . . . à buonconto dell'Angelo che d.o ua facendo p Seruitio del Ponte S. Angelo . . . Li 9 Aprile 1669 . . .

. . . ric.to . . . 16 Aprile 1669 . . .

133) 107

. . . al S.re Dom.co Guidi Scultore ▽ Cinquanta-m.ta . . . à bon conto dell'Angelo che detto ua facendo per Seruitio del Ponte S. Angelo . . . Li 8 Maggio 1669 . . .

. . . ric.to . . . 11 Maggio 1669 . . .

134) 116

. . . al Sig.re Dom.co Guidi Scultore ▽ Cinquanta m.ta . . . à buonc.to dell'Angelo che ua facendo p Seruitio dell'adornam.to del Ponte S. Angelo . . . Li 7 Giugno 1669 . . .

. . . ric.to . . . 14 Giugno 1669 . . .

135) 164

. . . al S.re Domenico Guidi Scultore ▽ Centocinquanta mta . . . p Compim.to di ▽ 700-mta . . . della Statua dell'Angelo che il med.o ha fatto p Seruitio del Ponte S. Angelo . . . Li 20 Luglio 1670 . . .

. . . riceuuto . . . 20 Sett.re 1670 . . .

Ercole Ferrata (*Angel Carrying the Cross*)

136) 44

. . . ad'Ercole Ferrata Scultore ▽ Cinquanta-m.ta . . . à bon conto dell'Angelo che detto fa per il Ponte S. Angelo . . . Li 31 Luglio 1668 . . .

. . . riceuto . . . 17 Ago.to 1668 . . .

137) 48

. . . al Sig.re Ercole Ferrata Scultore ▽ Cento-m.ta . . . à bon conto dell'Angelo, che detto ua per Seruitio del Ponte S. Angelo . . . Li 8 Ottobre 1668 . . .

... ricuto ... 16 ott.ᵉ 1668 ...

138) 62

... ad Ercole Ferrata Scultore ▽ Cinquanta-m.ᵗᵃ ... à bon conto dell'Angelo, che detto fa per Seruitio del Ponte S. Angelo ... Li 3 Decembre 1668 ...

... riceuto ... 10 Dicembre 1668 ...

139) 72

... ad Ercole Ferrata Scultore ▽ Cento mta ... à buonc.ᵗᵒ dell'-Angelo, che detto fa p Seruitio del Ponte S. Angelo ... Li 2 Genn.ʳᵒ 1669 ...

... ricuto ... 7 Genaro ...

140) 81

... al Sig.ʳᵉ Ercole Ferrata Scultore ▽ Cinquanta-m.ᵗᵃ ... à bon conto dell'Angelo, che detto ua facendo per Seruitio del Ponte S. Angelo ... Li 6 Febraro 1669 ...

... ricuto 12 febraro 1669 ...

141) 91

... al Sig.ʳᵉ Ercole Ferrata Scultore ▽ Cinquanta mta ... a buonconto dell'Angelo che detto ua facendo p seruitio del Ponte S. Angelo ... Li 7 Marzo 1669 ...

... ricuto ... 14 Marzo ...

142) 103

... al Sig:ʳᵉ Ercole Ferrata Scultore ▽ Cinquanta-m.ᵗᵃ ... à bon conto dell'Angelo che ua facendo per Seruitio dell'Adornamento del Ponte S. Angelo ... Li 9 di Aprile 1669 ...

... riceuto ... 24 Aprile 1669 ...

143) 108

... al S.ʳᵉ Ercole Ferrata Scultore ▽ Cinquanta-m.ᵗᵃ ... à bon conto dell'Angelo di Marmo che detto ua facendo per Seruitio del Ponte S. Angelo ... Li 8 Maggio 1669 ...

... ricuto ... 11 maggo 1669 ...

144) 117

... al. S.ʳᵉ Ercole Ferrata Scultore ▽ Cinquanta m.ᵗᵃ ... à buonconto dell'Angelo che ua facendo p Seruitio dell'adornam.ᵗᵒ del Ponte S. Angelo ... Li 7 Giug. 1669 ...

... ricuto ... 13 Giugnio 1669 ...

145) 167

... al S.ʳᵉ Ercole Ferrata Scultore ▽ Centocinquanta mta ... per Compimento di ▽ 700-mta ... della Statua dell'Angelo che il med.ᵐᵒ ha fatto p Seruitio del Ponte S. Angelo ... Li 20 Luglio 1670 ...

... riceuto ... primo ottobre 1670 ...

Antonio Raggi (*Angel Carrying the Column*)

146) 58

... al S.ʳᵉ Antonio Raggi Scultore ▽ Cinquanta-m.ᵗᵃ ... à bon

conto dell'Angelo, che detto ua facendo per Seruitio del Ponte S. Angelo ... Li 15 Nouembre 1668 ...

... riceuto ... 17 nouembre 1668 ...

147) 75

... ad'Antonio Raggi Scultore ▽ Cinquanta-m.ᵗᵃ ... à bon conto dell'Angelo di Marmo, che detto fa e ua facendo per Seruitio del Ponte S. Angelo ... Li 11 Gennaro 1669 ...

... riceuto ... 14 genaro 1669 ...

149) 85

... al Sig.ʳᵉ Antonio Raggi Scultore ▽ Cento-m.ᵗᵃ ... à bon conto dell'Angelo di Marmo che ua facendo per Seruitio del Ponte S. Angelo ... li 18 Febraro 1669 ...

... riceuto ... 27 febraro 1669 ...

149) 105

... al S.ʳᵉ Antonio Raggi Scultore ▽ Cento mta ... à buonc.ᵗᵒ dell'Angelo che ua facendo p Seruitio dell'Adornamento del Ponte S. Angelo ... Li 2 Mag. 1669 ...

... riceuto ... 8 aprile (sic.) 1669 ...

150) 122

... al Sig.ʳᵉ Antonio Raggi Scultore ▽ Cento mta ... à buonc-onto dell'Angelo di Marmo che detto ua facendo p Seruitio dell'adornam.ᵗᵒ del Ponte S. Angelo ... Li 6 Luglio 1669 ...

... receuto ... 6 luglio 1669 ...

151) 134

... al Sig.ʳᵉ Antonio Raggi Scultore ▽ Cento-m.ᵗᵃ ... à bon conto dell'Angelo che ua facendo per Seruitio dell'Adornamento del Ponte S. Angelo ... Li 16 Ottobre 1669 ...

... riceuto ... 21 ottobre 1669 ...

158) 155

... al S.ʳᵉ Antonio Raggi Scultore ▽ Duicento mta ... p Compi-mento di ▽ 700-mta ... della Statua dell'Angelo che il med.ᵐᵒ ha fatto p Seruitio del Ponte S. Angelo ... Li 20 Luglio 1670 ...

... riceuto ... 9 Agosto 1670 ...

Lazzaro Morelli (*Angel Carrying the Scourge*)

153) 74

... al S.ʳᵉ Lazzaro Morelli Scultore Scudi Cinquanta m.ᵗᵃ ... à buon conto dell'Angelo, che detto ua facendo p seruitio del Ponte S. Angelo ... Li 4 Genn.º 1669 ...

... reciuto ... 12 del presente 1669 ...

154) 86

... al Sig.ʳᵉ Lazzaro Morello Scultore ▽ Cinquanta-m.ᵗᵃ ... à bon conto dell'Angelo di Marmo che detto ua facendo per Seruitio del Ponte S. Angelo ... Li 21 Febraro 1669 ...

... reciuto ... 2 marzo 1669 ...

155) 100

... al S.^{re} Lazzaro Morello Scultore ▽ Cinquanta-m.^{ta} ... à bon conto dell'Angelo che ua facendo per Seruitio dell'Adornamento del Ponte S. Angelo ... Li 15 Aprile 1669 ...

... reciuto ... 16 Aprile 1669 ...

156) 109

... al Sig.^{re} Lazzaro Morello Scultore ▽ Cinquanta-m.^{ta} ... à bon conto dell'Angelo di Marmo che detto ua facendo per Seruitio dell'Adornamento del Ponte S. Angelo ... Li 16 Maggio 1669 ...

... reciuto ... 17 maggio 1669 ...

157) 120

... al s. Lazzaro Morello Scultore ▽ Cinquanta m.^{ta} ... a buonc.^{to} dell'Angelo di Marmo che d.^o ua facendo p Seruitio dell'Adormento del Ponte S. Angelo ... Li P.^o Luglio 1669 ...

... reciuto ... 5 luglio 1669 ...

158) 124

... al Sig.^{re} Lazzaro Morello Scultore ▽ Cinquanta mta ... à buonc.^{to} dell'Angelo di Marmo, che detto ua facendo p Seruitio dell'adornam.^{to} del Ponte S. Angelo ... Li 24 Luglio 1669 ...

... reciuto ... 24 di luglio 1669 ...

159) 129

... al Sig.^{re} Lazzaro Morello Scultore ▽ Cinquanta m.^{ta} ... à bon conto dell'Angelo di Marmo, che detto ua facendo per seruitio dell'Adornamento del Ponte S. Angelo ... Li 30 Agosto 1669 ...

... reciuto ... 3 setembre 1669 ...

160) 157

... al Sig.^{re} Lazzaro Morelli Scultore ▽ Trecentocinquanta mta ... p Compimento di ▽ 700-mta ... della Statua dell'Angelo che il med.^{mo} ha fatto p Seruitio del Ponte S. Angelo ... Li 20 Luglio 1670 ...

... reciuto ... 19 Agosto 1670 ...

Gian Lorenzo Bernini (*Angel Carrying the Superscription*)
161) 161

... al S.^{re} Cau.^e Lorenzo Bernini ▽ Settecento mta ... della Statua dell'Angelo che il med.^o ha fatto p Seruitio del Ponte S. Angelo ... Li 17 Agosto 1670 ...

... ric.^{to} ... 11 7bre 1670 ...

Paolo Bernini (*Angel Carrying the Crown of Thorns*)
162) 162

... al S.^{re} Paolo Bernini ▽ Settecento mta ... della Statua dell'Angelo che il medemo ha fatto p seruitio del Ponte S. Angelo ... Li 17 Agosto 1670 ...

... ric.^{to} ... 11 7bre 1670 ...

Paolo Naldini (copy of the *Angel Carrying the Crown of Thorns*)
163) 150

... à Pauolo Naldini ▽ Cinquanta-m.^{ta} ... à bon conto della Copia, dell'Angelo già fatto da Lui che tiene La Corona di Spine ... Li 10 Luglio 1670 ...

... ric.^{to} ... 12 luglio 1670 ...

164) 166

... à Pauolo Naldini Scultore ▽ Cinquanta-m.^{ta} ... à bon conto della Copia, che ua facendo dell'Angelo per Seruitio del Ponte S. Angelo ... Li 16 Sett.^{re} 1670 ...

... ric.^{to} ... 23 Sett.^{re} 1670 ...

165) 170

... al S.^{re} Pauolo Naldini Scultore ▽ Cinquanta-m.^{ta} ... à bon conto della Copia dell'Angelo che detto ua facendo per Seruitio del Ponte S. Angelo ... Li 8 Nouembre 1670 ...

... riceuto ... 15 9bre 1670 ...

166) 171

... Sig.^{re} Paolo Naldini Scultore ▽ Cinquanta mta ... à buonconto della Copia dell'Angelo che detto fa p Seruitio del Ponte S. Angelo ... Li 10 Dic.^{re} 1670 ...

... ric.^{to} ... 16 xmbre 1670 ...

167) 175

... al S.^{re} Pauolo Naldini Scultore ▽ Cinquanta-m.^{ta} ... à bon conto della Copia dell'Angelo che detto ua facendo per Seruitio del Ponte S. Angelo ... Li 16 Marzo 1671 ...

... ric.^{to} ... 18 Marzo 1671 ...

168) 177

... al Sig.^{re} Paolo Naldi (sic.) Scultore ▽ Cinquanta m.^{ta} ... à buonconto della Copia dell'Angelo che ua facendo p Seruitio del Ponte S. Angelo ... Li 8 Maggio 1671 ...

... riceuto ... 9 Maggio 1671 ...

169) 180

... al S.^{re} Paolo Naldini Scultore ▽ Cinquanta mta ... à buonc.^{to} della Copia dell'Angelo che ua facendo p Seruitio del Ponte S. Angelo ... Li 26 Giug.^o 1671 ...

... ric.^{to} ... P.^o Luglio 1671 ...

170) 182

... al Sig.^{re} Paolo Naldini Scultore ▽ Cinquanta m.^{ta} ... à buonc.^{to} della Copia dell'Angelo, che ua facendo p Seruitio del Ponte S. Angelo ... Li 6 Agosto 1671 ...

... riceuto ... 11 d.^o ...

171) 184

... al S.^{re} Pauolo Naldini Scultore ▽ Cinquanta-m.^{ta} ... à bon conto della Copia dell'Angelo che ua facendo per Seruitio del Ponte S. Angelo ... Li 15 Sett.^{re} 1671 ...

... ric.^{to} ... 19 7bre 1671 ...

172) 188

... à Pauolo Naldini Scultore ▽ DoiCentoCinquanta-m.^{ta} ...
per Compin.^{to} di ▽ 700-m.^{ta} ... della Copia dell'Angelo che il
medemo ha fatto per Seruitio del Ponte S. Angelo ... Li 12 Nou.^{re}
1671 ...

... ricuto ... 18 9bre 1671 ...

Giulio Cartari (copy of the *Angel Carrying the Superscription*)

173) 153

... à Giulio Cartari Scultore ▽ Cinquanta-m.^{ta} ... à bon conto
della Copia dell'Angelo qual tiene il titolo che detto ua facendo
per Seruitio dell'adornamento del Ponte S. Angelo ... Li 23
Luglio 1670 ...

... reciuto ... 30 Luglio 1670 ...

174) 165

... à Giulio Cartari Scultore ▽ Cinquanta-m.^{ta} ... à bon conto
dell'Angelo che ua facendo per Seruitio del Ponte S. Angelo ...
Li 16 Sett.^{re} 1670 ...

... riceuto ... 23 7ebre 1670 ...

175) 169

... al S.^{re} Giulio Cartari Scultore ▽ Cinquanta-m.^{ta} ... à bon
conto della Copia dell'Angelo che ua facendo per Seruitio del
Ponte S. Angelo ... Li 10 Nouembre 1670 ...

... riceuto ... 15 9eb.^{re} 1670 ...

176) 172

... al S.^{re} Giulio Cartari Scultore ▽ Cinquanta mta. ... à buon-
conto della Copia dell'Angelo, che ua facendo p Seruitio del Ponte
S. Angelo ... Li 9 Decem.^{re} 1670 ...

... riceuto ... 18 Decem.^e 1670 ...

177) 174

... à Giulio Cartari Scultore ▽ Cinquanta-m.^{ta} ... à bon conto
della Copia dell'Angelo, che ua facendo per Seruitio del Ponte S.
Angelo ... Li 4 Febraro 1671 ...

... Riceuto ... 16 Feb. 1671 ...

178) 178

... al S.^{re} Giulio Cartari Scultore ▽ Cinquanta mta ... à
buonc.^{to} della Copia dell'Angelo che ua facendo p Seruitio del
Ponte S. Angelo ... Li 8 Mag.^o 1671 ...

... riceuto ... 13 Magg.^o 1671 ...

179) 181

... al Sig.^{re} Giulio Cartari Scultore ▽ Cinquanta mta ... à
buonc.^{to} della Copia dell'Angelo che ua facendo p Seruitio del
Ponte S. Angelo ... Li 26 Giug.^o 1671 ...

... riceuto ... primo luli 1671 ...

180) 183

... al S.^{re} Giulio Cartari Scultore ▽ Cinquanta mta ... à

buonconto della Copia dell'Angelo che ua facendo p Seruitio del
Ponte S. Angelo ... Li 6 Agosto 1671 ...

... riceuto ... 13 Agos.^o 1671 ...

181) 185

... al S.^{re} Giulio Cartari Scultore ▽ Cinquanta-m.^{ta} ... à bon
conto della Copia dell'Angelo che ua facendo per Seruitio del
Ponte S. Angelo ... li 15 Sett.^{re} 1671 ...

... Riceuto ... 23 Sett.^{re} 1671 ...

182) 187

... al S.^{re} Giulio Cartari Scultore ▽ DoiCentoCinquanta-m.^{ta}
... per Compimento di ▽ 700-m.^{ta} ... della Copia dell'Angelo
che il medemo ha fatto per Seruitio del Ponte S. Angelo ... Li 12
Nou.^{re} 1671 ...

... Receuto ... 13 9uem.^e 1671 ...

Payments for putting the statues in place on the bridge:

183) 132

... à Mastro Pietro da Lugano ▽ Cento-m.^{ta} ... à bon conto
del Lauoro che detto fa in calare abasso Li Angeli di Marmo di
doue sono stati Lauorati nelle Case de Scultori, et alzarli Sopra i
Piedestalli nel Ponte S. Angelo il tutto a Sue Spese ... Li 16
Sett.^{re} 1669 ...

... receuto ... 19 7^{bre} 1669 ...

184) 136

... à Mastro Pietro da Lugano ▽ Cento-m^{ta} ... à bon conto delli
Lauori, che ua facendo in calare portare, et alzare Li Angeli per
Seruitio del Ponte S. Angelo ... Li 18 Nouembre 1669 ...

... receuto ... 23 9bre 1669 ...

185) 147

... à Mastro Pietro de Lugano Muratore ▽ Cinquanta-m.^{ta} ...
à bon conto della Calatura, portatura, et alzatura, che fa per
mettere in opera Li Angeli del Ponte S. Angelo ... Li 14 Maggio
1670 ...

... receuto ... 19 maggio 1670 ...

186) 189

... à Mastro Carlo Pagniotta Muratore ▽ Cinquantadue, e b 55
m.^{ta} ... per Saldo, et intiero pagamento della Calatura, Con-
duttura, e mettitura in opera delle due Statue degl'Angeli poste
Sopra il Ponte S. Angelo il tutto à Sue Spese dalli 12 Ott.^{re} 1671
a tutto Li 7 Nou.^{re} di d.^o anno ... Li 14 Nouembre 1671 ...

... riceuto ... 14 9bre 1671 ...

Payments to the Fabrica di S. Pietro:

187) 149

... alla Reu:^{da} Fabrica di S. Pietro, e per essa al Sig.^{re} Vicenzo
Baccelli Suo Depositario ▽ DoiCentosessantasette, e b 59 m.^{ta} ...
per il Logro di Canapi, Traglie, Argani, et altri Stigli come anco

per prezzo di Legnami, e chiodi posti, e Seruiti per fare Scolpire, e Lauorare in Casa de Scultori gl'Angeli posti nelle Sponde del Ponte S. Angelo, e doppo finiti di Scolpire calarli e tirarli per terra Sino à d.º Ponte et iui alzarli Sopra i loro Piedestalli . . . compressi in d.ª Somma ▽ 9:59 m.ta per La Scaricatura dell'altri tre pezzi rimasti à Ripa . . . Li 2 Luglio 1670 . . .
. . . ric.to . . . 2 Lugli 1670 . . .

188) 190
. . . alla Reu:da Fabrica di S. Pietro . . . ▽ Ventisette, e b 80 1/2 m.ta . . . per il Logro di Canapi Zaganelle Curli Piane, et altri Stigli Seruiti per mettere Le due ultime Statue Sopra il Ponte S. Angelo . . . Li 22 Nouembre 1671 . . .
. . . ric.to . . . 26 febb.º 1672 . . .
Attached to this authorization for payment is a notarial document demanding payment to the Fabrica di S. Pietro.

Payment for putting inscriptions on the bridge:
189) 191
. . . à Mastro Gabrielle Renzi Scarpellino di Palazzo ▽ Ottantuno, e b 97-m.ta . . . per Saldo d'un Conto in hauer fatto Le Lettere intagliate nel Marmo delli Piedestalli Sotto Le Statue degl'Angeli Sopra il Ponte S. Angelo, e fatte Le Armi della fe: me: di Papa Clemente Nono, et altro . . . Li 7 Aprile 1672 . . .
. . . riceuto . . . 8 Aprile 1672 . . .

Payments for real estate:
190) 144
. . . à Mons.re Antonio Altoviti tanto in nome proprio quanto come Cessionerio del S.re Cau.re Gra Filippo Altouiti suo Fratello come costa p Instrum.to Rogato p gl'atti del Consolato de fiorentini di Roma sotto Li 3 Giug.º 1661, e del S.re Gio. Fran.co Altoviti altro Suo Fratello come p Instrum.to Rogato nelli detti Atti Sotto Li 31 Ott.re 1659 Scudi MilleCentonouantuno e b 47 m.ta . . . p Saldo, e intiero pro delle Case ad uso di Rimene con Me Vomini Sopra già possedute da V.ra Ill:mi à Nome come Sop.ª poste Sopra La Ripa del Teuere nella Piazzetta di d.º Ponte S. Angelo confinante da una parte con Palazzo dell'istesso Mons.re Altoviti, dall'altra con La Casa del S.re Gio. Maria Antonetti e delli RR. PP. di S. Simone di Spoleto, dauanti La Piazza e dietro il fiume Teuere, Stimate in detta Somma dal S.re Cau.e Gio Lorenzo Bernini, Pauolo Picchetto, Carlo Fontana Misurat.ri Cam.li, quali Case p ordine del S.re Sono State demolite p ornare il Ponte S. Angelo e Li Sud.i ▽ Mille Centonouantuno b 47 m.ta gli doura d.º Mons.re Altouiti Lasciarli in cotesta Banca ad' effetto d'inuestirli con Sui in La del Magg.ne prò tempore del Sacro Palazzo Apost.co in altri beni Stabili o uero in Luoghi de Monti

Cam.li non uacati Li qui in Roma Li quali Li quali (sic.) Beni o Luoghi de Monti Siano Sempre primarie, e pricipalm.ti obligati, et hopotecati p Liberazione da tutte Le Molestie che La R.ª Cam.ª Apost.ca potesse in alcun tempo Riceuere in qualsiuoglia modo p causa delle dette Case demolite e Secondarie che s'intendono Serregati, e Stiano Sempre in Luogo delle dette Case con esser Sotto posti a tutti Li Vincoli pesi Ipoteche, Primogeniture, ò Fidecomissi alli quali Stassero Logette Le Medeme Case, et in Specie all' assorto Fidei-Comisso del q V.º Altouitto Suo Stuo Paterno e questo pato, e Vincolo Si debba apponere nell'Istrom.to della Compra de beni, nelle Patenti de Luoghi de Monti, et in Caso di diestrazione di questi d'alternat.ne de Beni il pro Si debba parimente Reinuestire in altri simili Luoghi de Monti, o in compra altri Stabili tutti, e sicuri col Medemo Vincolo qui in Roma con sei entra parim.te del Magg.mo pro tempore eciò tante uolte, quante uerra il Caso dell'estrazione de Luoghi de Monti, e uindita de beni Sud.i e Volendo il Sud.º Mons.re Altouiti inuestire il d.º denaro anco in Censi buoni, e Sicuri qui in Roma possa farlo con Le medesemi conditioni di Sopra espresse. Che pigliandone Receuuta con darne debito in Censo dell'Assegnamento p detto Ponte gli Saranno acettati e fatti buoni a Loro Conti Dalle Stanze in S. Pietro q.to 3 Decem.re 1669 . . .
. . . 14 Gen.º 1670 Ant. Altouiti m.oppa
Posti in Cred.º come Sopra qu.to di 16 Genn.º 1670
Piero, Filippo, e Giuseppe Nerli
(Attached is a document of 16 January 1670 by which the money is transferred.)

191) 145
. . . al S.re Gio: Maria Antonetti ▽ DioCentottanta, e b 36 1/2m.ta . . . per prezzo della metà d'un Casette demolita per La Nuoua fabrica del Ponte S. Angelo posta Sopra La Ripa del Teuere nella Piazzetta di d.º Ponte e confinata da una parte con Li beni del S. Marchese Oratio Spada, e dall'altra da SS:ri Altouiti auanti La d.ª piazzetta e per di dietro il fiume Teuere à d.º S.re Antonetti Spetante in uigore dell'Instro di Compra fatta dalla R.da fabrica di S. Pietro rogato dal Notaro di d.ª fabrica Sotto il p.mo Luglio 1662 che L'altri ▽ 280:36 1/2 m.ta per L'altra meta del prezzo di d.ª Casa Si riseruano alli Padri di S. Fran.co del Conuento di S. Simone di Spoleto alli quali Si dice Spettare L'altra metà della med.ª Casa come heredi instituti pro mediate con la d.ª Reu:da fabrica di S. Pietro dal q.m Achille de Santi per testam.to, rogato in d.º Luogo sotto Li 16 Maggio 1653 e prodotto nella Segretaria del Monte Fede Sotto Li 17 ott:re del med.º Anno 1653 come il tutto appare dalla Misura e Stima Sottoscritta dal S.re Cau:re Gio Lorenzo Bernini, e dalli Misuratore Pauolo Picchetti, e Carlo Fontana . . . Li 12 Febraro 1670

Gio: Maria Antonetti m.º ppa . . .

192) 146

. . . al S.ʳᵉ Marchese Oratio Spada ▽ DoiCentoNouantuno, e b 53 1/2 m.ᵗᵃ per prezzo d'una Casetta bassa che esso possedeua nella Piazzetta di Ponte S. Angelo confinata da una parte con L'altra Casetta, che era del S. Gio Maria Antonetti, e dalli PP. di S. Simone di Spoleto dall' altra parte col Ponte S. Angelo auanti La d.ᵃ Piazzetta e dietro il fiume Teuere à d.º S.ʳᵉ Marchese Oratio Spada Spettante come herede dalla bo: me: di Mons.ʳᵉ Virgilio Spada erede della fe: me: dell' Em:ᵐᵒ S.ʳᵉ Card.ˡᵉ Bernardino Spada in uigore della Compra che ne fece il S.ʳᵉ Gio: Carlo Vespignano dal S.ʳᵉ Comendat.ʳᵉ Alesandro Orlandini per instro rogato per L'atti del Rignani Notaro Cap.ⁿᵒ sotto Li 3 ott:ʳᵉ 1653 e d.º Gio: Carlo dichiarò poi nelli med:ᵐⁱ atti che d.ᵃ Casa Spettaua al d.º Card.ˡᵉ Spada come il tutto appare dalla Misura, e stima Sottoscritta dal S.ʳᵉ Cau.ʳᵉ Gio Lorenzo Bernini, e dalli Misurat.ʳᵉ Pauolo Picchetti, e Carlo Fontana . . . Li 21 Febraro 1670 . . .

(According to an attached document signed "Horatio Spada," the money was transferred "Li 31 Marzo 1670.")

193) 159

. . . al Monastero e Monache dell'Immaculata Concettione di Campo Marzo, e per esse al S.ʳᵉ Fran:ᶜᵒ Stefanelli Loro Procurat.ʳᵉ constituito capitolarm:ᵗᵉ à questo effetto Sotto Li 7 Giugno pass:ᵗᵒ per L'atto del Gerardini Notaro dell'Emin.ᵐᵒ Card.ˡᵉ Vicario ▽ CinqueCentotrentasette, e b 79 m.ᵗᵃ, quali Se Li fanno pagare per il prezzo cosi Stimato dalli SS.ʳⁱ Cau.ʳᵉ Gio Lorenzo Bernini, Pauolo Picchetti e Carlo Fontana Architetti, e Periti Cam:ˡⁱ d'una Casa posta nella piazza di Ponte S. Angelo uicino Li beni da una parte dell'Ospedale di S. Spirito dall'altra del S.ʳᵉ Perone, dietro il fiume Teuere, e d'avanti La piazza, demolita d'ord.ᵉ della S.ᵗᵃ me: di Papa Clem.ᵉ 9º per farui La confortaria de Condannati in occasione della restauratione, et abbellimento di d.º Ponte, et incorporata alla Cam.ᵃ Aplica con Suo Special Chirografo, qual Casa Spettaua al S.ʳᵉ Pietro Pauolo Orsini, e ultimamente Si possedeua da d.ᵉ Reu:ᵈᵉ Monache ad effetto di Sodisfarsi delli termini decorsi e da decorrere di un Legato di annui tredici-m.ᵗᵃ come costa negl'atti del Gerardini notaro dell' Em.ᵐᵒ S.ʳᵉ Card.ˡᵉ Vicario Sotto Li 28 Maggio 1643 . . . Li 2 Luglio 1670 . . . Li 7 Agosto 1670 . . . Io fran.ᶜᵒ Stefanelli mppº

194) 168

. . . al V.ˡᵉ archiosped.ˡᵉ di S. Spirito in Sassia, e p esse all'Ill.ᵐᵒ Mons.ʳᵉ Febei Commend.ʳᵉ ▽ duemilaSeisantatre, e b 03 m.ᵗᵃ . . . p il prezzo cosi stimato dalli S.ʳⁱ Cau.ᵉ Gio: Lorenzo Bernini, Paolo Picchetto, e Carlo Fontana architetti e Periti Cam.ᵉ delle casette tanto di muro quanto di legno, che d.º Archiosped.ˡᵉ p

ossedeua contigue a d.º Ponte, e reste nella Piazza di esso, che d'esd.ᵉ(?) S. me: di Papa Clemente 9º sono state demolite p ornam.ᵗᵒ di d.º Ponte et incorporate alla Reu. Cam.ᵃ Ap.ᶜᵃ con suo special chirografo, che con riceuuto Saranno ben pagati ad effetto pero deuano restar deposti . . . Li 20 Agosto 1670 . . .

. . . ric.ᵗᵒ . . . 22 oto.ʳᵉ 1670 . . .

195) 173

. . . alli Reu.ᵈⁱ PP. di S. Fran:ᶜᵒ del Conuento di S. Simone di Spoleto, o à Loro Legitmo Prore ▽ DoiCentottanta, e b 36 1/2 m.ᵗᵃ . . . per prezzo della meta d'una Casette demolite per La nuoua fabrica del Ponte S. Angelo posta Sopra La Ripa del Teuere nella Piazzetta di d.º Ponte, e confinata da una parte con Li beni del S.ʳᵉ Marchese Oratio Spada, e dall'altra de SS:ʳⁱ Altouiti, auanti La d.ᵃ Piazza, e per di dietro il Fiume Teuere à detti Padri Spettante come heredi instituiti pro medietate con La d.ᵃ Reu.ᵈᵃ Fabrica di S. Pietro dal q.ᵐ Achille de Santi per testam.ᵗᵒ rogato in d.º Luogo Sotto Li 16 Maggio 1653, e prodotto nella Segretaria del Monte Fede Sotto Li 17 ott:ʳᵉ del med.º Anno 1653, come il tutto appare dalla Misura, e Stima Sottoscritta dal S.ʳᵉ Cau.ʳᵉ Gio: Lorenzo Bernini e dalli Misurat:ʳⁱ Paolo Picchetti e Carlo Fontana esist.ᵉ in Computisteria, e Li Sud.ᵗⁱ ▽ 280:36 1/2-m.ᵗᵃ . . . Li 21 Febraro 1670 . . .

. . . riceuto . . . 12 Febraro 1671 . . .

196) 176

. . . alli SS.ʳⁱ Arcipreti e Can:ᶜⁱ della Chiesa Collegiata di SS.ᵗⁱ Celso, e Giuliano in Banchi ▽ Mille Ventinoue-m.ᵗᵃ . . . per il prezzo cosi stimato da SS.ʳⁱ Cau.ʳᵉ Gio: Lorenzo Bernini, Carlo Fontana, e Mattia de Rossi Architetti, e periti Cam:ˡᵉ del Sito, e Casette di Legno poste nella Piazza de Ponte S. Angelo Spettanti à d.ᵃ Chiesa, e demolite di ordine della S.ᵃ me: di Papa Clem.ᵉ 9.º per allagare e ingrandire La detta Piazza, et incoporate alla Cam. Aplica con Suo Speciale Chirografo che con riceuto Saranno ben pagati . . . Li 3 Aprile 1671 . . .

. . . rec.ᵗᵒ . . . 16 Mag.º 1671 . . .

3. *Avvisi* from the Diary of Carlo Cartari

The *Avvisi* are from the diary of Carlo Cartari (ASR, *Cartari-Febei*, 73-104), which covers the years 1642–91. Notices concerning the decoration of the Ponte S. Angelo occur in volumes 81–84. Those *avvisi* that have been published previously by Maria Cristina Dorati in *Commentari* 17 (1966), 349–52 (see p.107, n. 2) are marked with an asterisk.

Appendix I

vol 81

1668

197) fol. 161, 8 February

In Ponte di Castel S. Angelo si è pricipiato à mesterui li nuoui parapetti di treuertino, con le ferrate à mandole, impiombate in detti parapetti.

198) fol. 200, 18 May

In detto giorno di Sabbato si uiddero nella Piazza di Ponte demolite tutte le casette, che ui erano per Artigiani, si uiddero anche leuate le due statue di marmo fino, che erano nell'ingresso del ponte, rappresentanti SS. Pietro, e Paolo, forti per riporueli quando saranno compiti li parapetti, et altro, che cui si deue operare. Con gran diligenza si lauoraua nel parapetto uerso Ripetta, restando però non anche compito quello uerso S. Pietro.

199) *In detto giorno passarano della mia habitatione in Strada Giulia due marmi di smiserata grandezza, e però, uno la matina e l'altro dopo derinace, condotti da 18 bufale sopra un carro assai basso, e molto massiccio; il primo fù portato all'Armata, da lauorarsi da Domenico Guidi Scultore; l'altro uerso castello, forse da lauorarsi dal Bernini.

200) fol. 204, 1 June

In detto giorno si demoli il piedestallo di mattoni, doue staua il S. Paolo nell'ingresso di Ponte, e si prosegui poi nel demolire le casette contigue.

201) fol. 209^v, 6 June

... e uidde (il Papa) nel Ponte, esser quasi compiti li dui parapetti del ponte, et esser posto un trauertino della cantonata, o pilastro dell'istesso Ponte, uerso Torre di Nona. Senti li soliti applausi di uiuo Papa Clemente.

202) fol. 211, 10 June

In detto giorno passò da casa mia un gran marmo di Carrara, simile à gli altri, tirato da sedici Bufale, p una delle statue del Ponte di Castello S. Angelo.

203) fol. 219^v, 3 July

Sono quasi compiti li dui parapetti del Ponte di Castello, e si lauora nelle estremità uerso Castello, come nelli fondamenti del parapetto à hauesso, che deue farli nella Piazza di Ponte; dicendo alcuni, che iui andarano dui baluardi, cioè uno doue hora si lauora, e doue staua le cappellette; e l'altre dalla parte corrispondente, verso le case de gli Altouiti, doue hora sono alcune casette, non anco demolite.

204) fol. 220

Li 6 di Luglio fù posto in opera il secondo trauertino del pilastro dell'imbocatura di ponte, uerso Torre di Nona; e si continuaua à fare i fondam.^{ti} nell'istesso sito uerso la piazzetta, doue ere la chiesuola.

205) fol. 220, 19 July

Al Ponte si era posto il primo trauertino p pilastro, dall'altra parte del ponte, uerso le casette de gli Altouiti, e già si faceua il fondamento in dette casette per l'altro parapetto, e percio si uderanno demoliti quanto prima, dicendosi, che con questi dui parapetti, fabricati più in dentro uerso [fol. 220^v] la piazza di ponte, uerrà ad aprirsi un' arco piccolo del ponte, sotto il quale di presente non passa il fiume, che sara d'utile alla gran.^a del Teuere. E l'istesso si dice si farà dall'altra parte uerso Castello, doue parim.^{ti} dalla Terra è stato riserrato l'arco piccolo, che fece aprire Papa Urbano, con farui porre l'inscrittione in pietra, anco sempre si mantenesse aperto, à cagione delle inondationi.

206) fol. 225, 15 August

Nella Piazza di Ponte uiddi che si demoliuano le casette della parte de gli Altouiti, in corrispondenza delle altre già demolite, doue si uedeua la chiesette. E da questa parte, sopra il piedestallo di trauertino già collocatoui le settimane passate, uiddi esserci stato collocato il basamento di marmo con l'Arme, et Inscrittione di Clemente Settimo, che per prima ui erano, e sopra questo era collocata la Statua di S. Paolo, che parim.^{te} ui era, leuata in occasione di rifare il nuouo parapetto. Si uede da ciò, che il uiuente Pontifice uuole conseruare le memorie uecchie, anzi ui è chi dice, che in alcune delle sue fabriche non uuole che si ueda la sua Arma

207) fol. 228

Giouedi 6 di Settembre uiddi posta in opera la Statua di S. Pietro nell'ingresso del Ponte di Castello, con il uecchio basamento, come à quella di S. Paolo, senza memoria alcuna del uiuente Pontifice.

208) fol. 233^v, 17 September

Nel Ponte S. Angelo si collocauano piedestalli di marmo fino, sopra gli altri piedestalli grandi di treuertino, senza alcun'arme del Papa uiuente, per collocarui poi le dieci Statue de gli Angeli, paramenti di marmo fino.

209) fol. 244^v, 26 September

Nell'imboccatura del Ponte, uerso il Castello, si fabrica una uolta, p ingrandire la strada, incontro la Porta della Fortezza.

210) Si dice, che à Pasqua si cominciara à porre [fol. 245] in opera alcuno de gli Angeli di marmo alli lati del Ponte.

211) fol. 245^v, 1 October

In Ponte nel nuouo parapetto, uerso Torre di Nona si pongono sedici di trauertino.

212) f. 252, 16 October

Nella Piazza di Ponte vi sono posti in opera li trauertini lauorate, e le ferrata uniformi à quelle del Ponte, dalla Parte pero uerso Torre di Nona, lauorandosi hora nella parte uerso l'Altouiti.

213) Sabbato 27 di Ottobre si posero in opera alcuni trauertini nella suolta del Ponte, in faccia la porta di Castello, p rendere

quella imboccatura più spaziosa è più commoda per le carrozze, che in quella suolta si trouauano in qualche angustia nel tempo de'corteggi.

214) fol. 264, 19 November

*Intesi dal Segretario di Monsig.e Bernini, che quanto prima si porrà in opera la Statua del Constantino, alle Scale del Palazzo Vaticano fatto dal Caualiero, tutto d'un pezzo, tanto [fol. 264v] il cauallo, quanto l'huomo, eccetto un poco pezzo di coda del Cauallo, che è aggiunta. Che sono otti anni, che il detto Segretario serue, e che allhora la detta statua era un poco abbozzato, e che ogn'anno ci si è lauorato qualche poco, ma che da dui anni in quà il Caualiero l'ha compito; restano poco a dargli alcuni colpi di perfettione, che si farà quando sia posta in opera. Che il Caualiero lauora un'Angelo di collocarsi in uno de' piedestalli sopra il Ponte, et un'altro ne lauora uno de' suoi figli, quale benche operi assai bene in questo mestiere, si dubita però, che morto il padre, uorrà uiuere con le commodità, che esso gli lasciarà, et abandonar la fatica. Che il Caualiero ha circa 70 anni; che e di gran lena, operando incessantemente; che ogni matina sente messa assai per tempo nella chiesa di S. Andrea delle Fratte; che adesso si leua alle tredici hora, e tornato dalla Chiesa, lauora sino alle 18 hore senza intermissione; che non sdegna di esser ueduto lauorare; ma che bisogna farlo auuisare prima che si entra nella Camera terrena, che chiama il suo studio, et è à mano sinistra nel Cortile.

vol. 82
1669

215) fol. 2, 3 January

*In detto giorno fù ammesso dal d.o S. Caualiero nella stanza à terreno, doue esso, et il figlio operauano (che chiamano lo studio) e lauorauano attorno ad un'Angelo di marmo, che tiene in mano la Corona di spine, et è à qualche buon termine; un'altro suo allieuo lauoraua in un'altro Angelo, che tiene il titolo della Croce, e staua à miglior termine, hauendo anche in questo operato il detto Caualiero: sperauano fra due mesi di hauerli compiti tutti dui e deuono collacarli con altri otto nel Ponte di Castello, qual si lauorono diuersi Scultori.

216) fol. 2v, 4 January

In Ponte erano stati posti in opera sei piedestalli, delli dieci, che deuono esserui per le statue.

Il Parapetto uerso gli Altouiti era affatto compito, e faceua bella comparsa, essendo per appunto correspondente all'altro uerso Torre di Nona.

217) fol. 11, 21 Viddi, che si leuaua il Parapetto, che riesse in fiume, incontro la Cortina di Castello, doue sono molte armi della famiglia Barberina, per essere stato fatto in tempo di Papa Vrbano,

per metterui, penso io, trauertini noui e ferrate, in corrispondenza di quelle di Ponte.

218) fol. 14, 15 February

*Viddi di nuouo le due Statue, che il Caualier Bernini lauora per il Ponte di Castello, quali si trouano à qualche buon termine, mi disse però che il Papa haueua qualche pensiero di mandarle à Pistoia, benche anco non fusse risoluto, fin che non ie uederà compite. Mi disse, che l'istesso Ponteficio disideraua [fol. 14v] che quanto prima li compire il Costantino, nel quale resta anco ad operare, per con poco di mesi, ma all'incontro non uuole, che si leui mano dalle dette due statue, si che non porrà metter mano al Costantino, fin che quelle non siano compite.

219) fol. 15, 18 February

In Ponte erano posti altri dui pilastri di marmo fino p le statue, cioè nel principio del Ponte uerso Castello; restando à mettersene solamente altri dui per compimento deli dieci.

220) fol. 42, 14 April

Li parapetti del Ponte, quelli uerso la Piazzetta dalli dui lati, e quelli incontro alla Cortina di Castello sono affato compiti, con le ferrati, alle quali si e dato in questi giorni il color nero, con uerncie. Delli piedestalli di marmo finò per le Statue, otto ne sono posti in opera, mancandone, anche due.

221) fol. 91, 16 June

In Ponte li sono rifatti di nouo li muriue o li laterali, restando largato il detto Ponte circa un palmo, ma nella uolta incontro li cancelli del Castello resta ingrandita la Strada più di dui palmi. Le statue del Ponte non sono anco cominciate à metterui in opera.

222) fol. 92v, 20 June

*Nel Ponte si uedeuano collocati li dui piedestalli di marmo, che ui mancauano, essendo dieci in tutto!·Intesi dal S. Luigi Bernini, che già sono compiti quattro Angeli, e che fra un mese comincieranno à uedersi in opera: Li dui del Caualiere suo fratello mi confermo, che facilmente sarebono mandati à Pistoia.

223) fol. 131v, 20 August

*Viddi L'Angelo del S. Domenico Guidi, quasi compita, e dissi, che p la festa di S. Michele ArcAngelo il Papa uoleua uederne alcuno in opera; e questo sara fra gli altri, che sono quasi compiti.

224) fol. 135

*Lunedi 9 di Settembre fù posta in opera la prima Statua nel Ponte di Castello, cioè un'Angelo con li flagelli, uicino alla Statua di S. Pietro.

225) *Il S. Domenico Guidi Scultore, che haueua compito un'altr' Angelo, che tiene la lancia, è stato una di queste sere ferito mortalmente con più colpi di pugnale, non si sà da chi, ma si pensa sia stato in cambio.

226) fol. 135v, 13 September

*In detto giorno si pose in in(sic.) opera il secondo Angelo di marmo nel ponte di Castello, con chiodi.

227) *Martedi 17 d. il Pontefice, in lettica, si portò alle 22 hore alle chiesa di S. Agostino ... [fol. 136] Nel primo passaggio per il ponte, fece fermare la lettica, e per un miserere si fermò à uedere la statua dell'Angelo con i flagelli; e poi p un'altro miserere si fermò à uedere quella delli chiodi ... Nel mio ritorno, uiddi che in terra, nella Piazza del Ponte era una Statua coperta, p metterla in opera il giorno seguente, erano preparati il tracci al pilastro incontro l'Angelo con i chiodi.

228) fol. 136

*Mercoledi 18 d. fu posto in opera il terzo Angelo, che tiene la ueste con i tre dadi, incontro à quello de chiodi.

229) *Giovedi 19 d. fù posto in opera il quarto Angelo, che tiene la canna con la spongia, dicono che sia il migliore delli quattro collocatiui sin'hora, et essere opera del Giorgetti, si è [fol. 136ᵛ] situata nel primo piedestallo uerso S. Pietro, incontro il cancello della fortezza. Dicono, che mercordi, si metterà in opera il quinto, non che gli altri non sono compiti. Delli dui Angeli del Bernini fin'hora non puol sapersi se ui si porrono, o pure si mandaranno à Pistoia, come tuttauia uocifera il detto Caualiere.

230) fol. 149, 26 September

In detto giorno uiddi posto in opera il quinto Angelo nel Piedestallo del Ponte contiguo alli Cancelli di Castello, dirimpetto all'Angelo del Giorgetti; e perche ciascuno di questi due artefici è reputato di scultore primarij, che siano in Roma, perciò anche questi Angeli sono i migliori delli cinque posti fin'hora in opera. Tiene questo la lancia, et e opera di Domenico Guidi allieuo dell'Algardi.

231) fol. 155, 12 October

*Intesi, che il Papa desideraua, li mettesero in opera quanto prima tutte le statue sopra il Ponte, hauendo gran sodisfatione. Mi disse il S. Domenico Guidi Scultore celebre, che del suo Angelo, quale tiene la lancia ha hauuto à bon conto ▽ 550, e dice ualere ▽ 1200. Che sono fermati senza perno o ferro alcuno. Che quello delli chiodi era fin' hora l'inferiore. ...

232) fol. 168, 22 November

*In detto giorno fù posto in opera la sesta statua nel Ponte di Castello, di un Angelo con la Croce.

1670

233) fol. 265, 22 May

*Nel Ponte di Castello si è posta in opera la settima statua di un'Angelo, che tiene il volto santo.

234) *Iui ne à stata portata un'altra per collocaruela il giorno seguente: si che vi restano solo à collocarui le due del Caualiero,

e del suo figlio, Bernini, dicendosi tuttauia, che d.º Caualiero pensi di non ue le porre.

235) fol. 266, 25 May

*Si uidde in opera l'ottaua statua, di un'Angelo, che sostenta la Colonna: ui restano dui piedestalli dalla parte uerso S. Pietro, per collocarui il nono, et il decimo Angelo, del Caualier Bernino, o di altri Scultori, quando quello non uoglia collocarui i suoi, già compiti.

236) fol. 352ᵛ, 22 November

Essendo compito la nuoua selciata del Ponte S. Angelo, fino all'ingresso dei Borghi nouo, e uecchio, fatta di nuoo affatto

vol. 83

1671

237) fol. 176

*Lunedi 19 di Ottobre fù condotta nel Ponte di Castello la nona Statua, cioè l'Angelo con la Corona di spine.

238) fol. 185

*Domenica, giorno ottauo di Nouembre, uiddi nel Ponte di Castello collocato in opera il decimo Angelo con il titolo della SS. Croce; e uien compito il numero delle dette statue.

vol. 84

1672

239) fol. 28ᵛ

Venerdi 4 di Marzo alle 21 hore si portò il pontefice al Vaticano, partendo dal Quirinale, accompagnato da numerosa Caualcata. Nel passare per il Ponte, uidde nell'ultimo pilastro, cioè in quello che sostiene l'Angelo con la spongia (e nell'altro della lancia)** incastrata l'Arme di marmo di Papa Clemente Nono; et in altra parte dell' istesso pilastro intagliata una inscritione, fatta d'ordine del Santità/fol. 29/alla memoria dell'istesso Clemente Nono quale con somma modestia non uolse, che si ponesse di lui stesso alcuna arme, o inscrittione, benche l'ornamento del ponte sudetto fusse degno, che me restasse memoria: videssi anche nel piedestallo di ciascuno delli dieci Angeli scolpito un detto della sacra Scrittura, appropriato à quel Misterio della Passione

** signifies that the phrase in parentheses is a note in the margin of the manuscript.

4. Miscellaneous *Avvisi* and Documents

240) Archivio della R. Fabbrica di S. Pietro, *serie armadi*, vol. 303, fascicle inserted after fol. 17

Dali 5 Aprile 1668 per tutto li 8 Giugno 1668 Mons.ʳᵉ Ill.ᵐᵒ Rocci

maggiordomo della Santità di N.S. Clemente IX, deue dare alla R. Fabbrica di S. Pietro la preso [sic.] partite de stiglie datte con ordine del sig.re Caualiere Bernino per scaricare li marmi delle statue degli Angeli del Ponte S. Angelo a mastro Pietro Ostini e Carlo Pagniotta capoma.i mur.i.

There follows a list of material used in the transportation of the blocks of marble and an accounting of the cost (\triangledown 986·96). In the margin is a list of the dates on which the blocks were delivered. The list reads:

A di 13 Aprile Sig.re Cavaliere Bernino
A di 11 Mgio al Sig. Cavaliere Bernino
A di 17 Mgio Lucente
A di 19 Mgio Pauolo Naldini
A di 25 Mgio Domenico Guidi
A di 2 Giugnio Fancelli
di detto Giorgetti
A di 8 Giugnio Antonio Lombardi

(D'Onofrio, *Il Tevere*, p. 137, n. 17)

241) BV, *Barb. lat.* 6369, fol. 341
29 July 1668
Domenica . . . dopo desinare . . . Sua Santità . . . à cauallo si trasferi in Carozza . . . à uisitare le chiese . . . e la Basilica di S. Pietro, hauendo nel passar ad essa data una uista all'ornam.to che fare alli Capi, e sponde del Ponte di S. Angelo di Trauertini bianchi framezzati con fenestre, ferrate sopra à piedestalli pnli otto Angeli grandi, che terranno in Mano Li Misterij della passione del Redentore fatte dal Cau.re Bernino, et altri Pnli Scultori . . . , e prima fù nell'officina del. d.o Cau.re Bernino à ueder la statua, che questo ha fatto del Gran Constantino Imp.re da porsi incontro al Portico di d.a Basilica.

(Pastor, *History of the Popes*, XXXI, 334, n. 3)

242) Biblioteca Casanatense, MS 5006 (Diary of Don Giuseppe Cervini), fol. 50
13 September 1669
Posto il Primo Angiolo chi tiene Lancia Sopra il Ponte S. (A)ngelo doue douene esere 12. Et nei Giorni seguenti portouene altri 4 di diuersi Scultori tenendo tutto Li Misterij della Passione.

(Fraschetti, *Il Bernini*, p. 368)

243) BV, Barb. lat. 6371, fol. 275
21 September 1669
Il giorno seguente (Lunedi) . . . nostro Signore . . . nel passare il Ponte di Castello si conpiache di dare una uista à gli Angeli di marmo che ui si uanno erigendo sin al numero di dieci, di altezza circa quindici palmi ciascheduno tenenti li misterij della passione del nostra Redemptore fatti per ordine di Sanctita da altre tanti Scultori per ornamento del medemo Ponte.

(Pastor, *History of the Popes*, XXXI, 334, n. 6)

244) BV, *Barb.lat.* 6406, fol. 408n
9 May 1671
Gionto all'orecchio del Bernino l'arrivo quanto prima dell'Ambre francese à questa Corte, batte à più non posso lo scarpellino sù la statua di quel Rè, acciochè possa essere da questi veduta in qualche essere; mà se il lavoro sarà simile al cavallo di Costantino meritarà che sè gli ponga un capestro al collo, come scorticatore, e non come formatore di statue Reali, già che i due angeli, da porsi sul Ponte fabricati di sua mano vergognandosi di comparir frà gl'altri sono spariti con dubbio sè si siano buttati à fiume, ò pure andati à vivere con Elia nel Paradiso Terestre, dove non saranno veduti sino al giorno del Giuditio.

(Ermete Rossi, "Roma Ignorata," *Roma* 18 (1940), 58)

245) Archivio di Stato, Modena—Cancelleria Ducale—*Avvisi e notizie dell'estero*
Roma li 28 Ottobre 1671—Essendosi finalmente risoluto il signor Caualiere Bernini di ultimare il suo Angelo, resta il Ponte Sant'-Angelo frequentato da tutti si per amiraua il suo Valore, com'anche per Veder qual di questi scultori ha meglio indouinato il gusto del mondo, non potendosi negare che ciascheduno di loro non habiano fatto l'ultimo sforzo per non essere biasimato.

(Fraschetti, *Il Bernini*, p. 370, n. 12)

246) Bibliothèque Nationale, Paris, *Fonds Italiens*, vol. 2082, fol. 58—letter dated 18 February 1672 from Cardinal Massimi to Monsignor Gianuzzi who forwarded it to Bernini. Ill.mo Re.mo Signore, Hoggi la Santità di Nostro Signore si è degnata di rendermi l'acclusa inscrittione e comanda, che quanto prima si faccia intagliare nel vivo delli piedistalli dell'ultimi due Angeli verso Castello nella faccia che guarda la cortina, dupplicando l'istessa inscrittione nell'uno, e nell'altro. Nelle faccie poi, che guardano l'istesso ponte, si pongano le due Armi della Santa Memoria di Clemente Nono. Mi ha ordinato ancora che à ciaschedun piedistallo degli angeli si pongano respettivamente gli acclusi motti della Sacra Scrittura nelle faccie che voltano verso la strada del ponte, e alli piedistalli delli dui Angeli, che hanno l'Armi e l'inscrittione si dovranno porre li motti nella faccia del fianco, che viene ad essere nella parte avversa dell'inscrittione grande. Ne porto questa notitia a V. S. affinché ella possa commettere, che si eseguisca con ogni maggior prestezza, e resto pregandole vera prosperità.

(D'Onofrio, *Il Tevere*, p. 143, 146 ff.)

247) Archivio della R. Fabbrica di S. Pietro, serie 1, vol. 8, fols. 84 ff.—note addressed to Card. Massimi
S'inviano a V.S. Ill.ma li motti da porsi ne'Piedestalli degl'Angeli approvati dall'Em.mo s. Card.e Altieri, il quale hà risoluto che le

Armi della San. me. di Clemente Nono si facciano porre nelli Piedestalli delli due ultimi Angeli verso Castello nel modo à punto che stanno quelle di Leone X.^{mo} nelli Piedestalli di S. Pietro, e S. Paolo nel principio del Ponte.

VULNERASTI COR MEUM/Cant. 4	Lancia
CUIUS PRINCIPATUS SUPER HUMERUM	
EIUS/Isai. 9	Croce
POTAVERUNT ME ACETO/	Sponga (sic.)
ASPICIENT AD ME, QUEM	
CONFIXERUNT/	Chiodi
RESPICE IN FACIEM CHRISTI TUI/	Volto Santo
SUPER VESTEM MEAM MISERUNT	
SORTEM/Psal. 21	Vesti e Dadi
TRHONUS (sic.) MEUS IN COLUMNA/	
Ecclesiastici 24	Colonna
CONVERSUS SUM IN AERUMNA MEA	
DUM CONFIGITUR SPINA/Psal. 31	Corona di spine
IN FLAGELLA PARATUS SUM/Psal. 37	Flagelli
REGNAVIT A LIGNO DEUS/	Titolo

(D'Onofrio, *Il Tevere*, p. 147, n. 38)
248) BV, *Barb. lat.* 6375, fol. 51
12 March 1672
La Santità di Nro Sig.^{re} ha fatta porre al Ponte Elio sopra questo fiume Teuere L'inscrittione al piedestallo di ciascun'Angelo di marmo alludente al misterio dalla passione del Redentore, che tiene in mani, et alli primi due Scolpire L'Armi, e memoria di Papa Clemente Nono Suo Antecessore, che li fece fare per ornam.^{to} del med.^o Ponte.

(Pastor, *History of the Popes*, XXXI, 335, n. 1)
249) BV, *Vatic. lat.* 12010, fol. 91
undated
Angeli del Ponte Sant'Angelo sono opere degl'infras.^{ti} scultori
Quello che tiene La Colonna è di Antonio Raggi
Altro che tiene il Volto Santo è di Cosimo Fancelli
Altro che tiene la Croce è di Hercole Ferrata
Altro che tiene la lancia è di Domenico Guidi
Altro che tiene Li flagelli è di Lazzaro Morelli
Altro che tiene i Dadi è di Paolo Naldini
Altro che tiene le Spine è del med.^o Naldini
Altro col Titolo d.^{la} Croce è del Cau.^{re} Bernini
Nel fine del Ponte
Il San Pietro è opera del Lorenzetto
Il San Paolo è opera del Paolo Romano
a. altro con li chiodi è di Girol.^o Lucenti
a. altro con la sponga è di Ant.^o Giorgetti

250) BV, *Vatic. lat.* 12010, fol. 92
undated
Angioli che sono sul Ponte Sant'Angelo sono Opere de gl'infrascritti Scultori
Quello che tiene La Colonna è opera Di Antonio Raggi
Altro che tiene il uolto santo Cosimo Fancelli
Altro con li chiodi Girolamo Lucenti
Altro che tiene la Croce Hercole Ferrata
Altro che tiene la Lancia Domenico Guidi
Altro che tiene li flagelli Lazzaro Morelli
Altro che tiene i Dadi Paolo Naldini
Altro che tiene le Spine Paolo Naldini
Altro col titolo della Croce Cau.^{re} Bernino
Altro con la sponga Antonio Giorgetti
Il San Pietro nel prin.^o del Ponte Paolo Romano
 Lorenzetto
San Paolo . Paolo Romano
251) Archivio Capitolino, Rome, Cred. XIV, vol. 18 (Diary of Valesio), fol. 15^v
13 March 1729
Il Bernini hà donati à PP. di S. andrea delle fratte due statue del celebre Cau.^{re} Bernini rappresentanti due angeli uno col titolo della croce, et altro con la corona di spine, originali di quelli che sono al Ponte S. Angelo ad effetto ci collocargli nella [fol. 16] nella [sic] sontuosa Cappella che si fabrica ad onore di S. Fran.^{co} di Paolo una pò di questi, cioè quello che porta il titolo nel mouerlo cadde è se le ruppe un braccio.

(Ercole Scatassa, "Notizie e documenti," *Rassegna bibliografica dell'arte italiana*, 13 (1910), 154)

5. The Frugoni Suit

The following documents are transcribed from two printed pamphlets in ASR, *Camerale*, III, 1931, *fascicolo* dated 1715 and inscribed "*Marmi per le statue di Ponte S. Angelo, Romana Pecuniana Frugoni Gio Batta C. R.C.A.*" The first pamphlet is an affidavit consisting of thirty-two numbered paragraphs in which the heir of Filippo Frugoni, the marble merchant who supplied the marble for the statues of angels decorating the Ponte S. Angelo, argues that he should receive additional payment for the said marble. The first five paragraphs of the first pamphlet are quoted because they explain the nature of Frugoni's suit and in so doing add to our knowledge of the decoration of the Ponte S. Angelo. The remaining twenty-seven paragraphs deal with technicalities of the suit. Within each of the paragraphs there are italicized numbers (*Num. I. litt.*

B.) referring to documents printed in the second pamphlet. These are documents that support the arguments of the affidavit. Most of the documents contained in the second pamphlet add nothing to our knowledge of the decoration of the Ponte S. Angelo; those few that do are quoted in full.

Pamphlet 1

252)

1 Desiderando la santa memoria di Papa Clemente Nono adornare il Ponte Sant'Angelo di Statue di Marmo sino dagl'anni 1667., e 1668. fù data Commissione alli Signori Frugoni Mercanti de Marmi in Carrara, acciò prouedessero, e transportassero à Roma numero dieci pezzi Marmi per la struttura di dette Statue, come chiaramente si raccoglie delle Lettere delli Eminentissimi, e Reuerendissimi Signori Cardinali Nini, e Rocci di quei tempi Maggiordomi che si danno *Num. I. litt. B.*

2 A tenore di detti ordini, commissioni, e Lettere, che ordinauano la sollecitudine senza riguardo, e risparmio di spesa furono fatti cauare detti Marmi in tempo d'Inuerno, quando che per euitare li rigori delli detta Staggione, che continuamente in quelle alte Montagne fà Pioggie, Neue, e Giaccio fù di necessità fare fino le Case di Tauole, & altri ripari, e poi condotti à Roma con spese straodinarie, e di molta consideratione tanto rispetto agl'Operarij, quanto in riattare, riaccomodare, anzi fare di nuouo per più volte portate via dal Fiume le Strade in simili tempi impratticabili, come depongono 29 Testimonij con Fedi autentiche, e legalizate che si danno *Num. 2. litt. D. à Num. 9 ad 14.;* Gionti in Roma li detti dieci pezzi Marmi d'ottima perfettione, e di giusta misura in tutto, e per tutto nel modo, e forma erano stati ordinati, e secondo li Profili, e Disegni fatti, e sottoscritti di propria mano del Signore Caualieri Bernini con haueui notato in piedi il numero delle Carrettate che importano, come originalmente si vede dalle medemi Profili, e Modelli che si danno *Num. 3. litt. C. Num. 1., & 2.*, furono consegnati alli Scultori, quali mediante la loro Peritia, e Conscienza attestorno della bona qualita, & esquisitezza de medemi Marmi, come apparisce dal *detto Numero 3. littera C. Num. 3.;* Et in tanto ne furono ordinati altri due pezzi in luogo delli due mandati da Sua Santità nella Cappella di Pistoia lauorati dal Caualiere Bernini, come risulta dalla *detta lettera B. Num. 3., & 4.*

3 In questo mentre li Frugoni faceuano giustamente continue Istanze, che li fosse somministrata qualche somma di denaro à misura delle esorbitanti, & insolite spese, che haueuano fatto, e faceuano ascendenti à somma considerabile, ne mai furono esauditi, ne considerate le loro giuste Istanze, il che diede motiuo alli medemi d'esagerare apertamente gl'impedimenti, e contrarietà,

che forsi studiosamente li veniuano fatte dal Caualiere Bernini lamentandosi più volte li medesimi Frugoni di tal procedure del detto Caualiere con Lettere à Monsignor Maggiordomo date alla *detta lettera B. Num.I.*, e percio il detto Caualiere Bernini ricusò indebitamente l'vltimo pezzo, di Marmo compimento delli dieci benche bonissimo, e molto ben seruibile, per il che li detti Frugoni soffriuono idanno, e li conuenne prouederne vn'altro in luogo di questo, come si ricaua dalle medeme Lettere scritte da detto Monsignor Maggiordomo data alla *detta lettera B. Num. 1., & 2.*

4 Veniua in tanto sollecita la missione delli altri due pezzi Marmi aggiunti, & ordinati in vltimo in luogo delli due primi lauorati dal detto Caualiere Bernini, e figlio mandati à Pistoia, conforme in realtà furono mandati, li quali giunti alla Ripa di Roma à tutte spese di detti Frugoni riceuerno anco essi la disgratia dell'altro primo di non esser riceuuti, imponendo il detto Caualiere Bernini, che si douessero far venire di nuouo, il che fù apertamente ricusato dalli detti Frugoni per non riceuere maggior danno dallo scoperto odio del detto Caualiere, li quali furono commessi ad'altri, che poi riuscirono di puoca bona qualità, come ocularmente si ricons ce nelle due Statue della Corona, e del Titolo con Peli, e Macchie in faccia ad ambedue, che sono Copie Originali fatte da detti Signori Bernini delli due mandati a Pistoia.

5 E che li due vltimi Marmi mandati dalli Frugoni fossero buoni, e di ottima esquisitezza si puole ocularmente conoscere da tutti, mentre doppo il decorso di molto Anni ne hanno venduto vno, che hà seruito tagliato per mezzo in fare li due Angeli che stanno sopra il Cornicione dell'Altare in Sant'Ignatio dell'-Eminentissimo Signore Cardinale Sacripanti fatta da Signor Lorenzo Ottoni Scultore, onde chiaramente risulta il gran liuore, che ha pratticato il detto Caualiere con li detti Frugoni in rigettare li detti Marmi cauati, e condotti con tante spese, & incommodi su la Ripa di Roma.

Pamphlet 2

253) Num. 3. lit. C. Num. 1

254) Num. 2

255) Num. 3. *Attestato delli Scultori che lauorono le Statue quali depongono la buona qualità de marmi.*

Noi à pie sottoscritti facciamo piena, & indubita fede per la verità à che spetta di hauere ciascheduno di noi riceuuti dal Signor Luca Berrettini li Marmi per fare gl'Angeli del Ponte Sant'Angelo nella manira, e forma, che qui si dichiara.

Io Gioseppe Giorgetti faccio piena, & indubitata fede mediante

253)

254)

il mio giuramento, che il sasso riceuuto per l'Angelo fatto da Antonio mio fratello, & io sia stato d'ogni bonta, e di pasta stauaria. In fede &c. mano propria.

Io Cosmo Fancelli dico per verità à chi spetta, che il marmo del Angelo da me riceuuto, e lauorato sia stato di giusta misura, e in conformità del modello da me consegnato, e di pasta statuaria, e hona [sic] come si vede mano pp.

Io Girolamo Lucenti faccio piena, & indubitata fede hauere riceuuto il marmo dell'Angelo fatto da me quale dico esser stato d'ogni bontà di pasta statuaria in conformita del modello mano propria.

Io Domenico Guidi dico per verità à chi spetta che il marmo da me riceuuto per far l'Angelo della Lancia è stato di quella misura da me ordinato. E ben vero che mi fù dato ordine da che haueua la sopraintendenza alla detta opera di tagliarlo in diuerse parti; Non fu pero da me esseguito, e questa è la pura verità. Io sudetto mano pp.

Io infrascritto dico per verità à chi spetta che il marmo da me lauorato per fare la statua dell'Angelo del Ponte Sant'Angelo fù giusto in conformità dell'ordine, e mio modello da me dato. In fede &c.

Antonio Raggi mano propria.

Io Pauolo Naldini mano propria.

Io infrascritto fo fede come il marmo dell'Angelo fatto da me fosse come l'ordine, e modello dato dall'Caualiere Bernini. In fede &c.

Io Lorenzo Morelli mano propria.

256) Num. 4. *Litt. L. num. 1. Lettera di Luca Berrettini scritta alli Frugoni a Carrara.*

Foris— Alli Signori Filippo, e Giacomo Frugoni Carrara. Intus-Hò riceuuto la sua, e sento quanto mi dite, mi dispiace sentire che anco non siano capitati li modelli già molto tempo fa mandati; vi mando la misura de marmi che vi bisognarano, & anco la mostra mandatami dal Signor Caualiere Bernini, e vogliono, che siano abbozzati per l'appunto in conformita delle misure, che vi si mandano quì incluse, e me l'hanno raccommandata la puntualità di dette misure, come nelle presenti sentirete. Io credo che le misure datemi si pensino che li Scarpellini costì l'habbino da fare loro, che le vogliono per l'appunto, non l'hò possuto parlare, che me l'ha fatte dare per terza persona, quando l'ho viste mi son marauigliato di tanta puntualità.

Roma li 22. Ottobre 1663 [sic; should read 1667]. Luca Berrettini

Appendix 2

Oeuvre lists for the Sculptors

The following eight lists are not intended to be *catalogues raisonnés*, but rather indications of what is known about the work of the sculptors who collaborated with Bernini on the decoration of the Ponte S. Angelo. As such, the lists are meant to illustrate the degree of productivity achieved and the character of the commissions received by eight of the ten sculptors other than Bernini who carved statues for the decoration of the bridge. Lists of the works of Paolo Bernini and Giulio Cartari are not included because neither of these sculptors produced any known works outside the studio of Gian Lorenzo Bernini. Each of the lists is in chronological order. Each work is identified according to its location, its approximate size (omitted in some cases for lack of information), material (other than marble), type of work (statue, relief, portrait bust, or decoration), and subject. A work is to be found in Rome when not located by city. When a work was produced as part of a decorative project, the name of the architect or designer of the project is given in parenthesis at the end of the entry. The footnotes corresponding to most of the entries are limited to the citation of documents, as well as primary and secondary sources that explain the attribution and dating of the work. For the most part, works produced in collaboration with Bernini are not footnoted, because the history of and bibliography related to such works is recorded in the catalogue entries in Wittkower, *Gian Lorenzo Bernini*, and Fagiolo dell'-Arco, *Bernini*. There are no notes corresponding to the biographical data given in the lists, because the sources for the lives of the artists are cited in the notes to chapter 4.

1. Antonio Raggi

1624 Born in the village of Vicomorcote in the mountains above Lake Lugano

1646 Villa Doria-Pamphili, restoration of antique statues (Algardi).[1]

ca. 1647 S. Maria dell'Umiltà, niches in the walls of the nave, six over life-size stucco statues of female saints.[2]

1647–48 St. Peter's Basilica, pilasters of the nave and chapels, two reliefs of putti carrying papal tiaras and keys and two reliefs of putti holding medallions containing portraits of popes (Bernini)

1649 SS. Domenico e Sisto, Cappella Alaleona, *Noli me tangere*, over-life size statues of Christ and Mary Magdalen in an architectural setting, with a stucco glory in the lunette above the central group, in which an angel and several putti carry instruments of the Passion (Bernini)

1650–51 Piazza Navona, Fountain of the Four Rivers, colossal statue representing the Danube (Bernini)

1652 Sassuolo, Palazzo Ducale, several fountains, of which three still exist: two in the entry hall decorated with over life-size stucco statues of Galatea and Neptune, and one in the courtyard, in a niche opposite the entrance, decorated with an over life-size stucco statue of a Triton (Bernini)[3]

ca. 1654 S. Maria sopra Minerva, Tomb of Cardinal Pimentel, life-size statue of Charity (Bernini)

1654–56 S. Adriano (destroyed), tympanum of the high altar, life-size stucco statues of Faith and Charity[4]

1655–57 S. Maria del Popolo, spandrels of the second and fourth arches on the left of the nave, life-size stucco figures (in relief) of SS. Barbara, Catherine, Thecla, and Apollonia; over the arch separating the nave and the crossing, two life-size stucco angels carrying the arms of Pope Alexander VII; spandrels of the arch leading into the high-altar chapel, under the organ lofts, two stucco ornaments—each consisting of an over life-size angel and a putto carrying the coat of arms of Pope Alexander VII; altar of the left transept, left side, over life-size statue of an angel symbolically supporting the frame of the altarpiece (Bernini)

After 1655 S. Giovanni dei Fiorentini, Tomb of the marchesa Caldarina Pecori-Riccardi, life-size half-length portrait of the deceased in prayer and two putti[5]

ca. 1656 Paris, St. Joseph des Carmes, left transept chapel, over life-size statue of the Madonna and Child (Bernini)

1656 Vatican Palace, Sala Ducale, colossal stucco putti supporting a heavy stucco curtain that drapes the opening between two sections of the room (Bernini)

1657 Subiaco, Sacro Speco, life-size statue of St. Benedict seated in a grotto[6]

ca. 1658 S. Marco, Tomb of Cardinal Bragadin, wall tomb composed in two levels: below, a medallion containing a life-size portrait of the deceased floats in a field of black marble drapery and is flanked by two putti; above, two putti carry aloft the cardinal's coat of arms[7]

1658–64 St. Peter's Basilica, *Cathedra Petri*, miscellaneous work (Bernini)

1660–61 Castel Gandolfo, S. Tomaso da Villanova, dome, eight circular stucco reliefs illustrating scenes from the life of St. Thomas of Villanova; pendentives of the dome, four over life-size reliefs of

the Evangelists; high altar, stucco decorations including two life-size angels and a putto supporting the frame and a relief of God the Father accompanied by putti (Bernini)

ca. 1660 Castel Gandolfo, married to Giovanna Francesconi[8]

1661–63 Siena, Duomo, right transept, colossal statue of Pope Alexander VII (Bernini)

1662–63 Siena, Duomo, Cappella Chigi, life-size statue of St. Bernardino (Bernini)

1662–65 S. Andrea al Quirinale, dome, stucco decorations including over life-size statues of St. Andrew in Glory, eight fishermen holding shells and fish, twelve putti holding nets and garlands, and twenty-eight cherubs (Bernini)

1662–67 S. Agnese in Piazza Navona, altar left of the high altar, over life-size relief of the *Death of St. Cecilia* (begun by Giuseppe Peroni)[9]

1663 Formerly in S. Giovanni in Laterano, apse, two stucco angels carrying the coat of arms of Pope Alexander VII (Pietro da Cortona; destroyed)[10]

1665–77 S. Giovanni dei Fiorentini, niche over the high altar, *Baptism of Christ*, over life-size statues of Christ, John the Baptist, and an angel, as well as a stucco relief representing God the Father, the Dove of the Holy Spirit, and putti.[11]

1668–69 Ponte S. Angelo, colossal statue of the *Angel Carrying the Column* (Bernini)

1668–69 S. Nicola da Tolentino, Cappella Gavotti, niche in the left wall, under life-size statue of John the Baptist; lunette above the left wall, circular stucco relief containing the image of St. Charles Borromeo (Pietro da Cortona)[12]

ca. 1669 Milan, S. Maria della Vittoria, altar on the left wall, two statues of angels flanking the altarpiece[13]

ca. 1670–81 S. Andrea della Valle, Cappella Ginnetti, left wall, Monument of Cardinal Marzio Ginnetti, life-size statue of the cardinal kneeling in prayer and two life-size statues of virtues; corner left of the altar, life-size relief of the *Angel Announcing the Flight into Egypt to St. Joseph*; right wall, lunette under the dome, over life-size statue of Fame (Carlo Fontana)[14]

1671 London, Chelsea, Old Church, Tomb of Lady Jane Cheyne, life-size statue of the deceased reclining on her casket.[15]

1671–72 Lost, clay model of Mary Magdalen about 65 cm. (3 palmi) high that was cast in bronze, gilded, and placed at the base of an ivory Crucifixion owned by Cardinal Flavio Chigi[16]

1672–79 Il Gesù, stucco decorations, vault, colossal angels (in relief) supporting the frame of Gaulli's fresco; clerestory windows, colossal statues of putti carrying garlands and colossal statues of allegorical figures; below the clerestory windows, reliefs of music-making putti (Giovanni Battista Gaulli)[17]

1673–75 Chigi Collection (now part of the Staatlichen Skulpturensammlung, Dresden), restoration of four antique statues of gladiators[18]

1675 S. Carlo alle Quattro Fontane, façade, niche above the entrance, over life-size travertine statue of St. Charles Borromeo[19]

before 1678 Gesù e Maria al Corso, high altar, stucco relief of the *Annunciation* (removed in 1678)[20]

ca. 1678 Loreto, Santa Casa, Tomb of Cardinal Bonaccorsi[21]

1679–86 S. Maria dei Miracoli, high-altar chapel, Monument of Marchese Benedetto Gastaldi, life-size statues representing Prudence and Justice; above and within the frontispiece of the high altar, a complex composition of life-size figures of marble and stucco including: in the semi-dome, the Dove of the Holy Spirit in a glory of light rays and clouds; above the frontispiece of the altar, an angel carrying the Cross and descending on clouds into the broken pediment of the frontispiece; on the sides of the pediment, two seated angels; within the pediment, putti playing with garlands of flowers; within the frontispiece, four angels carrying an image of the Madonna; over the entrance to the high-altar chapel, two life-size stucco angels carrying the coat of arms of the Gastaldi (Carlo Fontana)[22]

1683–86 S. Marcello al Corso, façade, above the entrance, under life-size stucco relief representing St. Philip Benizzi's renunciation of the papal Tiara (Carlo Fontana)[23]

1686 1 August, died and was buried in S. Franceso di Paolo

1. A. Nava-Cellini, "L'Algardi restauratore a Villa Pamphilij," *Paragone* 14, no. 161 (1963), 31, 36.

2. Titi, 1674, p. 358. A. Nava, "Scultura barocca a Roma," *L'Arte* 40 (1937), 284 first suggested an early date for these statues.

3. A terracotta bozzetto for the Triton exists in the Galleria Estense, Modena. See A. G. Quintavalle, *Artisti alla corte di Francesco I d'Este* (Modena, 1963), fig. 44.

4. Titi, 1674, 222. The statues were part of the restoration and decoration of the church under the supervision of Martino Longhi the Younger. See: J. Varriano, "The 1653 Restoration of S. Adriano al Foro Romano: New Documentation on Martino Longhi the Younger," *Römisches Jahrbuch für Kunstgeschichte* 13 (1971), 287–95.

5. Mons. Emilio Rufini, *S. Giovanni de'Fiorentini*, Le Chiese di Roma illustrate, 39 (Rome, 1957), p. 55.

6. Pascoli, *Vite*, I, 250. The date 1657 is traditional but is not supported by published documents. See P. Egidi, et al., *I Monasteri di Subiaco* (Rome, 1904), I, 416.

7. See p. 109, n. 4.

8. Pascoli, *Vite*, I, 251, states that Raggi married while working in Castel Gandolfo.

9. G. Eimer, *La Fabbrica di S. Agnese in Navona* (Stockholm, 1970–71), II, pp. 497 and 500 cites documents that clarify the respective roles

played by Peroni and Raggi in the production of the relief.

10. K. Noehles, "Architekturprojekte Cortonas," *Münchner Jahrbuch der bildenden Kunst* 20 (1969), 202, quotes payments to Raggi and Antonio Nuvolone found in BV, *Cod. Chig.* M.VII.XL, fol. 232.

11. See p. 111, n. 36.

12. Titi, 1686, p. 305; Baldinucci, *Notizie*, VI, 520. Pietro da Cortona began the chapel in 1668, and it was completed in 1669 under the supervision of Cirro Ferri. See O. Pollak, "Pietro da Cortona," Thieme-Becker, VII, 495.

13. C. Torre, *Il Ritratto di Milano* (Milan, 1714), pp. 97, 99, attributes the statues to Raggi and cites an inscription that dates the completion of the church in 1669.

14. E. Coudenhove-Erthal, *Carlo Fontana und die Architektur des römischen Spätbarocks* (Vienna, 1930), pp. 34 ff.; L. Bruhns, "Das Motiv der ewigen Anbetung in der römischen Grabplastik," *Römisches Jahrbuch für Kunstgeschichte* 4 (1940), 355 ff.

15. R. Davies, *Chelsea Old Church* (London, 1904), pp. 57 ff., has published a set of letters that give a detailed account of the production of the tomb.

16. V. Golzio, *Documenti artistici sul seicento nell'archivio Chigi* (Rome, 1939), pp. 302 ff.

17. Wittkower, *Art and Architecture*, p. 205; R. Enggass, *The Painting of Baciccio* (University Park, Pa. 1964), pp. 31 ff., 176 ff.

18. Golzio, *Documenti*, p. 321. Recent photographs show that Raggi's restorations have been removed.

19. E. Hempel, *Francesco Borromini* (Vienna, 1924), p. 197, cites a contract (Archivio di S. Carlo alle Quattro Fontane, *busta* 24) of 6 August 1675 whereby Raggi agreed to carve and deliver the statue within eight months.

20. The relief was replaced by Giacinto Brandi's painting of St. Joseph in 1679. See I. Barbagallo, *La Chiesa di Gesù e Maria in Roma*, (Rome, 1967), pp. 21–24, 79. Raggi's relief might have been a model for a project for the decoration of the altar. Titi, 1674, pp. 416 ff. does not mention the relief.

21. Pascoli, *Vite*, I, 250, states that Raggi carved a figure for the tomb. *Marche*, Guida d'Italia del Touring Club Italiano, 13 (Milan, 1962), p. 324, attributes the entire tomb to Raggi. Cardinal Bonaccorso Bonaccorsi died on 18 April 1678 (Eubel, et al., *Hierarchia*, V. 5, no. 9).

22. Titi, 1686, p. 357; Coudenhove-Erthal, *Carlo Fontana*, pp. 41 ff.

23. L. Muñoz-Gasparini, *S. Marcello al Corso*, Le chiese di Roma illustrate, 16 (Rome, n.d.), p. 24; Coudenhove-Erthal, *Carlo Fontana*, pp. 51 ff.

2. Lazzaro Morelli

1608 born in Ascoli Piceno, on 30 October

before 1639 Ascoli Piceno, Civica Pinacoteca, portrait bust of Cardinal Felice Centini[1]

1639 Ascoli Piceno, S. Francesco, exterior of the right transept, *tabernacolo*[2]

1642 Ascoli Piceno, corner (*cantonata*), Palazzo del Seminario, coat of arms of Cardinal Gabrielli[3]

1646–47 St. Peter's Basilica, above the niche containing the Tomb of Pope Urban VIII, two putti carrying the coat of arms of the pope (Bernini)[4]

1647 St. Peter's Basilica, nave, third arch on the right, left spandrel, colossal stucco figure (in relief) representing Peace (Bernini)[4]

1655 S. Maria del Popolo, nave, second arch on the right, right spandrel, life-size stucco figure (in relief) of S. Pudenziana (Bernini)

1656 Porta del Popolo and S. Maria del Popolo, façade, decorative work in stucco and travertine (Bernini)[5]

1657–65 St. Peter's Basilica, *Cathedra Petri*, miscellaneous work including the supervision of construction while Bernini was in France (Bernini)

1661–72 Piazza di S. Pietro, colonnade, more than twenty colossal travertine statues of saints (Bernini)[6]

1669 Ponte S. Angelo, colossal statue of the *Angel Carrying the Scourge* (Bernini)

1670 Capitoline Hill, temporary triumphal arch in honor of the coronation of Pope Clement X, stucco statues of Hercules and Atlas (Carlo Rainaldi)[7]

1673–76 St. Peter's Basilica, Tomb of Pope Alexander VII, miscellaneous work including the carving of the travertine substructure of the shroud (covered with colored marble), work on the statue of Truth—which was completed by Giulio Cartari—and adjustments to the wax model of *Death* before it was cast in bronze (Bernini)

1674–76 S. Maria di Monte Santo and S. Maria dei Miracoli, attics of the façades, over life-size travertine statues of female saints[8]

between 1674 and 1686 S. Maria di Monte Santo, Cappella Aquilanti, stucco decoration[9]

between 1676 and 1686 St. Peter's Basilica, Tomb of Pope Clement X, colossal statue of Benignity (Mattia de Rossi)[10]

1680 France (?), one statue and ten busts (all unidentified)[11]

1691 8 September, died and was buried in S. Lorenzo in Lucina[12]

1. Fabiani, *Artisti*, p. 168. Centini became a cardinal on 12 August 1611 and died on 24 January 1641 (Eubel, et al., *Hierarchia*, IV, 12, no. 30).

2. Fabiani, *Artisti*, p. 168.

3. Pascoli, *Vite*, p. 448; Fabiani, *Artisti*, p. 167. Pascoli also states that Morelli carved a travertine statue that was placed in the *cortile* of the Casa dei Migliani. Fabiani does not mention such a statue.

4. C. Galassi-Paluzzi, *S. Pietro in Vaticano*, Le chiese di Roma illustrate, 74–78bis (Rome, 1963), II, 42.

5. See p. 109, n. 9.

6. Wittkower, *Art and Architecture*, p. 371, n. 39; J. Montagu, "Two Small Bronzes from the Studio of Bernini," *The Burlington Magazine* 109 (1967), 570. Both authors cite documents showing that Morelli also worked on a wooden model of the colonnade and on models of the statues.

7. Archivio Capitolino, Rome, *Cred.* VI, tom. 3, contains a list of payments to sculptors for the decoration of the arch.

8. V. Golzio, "Le chiese di S. Maria di Montesanto e di S. Maria dei Miracoli a Piazza del Popolo," *Archivi d'Italia* 8 (1941), 133 ff.

9. Titi, 1686, p. 356, states that the chapel was designed by Carlo Rainaldi and that the *stucchi* are by (Filippo) Carcani and Morelli.

10. Titi, 1686, p. 11; Galassi-Paluzzi, *S. Pietro*, II, 108.

11. J. Guiffrey, *Comptes des bâtiments du roi* (Paris, 1881), I, col. 1287.

12. Pascoli, *Vite*, II, 448 ff., states that Morelli worked on the travertine horse and lion of the Fountain of the Four Rivers in Piazza Navona and modeled *stucchi* in the Cappella del Sacramento of St. Peter's. Neither attribution is borne out by existing documents. Pascoli also notes that Morelli made tombs and portraits for S. Maria in Aracoeli, as well as works in stucco, travertine, and marble for various churches, palaces, and villas, and that he sent work to France, England, and other principal cities of Europe.

3. Paolo Naldini

1614 Born in Rome

ca. 1630 Apprenticed to Andrea Sacchi

ca. 1645 Velletri, Palazzo Ginnetti (destroyed), stucco decorations (Martino Longhi the Younger)[1]

ca. 1645 Velletri, S. Apollonia (destroyed), stucco decorations[2]

1649–52 S. Martino ai Monti, clerestory and entry walls, twelve colossal stucco statues of saints and ten stucco profile portraits of popes in medallions; above the colonnades of the nave, hieroglyphic frieze[3]

1655 Palazzo Cardelli, *piano nobile*, terrace fountain, over life-size stucco statue of Apollo[4]

1656 Naldini recorded as living in Campo Marzio and being poor[5]

1663 S. Nicola da Tolentino, nave vault above the entrance to the church, stucco relief representing St. William, duke of Acquitaine.[6]

1664 Ariccia, S. Maria dell'Assunzione, base of the dome, stucco decoration consisting of garlands, twelve putti, and four angels (Bernini)

1665 St Peter's Basilica, gilt stucco glory above the *Cathedra Petri*, miscellaneous work (Bernini)

1665 Palazzo Vaticano, Scala Regia, stucco figures and putti (Bernini)

1666 Piazza di S. Pietro, colonnade, two colossal travertine statues of saints (Bernini)[7]

1668–71 Ponte S. Angelo, colossal statues of *Angels Carrying the Robe and Dice and the Crown of Thorns* (Bernini)

1670 Capitoline Hill, temporary triumphal arch erected in honor of the coronation of Pope Clement X, two stucco figures representing fame carrying the arms of the pope (Carlo Rainaldi)[8]

ca. 1672 Il Gesù, drum of the dome, statues of Temperance and Justice[9]

before 1674 S. Giovanni in Fonte, Oratorio di S. Venanzio, putti (Carlo Rainaldi)[10]

before 1674 S. Marcello al Corso, life-size stucco statue of an angel seated on a celestial globe supporting the pulpit[11]

1674 Protomoteca Capitolina, life-size portraits of Raphael and Annibale Carracci[12]

after 1674 S. Maria del Suffragio, Cappella Marcaccioni, portrait busts and stucco decorations[13]

ca. 1675 Todi, S. Filippo Benizzi, over the high altar, statue of St. Philip Benizzi[14]

after 1675 S. Maria di Monte Santo, third chapel right, putti carrying stucco garlands[15]

1677 Pantheon, first chapel on the right, portrait bust of James Gibbs[16]

1678–80 Gesù e Maria al Corso, tympanum of the high altar, two life-size stucco statues of angels carrying the globe of the world; atop the lateral columns flanking the altar, two over life-size stucco statues of angels kneeling in prayer (Carlo Rainaldi)[17]

ca. 1680 S. Anna dei Funari (destroyed), four under life-size statues of angels carrying an image of the Madonna (Carlo Rainaldi)[18]

1691 died in Rome[19]

1. A. Tersenghi, *Velletri e le sue contrade* (Velletri, 1910), pp. 258 ff.; Passeri, *Die Künstlerbiographien*, p. 230, n. 4.

2. Tersenghi, *Velletri*, p. 223.

3. See p. 110, n. 12.

4. G. Scano, "Palazzo Cardelli," *Capitolium* 36, no. 10 (1961), 24, 26, n. 26.

5. Wittkower, *Art and Architecture*, pp. 211, 271, n. 41.

6. ASR, Corporazioni Religiosi, Agostiniani Scalzi, busta 274, fasc. 716, fol. 121, records the payment of ▽ 15 to Naldini for the relief on 4 November 1663. Naldini may have modeled other reliefs in the vault of the church, but I found no other payments to him. Naldini is mentioned

in conjunction with the decoration of the vault of S. Nicola da Tolentino by Eimer, *La Fabbrica*, II, 562.

7. Naldini received 220 scudi for carving the two statues on 30 December 1666 (Archivio della R. Fabbrica di S. Pietro, *serie armadi*, vol. 348, fol. 32).

8. See p. 142, n. 7.

9. Pascoli, *Vite*, II, 461. It seems likely that these statues were modeled as part of the decoration of the vaulting of the Gesù under the direction of Giovanni Battisti Gaulli.

10. Titi, 1674, p. 232; Pascoli, *Vite*, II, 461.

11. Titi, 1674, p. 382.

12. Titi, 1674, p. 393; V. Martinelli and C. Pietrangeli, *La Protomoteca Capitolina* (Rome, 1954), pp. 7, 29, 64, 80.

13. Bruhns, "Das Motiv", p. 380.

14. F. Mancini, *Todi e i suoi castelli* (Città di Castello, 1960), p. 106; Thieme-Becker, XXV, 336.

15. Titi, 1686, p. 356. The decoration of the chapels must postdate the completion of the church, which was finished for the Holy Year 1675 (Wittkower, *Art and Architecture*, p. 184).

16. Titi, 1686, p. 327; K. Noehles, *La Chiesa dei SS. Luca e Martina nell'opera di Pietro da Cortona* (Rome, 1970), pp. 106 ff., n. 233, notes that the bust of Gibbs seems to have been designed by Pietro da Cortona.

17. F. Fasolo, *L'Opera di Hieronimo e Carlo Rainaldi* (Rome, 1961), pp. 315 ff.; Barbagallo, *La Chiesa*, pp. 21 ff.

18. Titi, 1686, p. 78; M. Armellini, *Le chiese di Roma* (Rome, 1942), II, 1250, notes that the church was renovated between 1654 and 1682.

19. Pascoli, *Vite*, II, 461 ff., states that Naldini worked in Viterbo, Orvieto, and Perugia, that he carved two putti for Andrea Sacchi, and that he carved a coat of arms flanked by two travertine statues of Temperance and Justice for an unidentified Roman palace.

4. Cosimo Fancelli

ca. 1620 Born in Rome

ca. 1644 S. Maria Porta Paradisi, Tomb of dott. Matteo Caccia, statue of the deceased reclining on a bier and two putti flanking his coat of arms[1]

ca. 1646 S. Lucia alle Botteghe Scure (destroyed), Tomb of Faustina Gottardi Ginnasi, bust of the deceased[2]

1647 St. Peter's Basilica, nave, left spandrel of the second arch on the right, colossal stucco figure (in relief) of Contemplation (Bernini)[3]

between 1648 and 1660 SS. Luca e Martina, lower church, vestibule in front of the entrance to the Cappella di S. Martina, *peperino* statuettes of SS. Theodora, Sabina, and Dorothy; Cappella di S. Martina, ciborium, two small reliefs (alabaster on a field of lapis lazuli) of the Madonna and Child appearing to S. Martina (Pietro da Cortona)[4]

1650s Il Gesù, Cappella Cerri, under life-size statue of Justice and portrait bust of Antonio Cerri (Pietro da Cortona)[5]

1656 S. Maria della Pace, Cappella Chigi, niche in the right wall, under life-size statue of St. Catherine of Siena; altar, bronze relief of the Trinity; left of the entrance to the chapel, a small relief of putti carrying instruments of the Passion; inside of the façade of the church, over the main entrance, two stucco statues (Pietro da Cortona)[6]

before 1660 S. Agostino, first pier left of the nave, facing the entrance, under life-size statue of an angel carrying a holy-water font[7]

ca. 1660 S. Marco, Monument of Cardinal Vidmann, portrait of the cardinal, two putti, and an eagle (Pietro da Cortona)[8]

ca. 1660 S. Maria in Via Lata, lower church, altar, high relief representing SS. Peter, Paul, Luke, and Marshal; and a terracotta relief of the Holy Family (Pietro da Cortona)[9]

ca. 1660 S. Girolamo della Carità, Cappella Spada, right side, life-size statue of Tommaso Spada reclining on a black marble bench and three medallions containing life-size portraits (in relief) of members of the Spada family[10]

1662–65 S. Maria in Vallicella, vault, clerestory windows and spandrels of the arches of the nave, stucco decorations (in relief) consisting of over life-size figures of angels, putti, and allegories (Pietro da Cortona)[11]

1666 Monteporzio, Duomo, stucco decoration (Carlo Rainaldi)[12]

1667 Palazzo di SS. Apostoli, alcove of Cardinal Flavio Chigi (?), two stucco figures[13]

1667–68 Palazzo di Propaganda Fide, Chapel, tympanums of the entrance and altar, under life-size stucco figures (Borromini)[14]

1668–69 Ponte S. Angelo, colossal statue of the *Angel Carrying the Sudarium* (Bernini).

1668–69 S. Carlo al Corso, nave, stucco decoration (Pietro da Cortona)[15]

1668–69 S. Nicola da Tolentino, Cappella Gavotti, altar, under life-size relief representing the Madonna of Savona (Pietro da Cortona)[16]

1670 Capitoline Hill, temporary triumphal arch erected in honor of the coronation of Pope Clement X, two stucco statues of Justice and Nobility (Carlo Rainaldi)[17]

1671 S. Maria Maggiore, Tomb of Pope Clement IX, under life-size statue of Faith (Carlo Rainaldi)[18]

1671–72 S. Maria sopra Minerva, Cappella Altieri, portrait busts of two members of the Altieri Family[19]

1672–74 Palazzo Borghese, garden, model for the "theater" of fountains and for one of the fountains (Giovanni Paolo Schor);

gallery, stucco decorations (Carlo Rainaldi and Gio. Francesco Grimaldi)[20]

1673–76 S. Carlo al Corso, crossing, four over life-size reliefs of music-making angels[21]

before 1674 S. Giovanni in Fonte, Oratorio di S. Venanzio, Tombs of Cardinal and Monsignor Ceva, portraits[22]

before 1674 S. Maria sopra Minerva, Tomb of Cardinal Carlo Bonelli, over life-size statue of Justice (Carlo Rainaldi)[23]

1677 S. Carlo al Corso, tribune, flanking the high altar, two over life-size stucco reliefs, each containing two saints[24]

1688 Died 3 April[25]

1. Titi, 1674, pp. 418 ff., notes that the church was decorated "per un Legato del Medico Matteo Caccia da Orti." Matteo Caccia died in 1644. V. Forcella, *Iscrizioni delle chiese e d'altri edificii di Roma dal secolo XI fino ai giorni nostri* (Rome, 1869–84), XII, 94, no. 145; *Via del Corso*, Cassa di Risparmio di Roma (Rome, 1961), pp. 136 ff.

2. The tomb is first mentioned by Titi, 1686, p. 436, who attributes it to Giacomo Antonio and Cosimo Fancelli. Faustina Gottardi Ginnasi died in 1646 (Forcella, *Iscrizioni*, V, 404, no. 1104).

3. Galassi-Paluzzi, *S. Pietro*, II, 42.

4. In the vestibule is a fourth statue, under which is inscribed the name of St. Euphemia. This statue is traditionally attributed to Pompeo Ferrucci (1566–1637). The date of Fancelli's small statues and reliefs is unclear. Payments for work on the vestibule continue through 1659, and payments for casting parts of the bronze ciborium were still being made in the 1660s. See Noehles, *La Chiesa*, p. 104, n. 216, p. 108, n. 239, pp. 184–85.

5. H. Hibbard, "*Ut picturae sermones*: The First Painted Decorations of the Gesù," *Baroque Art: The Jesuit Contribution*, eds. Rudolf Wittkower and Irma B. Jaffe (New York, 1972), p. 43.

6. Titi, 1674, p. 453. For the dating, see H. Ost, "Studien zu Pietro da Cortonas Umbau von S. Maria della Pace," *Römisches Jahrbuch für Kunstgeschichte* 13 (1971), 243.

7. Martinelli, "Roma ornata," p. 6 (D'Onofrio, *Roma nel Seicento*, p. 11): "In ambedue li pilastri nell'entrar della porta grande sono due Angeli di marmo con uaso in mano p l'Aqua benedetta, e quello a mano manca è opera delli Fancelli Romani, l'altro di Monsù Adami."

8. Titi, 1674, p. 201. Cardinal Vidman died 30 September 1660 (Eubel, et al., *Hierarchia*, IV, 29, no. 16).

9. Titi, 1674, p. 350. The date of around 1660 is given by Wittkower, *Art and Architecture*, p. 209.

10. Titi, 1674, p. 120. The chapel is usually dated 1660 because the church was rebuilt in that year. For a recent discussion of the problem see Montagu, "Antonio and Gioseppe Giorgetti," p. 279, n. 13. The architecture of the chapel has often been attributed to Borromini. The attribution is questionable, for Martinelli, "Roma ornata," p. 92 (D'Onofrio, *Roma nel Seicento*, 71), states that "La cappella delli Spada tutta di pietre commesse che rappresentano un apparato di broccato in camera di riposo con diverse scolture di diversi giovani è architettura

di. . . ." To this he later added "non è stata completata neppure dal Borromini."

11. Briganti, *Pietro da Cortona*, p. 267.

12. The completion of the Duomo at Monteporzio is usually dated 1666 on the basis of an inscription. See A. Nibby, *Analisi storico topografico antiquaria della carta de'dintorni di Roma* (Rome, 1837), II, 358. Fasolo, *L'Opera*, p. 374, n. 13, dates the work to 1670–72. Fancelli's work at Monteporzio is recorded by Pascoli, *Vite*, II, 473.

13. Golzio, *Documenti*, pp. 14, 76.

14. Titi, 1674, p. 473. The decoration of the chapel was completed after Borromini's death (Wittkower, *Art and Architecture*, p. 144).

15. G. Drago and L. Salerno, *SS. Ambrogio e Carlo al Corso*, Le chiese di Roma illustrate, 96 (Rome, 1967), p. 92.

16. See p. 141, n. 12. Fancelli originally may have made models for statues of SS. Ann and Elizabeth to be placed in the niches above the tombs on the side walls of the chapel, for such statues are reported by G. A. Bruzio, "Chiese de' canonici e de' Regolari, et altre del clero romano," BV, *Vatic. Lat.* 11886, fol. 593. These niches were filled with statues of SS. Joseph and John the Baptist by Ercole Ferrata and Antonio Raggi.

17. See p. 142, n. 7.

18. Titi, 1674, p. 291. E. Rossi, "Roma Ignorata," *Roma* 18 (1940), p. 237, quotes an *avviso* of 1671 that records the placing of the statue of Pope Clement IX on his tomb.

19. Titi, 1674, p. 174; A. Schiavo, *The Altieri Palace* (Rome, 1964), p. 185.

20. H. Hibbard, "Palazzo Borghese Studies I: the Garden and its Fountains," *The Burlington Magazine* 100 (1958), 205–12; idem, "Palazzo Borghese Studies II: the Galleria," *The Burlington Magazine* 104 (1962), 9–20.

21. Drago and Salerno, *SS. Ambrogio e Carlo*, p. 64.

22. Titi, 1674, p. 232.

23. Titi, 1674, pp. 176 ff.

24. Drago and Salerno, *SS. Ambrogio e Carlo*, p. 97.

25. Pascoli, *Vite*, II, 473 ff., states that Fancelli was called to work in Naples and that he sent works to the Marches, Lombardy, Piedmont, and other parts of Italy. He also states that Fancelli made a bust of Jesus for the Church of S. Nicola in Arcione. No such bust exists or is cited in seventeenth-century sources.

5. Cavalier Girolamo Lucenti[1]

ca. 1625. Born in Rome

1647–49 St. Peter's Basilica, Pilasters of the nave and aisles, decoration (Bernini)

1654 Mentioned in Algardi's will as one of that master's chief assistants.

1658–63 Castel S. Angelo, bronze artillery pieces

1668–69 Ponte S. Angelo, colossal statue of the *Angel Carrying the Nails* (Bernini)

1668–98 Die engraver for the Papal Mint

1673–74 St. Peter's Basilica, Cappella del Sacramento, ciborium, casting the wax and wood model in bronze (Bernini)[2]

1674 Location unknown, bronze cast of a triton for Don Angelo Altieri[3]

1675 7 August, elected a member of the Università degli Orefici

1675–76 St. Peter's Basilica, Tomb of Pope Alexander VII, bronze cast of the figure of Death (Bernini)

1679–86 S. Maria dei Miracoli, Tomb of Cardinal Girolamo Gastaldi, life-size statues of Faith and Hope, two putti, and a life-size bronze portrait of the cardinal; Tomb of Marchese Benedetto Gastaldi, two putti and a life-size bronze portrait of the marchese (Carlo Fontana)[4]

1684–85 St. Peter's Basilica, chapel altars, casting of bronze candlesticks[5]

Before 1686 S. Maria di Monte Santo, apse, life-size bronze portrait busts of Popes Alexander VII, Clement IX, Clement X, and Innocent XI[6]

ca. 1692 S. Maria Maggiore, portico, colossal bronze statue of King Philip IV of Spain (Bernini)[7]

1692–93 Basilica of St. Peter's, project for the decoration of the baptistry, model of a figure representing Purity[8]

1698 4 April, died in Rome

1. See p. 110, nn. 18–19, for bibliographical sources for Lucenti's work in fields other than sculpture.
2. Lucenti was paid for casting the ciborium between April 1673 and December 1674. See Archivio della R. Fabbrica di S. Pietro, *secondo piano, serie* 4, vol. 14, fols. 11ᵛ, 21ᵛ, 28, 32ᵛ, 41, 47ᵛ, 56, 65ᵛ, 72; vol. 15, fols. 4, 12, 17ᵛ, 18ᵛ, 29ᵛ, 30, 40, 46, 70, 73ᵛ; Weil, "A Statuette of the Risen Christ," pp. 8–12.
3. Archivio della R. Fabbrica di S. Pietro, *serie armadi*, vol. 312, fol. 34ᵛ.
4. See p. 141, n. 22.
5. Archivio della R. Fabbrica di S. Pietro, *serie armadi*, vol. 375, fols. 198, 200, 204; *secondo piano, serie* 4, vol. 26, list of payments dated 21 February 1684.
6. Titi, 1686, p. 365.
7. Brauer and Wittkower, *Die Zeichnungen*, pp. 157–60.
8. Archivio della R. Fabbrica di S. Pietro, *serie armadi*, vol. 391, fols. 41, 47ᵛ.

6. Ercole Ferrata

1610 Born in Pelsotto, Lombardy

1630–ca. 1637 Genova, apprenticed to the sculptor Tommaso Orsolino

1637 Naples, member of the Corporazione dei Scultori e Marmorari[1]

1637–41 Naples, unidentified decorative sculpture; unidentified statue of Marchese Taragusa's son, a youth who had died a few years earlier in a battle before the gates of Barcelona

1641 Naples, Chiesa dell'Annunziata, high altar, statues (destroyed by fire in 1757; Cosimo Fanzago)

between 1641 and 1646 Naples, S. Maria la Nova, Cappella di S. Giacomo della Marca, life-size statues of St. Andrew, St. Thomas Aquinas, and two members of the D'Aquino family kneeling in prayer

between 1641 and 1646 Made in Naples for the Duca di S. Giorgio, a statue of Venus and other figures, some of which were sent to Spain

between 1641 and 1646 S. Maria di Capua, garden of a Palazzo or Villa Corsini (?), a group of *Orpheus on the Mountain Surrounded by Animals*

between 1641 and 1646 Made in Naples for Cardinal Savello, Archbishop of Salerno, a statue (?) of a seated Venus and Cupid later sent to Rome

1646 Formerly Aquila, S. Maria di Roio, high altar, statue of S. Rocco[2]

1646 Formerly Aquila, S. Antonio di Padova, over the main entrance, statue of St. Anthony of Padua

1647–49 St. Peter's Basilica, pilasters of the nave and chapels, two reliefs of putti carrying the papal tiara and keys and two reliefs of putti carrying medallions containing portraits of popes (Bernini)

ca. 1649 S. Francesca Romana, crypt, medallion of S. Francesca Romana and an angel holding a book (Bernini)

1653–54 S. Nicola da Tolentino, high altar, life-size statue of S. Nicola da Tolentino; tympanum above the altar, relief of God the Father (Algardi); vaulting above the transept altars, stucco decoration (Giovanni Maria Baratta)[3]

ca. 1654 S. Maria sopra Minerva, Tomb of Cardinal Pimentel, over life-size figures of the cardinal kneeling in prayer, Faith, and Wisdom (Bernini)

1654 Spain, Aranjuez, palace park, under life-size bronze statue of Neptune (Algardi)[4]

1654 S. Agnese in Piazza Navona, four under life-size reliefs, each of one putto; one under life-size relief of two putti[5]

1654 Palazzo dell' Oratorio dei Filippini, work on the colossal stucco relief of a miracle of St. Agnes (Algardi)[6]

ca. 1656 S. Maria della Pace, Cappella Chigi, niche left of the altar, life-size statue of St. Bernardino of Siena; tympanum of the

altar, two putti; right of the entrance to the chapel, small relief of putti carrying instruments of the Passion (Pietro da Cortona)[7]

1657–60 St. Peter's Basilica, *Cathedra Petri*, miscellaneous work (Bernini)

ca. 1659 S. Giovanni dei Fiorentini, right transept, portrait bust of Ottaviano Acciajoli[8]

ca. 1660 S. Girolamo della Carità, Cappella Spada, left side, life-size statue of Bernardino Lorenzo Spada reclining on a black marble couch, and three medallions containing life-size portraits of members of the Spada Family[9]

1660–72 S. Agnese in Piazza Navona, right transept, over life-size statue of *St. Agnes on the Pyre*, two angels, and three putti (above the statue); altar to the right of the high altar, over life-size relief of the *Martyrdom of St. Emerenziana;* altar to the left of the entrance, over life-size relief of St. Eustace (begun by Melchiorre Caffà); lunettes above the reliefs decorating the four corner altars, stucco reliefs of putti carrying emblems referring to the scenes below; and three models for the high altar[10]

1661–63 Siena, Duomo, Cappella Chigi, statue of St. Catherine of Siena (Bernini)

1662 S. Francesco a Ripa, pilaster between the third and fourth chapels on the left, Tomb of Giulia Ricci Paravicino, bust of the deceased[11]

1662–65 S. Maria in Vallicella, vault, clerestory windows and spandrels of the arches of the nave, stucco decorations (in relief) consisting of over life-size figures of angels, putti, and allegories (Pietro da Cortona)[12]

1662–71 S. Agostino, Cappella Pamphilij, tympanum above the altar, over life-size figures of God the Father and two angels (begun by Giuseppe Peroni); niche above the altar, over life-size statues of Charity and two putti of the group of the *Charity of St. Thomas of Villanova* (begun by Melchiorre Caffà; Giovanni Maria Baratta, architect)[13]

1664–65 S. Andrea della Valle, façade, to the right of the entrance, over life-size travertine statues of St. Andrew and the Blessed Andrew of Avellino; left of the attic, colossal statue of an angel (Carlo Rainaldi)[14]

1665–85 S. Giovanni dei Fiorentini, Cappella Falconieri, Monument of Cardinal Lelio Falconieri, life-size statue of Faith[15]

1666–67 Piazza di S. Maria sopra Minerva, *Elephant Carrying an Obelisk* (Bernini)

1668 Siena, Duomo, right transept, over life-size statue of Pope Alexander III (begun by Melchiorre Caffà)[16]

1668–9 Ponte S. Angelo, colossal statue of the *Angel Carrying the Cross* (Bernini)

1668–69 S. Nicola da Tolentino, Cappella Gavotti, niche in the

right wall, under life-size statue of St. Joseph; lunette above the right wall, circular stucco relief containing the image of St. Philip Neri (Pietro da Cortona)[17]

1669 Palazzo dei Conservatori, over life-size statue of Tommaso Rospigliosi, Governor of the Castel S. Angelo, 1667–69[18]

before 1670 Marino, S. Barnaba, life-size statue of St. Anthony Abbot[19]

1671 S. Maria Maggiore, Tomb of Pope Clement IX, under life-size statue of Charity (Carlo Rainaldi)[20]

before 1674 S. Maria sopra Minerva, Tomb of Cardinal Michele Bonelli, life-size relief (white marble against a black marble ground) of Eternity and a putto carrying a bronze medallion containing a portrait of the cardinal (Carlo Rainaldi)[21]

1676 S. Maria dei Miracoli, attic of the portico, over life-size travertine statue of a female saint[22]

1676–86 St. Peter's Basilica, Tomb of Pope Clement X, colossal statue of the pope blessing *ex cathedra* (Mattia de Rossi)[23]

1677–78 Florence, restoration of antique statues in the collection of the grand duke[24]

1679–83 Poland, Breslau, Cathedral, Elisabethkapelle, altar, statue of St. Elisabeth accompanied by three putti, six cherubs, and two statues of angels on columns flanking the altar[25]

before 1686 Gesù e Maria al Corso, left of the entrance, Tomb of Iulio a Cornu, under life-size figure of Time crouching on a sarcophagus, tearing a black marble drapery containing an inscription; two putti flanking the sarcophagus; and two putti carrying a portrait medallion at the top of the tomb (Carlo Rainaldi)[26]

before 1686 S. Maria dell'Anima, second chapel on the right, right wall, life-size half-length portrait of Monsignor Gaultiero Gaultieri[27]

before 1686 Nepi, Duomo, below the high altar, relief of S. Romano on his bier surrounded by three angels and a woman[28]

1686 S. Anastasia, under the high altar, statue of St. Anastasia dying (begun by Francesco Aprile)[29]

1686 11 July, died in Rome[30]

1. For Ferrata's Neapolitan period, see p. 110, n. 22.

2. Ferrata's work in Aquila is recorded by Baldinucci, *Notizie*, IV, 519; G. Rivera, *Elenco dei monumenti aquilani* (Aquila, 1896), p. 21.

3. See pp. 110, n. 23, 111, n. 34.

4. See p. 110, n. 23.

5. L. Montalto, "Ercole Ferrata e le vicende litigiose del basso rilievo di Sant' Emerenziana," *Commentari* 8 (1957), 47–68, quotes documents concerning all of Ferrata's work for S. Agnese.

6. N. Wibiral, "Die Agnesreliefs für S. Agnese in Piazza Novona," *Römische historische Mitteilungen* 3 (1958–50), 255–78; Eimer, *La Fabbrica,*

I, p. 349.

7. See p. 144, n. 6.

8. Titi, 1674, p. 469. Ottaviano Acciajoli died in 1659 (Forcella, *Iscrizioni*, VII, 31, no. 75).

9. See p. 144, n. 10.

10. Montalto, "Ercole Ferrata," pp. 47–68; Eimer, *La Fabbrica*, II, 484 ff. and 494–501.

11. Baldinucci, *Notizie*, IV, 520 ff. The inscription on Giulia Ricci Paravicini's tomb informs us that she died in 1662. See A. Nava-Cellini, "Per Alessandro Algardi e Domenico Guidi," *Paragone* 11, no. 121 (1960), 67.

12. See p. 144, n. 11.

13. Ferratta was commissioned to carve the figures of God the Father and two angels on 23 August 1662 (ASR, *Notari dell' A. C.*, vol. 6689, fols. 640, 640,ᵛ and 663). A document of 9 September 1669 (ASR, *Notari dell' A. C.*, vol. 6729, fols. 756, 756,ᵛ and 791) informs us that before his death Caffà had almost finished the statue of St. Thomas of Villanova and had roughed out the marble for the statue of Charity. A. Nava-Cellini, "Contributi a Melchior Caffà," *Paragone* 7, no. 83 (1956), 17–31, has attempted to reconstruct the history of the chapel.

14. The sculptural decoration of the façade of S. Andrea della Valle was commissioned in 1664 (contracts in ASR, *Corp. relig.* 2119, fasc. 39). The statues of St. Andrew and the Blessed Andrew of Avellino were commissioned on 25 April 1664, as were Domenico Guidi's statues of St. Sebastian and S. Gaetano. Giacomo Antonio Fancelli was commissioned to carve the statues over the frontispiece of the door and the putti carrying medallions over the niches containing the statues by Ferrata and Guidi on 14 May 1664. All three sculptors promised to carve the statues according to the designs of Cavalier Rainaldi. Payments to the three sculptors began immediately and continued through 1665 (ASR, *Corp. Relig.* 2197, fols. 38–44). See Hibbard, *Carlo Maderno*, p. 154.

15. See p. 111, n. 36.

16. W. Hager, *Die Ehrenstatuen der Päpste* (Leipzig, 1929), p. 25.

17. See p. 144, n. 11.

18. Archivio Capitolino, Rome, *Cred.* VI, vol. 3, fol. 407, contains a document of 10 September 1669 that records a payment for the delivery of two blocks of marble to Ferrata for the statue of Tommaso Rospigliosi.

19. Baldinucci, *Notizie*, IV, 524. The statue seems to be stylistically related to Ferrata's work of the 1660s.

20. See p. 144, n. 18.

21. See p. 144, n. 23.

22. See p. 142, n. 8.

23. See p. 142, n. 10.

24. See Baldinucci, *Notizie*, IV, 521, who also notes that before receiving the commission for the statue of Pope Clement X, Ferrata had been commissioned to carve the statue of Pope Innocent X for the latter's tomb in S. Agnese in Piazza Navona. Ferrata made a model and acquired a block of marble but lost the commission because Principe Pamphili thought that he was too old to complete the work. See also Eimer, *La Fabbrica*, I, 95, and above, p. 110, n. 24.

25. A description of the Elisabethkapelle is published in C . . . , "Beschreibung der churfürstlichen und Kardinals-Kapelle in Kathedralkirche zu St. Johann, auf dem Dom zu Breslau," *Neue Miscellaneen artistischen Inhalts für Künstler und Kunstliebhaber*, (Leipzig, 1795), I, 53 ff. Documents have been published by D. R., "Hochmesswürdige Kunstschassung," *Kunstblatt*, no. 73 (10 September 1821), 292. Bruhns, "Das Motiv," pp. 360–64, cites additional sources.

26. Titi, 1686, pp. 351 ff.

27. Baldinucci, *Notizie*, IV., 521. A. Nava-Cellini, "Per l'integrazione e la svolgimento della retrattistica di Alessandro Algardi," *Paragone* 15, no. 177 (1964), p. 30, dates the bust around 1660 because she finds it to be Algardesque. The bust is dated late here because the handling of details such as the attenuation of the fingers and focus of the eyes seems to reflect the late portraits of Bernini.

28. Baldinucci, *Notizie*, IV, 521.

29. Titi, 1686, p. 373, states that this was Ferrata's last work.

30. Baldinucci, *Notizie*, IV, 521, 524, cites the following works, none of which have been identified: a portrait of Principe Giustiniani (Palazzo Giustiniani?), a portrait of Cardinal Alderrano Cybo, statues of Neptune, four tritons and several dolphins for a fountain in Portugal, and small groups of two putti fighting and the infant Hercules strangling a serpent.

7. Antonio Giorgetti

ca. 1635 Born in Rome[1]

1658 Location unknown, aventurine casket made for Cardinal Francesco Barberini; several silver statuettes (Michele Sprinati)

1659–68 Grottaferrata, Abbey, iconostasis, including two over life-size statues of angels draped in bronze, kneeling in adoration before an icon of the Madonna and Child; frame of the icon; relief of putti and cherubs on a field of lapis lazuli; atop the frame, two putti carrying a crown

ca. 1660 S. Girolamo della Carità, Cappella Spada, two life-size statues of angels holding a cloth of Sicilian jasper

1660 St. Peter's Basilica, crystal reliquary or vase containing the tip of the Lance, top

1661 S. Lorenzo fuori le mura, Tomb of Girolamo Aleandro, bust of the deceased

1661–63 S. Maria dell'Anima, Tomb of Lucas Holstenius

1661–68 Miscellaneous work for Cardinal Francesco Barberini, including the restoration of antiquities, the making of alabaster columns, frames of colored marbles, a *presepio*, and inscribed tablets for the tombs of John Barclay (location unknown) and Monsignor Spada (S. Lorenzo in Damaso)

1662 *Tableau vivant* for a display of fireworks held on 19 February in honor of the birth of the Spanish prince Don Carlos

1662 London, private collection, octagonal gilt bronze relief (31·5 x 41·2 cm.) of the Nativity

1666–67 Fossanova, Abbey, room in which St. Thomas Aquinas is said to have died, altar, under life-size relief of the *Death of St. Thomas Aquinas*

1667–68 Santa Marinella, Chiesa delle Figlie di Nostra Signora al Monte Calvario, high on the wall behind the high altar, under life-size relief of the *Nativity*

1668–69 Ponte S. Angelo, colossal statue of the *Angel Carrying the Sponge* (Bernini)

1669 Christmas Night, died in Rome

1. The date given for Giorgetti's birth is an estimate based on the fact that by 1660–61 he was fairly well established as a sculptor. For further information about Giorgetti's work, see p. 110, n. 28.

8. Domenico Guidi

1625 Born in Torano, a village in the marble quarries above Carrara

ca. 1643 Naples, Duomo (S. Gennaro), treasury, bronze casts of several statues modeled by Giuliano Finelli[1]

1647–53 St. Peter's Basilica, Altar of Pope Leo the Great, work on the colossal relief of the *Meeting of Pope Leo and Attila* (Algardi)[2]

ca. 1650 SS. Apostoli, crypt, life-size stucco statue of St. Claudia[3]

ca. 1650 S. Alessio al Monte Aventino, Tomb of Cardinal de' Bagni, life-size statue of the cardinal[4]

ca. 1652 Parma, S. Rocco, Tomb of the Duchessa di Poli, portrait of the decesased (Algardi)[5]

1653–54 S. Nicola da Tolentino, high altar, life-size group (in relief) of the *Madonna and Child, St. Augustine, and St. Monica* (Algardi)[6]

1654 St. Agnese in Piazza Navona, three under life-size reliefs, each of one putto; one under life-size relief of two putti[7]

1654 Palazzo dell' Oratorio dei Filippini, work on the colossal stucco relief of a miracle of S. Agnes (Algardi)[8]

ca. 1654 Spain, Aranjuez, palace park, under life-size bronze statue of Cybele (Algardi)[9]

ca. 1654 Bologna, Museo Civico, bronze statuette of the Archangel Michael (Algardi)[10]

ca. 1654 Formerly, S. Giovanni dei Bolognesi, Tomb of Algardi, portrait bust of the deceased (lost)[11]

ca. 1654 Gesù, Cappella Cerri, under life-size statue representing Prudence (Pietro da Cortona)[12]

1654–60 Gesù, chapels, bronze statuettes of Apostles[13]

between 1656 and 1661 France, Versailles, gardens, three life-size herms representing Pan, Minerva, and Faunus (Poussin)[14]

ca. 1657 S. Maria del Popolo, left aisle, second nave pier, Tomb of Natale Rondanini, including a life-size portrait bust of the deceased[15]

ca. 1657 Private collection, portrait bust of Paolo Emilio Rondanini, one of several busts carved by Guidi for the monuments of the Rondanini family in S. Maria della Concezione dei Monti (destroyed) and for the Palazzo Rondanini[16]

1659 Spain, El Escorial, Pantéon de los Reyes, gilt bronze crucifix[17]

1659, 1667–76 Palazzo del Monte di Pietà, chapel, colossal relief of the Pietà[18]

ca. 1660 S. Girolamo della Carità, chapel to the right of the high altar, above the entry arch, two putti carrying a coat of arms[19]

1660–61 Palazzo della Sapienza, Biblioteca Alessandrina, over life-size half-length portrait of Pope Alexander VII[20]

ca. 1661 S. Maria sopra Minerva, right aisle, second nave pier, Tomb of Monsignor Carlo Emanuele Vizzani, including a life-size portrait bust of the deceased in a niche embraced by a skeleton[21]

ca. 1662 S. Maria della Scala, left transept, Tomb of Livia Santacroce, bust of the deceased[22]

ca. 1663 S. Maria di Monserrato, refectory, Tomb of Francesco de Vides, including a life-size portrait bust of the deceased and two large putti[23]

1664–66 S. Andrea della Valle, façade left of the entrance, over life-size travertine statues of SS. Gaetano and Sebastian (Carlo Rainaldi)[24]

begun 1665 S. Giovanni dei Fiorentini, Cappella Falconieri, Tomb of Orazio Falconieri, over life-size group representing Charity[25]

ca. 1665 Carpegna, Palazzo Principale, dining room, portrait bust of Orazio Falconieri[26]

ca. 1668 Perugia, S. Agostino, Tomb of Monsignor Marcantonio Oddi[27]

1668–69 Ponte S. Angelo, colossal statue of the *Angel Carrying the Lance* (Bernini)

1671 S. Maria Maggiore, Tomb of Pope Clement IX, under life-size statue of Pope Clement IX (Rainaldi)[28]

begun ca. 1674 S. Agnese in Piazza Navona, high altar, over life-size relief of the *Holy Family with SS. John, Elizabeth, and Zachariah*[29]

begun 1674 S. Agostino, left transept, Tomb of Cardinal Lorenzo

Imperiali, including over life-size statues of the cardinal, Death, Time, Fame, and an eagle flying out of the cardinal's burial urn[30]

1677–86 France, Versailles, gardens, colossal group of *Fame Writing the Deeds of Louis XIV into the Book of History Carried by Time*, together with a medallion portrait of the same king (Charles Lebrun)[31]

ca. 1678 S. Andrea della Valle, entry passage left of the nave, door leading to the third chapel on the left, Cenotaph of Conte Gaspar Thiene, over life-size statues of Abundance and Prudence flanking the doorway, and an over life-size portrait bust of the deceased placed on a funeral urn above the doorway[32]

1679–83 Poland, Breslau, Cathedral, Elisabethkapelle, Monument of Cardinal Landgraf von Hessen, life-size statues of the cardinal kneeling in prayer, Truth, Eternity, and two putti[33]

ca. 1680–86 Malta, Valletta, S. Giovanni, Monument of the Grand Master Fra' Nicolao Catoner (1663–80), two life-size statues of enslaved Moslems crouching below a panoply of cannons, arms, and battle trophies that surround a bronze bust of the grand master, behind which rises an obelisk carrying a Maltese cross, flanked by two angels (or figures of Fame), the one on the right in flight, sounding a trumpet, and the one on the left holding the shield of Malta in front of the center of the obelisk[34]

ca. 1680–86 Gesù e Maria al Corso, Tomb of Monsignor Camillo del Cornu, under life-size figures in relief representing Death and two angels carrying a medallion portrait of the deceased[35]

ca. 1682 S. Francesco a Ripa, first chapel on the right, Tomb of Cardinal Michelangelo Ricci, life-size portrait bust of the cardinal[36]

before 1686 Palazzo Altieri (?), two putti fighting for a palm[37]

1686 France, Chateauneuf-sur-Loire, parish church, Tomb of Louis Phélipeaux, Sieur de la Vrillière, group of a guardian angel guiding the deceased to heaven[38]

after 1686 S. Maria della Vittoria, right transept, group of an *Angel Announcing the Flight into Egypt to St. Joseph*[39]

1690 Collection Principe Ottoboni, over life-size bronze portrait bust of Pope Alexander VIII[40]

1690 Spirito Santo de' Napolitani, Tomb of Cardinal Giovanni Battista de Luca, portrait of the cardinal in prayer at a prie-dieu, statues of Justice, Prudence, and two putti[41]

1692–93 St. Peter's Basilica, project for the decoration of the baptistry, model for a group of the *Baptism of Christ* (destroyed)[42]

begun 1693 S. Maria in Traspontina, Tomb of Cardinal Francesco Albizi[43]

ca. 1694 Formerly Modena, Palazzo Ducale, statue of Andromeda (lost or destroyed)[44]

ca. 1694 Formerly Sarzanna, S. Maria dell'Assunta, statues of Faith and Charity (lost or destroyed)[45]

1694–96 Perugia, S. Domenico, Tomb of Monsignor Alessandro Benincasa, portrait bust of the deceased[46]

1695 Torano, S. Maria degl'Abbandonati, statue of St. Apollonia[47]

ca. 1695 Genoa, S. Filippo Neri, pediment above the high altar, statues of S. Philip Neri and two angels[48]

1699 London, Public Records Office, Shaftbury Papers, drawings for projected statues of Prudence and Justice[49]

1701 28 March, died and was buried in S. Francesco delle Stimmate[50]

1. Baldinucci, "Notizie di Domenico Guidi," fol. 53, and Pascoli, *Vite*, II, 432, both state that Guidi, aged eighteen, cast seven of the thirteen statues that Finelli modeled for this project.

2. Passeri, *Die Künstlerbiographien*, p. 204.

3. Ibid., p. 317, n. 6. Baldinucci, "Notizie di Domenico Guidi," fol. 55 mentions this statue and adds, "e nella medisima chiesa all'altar maggiore fece quattro putti di marmo, e doi medaglie di San Filippo, e Giacomo."

4. Titi, 1674, p. 67. The cardinal died on 24 July 1641 (Eubel, et al., *Hierarchia*, IV, 22, no. 271).

5. Baldinucci, "Notizie di Domenico Guidi," fol. 57, states that Guidi carved the bust after Algardi's model and that he also made two marble putti and two bronze angels for this tomb. Neither putti nor angels are part of the tomb as it exists today. See Nava-Cellini, "Per Alessandro Algardi," pp. 61–68, fig. 39.

6. See p. 111, n. 34.

7. Montalto, "Ercole Ferrata," pp. 57 ff.

8. See p. 146, n. 6.

9. See p. 110, n. 23.

10. Hess, "Ein Spätwerk," pp. 300 ff.

11. G. P. Bellori, *Le Vite de' pittori, scultori et architetti moderni* (Rome, 1672), p. 402.

12. Titi, 1674, p. 201. Baldinucci, "Notizie di Domenico Guidi," fol. 54ᵛ, states that this was Guidi's first work after the death of Algardi. See p. 144, n. 5.

13. P. Pecchiai, *Il Gesù di Roma* (Rome, 1952), p. 200, notes that in about 1650 bronze statues of the Twelve Apostles and ten or twelve angels were made to decorate the altar of S. Ignazio, and that the statues were distributed among the minor altars of the church when the altar of S. Ignazio was redecorated at the end of the century. Jennifer Montagu has called my attention to documents that record payments for the Apostles. The documents, which are to be found in the Archivio della Chiesa del Gesù in deposito presso L'Archivio Romano della Compagnia di Gesù, Rome, vols. 2009–12, raise as many problems as they solve, but they make it clear that Algardi originally was responsible for the statues. Guidi's name first appears in the accounts in November

1654 when he received the final payment for two apostles. Guidi continued to receive payments through 1657. Payments for casting the Apostles in bronze continue through March 1660.

14. Bershad, "Guidi and Poussin," pp. 544–47.

15. Titi, 1686, p. 362. Rondanini died in 1657 (Forcella, *Iscrizioni*, I, 387, n. 1484).

16. Nava-Cellini, "Per l'integrazione," pp. 22 ff. Baldinucci, "Notizie di Domenico Guidi," fols. 55r&v, states that Signora Felice Zacchia Rondanini had Guidi carve five portraits placed "in un deposito nella chiesa della Concettione alli Monti e sono li infri il Cardinale Zacchia Padre della med.a Signora, il Cardinal S. Marcello fratello di Sup.a Cardinale, e il Cardinal Rondanini suo fratello, quale furo da esso fatti mediante il assistenza di Mons.re Marcello Rondanini suo figliolo, essendo nel med. tempo morta La Madre e doppo fece il Ritratto di Lei, e del Mons.re Auditore di Roma, Li quale doppo la sua morte furono da Alessandro Rondanini suo nipote portato in casa sua, dove al p.nte si conservano."

17. Federico Navarro Franco, "El Real Pantéon de San Lorenzo de El Escorial," *El Escorial, 1563–1963* (Madrid, 1963), II, 735 ff.

18. See p. 111, n. 31.

19. Baldinucci, "Notizie di Domenico Guidi," fols. 55v–56.

20. Guidi received *a conto* payments for the portrait on 20 July, 2 September, and 29 November 1660 and 7 February 1661 (ASR, *Camerale* I, *Giustificazioni*, busta 138, fols. 139, 151, 177, 187).

21. Baldinucci, "Notizie di Domenico Guidi," fol. 55v. Vizzani died in 1661 (Forcella, *Iscrizioni*, I, 500, no. 1930).

22. Nava-Cellini, "Per Alessandro Algardi," pp. 64 ff.

23. The inscription on the tomb informs us that Francesco de Vides died in 1663. The tomb was originally in S. Giacomo degli Spagnoli and was transferred to its present location at the end of the nineteenth century, when that church passed from the possession of the Spanish to the French. Campori, *Memorie*, p. 133, probably was referring to this tomb when he noted that Guidi carved a portrait and two putti for the Tomb of Giuseppe di Ardes in S. Giacomo degli Spagnoli.

24. See p. 147, n. 14.

25. The bust was probably carved at the time that Guidi was commissioned to carve the group of Charity for the Cappella Falconieri in S. Giovanni dei Fiorentini.

26. See p. 111, n. 36.

27. Pascoli, *Vite*, I, 254. Monsignor Oddi died 24 February 1668 (Eubel, et al., *Hierarchia*, V, 311, n. 2).

28. See p. 144, n. 18.

29. Eimer, *La Fabbrica*, II, 500, 565, notes that the decision to have the altar carved by Guidi was made in 1672 but cites no source for this information. Eimer also cites a passage from the diary of Carlo Cartari dated 17 February 1677, in which the diarist quotes Guidi as saying that he was about to begin carving the relief. Titi, 1674, p. 139, notes that the relief is to be made by Guidi. The formal contract between Guidi and the Pamphili is dated 27 November 1676 (ASR, Notari dell' A.C., 801, fols. 257, 257v, and 262).

30. ASR, *Corporazioni Religiosi*, S. Agostino fol. 31v, records a verbal agreement between (30 June 1674) the church and Cardinal Azzolino, the executor of Cardinal Imperiali's will, that the tomb of the latter was to be placed in its present location. Titi, 1674, p. 438, notes that Guidi has designed the tomb and is in the process of carving the statues. Titi, 1686, p. 373, describes the tomb, identifying the different statues.

31. See p. 111, no. 32.

32. Titi, 1686, p. 117. Thiene died in 1676 (Forcella, *Iscrizioni*, VIII, 270, no. 679).

33. See p. 147, n. 25.

34. H. P. Scicluna, *The Church of St. John in Valletta*, Rome, 1955, p. 101, fig. 128.

35. Titi, 1686, p. 350.

36. Baldinucci, "Notizie," fol. 57. Cardinal Ricci died in 1682 (Eubel, et al., *Hierarchia*, V, 12, no. 16).

37. Baldinucci, "Notizie di Domenico Guidi," fol. 56v, reports that Queen Christina of Sweden commissioned Guidi to carve such a group when she came to his studio to see the group he made for the king of France. Nicodemus Tessin reported seeing the two putti in the Palazzo Altieri during his visit to Rome in 1686. See O. Sirén, *Nicodemus Tessin d. y:s studiersor i Danmark, Tyksland, Holland, Frankrike och Italien* (Stockholm, 1914) pp. 182 ff.

38. A Sobotka, "Die Tonstatuette eines französischen Kavaliers" and "Das Grabmal des Staatssekretars Phélypeaux in Chateauneuf-sur-Loir und sein Modell," *Amtliche Berichte aus den königlichen Kunstsammlungen* 32 (1911), 235–40, fig. 132, and 33 (1912), 113–24, figs. 63, 64.

39. Pascoli, *Vite*, I, 253.

40. Bershad, "A Series of Papal Busts," pp. 805–9. Bershad attributes a similar bust in the Victoria and Albert Museum, as well as several portraits of Alexander VII, Innocent X, and Innocent XII, to Guidi.

41. In 1690 Carlo Cartari noted in his diary that Guidi was working on the tomb and that it was to be placed in S. Girolamo de' Schiavoni (ASR, *Cartari-Febei*, vol. 101, fol. 23). Baldinucci, "Notizie di Domenico Guidi," fol. 56v, also places the tomb in S. Girolamo de' Schiavoni.

42. Archivio della R. Fabbrica di S. Pietro, *serie armadi*, vol. 391, fols. 41, 47; M. Anatole de Montaiglon, *Correspondance des directeurs de l'Académie de France à Rome* (Paris, 1887), I, 311, 325, 334, 451, 456, 457.

43. Bershad, "A Series of Papal Busts," p. 806. The bust was finished by Vincenzo Felice after Guidi's death.

44. Thieme-Becker, XV, 274.

45. Lazzoni, *Carrara*, p. 183. *Toscana*, Guida d'Italia del Touring Club Italiano (Milan, 1959), p. 183. The statues were not in the church in the summer of 1966.

46. R. Boarini, *Descrizione storica della chiesa di S. Domenico di Perugia* (Perugia, 1778), p. li: O. Guerrieri, *La Chiesa di San Domenico in Perugia* (Perugia, 1960), p. 23.

47. The statue is illustrated in an engraving designed by Guidi and dated 1 January 1696. There is a copy of the engraving in the British Museum (1874–8–6–1617).

48. Baldinucci, "Notizie di Domenico Guidi," fol. 56v.

49. E. Wind, "Shaftsbury as a Patron of the Arts with a Letter by Closterman and Two Designs by Domenico Guidi," *Journal of the Warburg and Courtauld Institutes* 2 (1938–39), 185–88.

50. Baldinucci, "Notizie di Domenico Guidi," fols. 55–57ᵛ, attributes the following works, which have yet to be identified or verified, to Guidi: six marble busts representing Hercules and Iole, Apollo and Diana, and Bacchus and a baccante for the Cardinal de Medici; a bust of Pope Alexander VII sent to the Casa Vizzani in Bologna; a terracotta bust of Signore Canonico Fabretti, sent to Urbino; a figure of the Virgin Anunciate that was in his studio when he died; a model of Christ that was to be cast in silver for Cardinal Albitij, who died before it could be cast; a low relief eight palmi high of the Resurrection of Christ, sent to Pisa.

Appendix 3

Iconographic Text

De Ponte Aelio statuis angelorum exhibentium cruciatus, quos Christus
Dominus pro nobis perpessus est. Decorato a Sanct.^{mo} *D. Nostro Clemente*
IX, Pontifice Maximo elegia.
Rome, 1669 (BV, R. B. Miscell., IV, III [3]).

Aelia quà moles celsis se nubibus insert,
 E summa Michaël signifer arce micat;
(Depulit è Caelo Genios tum numinis hostes,
 Tartara cum cecidit dirus in ima Draco;
Arcet & è Terris; mortales vrget ad Orcum
 Invidus hinc Coluber, Dux pius inde trahit)
Iungitur Vrbs Vrbi, Latioque Etruria Ponte,
 Captivis Tiberis dissecat auctus aquis;
Dum vario flexu (santa est pellacia Romae)
 Indicat hoc aegrè dulce solum;
Sacra via est PETRI ducens ad limina, CHRISTVS
 Claudere cui Caelum, cui reserare dedit;
Ipsius exuvijs Aedes, Palique coruscat,
 Irradiant Orbis lumina bina caput;
Structura, mole, ornatu nitet alter Olympus,
 Sacrorum Sedes, Relligionis apex;
Atria Prisci etiam Paradisi nomine signant,
 Tot quippe Heroüm Pignora cara tenet;
Intervalla igitur Pontis per singula CLEMENS
 Aligerûm meritò singula signa locat;
Mollitèr ut spirant vultus de marmore ducti,
 Sentit, eos venerans Ciuis, & Hospes opem;
Pons iter annectit, quod fluctus dividit; Ales,
 Quam scelus auertit, reddit ad astra viam;
Dirigit & callem curuo Pons fornice, rectà
 Per Mundi anfractus Angelus ire docet.
ORBIS AMOR CLEMENS, valeat quis dicere fando
 Quantum jam debet maxima Roma tibi?
Amplificata Ceres, nova vectigalia cessant;
 Omnibus immunis libera Porta patet;
Fundis opes inopi, mensa dignaris egenum,
 Et lustras pedibus Xenodochia sacris,
Agmina jamdudùm cohibentem Turcica Cretam,

Et Venetos auro; milite, classe juvas;
Fluctibus in mediis Echeneis parvula sistit
 Impulsam ventis, remigioque ratem;
Fisa Deo soli Turcas ita Creta moratur,
 Vincereque assueti detinet arma Scythae;
Lustraque fluxerunt quinque, & vix busta supersunt;
 Hic tamen Eois viribus obstat obex.
Scala sacro CHRISTI, quae (Praesidis ipse Tribunal
 Dum caesus subiit) tincta cruore riget,
Saepiùs illa tuo quamquam aegro poplite pressa est,
 Saepiùs illa tuis fletibus immaduit;
Vtque reos solvis noxis, quas excipis aure,
 Clara aliis veniam pandere voce soles;
Suscipis applausus clamantum fausta Quiritum,
 Omnibus laetis compita quaeque sonant;
Indicisque preces ut places Nummis iram,
 Et lustras habitu supplice Templa frequens,
Sivè domi residens cunctorum vota requiris,
 Nullus abitque tuo tristis ab alloquio;
Compositis floret tranquilla Ecclesia rixis,
 Haeresis in latebras undique pulsa fugit;
Quid Reges memorem unanimes, extinctaque bella,
 Quae Bellona minax exagitare furit?
Haec quoque servabunt laudem monumenta perennem,
 Tamque pium Tellus nulla silebit opus,
Tendet ad effigiem hanc Caeli quòd quisquis in Vrbe
 Angelicis poterit se sociare Choris.
Porrigit humanae quisque instrumenta salutis
 Aliger, is Clauos sustinet, ille Crucem;
Sarcinaque istius fit Lancea, quae latus hausit,
 Alterius saevis texta Corona rubis;
A quodam Flagra, abs alio gestatur aceto
 Imbuta, & tetro Spongia felle tumens;
Est & qui Tunicam, quam Miles sorte lucratus,
 Est Crucis Inscriptum qui Titulum exhibeat;
Dulcitèr hunc onerat praedura Columna, revinctus
 Cui rerum Dominus verbera tanta tulit;
Horruit! heu sputis facies, colaphisque, decoia
 Prae cunctis, & cui flectitur omne genu,
Hanc etiam impressam tenui lino ingerit Ales.
 !En quanta insumpsit Lytra redemptus homo.
Morte uti devicta tot per tormenta, Paterna
 Filius in dextra jam super astra sedet,
Nitere poenarum pennis celer hisce viator,
 Supremum poteris sic penetrare Polum.

SANCTITATIS VESTRAE
Beatissimis Pedibus affusus
Devotissimus Servus, ac Subditus eam pangebat
Iosephus Maria Suaresius Episcopus olim Vasionensis,
Vicarius Basilicae S. Petri, et Sanctitatis Vestra
in Capella Assistens.

Translation[1]

An Elegy on the Aelian Bridge, Decorated by Our Most Holy Lord
Clement IX, Pontifex Maximus, with Statues of Angels Who Show the
Torment that Christ the Lord Endured for Us.

Where the Mausoleum of Hadrian rises up to the clouds,
 From the top of its citadel gleams Michael the Standard-bearer;
(He drove from heaven the spirits who were enemies of God,
 When the dreadful serpent fell into Tartarus' depths;
He also wards them off from the lands; the envious snake
 Thrusts mortals to hell, the faithful leader draws them back
 from there).
City is joined to city, and Etruria to Latium by the bridge;
 The Tiber, swollen with captive waters, cuts them asunder;
While with its varied bends (so great is Rome's allurement)
 The river shows reluctance to leave this sweet soil;
There is a sacred way leading to the threshold of Peter, to whom
 Christ gave the power to close heaven, the power to open it
 again;
With his remains and with Paul's the shrine gleams;
 These two illuminate the capital of the world;
Another Olympus shines in structure, mass, and decoration,
 The seat of saints, the summit of religion;
They call its halls the paradise of old,
 So many of the dear remains of the saints does it hold;
And so at regular intervals along the bridge Clement
 has fittingly placed statues of angels, one by one;
Perceiving their softly breathing countenances drawn in marble,
 The citizen venerates them, and the stranger admires their
 worth,
The bridge joins the route that the waves separate; the angel
 Leads back to the stars the path that sin has turned aside;
The bridge with its curved vault also shows a path,
 An angel teaches it to go straight through the world's devious
 ways.
CLEMENT, LOVE OF THE WORLD! Who could put in words
 How much mighty Rome owes to you already?

The grain supply is increased, new taxes cease;
 For all men the gate lies open, untaxed and free;
You pour forth your wealth for the poor, you are honored by the
 table of the needy.
 And with your sacred feet you visit the almshouses,
You aid Crete, which has long restrained the Turkish forces,
 And assist the Venetians with gold, soldiers, and a fleet;
In the middle of the sea the little fish stops
 A craft driven by winds and oars;
Thus, trusting in God alone, Crete delays the Turks,
 Detains the arms of the Scythian, who is accustomed to conquer;
Twenty-five years have passed and the tombs scarcely suffice,
 Yet this barrier blocks the power of the East.
The stairway, stained with the sacred blood of Christ, ascends
 (He himself, until slain, submitted to the ruler's tribunal).
It has been pressed often by your knee, though weak;
 It has so often grown wet with your tears;
And as you release the accused from crimes to which you give ear,
 To others you are accustomed to extend pardon with clear voice;
You receive the applause of Romans shouting joyfully,
 With happy omens each crossroad resounds;
And you proclaim prayers to appease the wrath of God,
 And often you walk through temples in suppliant's garb,
Or, residing at home, you listen to the desires of all,
 And no one departs unhappy after speaking with you;
Quarrels settled, the tranquil Church flourishes;
 Heresy flees, on all sides driven into hiding;
Why should I mention kings in agreement, and wars extinct
 Which the threatening goddess of war rages to incite?
These monuments, too, will keep your praise everlasting,
 And so devoted a work no land will pass over in silence,
Everyone in the city will hasten to this image of Heaven
 Because they will be able to join the angelic choir.
Each angel holds out the instruments of human salvation,
 This one holds the Nails, that one the Cross,
The burden of this one is the Lance that drained his side,
 Of another, it is the Crown woven with cruel brambles;
By one is carried the Scourge, by another the Sponge
 Steeped in vinegar and swollen with black bile;
There also is one showing the Tunic that the soldier gained by lot,
 There is one who displays the Title inscribed on the Cross;
The hard Column sweetly burdens this one, to which the Lord of
 the world
 Was bound and bore so many beatings;
Alas, for the spittings and blows on that face,
 Comely before all others and before which every knee is bent;

Its impression, too, an angel carries on delicate linen.
 Behold how great a ransom the redemption of man required!
Having conquered death through so many torments,
 The Son now sits at his Father's right hand above the stars;
Swift wayfarer, fly on the wings of these sufferings,
 Thus you will be able to reach the highest pole.

YOUR HOLINESS
 Your most devoted servant and subject, prostrate at the most blessed feet of Your Holiness, composed this work—Joseph Maria Suarez, former Bishop of Vaison, Vicar of the Basilica of St. Peter, and Assistant in the Chapel of Your Holiness.

1. The translation was corrected by Professor Kevin Herbert of Washington University, St. Louis, Missouri.

Selected Bibliography

Alberti, Leon Battista. *De re aedificatoria*. Florence, 1485: 1st English edition translated by James Leoni, London, 1726; reprint edited by J. Rykwert, London, 1955.

Alveri, Gasparo. *Roma in ogni stato*. 2 vols. Rome, 1664.

Armellini, Mariano. *Le Chiese di Roma*. 2 vols. Rome, 1942.

Ashby, Thomas. "Lievin Cruyl e le sue vedute di Roma." *Memorie della Pontificia Accademia Romana di Archeologia* 1 (1923), 221–29.

———, *Topographical Studies in Rome in 1581*. London, 1916.

Baglione, Giovanni. *Le Vite de'pittori, scultori et architetti*. Rome, 1642.

Baldinucci, Filippo. *Notizie de' professori del disegno da Cimabue in qua*. 4 vols. Florence, 1681–1728.

———. "Notizie di Domenico Guidi e Giuliano Finelli, scultori." Biblioteca Nazionale Centrale, Florence, MS II, 110, fols. 53–60.

———. *Vita del Cavaliere Gio. Lorenzo Bernino, scultore, architetto e pittore*. Florence, 1682. Annotated Italian edition by Sergio Samek Ludovici, Milan, 1948. English translation by Catherine Enggass, University Park, Pa. 1966.

Bellori, Giovanni Pietro. *Le Vite de' pittori, scultori et architetti moderni*. Rome, 1672.

Bernini, Domenico. *Vita del Cavalier Gio. Lorenzo Bernino*. Rome, 1713.

Bershad, David. "A Series of Papal Busts by Domenico Guidi." *The Burlington Magazine* 112 (1970), 805–9.

———. "Domenico Guidi and Nicolas Poussin." *The Burlington Magazine* 113 (1971), 544–47.

Bonanni, Filippo. *Numismata pontificum romanorum quae à tempore Martini V usque ad annum M.D.C.XCIX*. 2 vols. Rome, 1699.

Bonini, F. M. *Il Tevere incatenato, overo l'arte di frener l'acque correnti*. 1st edition Rome, 1663. Rome, 1931.

Borsari, Luigi. "Notizie degli scavi." *Atti della R. Accademia dei Lincei*, ser. 4, 9 (1892), 230–33, 412–28.

Brauer, Heinrich, and Wittkower, Rudolf. *Die Zeichnungen des G. L. Bernini*. 2 vols. Berlin, 1931.

Briganti, Giuliano. *Pietro da Cortona, o della pittura barocca*. Florence, 1962.

Bruhns, Leo." Das Motiv der ewigen Anbetung in der römischen Grabplastik des 16., 17. und 18. Jahrhunderts." *Römisches Jahrbuch für Kunstgeschichte* 4 (1940), 253–432.

Campori, Giuseppe. *Memorie biografiche degli scultori, architetti, pittori, ecc. nativi di Carrara e di altri luoghi della Provincia di Massa*. Modena, 1873.

Cancellieri, Francesco. *Storia de' solenni possessi de'sommi ponifici*. Rome, 1802.

Canons and Decrees of the Council of Trent. Translated H. J. Schroeder. London and St. Louis, 1960.

Castagnoli, Ferdinando, et al. *Topografia e urbanistica di Roma*. Rome, 1958.

Castellani, P. Giuseppe. *La Congregazione dei Nobili presso la chiesa del Gesù*. Rome, 1954

Castelli, Domenico. "Prospetti e piante di tutti gl'edificij eretti dentro come fuori di Roma dalla felice mem.ª d' Urbano VIII." BV, *Barb. lat.* 4409.

Cempanari, Atanasio, and Amodei, Tito. *La Scala Santa*. Le chiese di Roma illustrate, no. 72. Rome, 1963.

Coudenhove-Erthal, Eduard. *Carlo Fontana und die Architektur des römischen Spätbarocks*. Vienna, 1930.

Cugnoni, G. "Appendice al commento della vita di Agostino Chigi il Magnifico." *Archivio della Società Romana di Storia Patria* 4 (1883), 523–39.

De Ayala, Giovanni Interian. *Istrutioni al pittor cristiano*. Translated by Luigi Napoleone Cittadella. Ferrara, 1854.

De Santi, Angelo, S.J. *L'Orazione delle quarant' ore e i tempi di calamità e di guerra*. Rome, 1919.

Disegni de le ruine di Roma e come anticamente erono. Facsimile edition with an introduction by Rudolf Wittkower. Milan, 1963.

Donati, Ugo. *Artisti ticinesi a Roma*. Bellinzona, 1942.

Dorati, Maria Cristina. "Il Bernini e gli angeli di Ponte S. Angelo nel diario di un contemporaneo." *Commentari* 17 (1966), 349–52.

Dudden, Frederick Homes. *Gregory the Great*. 2 vols. London, 1905.

Egger, Hermann. *Römische Veduten, Handzeichnungen aus dem XV.–XVIII. Jahrhunderts*. 2 vols. 2nd ed. Vienna, 1932.

Eimer, Gerhard. *La Fabbrica di S. Agnese in Navona, römische Architekten, Bauherren und Handwerker im Zeitalter des Nepotismus*. 2 vols. Stockholm, 1970–71.

Enggass, Robert. *The Painting of Baciccio*. University Park, Pa., 1964.

Erizzo, Sebastiano. *Discorsi sopra le medaglie degli antichi*. 2nd ed. (?) Venice, 1568.

Eubel, Conrad, et al. *Hierarchia catholica medii et recentioris aevi . . .* 6 vols. Regensberg, 1933–58.

Evers, Hans Gerhard. *Die Engelsbrücke in Rom*. Berlin, 1948.

Fabiani, Giuseppe. *Artisti del sei- settecento in Ascoli*. Ascoli Piceno, 1961.

Fagiolo dell' Arco, Maurizio and Marcello. *Bernini, una introduzione al gran teatro del barocco*. Rome, 1967.

Fasolo, Furio. *L'Opere di Heironimo e Carlo Rainaldi*. Rome, 1961.

Forcella, Vincenzo. *Iscrizioni delle chiese e d'altri edificii di Roma dal secolo XI fino ai giorni nostri*. 14 vols. Rome, 1869–84.

———. *Tornei e giostre, ingressi trionfali e feste carnevalesche in Roma sotto Paolo III*. Rome, 1885.

Francis, Henry S. "Drawings by Lievin Cruyl of Rome." *The Bulletin of the Cleveland Museum of Art* 30 (1943), 152–59.

Fraschetti, Stanislao. *Il Bernini*. Milan, 1900.

Frutaz, Amato Pietro. *Le Piante di Roma*. 3 vols. Rome, 1963.

Fulvio, Andrea. *Antiquaria urbis*. Rome, 1513; 1st Italian edition, *Delle Antichità della città di Roma*. Venice, 1543.

Galassi-Paluzzi, Carlo. *S. Pietro in Vaticano*. 3 vols. Le chiese di Roma

illustrate, nos. 74–78 bis. Rome, 1963.

Gnecchi, Francesco. *I Medaglioni romani*. 3 vols. Milan, 1912.

Golzio, Vincenzo. *Documenti artistici sul seicento nell'archivio Chigi*. Rome, 1939.

———. "Documenti berniniani." *Archivi d'Italia* 1 (1933–34), 143–45.

———. "Lo 'Studio' di Ercole Ferrata." *Archivi d'Italia* 4 (1937), 64–74.

Grassi, Luigi. "Disegni inediti del Bernini e la decorazione di Ponte S. Angelo." *Arti figurative* 2 (1946), 186–99.

———. *Gianlorenzo Bernini*. Rome, 1962.

Haskell, Francis. *Patrons and Painters*. London, 1963.

Henkel, Arthur, and Schöne, Albrecht. *Emblemata, Handbuch zur Sinn-bildkunst des XVI. und XVII. Jahrhunderts*. Stuttgart, 1967.

Hibbard, Howard. *Bernini*. Harmondsworth, 1965.

———. *Carlo Maderno and Roman Architecture 1580–1630*. London and University Park, 1971.

Huelsen, Christian. "Vierter Jahresbericht ueber neue Funde und Forschungen zur Topographie der Stadt Rom." *Römische Mitteilungen des Deutschen Archaeologischen Instituts* 8 (1893), 259–325.

Ignatius, St. *The Spiritual Exercises*. Translated by Thomas Corbishley, S.J. New York, 1963.

Kauffmann, Hans. *Giovanni Lorenzo Bernini, die figürlichen Kompositionen*. Berlin, 1970.

Kronig, Wolfgang. "Geschichte einer Rom-Vedute." *Miscellanea Bibliothecae Herzianae zu ehren von Leo Bruhns, Franz Graf Wolff Metternich und Ludwig Schudt*. Munich, 1961.

Kruft, Hanno-Walter, and Larsson, Lars Olaf. "Entwürfe Berninis für die Engelsbrücke in Rom." *Münchner Jahrbuch der bildenden Kunst* 17 (1966), 145–60.

Lanciani, Rodolfo. "Recenti scoperti di Roma e suburbia." *Bullettino della Commissione Archeologica Comunale di Roma* 21 (1893), 3–29.

Lankheit, Klaus. *Florentinische Barockplastik*. Munich, 1962.

Lavagnino, Emilio; Ansaldi, Giulio; and Salerno, Luigi. *Altari barocchi in Roma*. Rome, 1959.

Lavin, Irving. *Bernini and the Crossing of Saint Peter's*. New York, 1968.

———. "Bozzetti and Modelli: Notes on Sculptural Procedure from the Early Renaissance through Bernini." In *Akten des 21. Internationalen Kongresses für Kunstgeschichte in Bonn 1964*, III, 93–104. Berlin, 1967.

———. Review of Rudolf Wittkower, *Gian Lorenzo Bernini*. *The Art Bulletin* 38 (1956), 255–60.

———. "The Bozzetti of Gianlorenzo Bernini." Ph.D. dissertation, Harvard University, 1955.

Lazzoni, Carlo. *Carrara e le sue ville*. Carrara, 1880.

Le Gall, Joel. *Le Tibre fleuve de Rome dans l'antique*. Paris, 1953.

Mâle, Emile. *L'Art religieux après le Concile de Trente*. Paris, 1932. 2nd rev. ed. Paris, 1951.

Mandowsky, Erna, and Mitchell, Charles. *Pirro Ligorio's Roman Antiquities*. London, 1963.

Missirini, Melchiorre. *Memorie per servire alla storia della romana Accademia di S. Luca, fino alla morte di Antonio Canova*. Rome, 1823.

Montagu, Jennifer, "Antonio and Gioseppe Giorgetti: Sculptors to Cardinal Francesco Barberini." *The Art Bulletin* 52 (1970), 278–98.

Montaiglon, Anatole de. *Correspondance des directeurs de l' Académie de France à Rome*. 17 vols. Paris, 1887–1908.

Montalto, Lina. "Ercole Ferrata e le vicende litigiose del basso rilievo di Sant' Emerenziana." *Commentari* 8 (1957), 47–68.

Moroni, Gaetano, ed. *Dizionario di erudizione storico-ecclesiastica da S. Pietro sino ai nostri giorni*. 103 vols. Venice, 1840–61.

Nash, Ernest. *Pictorial Dictionary of Ancient Rome*. 2 vols. New York, 1962.

Nava, Antonia. "I Bernini e gli angeli di Ponte S. Angelo." *L'Illustrazione vaticana* 7 (1936), 619–22.

———. "Scultura barocca a Roma." *L'Arte* 40 (1937), 284–305.

Nava-Cellini, Antonia. "Contributi a Melchior Caffà." *Paragone* 7, no. 83 (1956), 17–31.

———. "Contributo al periodo napoletano di Ercole Ferrata." *Paragone* 12, no. 137 (1961), 37–44.

———. "Per Alessandro Algardi e Domenico Guidi." *Paragone* 11, no. 121 (1960), 61–68.

———. "Per i'integrazione e lo svolgimento della ritrattistica di Alessandro Algardi." *Paragone* 15, no. 177 (1964), 15–36.

Nibby, Antonio. *Roma nell'anno* MDCCCXXXVIII. 4 vols. Rome, 1838–41.

Noehles, Karl. *Roma l'anno 1663 di Giov. Batt. Mola*. Berlin, 1966.

Norton, Richard. *Bernini and Other Studies*. New York, 1914.

Onofrio, Cesare D'. *Il Tevere e Roma*. Rome, 1968.

———., ed. *Roma nel Seicento*. Florence, 1968.

Ozzola, Leandro. "L'Arte alla corte di Alessandro VII." *Archivio della Società Romana di Storia Patria* 31 (1908), 5–91.

Paeseler, Wilhelm. "Die römische Weltgerichtstafel im Vatikan." *Römisches Jahrbuch für Kunstgeschichte* 2 (1938), 311–94.

Palladio, Andrea. *I Quattro Libri dell'Architettura*. Venice, 1570.

Panofsky, Erwin. *Early Netherlandish Painting*. London, 1953.

Pascoli, Leone. *Vite de' pittori, scultori ed architetti*. 2 vols. Rome, 1730–36.

Passeri, Giovanni Battista. *Die Künstlerbiographien*. Edited by Jacob Hess. Leipzig and Vienna, 1934.

Pastor, Ludwig von. *The History of the Popes from the Close of the Middle Ages*. 40 vols. London and St. Louis, 1894–1953.

Pierce, S. Rowland. "The Mausoleum of Hadrian and the Pons Aelius." *The Journal of Roman Studies* 15 (1925), 95 ff.

Platner, Samuel B., and Ashby, Thomas. *A Topographical Dictionary of Ancient Rome*. London, 1929.

Pollak, Oskar. *Die Kunsttätigkeit unter Urban VIII*. 2 vols. Vienna, 1927–31

Pradel, Jean. *Le Sacrifice eucharistique d'aprè Saint Grégoire le Grand*. Brignais, 1913.

Rainaldi, Giuseppe. *Cibo dell'anima, overo dell'orazione mentale, pratica ordinata alla Passione di Christo Signore Nostro per tutti li giorni del mese*. Rome, 1641. 1st ed. Rome, 1633.

Réau, Louis. *Iconographie de l'art chrétien*. 3 vols Paris, 1955–59.

Reymond, Marcel. "Le Pont Saint-Ange par le Bernini." *Revue de l'art ancien et modern* 32 (1912), 99–112.

Richmond, Ian A. *The City Wall of Imperial Rome*. Oxford, 1930.

Ripa, Cesare. *Iconologia*. 1st illustrated edition Rome, 1603.

Rodocanachi, Emmanuel. *Le Château Saint-Ange*. Paris, 1909.

Salviatti, Jacopo. *Fiori dell'orto di Gessemani e del Calvario, sonetti . . . alla santità di N. S. Clemente IX Pont. O. M.* Florence, 1667.

Schlosser Magnino, Julius. *La letteratura artistica*. 3rd Italian ed. Florence, 1964.

Schudt, Ludwig. *Le Guide di Roma*, Vienna, 1930.

Serlio, Sebastiano. *Tutte l'opere d'architettura et prospetiva*. Venice, 1619.

Severano, Giovanni. *Memorie sacre delle sette chiese di Roma e di altri luoghi che si trovano per le strade di esse*. 2 vols. Rome, 1630.

Teresa of Jesus, St. *The Complete Works*. Translated by E. Allison Peers. 3 vols. London and New York, 1957.

Titi, Filippo. *Ammaestramento utile e curioso di pittura, scoltura et architettura nelle chiese di Roma*. Rome, 1686.

——. *Descrizione delle pitture, sculture e architettura esposte al pubblico in Roma*. Rome, 1763.

——. *Studio di pittura, scoltura et architettura nelle chiese di Roma*. Rome, 1674.

Tolnay, Charles de. *Michelangelo*. V: *The Final Period: Last Judgment, Frescoes of the Pauline Chapel, Last Pietàs*. Princeton, 1960.

Totti, Pompilio. *Ritratto di Roma moderna*. Rome, 1638.

Valentini, Roberto, and Zucchetti, Giuseppe, eds. *Codice topografico della città di Roma*. 4 vols. Rome, 1940–53.

Vloberg, Maurice. *L'Eucharistie dans l'art*. 2 vols. Grenoble and Paris, 1946.

Voragine, Jacobus de. *The Golden Legend*. Translated G. Ryan and H. Ripperger. 2 vols. New York, 1941.

Weibel, Walther. *Jesuitismus und Barockskulptur in Rom*. Strassburg, 1909.

Weil, Mark. "Antonio Raggi." Master's Essay, Columbia University, 1964.

——. "The Angels of the Ponte Sant'Angelo: A Comparison of Bernini's Sculpture to the Work of Two Collaborators." *Art Journal* 30 (1971), 252–59.

Wirth, Karl-August. "Engel." In *Reallexikon zur deutschen Kunstgeschichte*, 5, cols. 341–555. Stuttgart, 1960.

Wittkower, Rudolf. *Art and Architecture in Italy 1600–1750*. 2nd ed. Harmondsworth, 1965.

——. "Domenico Guidi and French Classicism." *Journal of the Warburg and Courtauld Institutes* 2 (1938–39), 188–90.

——. *Gian Lorenzo Bernini, the Sculptor of the Roman Baroque*. 2nd ed. London, 1966.

——. "The Role of Classical Models in Bernini's and Poussin's Preparatory Work." In *Studies in Western Art. Acts of the Twentieth International Congress of the History of Art*, III, *Latin American Art and the Baroque Period in Europe*, pp. 41–50. Princeton, 1963.

Zeri, Federico. *La Galleria Pallavicini in Roma*. Florence, 1959.

Photographic Credits

Index